American Writers at Home

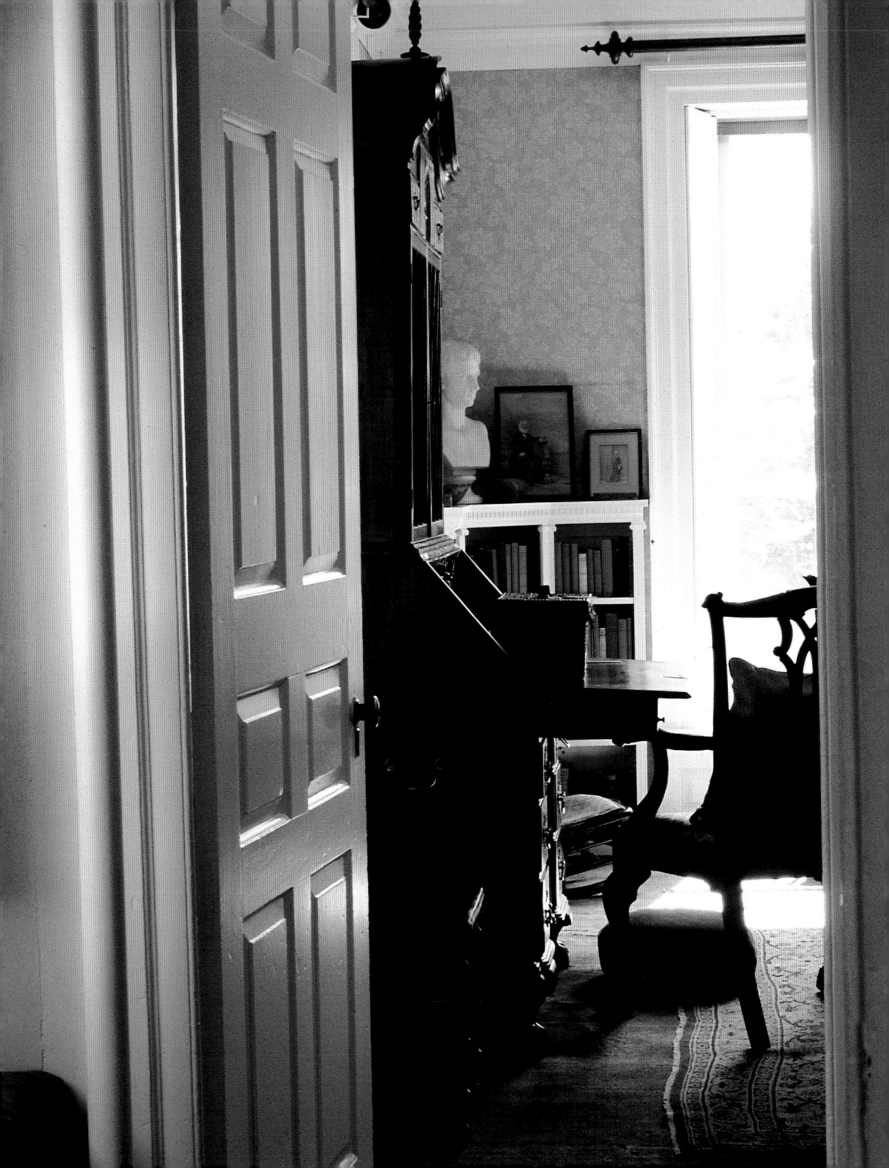

American Writers at Home

J. D. McClatchy

Photographs by Erica Lennard

Acknowledgments

For general help, I would like to thank Sarah Davis, Kamran Javadizadeh, Susan Bianconi, Max Rudin, Cheryl Hurley, Sharon Graham, Mark Magowan, Alex Gregory, Isabel Venero, and Chip Kidd.

For facilitating my visits to the various houses, I would like to thank:
Orchard House: Jan Turnquist, Maria Powers;
The Kate Chopin House: Amanda Chenault, Ada Jarrett;
The Mark Twain House: Rebecca Floyd, Joseph Fazzino, Margaret Moore;
Dickinson Homestead: Cindy Dickinson;
The Frederick Douglass House: Eola Dance, Cathy Ingram, Julie Galonska;
The Emerson House: Joanne Mente, David Wood, Carol Haines, Margaret Bancroft;
Rowan Oak: William Griffith, David Galef;
The Robert Frost Farm: Lesley Lee Francis, Jack Hagstrom, Ben Fontaine;
The Old Manse: Laurie Butters, Robert Derry, Nancy Joroff;
Ernest Hemingway Home: John Dentinger;
Sunnyside: Sharon Heule;
Tor House: Lindsay Jeffers, Alex Vardamis, Joan Hendrickson;
The Jewett House: Martha Sulya;
Craigie House: James Shea, Paul Blandford, Anita Israel;
Arrowhead: Mary Catherine Murphy, Catherine Reynolds;
Steepletop: Elizabeth Barnett and her daughter Vincent, Holly Peppe, Whitney North Seymour Jr.;
Andalusia: Louise Florencourt, William Sessions;
Tao House: David Blackburn, Margaret Styles;
The Eudora Welty House: Mary Alice Welty-White, Suzanne Marrs;
The Mount: Erica Donnis, Pamela Kueber;
The Walt Whitman House: Leo Blake.

— *J. D. McClatchy*

When Francesca Premoli-Droulers and I embarked on our first book, *Writers' Houses*, I was living in Paris and we put together a list of internationally recognized twentieth-century writers whose homes we found inspiring. When I was asked by Vendome Press and The Library of America to explore the subject of great American writers' homes, I was excited by the prospect of being able to include in this new volume many important writers we had left out of the first volume.

The journey has been long and enriching, though sometimes daunting. It has been a challenge to try to bring these houses to life, breathe some soul and light into them and help the reader get a sense of what the lives of these great men and women might have felt like as they created their literary masterpieces. Perhaps the richness of their stories so beautifully told by J. D. McClatchy may also be more profoundly enhanced when you have had the privilege to read (or re-read) their words as I did just before I embarked on each trip. I was able to hear the echo of their voices as I tried to capture with my camera fragments of what they might have seen or felt. I would like to thank all those who have helped me along my way: the editorial staff of Vendome Press, including Mark Magowan, Alex Gregory, Isabel Venero, and Sarah Davis; the book's designer Marc Walter at StudioChine; and to the "keepers of the flame," including family descendants, curators, national park rangers, and trustees who were always available to lend a helpful hand. Special thanks to Eleanor Briggs, Leslie and Andrew Cockburn, Brook Adams, and Lisa Liebman for their comfortable lodgings; to my husband Denis Colomb whom I missed when was on the road; and finally to my mother and father who allowed me to grow up surrounded by books. I would like to dedicate this book to my stepmother Suzanne Crowhurst Lennard whose continued passion and study of the homes of great writers deserves to be praised and to Francesca Premoli-Droulers for her wise words and supportive company during the creation of the first *Writers' Houses*.

— *Erica Lennard*

First published in the United States of America by
The Library of America and The Vendome Press.

Compilation copyright © 2004 Literary Classics of the United States, Inc., and The Vendome Press
Text copyright © 2004 J. D. McClatchy
Photographs (unless otherwise noted below) copyright © 2004 Erica Lennard

Designed by Marc Walter and Studio Chine
Printed in China

ISBN: 1-931082-75-8

Library of Congress Cataloging-in-Publication Data

McClatchy, J. D., 1945-
American writers at home / J. D. McClatchy ; photographs by Erica Lennard.
 p. cm.
ISBN 1-931082-75-8
 1. Literary landmarks—United States. 2. Authors, American—Homes and haunts—United States. 3. Authors, American—Biography. I. Lennard, Erica. II. Title.

PS141.M34 2004
810.9—dc22
[B] 2004048431

Photo credits: 11: Louisa May Alcott, c. 1850. Courtesy Orchard House. 12 bottom and 19 bottom: courtesy Orchard House. 21: Kate Chopin, before 1899. The Newberry Library, Chicago. 24 left and 25 bottom: Northwestern State University of Louisiana, Watson Memorial Library, Cammie G. Henry Research Center. 29: Mark Twain, c. 1900. Yale Collection of American Literature, Beinecke Rare Book and Manuscript Library. 30: Yale Collection of American Literature, Beinecke Rare Book and Manuscript Library. 37 bottom: Library of Congress Prints and Photographs Division [LC-USZ62-96127]. 41 left: Amherst College Archives and Special Collection. By permission of the Trustees of Amherst College. 41 right and 42 right: by permission of the Jones Library, Inc., Amherst, MA. 44 right: Amherst Historical Society, Amherst, MA. 47 both: Amherst College Archives and Special Collection. By permission of the Trustees of Amherst College. Left also: Reprinted by permission of the publishers from *The Poems of Emily Dickinson*, Thomas H. Johnson, ed., Cambridge, MA: The Belknap Press of Harvard University Press, Copyright © 1951, 1955, 1979 by the President and Fellows of Harvard College. 49 left: Frederick Douglass, c. 1890. Yale Collection of American Literature, Beinecke Rare Book and Manuscript Library. 49 right: courtesy National Park Service. Frederick Douglass National Historic Site. 56 left: The Schlesinger Library, Radcliffe Institute, Harvard University. 61: Ralph Waldo Emerson, c. 1850. Yale Collection of American Literature, Beinecke Rare Book and Manuscript Library. 62 bottom: courtesy Concord Free Public Library. 65 bottom: courtesy Houghton Library, Harvard University. 70 right: courtesy Concord Free Public Library. 73: William Faulkner, 1947. 75 left: United Press International. 78 right: © Bettman/CORBIS. 80 bottom: Cofield Collection, Southern Media Archive, University of Mississippi Special Collections. 83 left: Robert Frost, c. 1915. Library of Congress Prints and Photographs Division, NYWT & S Collection, [LC-USZ62-116102]. 84 right: by permission of the Jones Library, Inc., Amherst, MA. 93: Nathaniel Hawthorne, c. 1860. Library of Congress Prints and Photographs Division, Brady-Handy Collection [LC-DIG-cwpbh-033440]. 94 right: courtesy Concord Free Public Library. 103 left (detail of 108 right): Historical Museum of Southern Florida (HMSF). 107 left: Ernest Hemingway Photograph Collection, John Fitzgerald Kennedy Library, Boston. 113 left: Washington Irving, c. 1849. Library of Congress Prints and Photographs Division, Brady-Handy Collection [LC-USZ61-1844]. 114 right: Robert N. Dennis Collection of Stereoscopic Views, Miriam & Ira D. Wallach Division of Art, Prints & Photographs, The New York Public Library, Astor, Lenox and Tilden Foundations. 125: Robinson Jeffers, c. 1930. Courtesy Robinson Jeffers Tor House Foundation. 126 right and 128 bottom: Courtesy Robinson Jeffers Tor House Foundation. 135: Sarah Orne Jewett, c. 1890. The Schlesinger Library, Radcliffe Institute, Harvard University. 139: courtesy Houghton Library, Harvard University. 140: New Hampshire Historical Society, Concord. 145: Photograph by Julia Margaret Cameron. Henry Wadsworth Longfellow, 1868. University of Washington Libraries, Special Collections, 17891. 146 left and 150 left: courtesy National Park Service. Longfellow National Historic Site. 155 left: Herman Melville, 1861. Berkshire Athenaeum, Pittsfield, MA. 156 right: Berkshire Athenaeum, Pittsfield, MA. 160

Contents

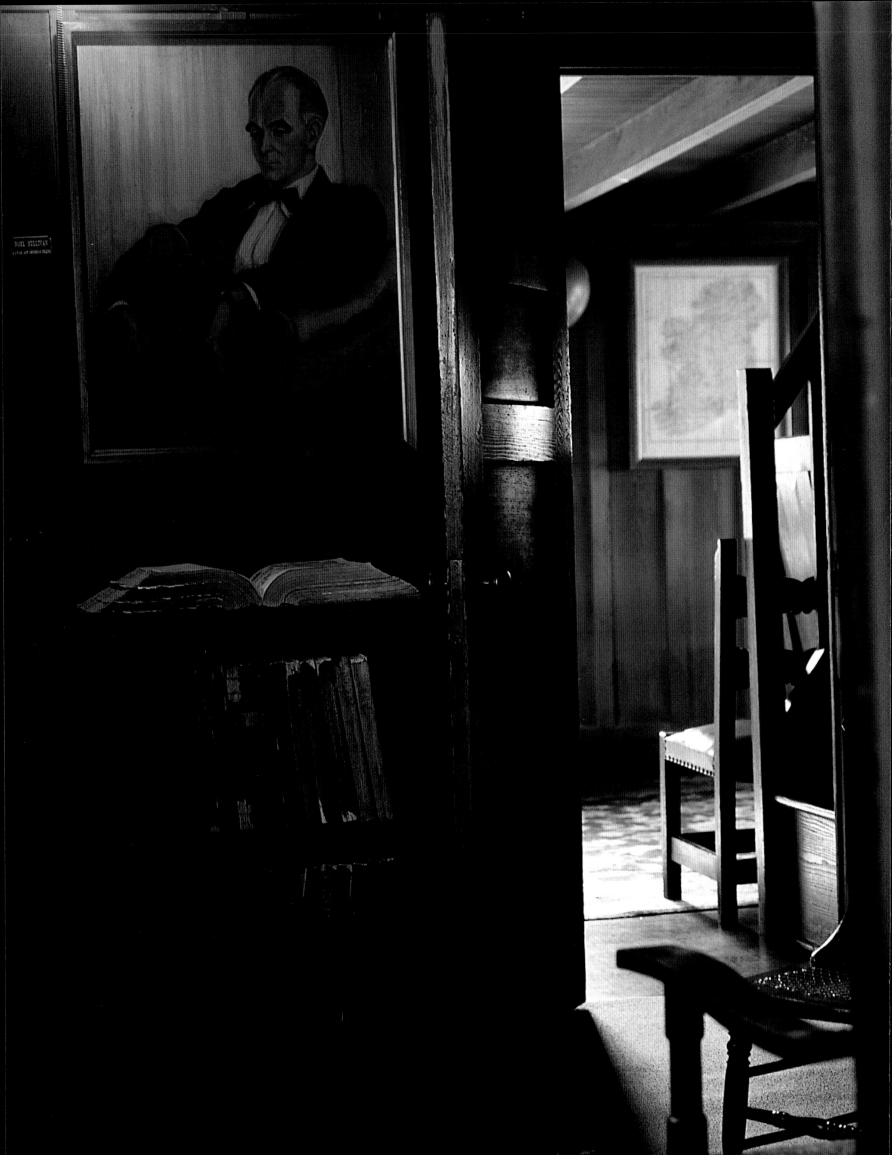

Introduction

M yself, I live in what might be called a literary village. Stonington, Connecticut, has had a long history. It was settled in 1752, and we still call our mayor and town councilmen the warden and burgesses. There was a minor battle in the War of 1812 fought here, but Stonington in its day was a major center for shipbuilding, sealing, and fishing. (On one voyage to explore new seal-hunting grounds, a young Stonington captain, Nathaniel Palmer, discovered Antarctica.) Before there was a direct rail line between Boston and New York, trains from the north stopped in Stonington and passengers continued on to Manhattan by boat. Still, it is a tiny place—half fishing fleet, half Yankee clapboard—just two streets wide, a finger of granite sticking out into Long Island Sound. One wag said the place, with its library at one end of town and its lighthouse at the other, reminded him of ancient Alexandria. But the cozy routines of village life prevail here. It may be some combination of seaside traditions and picturesque calm that has drawn writers for decades now. Stephen Vincent Benét grew up on Main Street (in the house where the painter James Abbott McNeill Whistler, with his mother, lived as a child), and poet James Merrill lived on Water Street for forty years. Mary McCarthy honeymooned here, and Truman Capote summered here. Elizabeth Bowen and Yukio Mishima came for weekends. So did William Faulkner and Gore Vidal and John Updike. Writers are drawn to the village as well because there are other writers around. A few years ago, our library threw a benefit party for itself on the town green, honoring the local Literary Lions. Quite a pride of them showed up. Like other professionals, writers like shop talk and gossip over drinks. They like company—but only at certain times. What they like less but need more is solitude.

America has always been a nation of *isolatos*, solitaries striking out on their own. Thornton Wilder once said that Americans are people who have outgrown their fathers. As in Walt Whitman's poems, Wilder's Americans work alone. They are energetic, inventive, and restless, but disciplined. They are responsible but detached. They are one with the cold moonlight that falls equally on corpse and cradle, apple and ocean. Europeans could never understand why we didn't stay close to clan, why we headed off into the unfamiliar, why we built our cabins on the pond's edge. In part, our cramped origins in the Old World and the vastness of the new land sprang us all loose. I had a good friend, only recently dead now, whose grandfather had been born in the eighteenth century, when John Adams was president. Our history is abrupt and extraordinary, almost an octave one hand can span. Floods of people have washed up here, and poured over the land, all of them struggling to make up a history of their own. They move toward the wilderness and the West, toward opportunities in the anonymous city, toward the promise of freedom up North, toward a homestead on the prairie, each man and woman striking out to erase a past and create a future. Each day, Americans begin all over again. In that, they resemble the

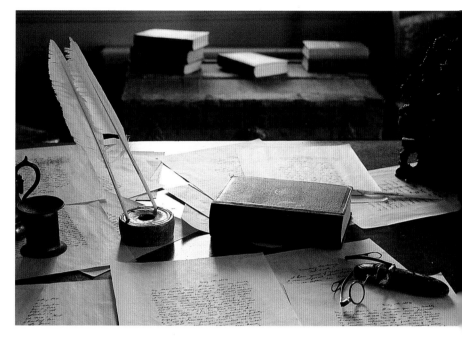

writer, who each morning sits down to a blank piece of paper. But few writers are as adventurous as the true pioneers whose spiritual descendants they are. Writers need solitude, but it must be a protected privacy . . . a shelter in which to dream . . . a home.

This is not a book about writers, or about houses, or about America. It is a book about where and why and how American writers made a home for themselves—a place to live, yes, but above all a place to work—in a restless, rugged country. And given the immense scope of American writing, some decisions were in order. Celebrated authors of our day are often visited at home by magazine and television profilers. It seemed better to travel back, to look into places where our literary heritage was born. We decided too that we wanted to concentrate on homes where books—many of them now our classics, the touchstones of our national greatness—were actually written, to visit the rooms where *Moby-Dick, Adventures of Huckleberry Finn, Light in August,* or *Long Day's Journey into Night* were, line by line, page by page, put together. These homes are often quite humble, sometimes eccentric. America rarely offers its writers any grandeur, which is why the luxuriousness of Edith Wharton's house in Massachusetts or Mark Twain's in Connecticut stand out. Most authors could not afford, and even more would not want, the sumptuous scale of Wharton's The Mount or the custom-made detail of Twain's interiors, because the larger the home, the greater the distractions. In any case, whatever it cost those two writers to build the houses of their dreams, both stories ended in sorrow. Houses have their own stories, of course, no matter who lives in them.

Homes are hostages to circumstance. War or bankruptcy, a windfall or a disease—things rush at us all unexpectedly and force a

change. Indeed, on second thought it can seem remarkable that many of these homes can be visited at all. When houses pass into new hands, those hands are not always interested in holding on to the past. Only the passion of those individuals—some in government service, some with a private fervor—who have cherished the work of these writers and sensed its value for generations to come have helped save them. And not just save the houses, but preserve the homes. This has meant keeping them as they were, or restoring them to their original condition, meticulously using old records or vintage photographs to ensure that things are exactly right. Through their efforts, we can capture for ourselves the daily lives—where they slept and ate and walked—of men and women who sought in their work always to be elsewhere. When you look at one of Erica Lennard's photographs—say, of the hallway in Robert Frost's old farm in New Hampshire—it's difficult not to imagine the poet about to come in the door. The palpable presence of the author is something felt throughout this book. How a writer lives day by day, after all, is one key to his or her imagination.

The decision to focus on houses where writers actually wrote has meant that many interesting and valuable sites had to be ignored. All across the country, for instance, the birthplaces of famous writers are preserved, or at least landmarked. But Willa Cather never wrote anything in Red Cloud, Nebraska, nor Sinclair Lewis in Sauk Center, Minnesota. The Midwest has often been the nursery of genius, but rarely its home. The fact that writers born in the Midwest—from William Dean Howells to F. Scott Fitzgerald—so often hurried East as soon as they could, both to learn and to write, has meant that we have passed them up. They wrote *about* Back Home, but they had long since left it to do so, and we have wanted to capture the look and atmosphere of the working writer's home. On the other hand, writers who lived in our big cities have been subject to other forces—urban renewal, say, or the real estate market. In cities, houses over time are torn down or re-rented: landlords and new owners aren't soft-hearted. The apartment in Brooklyn where Hart Crane wrote *The Bridge*? Demolished. The house in Salinas where John Steinbeck grew up? Now a restaurant. And the house in Monte Sereno where he wrote *The Grapes of Wrath*? The new owner wasn't impressed: "I bought the house because I liked it. When they said it was John Steinbeck's, I said, 'So what?'" And when the city wouldn't let him make significant renovations to the house, he got himself elected to the city council in order to help repeal its preservation laws. Four members of the Monte Sereno historic commission resigned in disgust. From coast to coast, there are sadder stories of our cultural heritage bought and sold, destroyed or ignored. That sorry fact only makes the work of preservationists more precious and heartening. The houses they saved and restored are a crucial part of our national archive, and the scope of this book, traveling from the rocky cliffs of California to the bayous of Louisiana, is a vivid testimony to the varied landscape of our literature.

"Home is where one starts from," said T. S. Eliot. But that is the home lodged in the heart and constantly remodeled in memory. The new homes writers make for themselves and their families contain those old memories, to be sure, but are meant to be more refuge than reminder. A *house* is a dwelling. A *home* is a house and everything in and around it: landscape and neighbors, children and animals, the scale, the light, the lore, the love. The old saying has it that "God setteth the solitary in families," but that can seem a mixed blessing. Writers tend to be picky individuals, sometimes even neurotic, when it comes to the part of a home reserved for work. It's not just that they are creatures of habit, though Hemingway, say, would

At the heart of any writer's house is a desk. Whether ornate or plain, the desk—and often the room around it—becomes a landscape of its own, ideas in the distance, an unfinished paragraph or stanza looming, perhaps a calm shelf nearby of already published books. On this book's jacket, William Faulkner's eyeglasses are still on the desk in his old study. Opposite the title page is the desk where Henry Wadsworth Longfellow first started writing in Craigie House, while still renting rooms there; on page 6, a corner of Robinson Jeffers's home. On page 7 is a view of Herman Melville's desk. Above, a stand-up desk in Nathaniel Hawthorne's Old Manse. And opposite, a day bed on which Eudora Welty laid out family photographs.

sharpen twenty pencils before he began writing in the morning, and Mark Twain would play a game of billiards. It's more the fact that writing is a ritual and requires its ceremonies. A certain time of day, a certain chair, a certain brand of paper and type of pen, a pipe and a cup of tea—writers can be like the dog circling and circling a specific spot on the hearth rug before he'll finally lie down on it. The rites guarantee a kind of continuity, and are meant to invoke the weary muse. But above all, they must be enacted in and devoted to a necessary privacy. To that extent, the writer may seem selfish or pampered, until one recalls that he or she is usually the family's source of income. Until the early decades of the twentieth century, nearly every middle-class home had servants, though houses were often fuller of family. The result, for the writer, was less privacy but more freedom. Modern writers are more likely to have quiet rooms of their own, but have to dry the dishes. Modern writers have halogen lamps and computers, while older writers had flickering wicks and sputtering nibs—and it is hard to say which arrangement offers more frustrations. Unheated rooms, bad light and foul air, a bawling baby downstairs—everywhere lurk distractions. This is what those rituals for concentration are meant to guard against. Robert Frost liked to write in an upright wooden chair with a wooden board on his lap. Other authors wrote in bed—Edith Wharton because she preferred it, Sarah Orne Jewett because of illness. Bed or chair, the place of dreams or daydreams . . . each author's "study" is a private arrangement. It is not surprising that when an author—Nathaniel Hawthorne, say, or Robinson Jeffers—has an alluring view out the window of his writing room, he turns his desk to the wall. That way, the view is inward.

Likewise, it should not surprise readers that *home* is so often the writer's subject. This has been true from the very beginning: Homer's Odysseus is driven in his wandering adventures by "nostalgia," a term that has grown sentimental in English but in ancient Greek was more primitive and means an ache-for-home. From Huck Finn fleeing home to Faulkner's heroes building their mansions, from Louisa May Alcott's *Little Women* to Robert Frost's "Home Burial," American literature has returned again and again to the idea of home—as a place that obsesses or frightens us, shelters or suffocates us. Behind such feelings, in part, has been the very precariousness of living in America. Good intentions have been thwarted by harsh climates or a scarcity of materials. If clapboard and homespun are the rule, then out of everyday necessities extraordinary books have been fabricated. And if we watch for secret signs, it is possible to see how a writer's room is projected onto the story being written. While writing *Moby-Dick*, for instance, Melville felt his room had become a ship's cabin.

Erica Lennard's photographs allow us an intimate view of authors at home—the tables they wrote at, the beds they slept in, the halls they paced. Her use of natural lighting renders the actual *tone* of the life in each house, and her composition of details and her haunting perspectives are masterful evocations of distant times and quiet moments. Books devoted to the homes of writers have always fascinated readers. *Homes of American Authors*, for example, was published as early as 1853. The texts are by several hands, and each chapter includes woodcuts or engravings of the author and the house, plus a sample page of manuscript in reproduction. There are seventeen authors "visited," and they include Washington Irving, Ralph Waldo Emerson, Henry Wadsworth Longfellow, and Nathaniel Hawthorne. But here too are James K. Paulding, William Gilmore Simms, and Miss C. M. Sedgwick—reputations not carried forward by history. The book had a chauvinist purpose, it turns out, and a decided inferiority

complex. The introduction notes that "we feel a degree of pride in showing our countrymen how comfortably housed many of their favorite authors are, in spite of the imputed neglect with which native talent has been treated." A later book too, *Little Journeys to the Homes of American Authors*, which first appeared serially in 1896, shows the early and enduring popularity of these excursions to important national shrines. There have been many such guides since, but never before have these homes been matched in a book with such exquisite photographs or extensive commentary.

We revere our writers because they have helped make each of us into the people we are. Washington Irving, Louisa May Alcott, Henry Wadsworth Longfellow fired our childhood imaginations. Later in our reading lives, Hemingway's heroes are mandatory rites of passage. Later still, we return to certain authors read early on—Mark Twain, perhaps, or Hawthorne—and discover not only new depths in their books but unsuspected feelings in our own hearts. Today, our shelves have these writers side by side. The Library of America, in its extraordinary enterprise over many years now to publish in elegant editions the classics of our national literature, made the writers gathered here the cornerstone of its pantheon. History, too, has often put them side by side. The chain of associations in our literary history is telling: Washington Irving encouraged the young Henry Wadsworth Longfellow who, when he was an old man, helped Edith Wharton publish her first story. Longfellow and Hawthorne were college classmates. Edna St. Vincent Millay visited Robinson Jeffers in his California fortress, and kept a photograph of him by her reading chair in rural New York. William Faulkner encouraged the fledgling Eudora Welty, who in her turn helped a young author named Flannery O'Connor. The long links continue. As a freshman in college, I went to a reading by Flannery O'Connor, not six months before her death. I remember shyly approaching her afterward, her crutches tucked into a flaring skirt, and gushing my admiration.

In each house you'll see and read about in this book, such meetings occurred, whether in person or in books. Encountering other writers, responding to the demands of their imaginations, inspired each of these authors. In each house as well, the walls witnessed struggles and triumphs, and they stand today to remind us of what went on there—our history turned into myth, our lives turned into fables, our passions and sorrows turned into the books that have told us, over the years, how we are Americans.

JDMcC

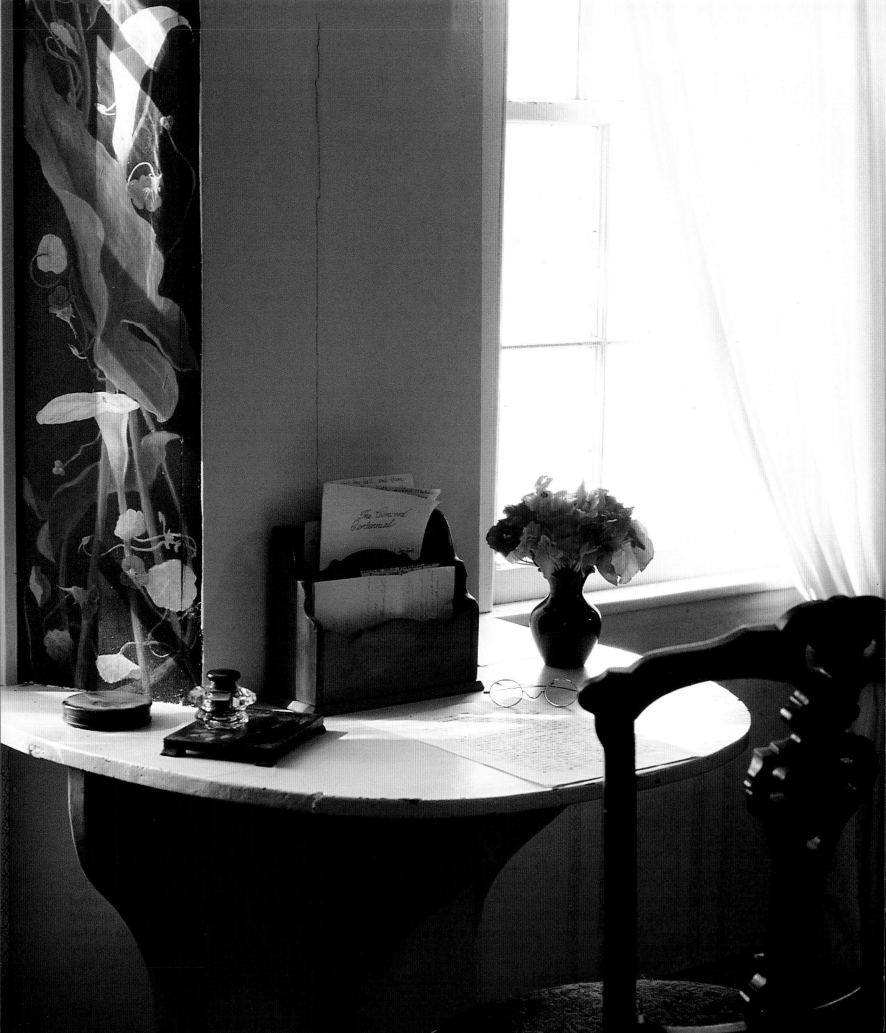

Louisa May Alcott

1832 – 1888

In Chapter 13 of *Little Women*, the four sisters and their devoted friend Laurie are off on a picnic, and decide to play a game called Castles in the Air. Each in turn is to name a wish, "the castle in the air which we could make come true, and we could live in them." Jo, the stand-in for Louisa May Alcott herself, answers: "I want to do something splendid before I go into my castle—something heroic or wonderful that won't be forgotten after I'm dead. I don't know what, but I'm on the watch for it, and mean to astonish you all some day. I think I shall write books, and get rich and famous: that would suit me, so that is *my* favorite dream." Jo doesn't get rich and famous, but Alcott did. By the time she died at the age of fifty-five, her royalties had come to—this was an enormous sum in those days—$200,000, and one million copies of her books had been sold. Ever since the first part of *Little Women* was published in 1868, it and her subsequent books have been beloved by readers around the world.

The peculiarities of the March household can't approximate that of the Alcotts. Before they moved into Orchard House in 1857, they had lived in twenty different homes. The family patriarch, Bronson Alcott (1799–1888), was an author and innovative educator, and a leader of the Transcendentalist movement, but his ideas were always slightly too far ahead of his time and his luck was poor. Noble and visionary, he was so impractical that his daughter Louisa once compared him, with affectionate exasperation, to a hot-air balloon that needed its ropes held by stronger female sorts with their feet on the ground. His wife, Abba May, was a strong-willed woman devoted to her husband and to her role in the marriage, but also an abolitionist, a force in the women's rights movement, and one of the first female social workers in this country. They raised their four daughters in unconventional and idealistic ways, encouraged their independence and enthusiasms. Duty and self-sacrifice were their golden rules. But because they were girls, the society around them had attitudes and expectations that their parents may have deplored and challenged but had still to some extent absorbed. Abba, for instance, lamented her lowly status as a woman. All the rest of creation, she wrote, was "pronounced *good*—but no such benediction was pronounced on her—but a tacit curse—and she has ever been an illogical indefinable medley of good and evil, angel and devil in consequence—I think God a little ashamed of this piece of his handywork—and therefore takes little account of us." In any case, they were loving, if eccentric, parents. Still, it must have been with a sense of relief that the family settled into Orchard House. Louisa wrote in her journal, "Much company to see the new house. All seem to be glad the wandering family is anchored at last." The girls had spent a good bit of their childhood next door at Hillside, whose domestic routines—chores and learning, adventures and theatricals—Alcott lovingly re-created in *Little Women*. Louisa would walk to Walden Pond and take boat rides with Henry David Thoreau. Ralph Waldo Emerson would let her visit his library, where she read William Wordsworth and Charles Dickens. But the family finances continued to worsen; Abba took a job in Boston in 1848 and Hillside was rented out. A few years later, Louisa and her older sister Anna started teaching to supplement the family income, and Louisa's writing began appearing in print. Her first published poem, "Sunlight," written under the pseudonym of Flora Fairfield, appeared in 1851. Three years later, her first book, *Flower Fables*, was published. But her sister Elizabeth was ill with scarlet fever, and because the family feared for her health, it was decided that they should return to Concord. In 1857, Bronson

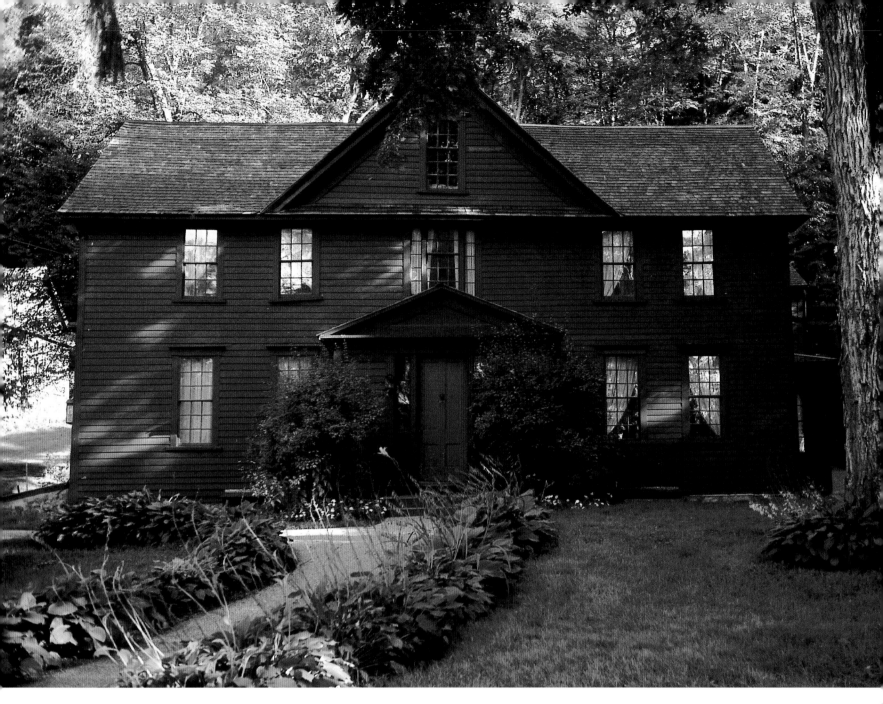

bought the two-over-two house for $945 from farmer John B. Moore. It stood next to Hillside—which he had sold to Nathaniel Hawthorne five years earlier—and because of its extensive apple trees, he called it Orchard House. There were nine acres, a manor house, and an ell-shaped tenant shack, which he later rolled twenty feet forward and joined to the main house. Mrs. Alcott thought it "a house fit for pigs," but her husband set about making improvements. He enlarged windows, enclosed a porch, added pilastered chimney caps and a gable, and then painted it all brown. Because of the orchards and the rickety condition of the house, Louisa's private name for it was "Apple Slump." But, although she frequently went to Boston, this was to be her home for twenty years—the longest period of peace and security she had known. And it was here that, drawing on memories of life at Hillside, she wrote *Little Women*.

She wrote in her bedroom. All her life she had wanted her own room, less for the sake of her privacy than for the sake of her imagination. When the family moved to Orchard House, she shared a front bedroom, with its double sleigh bed, with her older sister Anna. But when in 1860 Anna left to get married, the room was Louisa's. The room is crowded with necessities—a velvet bag for her letters, a sewing basket and tartan pin cushions, dresser and armchair, a bookcase with editions of Dickens and Mrs. Sigourney. As does Jo in the novel, Alcott would write almost anything for money, to help support her family. She wrote sensational thrillers, with titles like *Thrice Tempted* and *Pauline's Passion and Punishment*. During the Civil War she volunteered as a nurse in Washington military hospitals and published *Hospital Sketches* in 1863. She wrote these books, and *Little Women* as well, not at the

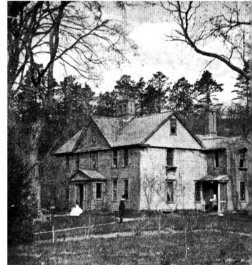

OPPOSITE: The Orchard House entrance, with its hosta-lined walk and soberly dignified facade. The archival photograph below, c. 1865, showing members of the Alcott family outside the house, clearly reveals how Alcott had combined the structures on his property to create a larger main house. The original locations of the joined buildings can still be seen in the survey plan drawn for Alcott by Henry David Thoreau in 1857.
RIGHT: The rustic Concord School of Philosophy, founded and built by Bronson Alcott in 1880, the first summer school for adult education, was dedicated to the study of American thought. Classes were held here for eight years, until Bronson's death, and attracted the leading intellectuals of the day along with their students and admirers.

small but ornate writing desk where she would be photographed. That came later, when she had money. Before that, she wrote at a desk her father made from boards and built in her room between the two windows facing onto the road. In a time when some doctors warned that "brainwork" could endanger a woman's health, it was rare for a father so to encourage his daughter to become a writer. Not only did Bronson applaud her, but Lousia's mother gave her the pen she wrote with, a gift that was accompanied by a poem by Abba that begins "Oh may this pen your muse inspire, / When wrapped in pure poetic fire . . ." Louisa's own term for that fire was "the vortex," and when she was in the vortex she would write up to fourteen hours a day. While writing *Little Women*, she finished a chapter a day. The steel pens she used eventually damaged her thumb, so fiercely did she bear down on the paper. But the great success the novel enjoyed, and the sequel to it she published the next year, enabled her to buy a furnace and carpets for Orchard House and to employ household help. She also paid to send her youngest sister, May, to Paris to continue her art studies.

It is May's drawings and paintings that are everywhere at Orchard House. In Louisa's bedroom, on the mantel above the fireplace, she painted an owl on a branch, and on the wall is a fine painting of a stuffed owl—May said it re-

minded her of Louisa—perched above an open book. John Ruskin was said to have admired the way May had painted the book's pages, and also noted that she was the best copyist of Turner paintings he knew of. In May's own room there are sketches on the walls, including one of

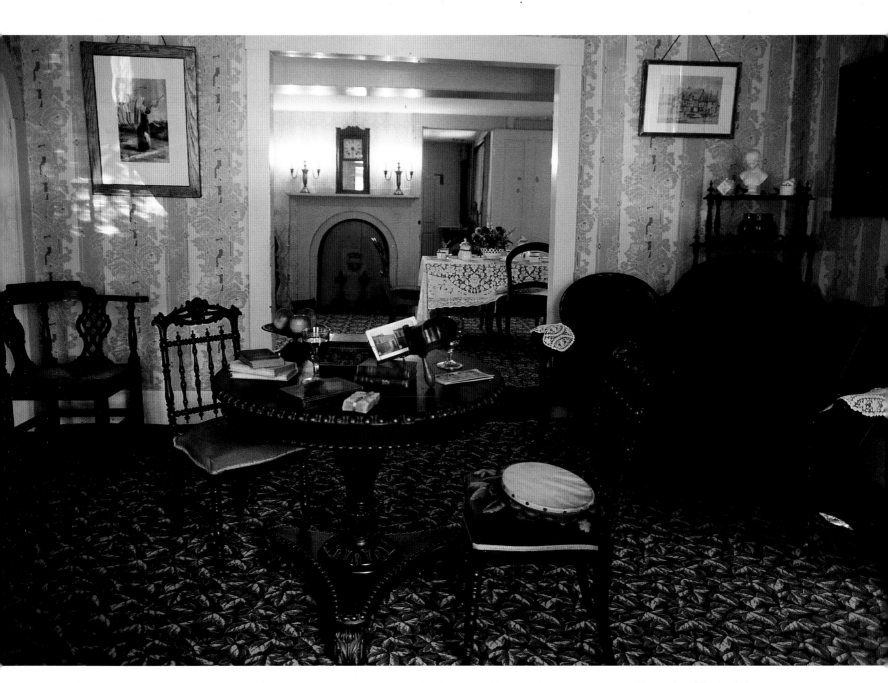

Concord's favorite paintings, Guido Reni's *Aurora*. She sketched too on the walls of her studio downstairs, a room her father had fitted with a special skylight. May stayed in Europe, exhibiting her paintings, and in 1878 married a Swiss businessman and musician, Ernest Nieriker. The next year she gave birth to a daughter she named Louisa May, but died of meningitis when the baby, nicknamed Lulu, was just seven weeks old. Lulu was soon sent, with a nurse and Nieriker's sister, to live with her Aunt Louisa, who diligently raised her until she was returned to her father in Germany after Alcott's death. (Lulu died in 1975 at age 96.)

It was May's room that the sisters used as a changing room for the theatricals they still loved to perform even in their twenties. There is a costume trunk here, with Louisa's costume for her character Rodrigo, so humorously described in her novel. They would rush down the back staircase into the dining room, which was their stage, a curtain having been improvised between that room and the parlor, where their rapt audience sat. Also on the second floor of the house is a small nursery used by Anna's children, three rooms for boarders, and the master bedroom. There are pictures of Abba's ancestors on one wall (including Samuel Sewall, who presided over the Salem witch trials in 1692), her sewing basket and Bible, and draped over a side table a quilt stitched in the flying geese pattern.

Downstairs, when it was not, say, a Castilian castle, the family dining room was flanked by a melodeon near the stairs and a tall cabinet Bronson built to contain the May family English Coalport bone china Abba had brought to the marriage. The formal parlor adjacent, the scene

The parlor at Orchard House. It was here that the famous Alcott hospitality was vividly in evidence. Ralph Waldo Emerson's son Edward recalled one such evening: "There was a piano, by no means too good to use, and May, in kindest spirits would swoop to the stool, and all would fall to dancing, the mother herself often joining us. . . . Then with or without voices we stood by the piano and sang. . . . Storytelling, games or impromptu dramatics might follow and chestnuts and apples would often end the evening."

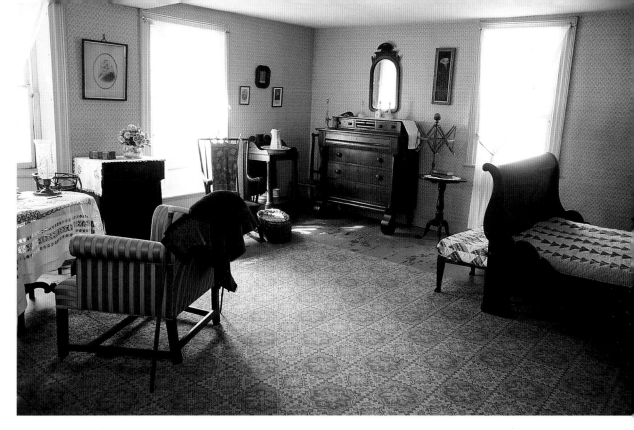

ABOVE, RIGHT: The master bedroom. As so often in the nineteenth century, the wife's taste predominates in this room. Louisa was devoted to her mother. After her death, she wrote: "My only comfort is that I *could* make her last years comfortable and lift the burden she carried so bravely all these years. She was so loyal, tender and true, life was hard for her and no one understood all she had to bear but her children."

BELOW, RIGHT: The dining room, where Bronson Alcott encouraged lively conversation and debate. But he was also a vegetarian and insisted that his family follow a diet of unbolted wheat bread, rough cereals, vegetables, and fruit.

BELOW, LEFT: The drawing table in May's room.

OVERLEAF: Louisa's bedroom. All her life she had longed for a room of her own, eager for the solitude in which her crowded imagination could work.

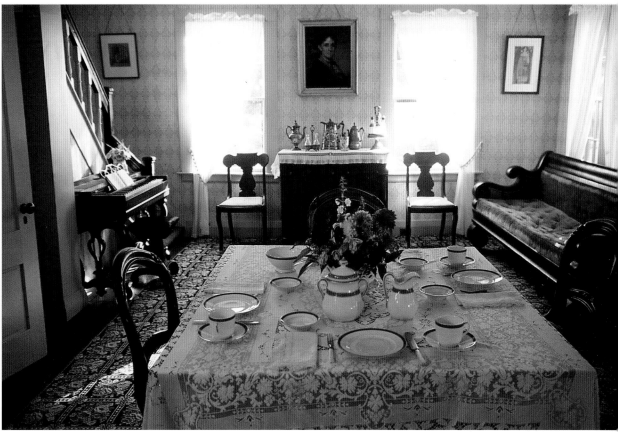

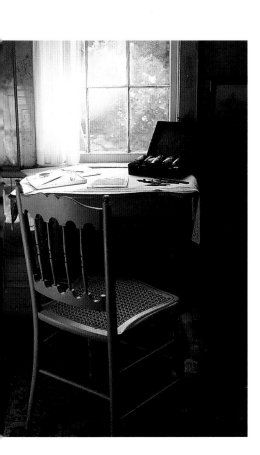

of much entertaining, has a Chickering piano, a horsehair sofa over which hangs a portrait of Bronson, and on which rest Louisa's "mood pillow," turned sideways when she was in a bad mood and straight on end when her mood was good. There are decorative niches and window seats, and in front of the arched fireplace is a wooden firescreen on which May drew an imposing Moses. Across the entrance hallway is Bronson Alcott's study, with writing table, highboy desk, revolving bookstand, and a bookcase fashioned by Bronson out of old doors and the top of a ruined melodeon. A visitor in 1874 noted, "If in Emerson's study perpetual twilight reigns, in Alcott's it is always noon." The speculative energy radiates in the room. He had started the Temple School in 1839, and its guiding principle was that "the Child is the Book. The operations

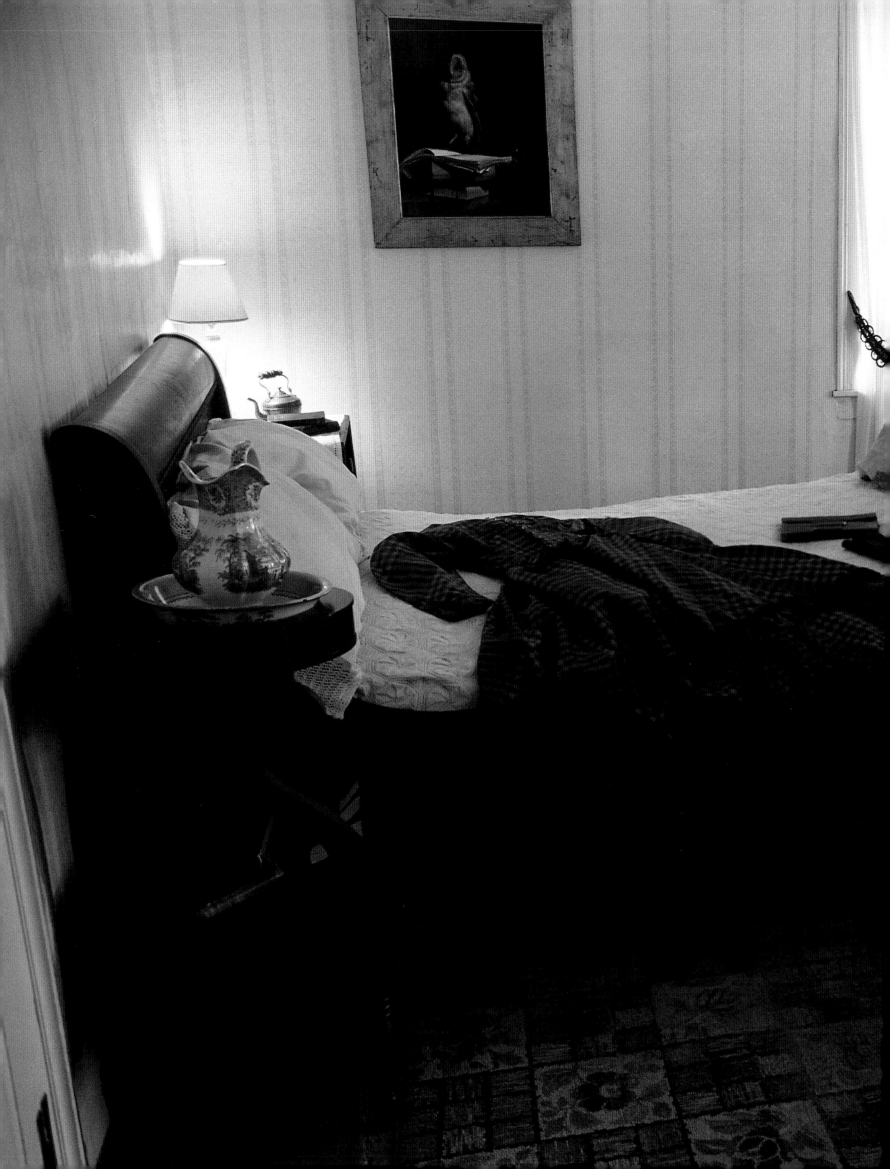

of his mind are the true system." Bronson served, but only for a year, as the Concord Superintendent of Schools, but his dreams were fulfilled when in 1879 he founded his School for Philosophy, modeled on Plato's Academy and the Lyceum movement in America, and meant to foster the ideals of Transcendentalism and counter the perceived intellectual and spiritual dearth that followed the Civil War. Behind Orchard House, he built his plain wooden school, in effect the first adult summer school, open to both men and women. The rooms and grounds were crowded to hear lecturers such as William James and Julia Ward Howe (the audience would not let her go until she sang her famous "Battle Hymn of the Republic"). The school died with Bronson, in 1888, but his study in Orchard House still rings with his spirit. It is presided over by a bust of Bronson by the important sculptor Daniel Chester French, who was a student of May Alcott and is best known for his monumental seated figure of Lincoln in Washington's Lincoln Memorial. May had also painted under the mantel her father's favorite

motto, by Ellery Channing: "The hills are reared, the seas are scooped in vain / If learning's altar vanish from the plain."

Bronson Alcott's dedication and doggedness are qualities he passed on to his daughter Louisa, who wrote with a pastel portrait of her father over her shoulder. She had wanted to make Jo a literary spinster like herself, but letters flooded in from her anxious readers, urging her to marry off all the sisters. Her publisher did too. While she had been "happy to paddle my own canoe," she did in the end marry off Jo to sweet old Prof. Bhaer, whose educational ideas resemble those of Bronson Alcott. At the end of her life, beset with ill health and living in a nursing home, she suddenly paid a visit to her dying father. She knelt at his bedside in Boston and whispered, "Father, here is your Louy. What are you thinking of as you lie here so happily?" Bronson reached for her hand, and said, "I am going up. Come with me." "Oh, I wish I could," Louisa said as she kissed him. But in fact she could. She died two days after her father did. At their joint funeral, the orator proclaimed, "She

A trunk in May's bedroom, in which the sisters kept costumes for their theatricals. May's work is to be seen all over the house, and in her bedroom she even sketched on the walls, often copying from Flaxman's design book. May and Louisa shared an artistic temperament and a desire for independence. Eventually, May studied in Europe and married a Swiss businessman, Ernest Nieriker, with whom she settled near Paris into what she called "an ideal life—painting, music, love . . ."

OPPOSITE, TOP: Bronson Alcott's study, a room that reflects his lifelong mission to improve the moral, intellectual, and spiritual culture of his nation. Many of his educational ideas, often considered radical in his day, have since been incorporated into school curriculums.

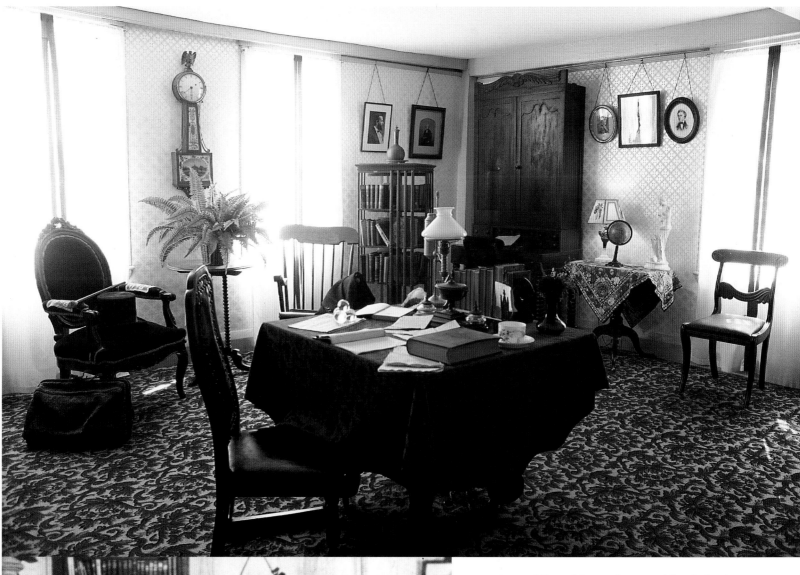

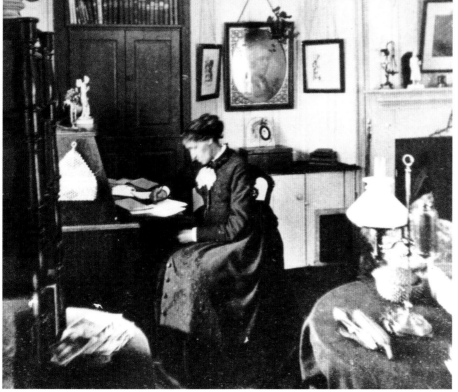

was her philosophic and unworldly father's counterpart in lucid conception, with an added literary gift. She was that mystic thinker's translation, clear as crystal, into the mother tongue of unquestionable truth. She was his indisputable popularity." No, her popularity was all her own, because in her best books she told the heart's truth.

LEFT: Louisa May Alcott in her bedroom, c. 1872. When she had earned sufficient money from her writings, she bought this desk to replace the more improvised one her father had built for her. Her father's portrait hangs on the wall behind her, and in the bookcase are copies of her favorite authors, from Jane Austen and Charles Dickens to Lydia Maria Child and Harriet Beecher Stowe.

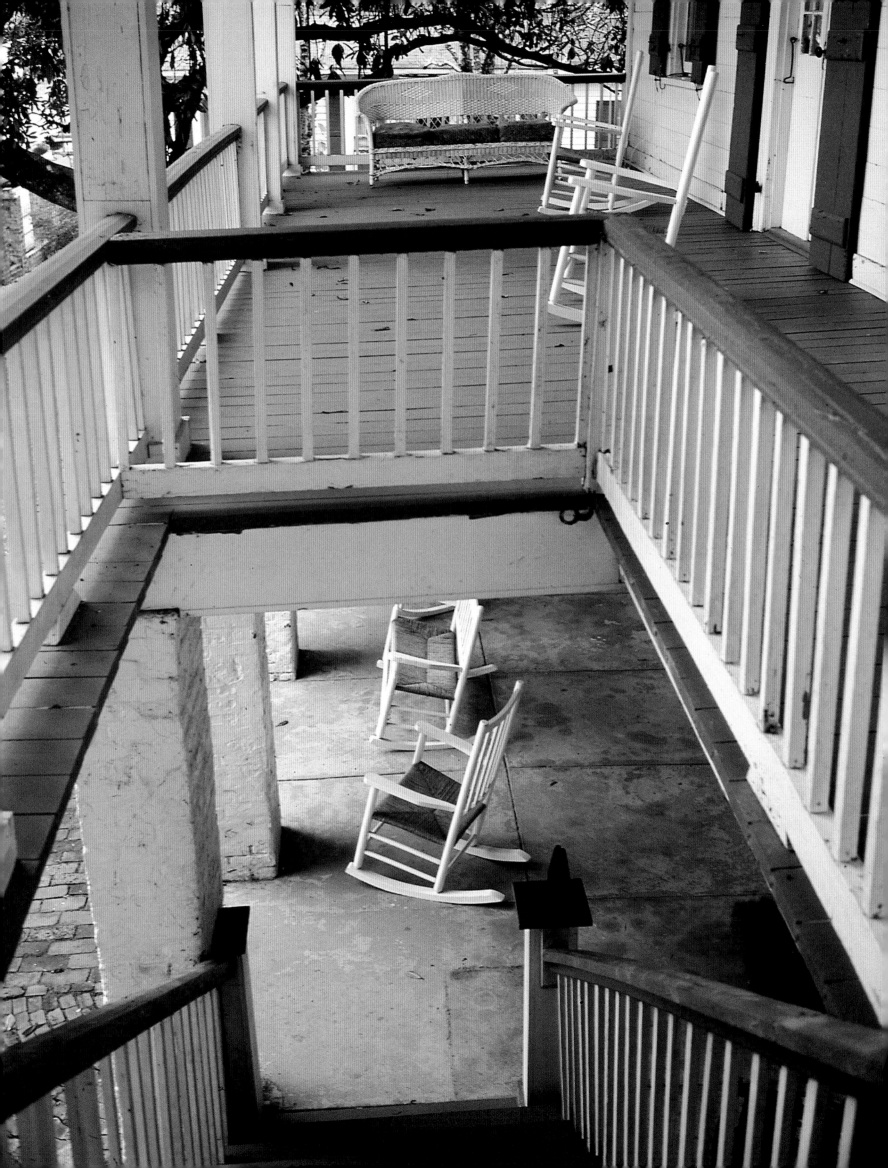

Kate Chopin

1850 – 1904

OPPOSITE: The front porches of the Chopin house that function almost like open decks on a ship, catching the breeze. Outside staircases lead from floor to floor. On the main street of a quiet village, the porches were an ideal place to observe comings and goings— though Chopin preferred to walk and ride, often by herself, scandalizing her neighbors. The rocking chairs were for reverie as well. One of her poems begins: "A day with a splash of sunlight, / Some mist and a little rain. / A life with a dash of love-light, / Some dreams and a touch of pain." OVERLEAF: The front parlor.

Driving to Cloutierville, north on the highway from Alexandria, Louisiana, past stretches of scrub pine, one comes to the exit marked "Chopin." By that time, the land has flattened to perfect planting terrain. Chopin hasn't had a post office since the 1950s, and isn't really a town at all. But the sign still marks the area once home to the large cotton plantations owned by Kate Chopin's father-in-law, the French-born Dr. Jean Baptiste Chopin, a man notorious for his cruelty to his slaves, his children, and his wife. It was said in later years that Kate Chopin's "scandalous" behavior was tolerated by her husband because he was haunted by his own mother's early death, after years of being isolated, beaten, and hounded by her husband. To the horror of the locals, Kate would smoke Cuban cigarettes in public, play cards with men, wear lavish dresses, walk by herself to go visiting, and was said to show a little too much ankle when she lifted her skirts to cross the street. If such gestures were shocking at the time, behind them was not only a righteous defiance of stifling convention but the sorry ghosts of women before Chopin whose lives were caged and whose stories were lost. Chopin's behavior is still remembered in Cloutierville, but the rest of the world remembers her stories of bayou folk and Creole culture, and above all her novel *The Awakening*, one of the first American books to dramatize a woman's inner life with the complexity and understanding it calls for. When the novel was published in 1899, it was considered the most contemptible thing she had yet done, and it was denounced as vile and degrading because it told the truth.

Cloutierville is named for Alexis Cloutier, who acquired an immense property in the 1770s from a Spanish land grant in Cane River country, thirty miles from the town of Natchitoches, the oldest permanent settlement in the Louisiana Purchase of 1803. Cloutier's son Oscar began building a house with slave labor in 1805 on the 2700-acre plantation and completed it in 1809. In 1816, he founded a town around his home, laying out lots and even constructing a courthouse in a bid to become the parish seat. Though just a block long, Cloutierville, set on a natural levee, was a prosperous town. River traffic was steady (steamboats plied the Cane, a tributary of the Red River, until 1907). The seasonal harvestings, of cotton, pecans, rice, and crawfish, kept to a steady round. Residents would go by boat to New Orleans—a three-day voyage—for a couple of weeks a year, to shop in the fashionable stores. But there were stores in Cloutierville itself, seven of them, and commerce thrived. Still, Cloutier's dreams of prosperity faded when the Louisiana legislature denied his town the municipal charter he craved, and in 1822 he sold the town—and his house—to his brother-in-law. By the time Kate Chopin and her family moved there in 1879, the town had further declined. They had been forced to move from New Orleans because Oscar Chopin's cotton factory business had failed, and they needed to live less expensively. He bought Cloutier's old house in the sheriff's sale, and soon after the general store next door, which he ran until his death a few years later.

The house is a typical Louisiana Creole structure of the period, a so-called raised cottage. The first story was built of homemade brick, the second of heart cypress joined with square wooden pegs. The interior walls were made of *bousillage*, a mixture of mud and Spanish moss, to which animal hair was added in order to deter insects. Originally, at the front of the house, was a great, wide wooden staircase leading to the galleries that surrounded the second floor, which is where the family lived. All these rooms opened onto the galleries, or

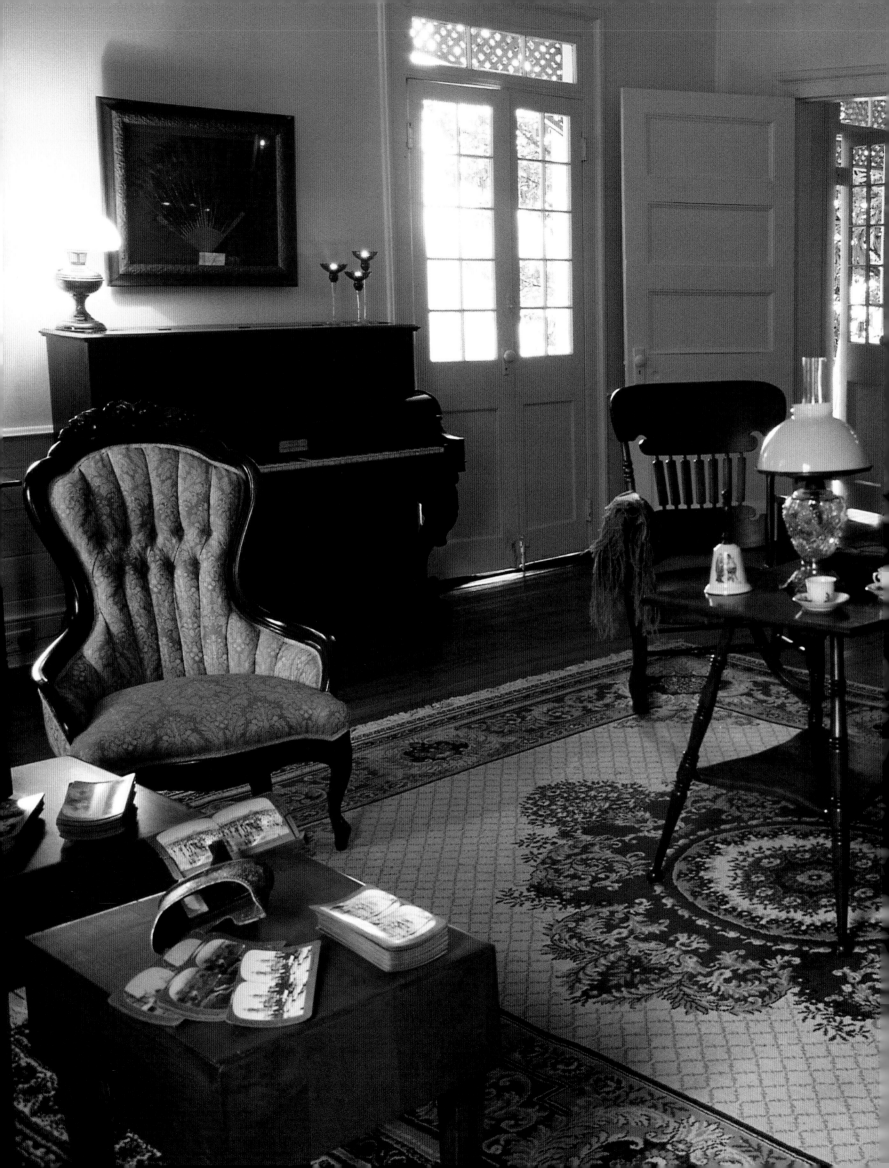

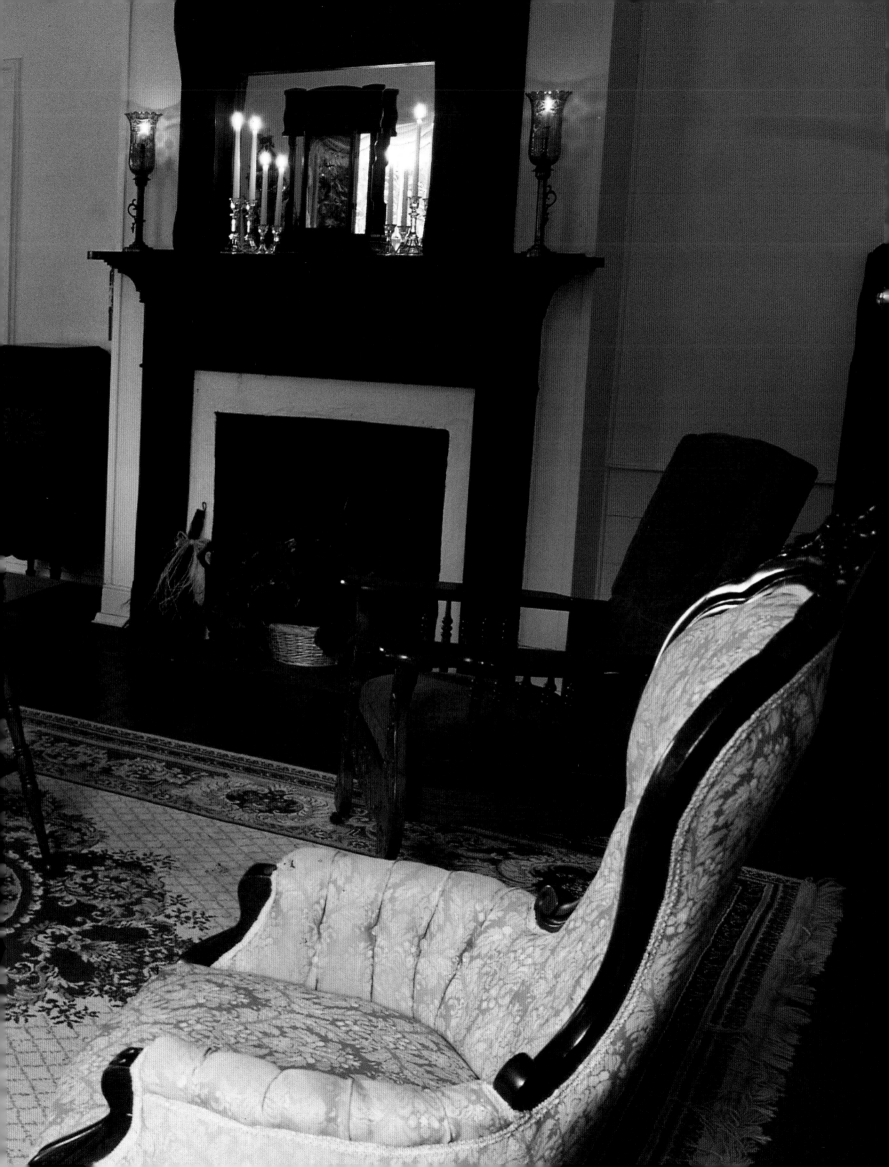

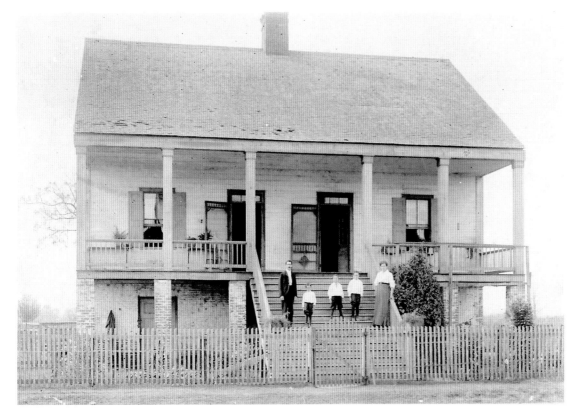

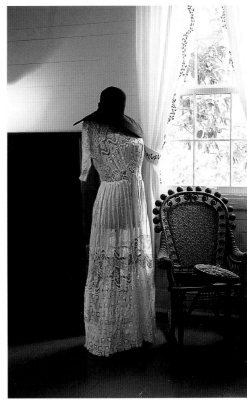

balconies, that ran right around the house, and there were no windows or doors, just wooden shutters, so that nothing interfered with the cooling flow of air. (It was thought, too, that "bad air," then considered the cause of the vicious yellow fever epidemics that ravaged Louisiana, stayed close to the ground.) There are two fireplaces on the ground floor, and two upstairs, but the lower level was essentially an above-ground basement and had dirt floors. It was used to store coal and provisions, as a place for the children to play and the help to prepare food or do laundry. On the rear porch was a *branle*, a small cotton hammock suspended from a hook in the gallery above and used to rock babies. Farther from the house were a kitchen and stable, and beyond them 80 *aspins* (acres) of property with stands of hardwoods, sweetgum, and hackberry.

Upstairs, where the family lived, is a formal front parlor for receiving guests. With its hard pine floors and cypress mantel, it has the austere primness of a room infrequently used. But there is a Pleyel piano and other accouterments of refinement. Behind the parlor was the family dining room, to which food was brought upstairs from the kitchen by servants. With six children, Chopin would have had a busy and noisy household, and the dining room was where the family came together three times a day. In those days, and in Creole culture generally, the main bedroom was not reserved exclusively for parents, but was a sort of family room where domestic business would take place,

where children might be schooled or pampered or even bathed. Behind the main bedroom is a guest room, often used by Kate's mother, Eliza, on her visits from St. Louis. Farther back was a sleeping porch, now enclosed, where Chopin's sons slept.

In 1928, the Cloutierville school library's copy of Chopin's stories went missing. Someone had annotated them with the real names of her characters, and since she wrote on strong subjects— interracial marriage, venereal disease, adultery, prostitution, the aftermath of the Civil War—the town's embarrassment had reached its limit.

She had watched and listened during her years in Cloutierville, and was always alert to gossip. The letters she wrote to friends in St. Louis, with her vivid accounts of Creole life, attracted attention, and Dr. Frederick Kolbenheyer, a family friend and the obstetrician who had attended at the births of two of her sons, was so taken with her descriptions that he urged her to write for publication. She had been born Katherine O'Flaherty. Her father, an Irish immigrant, had married into an aristocratic but impoverished Creole family in St. Louis. In 1870 she married Oscar Chopin and settled in New Orleans, becoming even better acquainted with both the South (her sympathies, even as a child, were boldly Confederate) and with the Creole culture. During her years in New Orleans—a time when her five sons were born (a daughter, her youngest child, was born in Cloutierville)—she had explored the neighborhoods, visited the cotton warehouses, and

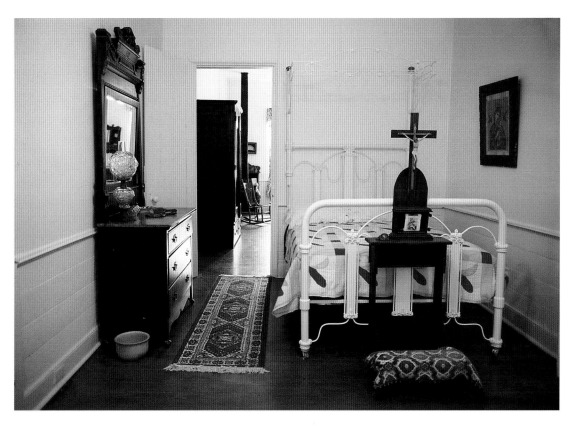

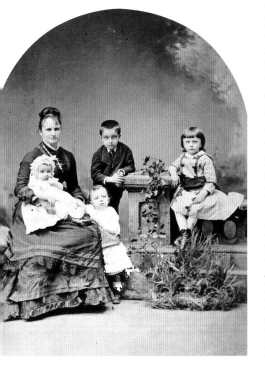

spent her summers at Grand Isle, the popular Creole resort. When the family, in straitened circumstances, moved to Cloutierville, Kate was no less observant of her surroundings. On her own, she was reading Darwin and Huxley, but she never failed to listen as well to the customers in Oscar's general store who always had stories to tell. And when Oscar died of malaria in 1882, leaving a mountain of debts, Kate herself ran the store and managed the accounts. She was a success at it, and even seems to have had a discreet affair with a wealthy married planter, Albert Sampite. But she was increasingly drawn to fiction, and in addition to encouragement from friends, she found a literary model in Guy de Maupassant. "Here was a man," she said, "who had escaped from tradition and authority, who had entered into himself and looked out upon life through his own being and with his own eyes; and who, in a direct and simple way, told us what he saw." That is just what she did for herself, writing three novels and over a hundred stories, while caring for her children and leading a busy social life.

It is not surprising that Maupassant's melodramatic style became a touchstone for Chopin. Her own stories, in the collections she published during her lifetime, *Bayou Folk* and *A Night in Acadie*, are often short, sharp shocks. In "Désirée's Baby," for instance, Armand and Désirée are the happy parents of their first child, when her mother visits and is horrified by the baby—horrified by something in its looks. Désirée's husband now avoids her, until in desperation she pleads to know the reason. "The child is not white; it means you are not white," he coldly replies. Frantic, she begs her mother to take her in, then takes the baby and flees her home: "She disappeared among the reeds and willows that grew thick along the banks of the deep, sluggish bayou; and she did not come back again." Weeks later, Armand has lit a large fire and in disgust is burning every memory of her, gowns and gloves and the baby's *layette*. In the back of a desk drawer he discovers an old letter from his mother to his father: "I thank the good God for having so arranged our lives that our dear Armand will never know that his mother, who adores him, belongs to the race that is cursed with the brand of slavery." If the plot seems old-fashioned, it still resonates with secret shames and social cruelty.

Edna Pontellier, the heroine of Chopin's masterpiece, *The Awakening*, is a character female readers were slow to admire. Young Willa Cather dismissed the novel as "a Creole *Bovary*" and sniffed: "I shall not attempt to say why Miss Chopin has devoted so exquisite and sensitive, well-governed a style to so trite and sordid a theme." Chopin even issued a statement of her own, slyly claiming, "I never dreamed of Mrs. Pontellier making such a mess of things and working out her own damnation as she did. . . . But when I found out what she was up to, the play was half over and then it was too late." Bored with her husband and children, infatuated with handsome young Robert Lebrun, Edna staggers from one hapless decision to another,

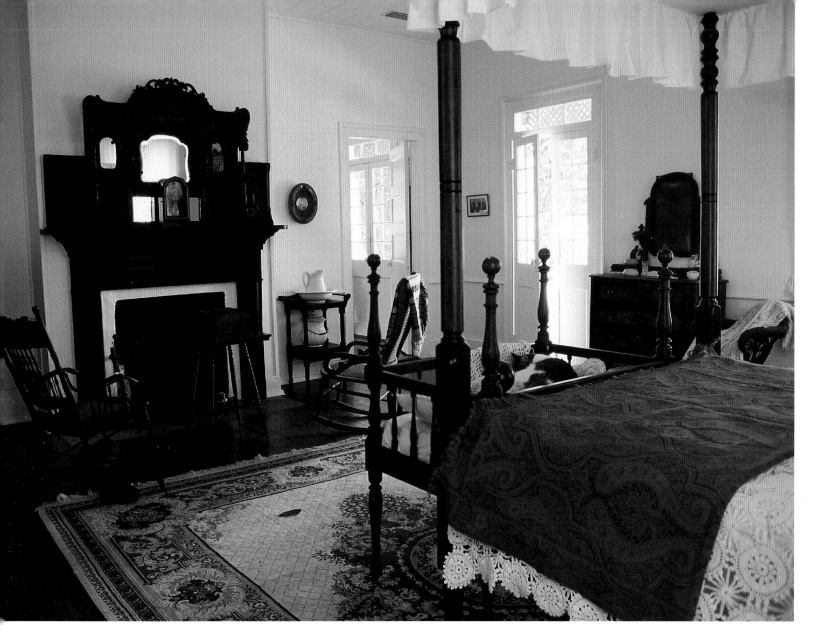

unable to fathom her own desires even as they pulse in her. She tries to become a painter, and leaves her comfortable life in the hope of achieving some independence, but frustration and unhappiness haunt her. Robert returns from abroad and declares his love for her, but cannot act on it. He disappears, having left behind a note that said, "Good-by—because, I love you." Her emotional life has "awakened," she has abandoned the conventional expectations of others, but she cannot find a way to live with her freedom. In the astonishing last pages of the novel, she returns at night to the beach at Grand Isle where she had first met Robert. She strips off her clothes: "How strange and awful it seemed to stand naked under the sky! how delicious! She felt like some new-born creature, opening its eyes in a familiar world that it had never known." She walks into the surf and begins to swim. "The touch of the sea is sensuous, enfolding the body in its soft, close embrace." Exhausted and exhilarated, she swims on toward her death. Her drowning, with its flashing of the past, is handled with mastery:

She looked into the distance, and the old terror flamed up for an instant, then sank again. Edna heard her father's voice and her sister Margaret's. She heard the barking of an old dog that was chained to the sycamore tree. The spurs of the cavalry officer clanged as he walked across the porch. There was the hum of bees, and the musky odor of pinks filled the air.

Chopin put everything she knew, about herself and others, into *The Awakening*. And what prompted work on the novel was a return visit to Cloutierville in 1897. In the novel, Edna Pontellier is twenty-nine years old, the age Kate Chopin was herself when she first moved to Cloutierville. Her feelings for Oscar or Sampite were, of course, refracted through a novelist's lens. But when Edna Pontellier, brooding on her desires, fantasizes in the novel about "the artist with the courageous soul that dares and defies," she might as well have been thinking of the very woman writing down her story, Kate Chopin.

ABOVE: The master bedroom. In addition to caring for her children in this room, Chopin was an avid reader. Her "daily companions" were the works of Charles Darwin, Thomas Hardy, and Herbert Spencer. As a friend later wrote, "The study of the human species, both general and particular, has always been her constant delight." But she also found time to play cards and to frequent the local dance hall and the visiting showboats.

OPPOSITE: A bureau in her bedroom. She and her husband liked to give formal dinner parties and sometimes informal *veillées* with singing, dancing, and gaming. Kate liked to dress up, and young men paid her attentions. The heroine of *The Awakening* also liked to dress up and dream: it moved her "to thoughtfulness, to the shadowy anguish which had overcome her, the midnight when she had abandoned herself to tears."

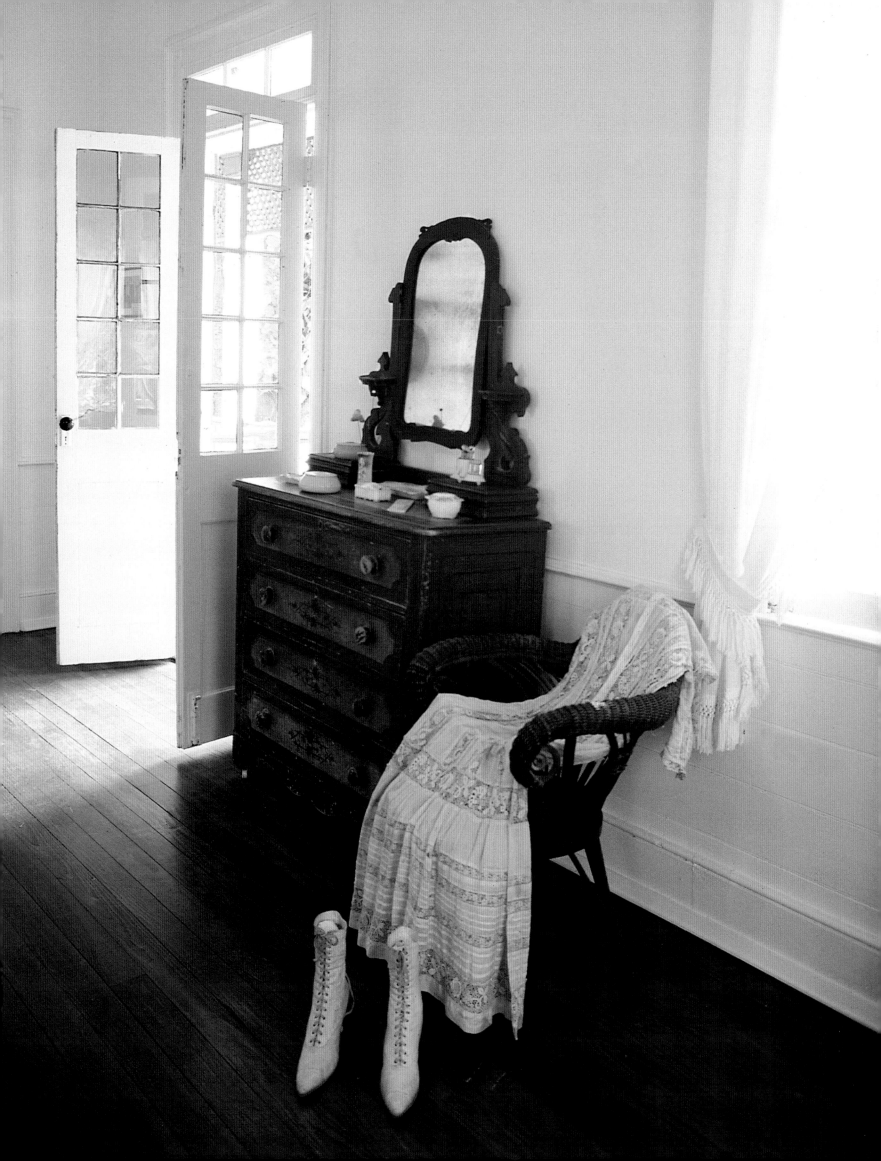

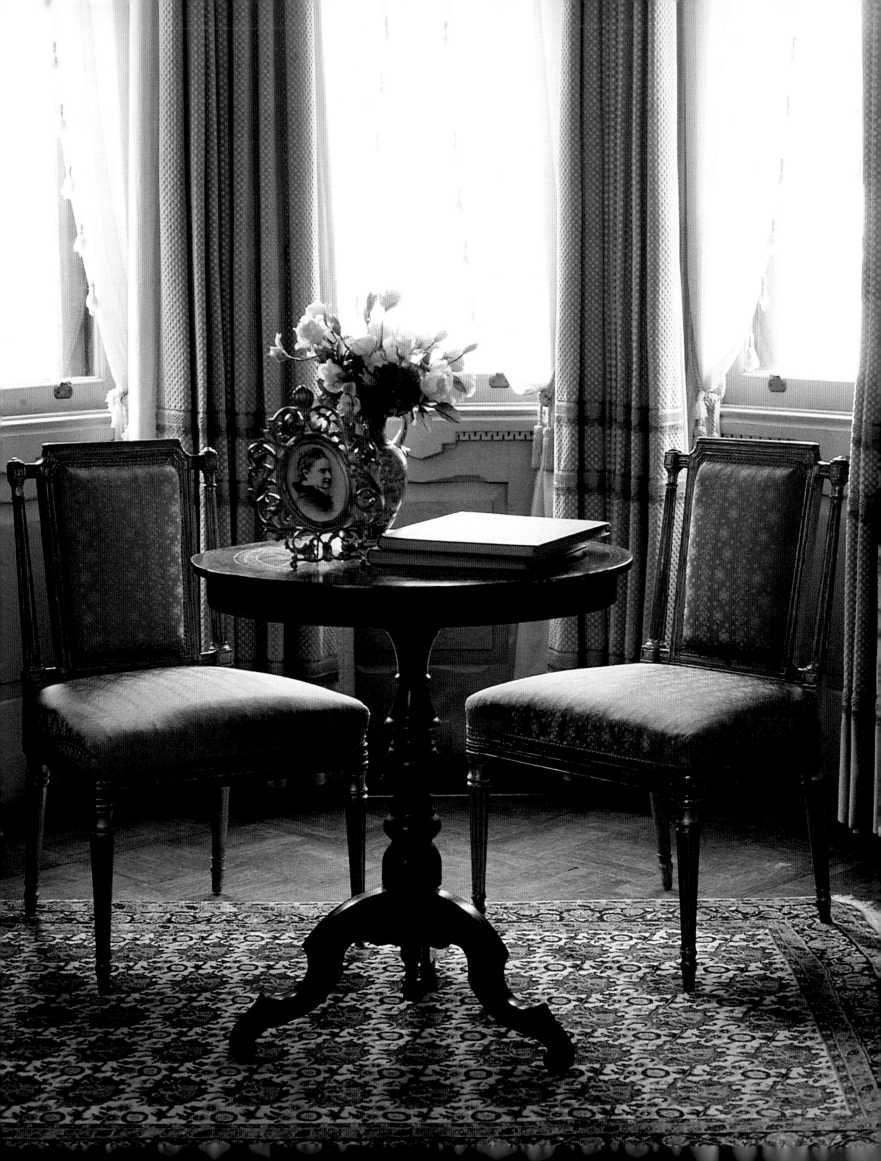

Samuel L. Clemens (Mark Twain)
1835 – 1910

OPPOSITE: In the drawing room, very much his wife's decorous domain. His own style was looser. In 1875, he addressed the crowd at a Hartford spelling bee: "I don't see any use in having a uniform and arbitrary way of spelling words. We might as well make all clothes alike and cook all dishes alike. Sameness is tiresome; variety is pleasing. I have a correspondent . . . who always spells Kow with a large K. Now that is just as good as to spell it with a small one. It is better. It gives the imagination a broader field, a wider scope. It suggests to the mind a grand, vague, impressive new kind of cow."

"I am not *an* American," Mark Twain once stipulated. "I am *the* American." The world agreed. He was once dubbed "the most conspicuous person on the planet." He was everywhere famous as a novelist and a humorist, his shaggy mop of hair, his mustache and white suit familiar on any street and in every home around the globe. But he was also *the* American because, as Ernest Hemingway said, Twain is "the headwater of American fiction." It has been claimed that once the novel was stamped by his command of the American idiom and by his singular grasp of homegrown truths, American novelists never again needed to look for European models. His *Adventures of Huckleberry Finn* alone—"the best book we've ever had," claimed Hemingway—delves into the dark heart of the national culture in ways that continue to arouse controversy. The tale of Huck and Jim, the one fleeing civilization and the other fleeing slavery, is a remarkable account of how, in Twain's own words, "a sound heart & a deformed conscience come into collision & conscience suffers defeat." How Huck learns first to recognize Jim's humanity and then to love it is an American morality tale. Its climax comes after Huck has written a letter to Jim's owner to inform her of Jim's whereabouts and begins to think about his time with Jim, "in the day and in the night-time, sometimes moonlight, sometimes storms, and we a-floating along, talking and singing and laughing. But somehow I couldn't seem to strike no places to harden me against him, but only the other kind." Huck picks up the letter he's written. "I was a-trembling because I'd got to decide, forever, betwixt two things, and I knowed it. I studied a minute, sort of holding my breath, and then I says to myself: 'All right, then, I'll go to hell'—and tore it up."

Twain's genius was nurtured and sustained by his childhood in Hannibal, Missouri, listening to slave stories, frontier tales, and river lore. Born Samuel Langhorne Clemens (known all his life to friends as "Sam," and to his wife as "Youth"), he adopted the pen name "Mark Twain" as a young writer in homage to his days as an apprentice steamboat pilot. (A leadsman would drop his knotted ropeline overboard to measure the river's depth, and call out to the pilot "quarter-twain," or "half-twain," or "mark twain," meaning twelve feet, or safe water.) He had left school by the age of fourteen, but knew he wanted to be a writer, and the next year was already working for a newspaper. By seventeen, he had set out to see the world. By the time he landed as a reporter in Nevada in 1862, nosing around its whorehouses and jails, he was beginning to write fictional sketches for newspapers. One story, "Jim Smiley and His Jumping Frog," was reprinted nationwide, and his course was set. Still, he was on the move—Nicaragua, San Francisco, Honolulu, Athens, Egypt. His dispatches were admired, a book of stories appeared, his career was launched. But at the age of thirty-two, he thought about settling down. He had a new book in manuscript, and a friend in Elmira, New York, had introduced him to his sister, Olivia. She was, Twain thought at once, "the best girl in all the world, & the most sensible." But it was not until he moved to Hartford, Connecticut, that his restless days seemed finally over.

Mark Twain first visited Hartford in 1868. He had come to see his publisher, Elisha Bliss, to discuss the imminent appearance of the book that would be his first great success, *The Innocents Abroad.* "Of all the beautiful towns it has been my fortune to see," he wrote, "this is the chief." In fact, when Twain moved there, Hartford was the wealthiest city per capita in the nation, a busy center for manufacture, publishing,

and invention. In the same month he wrote of his delight in Hartford, he proposed to Olivia Langdon, the delicate beauty who steadied Twain and became his muse, closest reader, and beloved companion. Between them, Livy and Hartford settled Twain into the happiest years of his life.

During his first visit to Hartford he stayed with Isabella Beecher Hooker, youngest of the three famous Beecher sisters (Catharine Beecher was a celebrated suffragette, and Harriet Beecher Stowe's *Uncle Tom's Cabin* had prompted Lincoln to remark, on meeting her, "so you're the little woman who wrote the book that made this great war"). Twain's new wife also had friends in town, and the death of her father and her best friend pushed them to leave Buffalo, where they had been living, and make a fresh start. In 1871, they leased the Hooker house, in an area about a mile west of downtown Hartford known as Nook Farm, an enclave of houses already home to several prominent intellectuals. Soon after, they purchased a lot on which to build their own home. (Actually the house was paid for by Livy, out of her inheritance.) It was a wooded lot overlooking a turn of the Park River. They engaged the fashionable New York architect Edward Tuckerman Potter to draw up the designs based on their own suggestions. In September 1874, they moved in—already haunted by circumstances. Their first

child, a son named Langdon, had died at age two, just weeks after the birth of their second child, Susan. In addition, the building costs had nearly bankrupted Twain, and several rooms in the house were unfinished when they first lived there. Twain loved this house more than any place he would ever live. Two more children were born there, his daughters Clara and Jean, and the house still radiates the warmth of a close-knit family and the panache of its attic billiards room where Twain wrote the books that made him more famous still. And it obviously fulfilled a deep need in a man whose early life had been solitary and deprived, a man whose restless spirit had set him wandering all over the world. The house allowed him, for the first time, to feel both successful and rooted. "For us," he wrote in 1896, "our house was not unsentient matter—it had a heart, and a soul, and eyes to see us with; and approvals, and solicitudes, and deep sympathies; it was of us, and we were in its confidence, and lived in its grace and in the peace of its benediction. We never came home from an absence that its face did not light up and speak out its eloquent welcome—and we could not enter it unmoved." But for all that joy, this house was also to be the scene of such later sadness that when he finally sold it in 1903, he had long been unable even to set foot in the place.

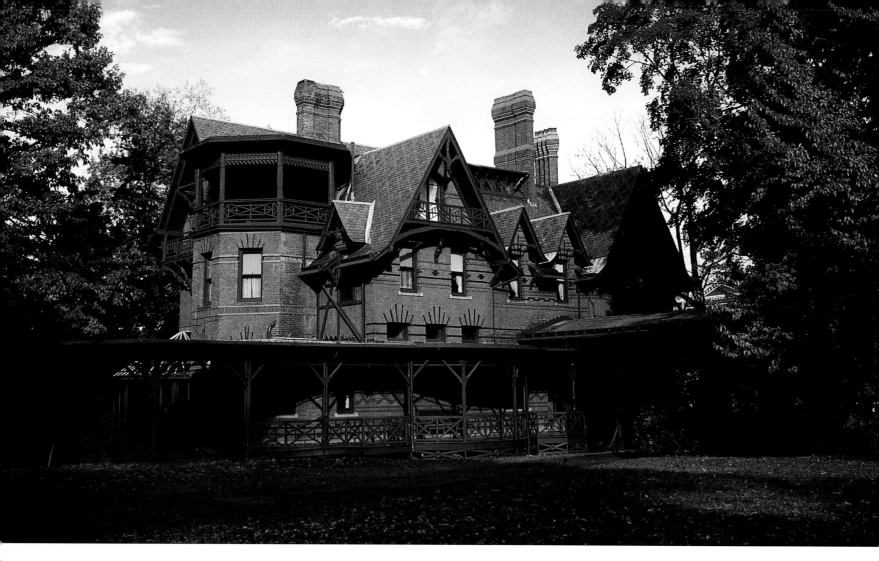

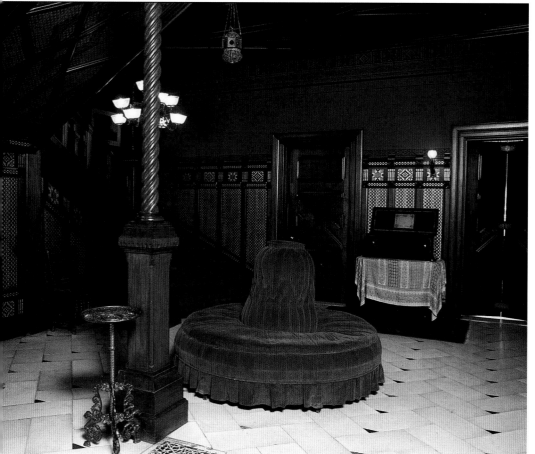

As he watched his house being built, he wrote to Livy, fairly bursting with pride, "You may look at the house or the grounds from any point of view you choose & they are simply exquisite. It is a quiet, murmurous, enchanting *poem* done in the solid elements of nature." In fact, as someone remarked, the house looks like a cross between a steamboat and a cuckoo clock. At the time, the *Hartford Daily Times* wrote that it was "one of the oddest looking buildings in the State ever designed for a dwelling, if not in the whole country." Potter's Stick-style design uses brick in both a decorative and a structural way. Plain bricks are sometimes painted black or vermilion; their pattern is often varied to create angles that offer texture to the surface of walls. And all over the exterior is the ornamental "stickwork" that gives the house its storybook picturesque Gothic character, each gable and porch, every railing and hanging frieze different from the others, and resulting in a general impression of rambling asymmetry. Extending from the porte cochere to the large veranda is an *ombra*, or shaded porch, for hot afternoons, where the family could relax and admire their carriage house and greenhouse, the lawn and high trees.

Since the house was meant to impress visitors, the entrance hall makes a particularly striking

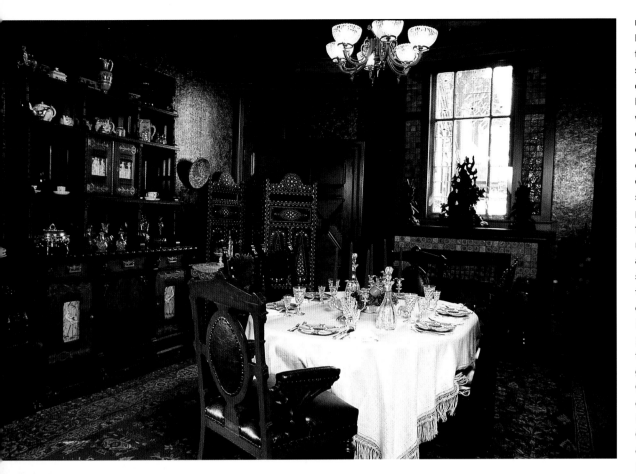

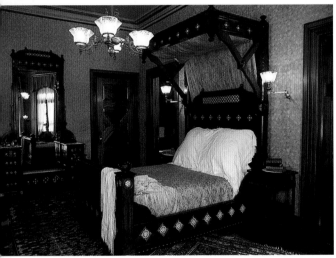

LEFT: The dining room. The housekeeper, Katy Leary, recalled the parties here when "we had soup first, of course, and then beef or ducks, you know, and then we'd have wine with our cigars, and we'd have sherry, claret, and champagne, maybe—Now what else? Oh, yes! We'd always have crème de menthe and most always charlotte russe, too. Then we'd sometimes have Nesselrode pudding and very often ice cream for the most elegant dinners. No, never plain ordinary ice cream—we always had our ice cream put up in some wonderful shapes—like flowers or cherubs, little angels—oh, everything lovely!"

BELOW, LEFT: For the sake of privacy—both that of visitors and that of the Clemens family—the guest room was on the first floor.

OPPOSITE: *The Flower Girl,* an 1880 oil painting by Rudolph Epp, hangs in the dining room.

OVERLEAF: The semi-circular conservatory at the end of the library. Performances of a dramatic adaptation of *The Prince and the Pauper* were sometimes given in the library, and the conservatory served as the palace garden. "The children were crazy about acting," housekeeper Katy Leary remembered later, "and we all enjoyed it as much as they did, especially Mr. Clemens, who was the best actor of all. . . . I have never known a happier household than theirs was during those years."

effect. Twain had hired Associated Artists, the firm of interior decorators prominent in the so-called American Renaissance of decorative art, to take charge. Among the principals of the firm was Louis Comfort Tiffany, who played a large part in the look of this hall. It is pure Gilded Age, with a twist, and evidence of just the sort of lifestyle that was often the butt of Twain's satire. But then, he was an insecure man who lived inside a larger-than-life persona, so such contradiction shouldn't be surprising. The ornamental carving in black walnut was done by Leon Marcotte, and in 1881 Tiffany transformed the room's neo-Tudor look with stenciled walls

and ceiling. His patterns sometime resemble American Indian designs, and the fireplace is flanked by carved teak panels with pierced brass panels made in Ahmedabad, India.

Guests were brought first into the drawing room, which was Livy's domain. The piano recalls the recitals she organized. (Twain himself liked to bang out old Negro spirituals on it.) One visitor described the room as "luminous with white and silver and pale blue," and the great mirror at the front end of the room reflects the kilims and upholstered chairs—along with the quite conventional art Twain seemed to prefer. The room gives onto the dining room, whose walls are covered with Japanese leather embossed in a lily pattern of dark red and gold devised by Candace Thurber Wheeler. Above it is a frieze with a stylized Japanese jumping fish motif, and a stenciled ceiling with another Japanese design. There is an elaborate mantel designed by Tiffany in glass tiles, and the heavy sideboard, specially made in Boston to fit its shallow alcove, faces the table around which Twain gathered company that ranged from the general William Tecumseh Sherman to the actor Edwin Booth to the explorer Henry Morton Stanley. Everyone felt brilliant around Twain, though he was always the center of attention, shaping and polishing during dinner conversation his stories for the lecture circuit. After dinner, the men would retire to the adjoining library with its

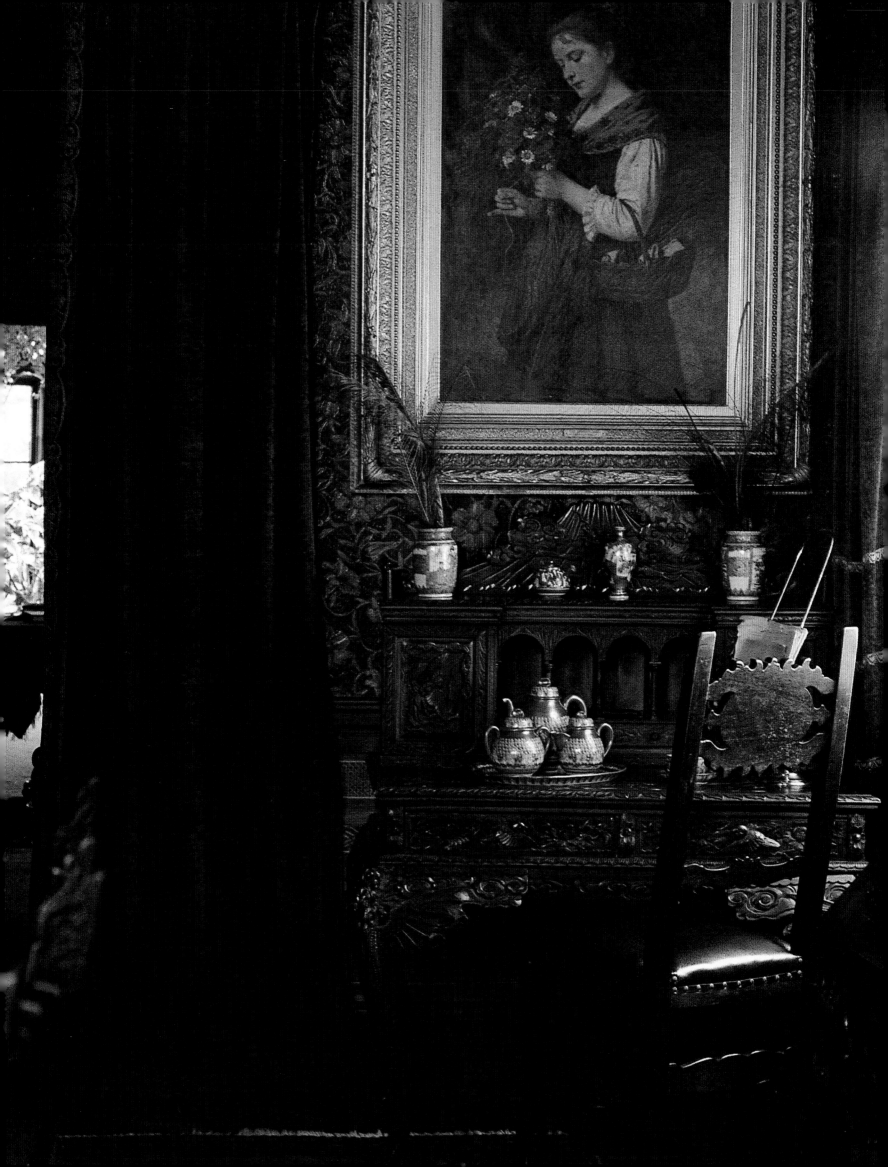

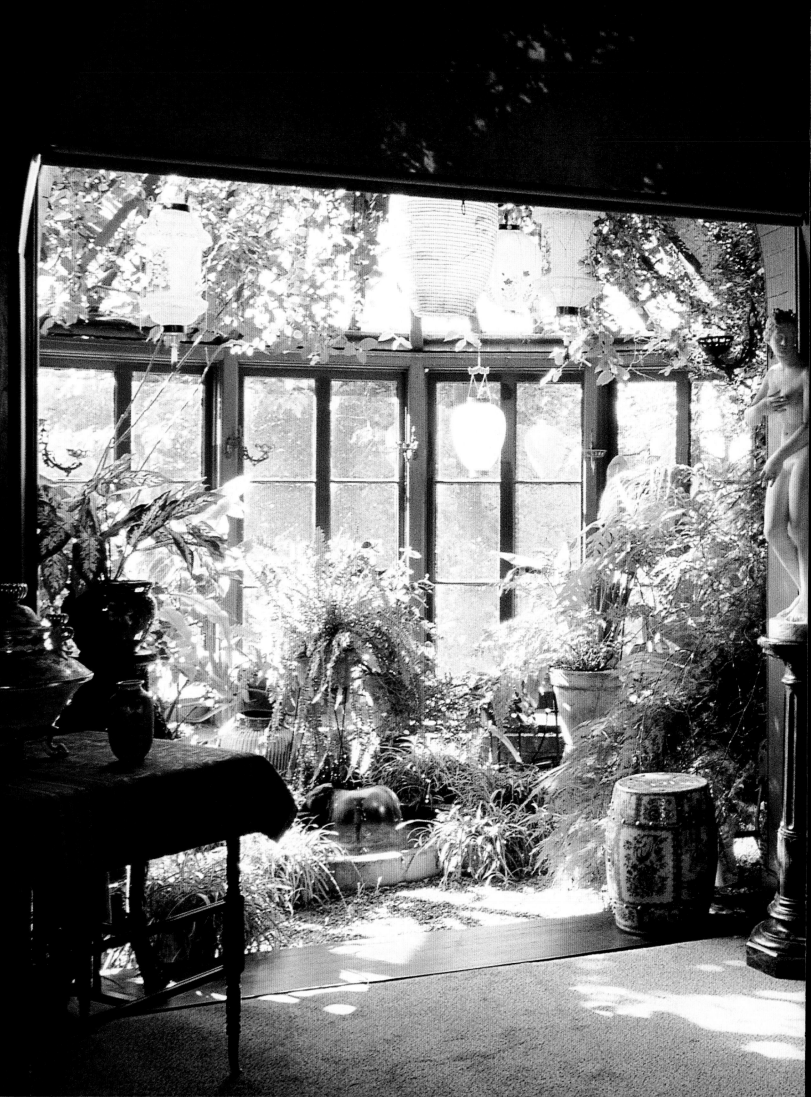

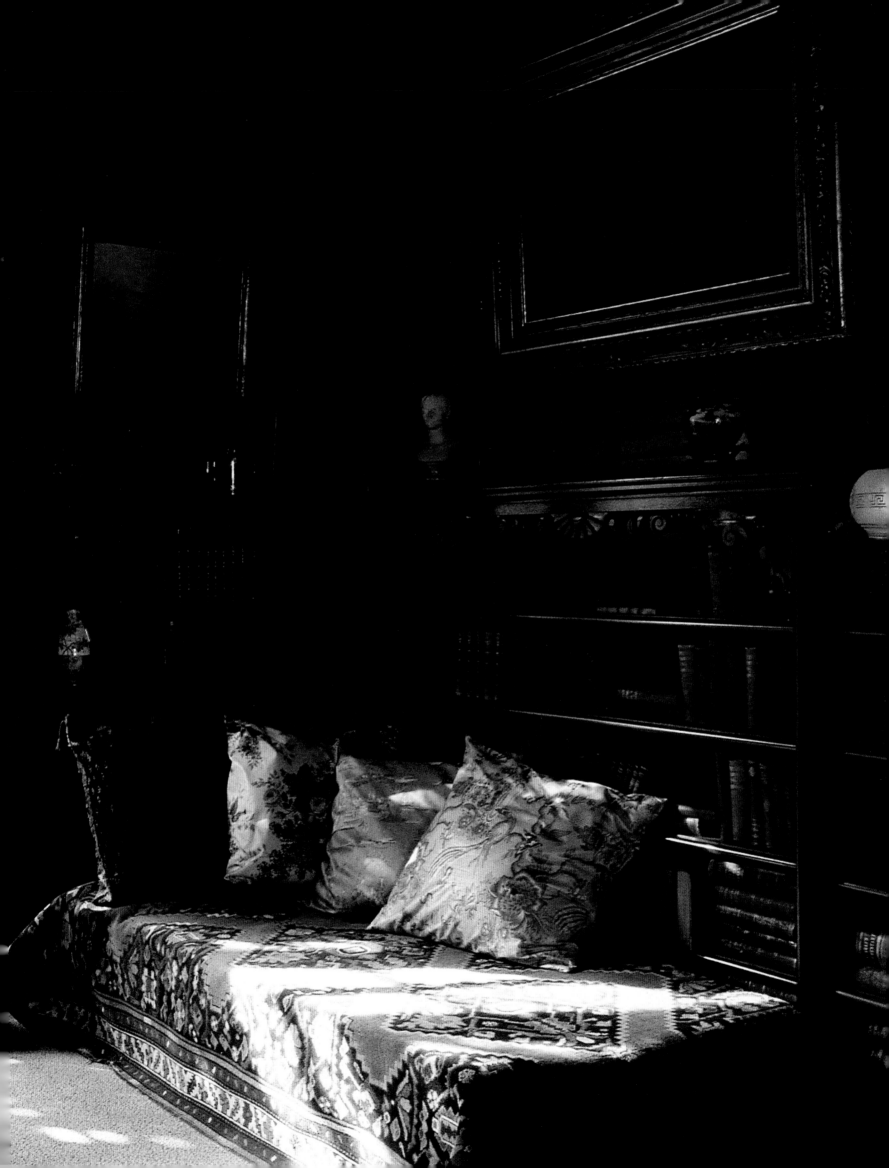

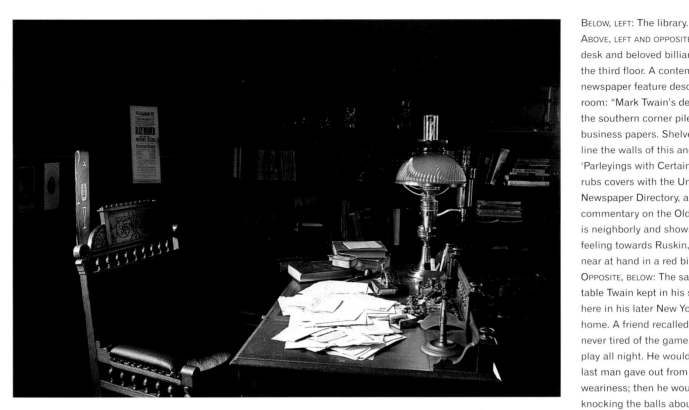

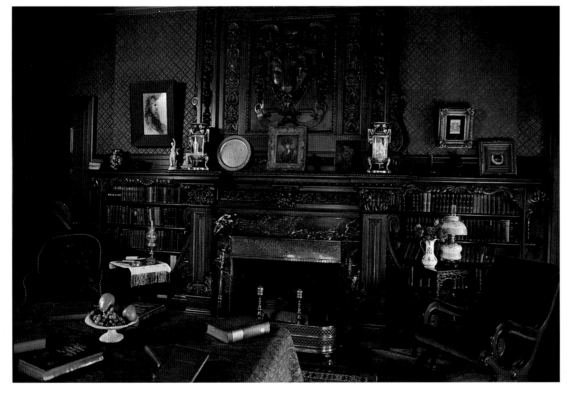

BELOW, LEFT: The library.
ABOVE, LEFT AND OPPOSITE: Twain's desk and beloved billiards table, on the third floor. A contemporary newspaper feature described this room: "Mark Twain's desk stands in the southern corner piled with business papers. Shelves of books line the walls of this angle. 'Parleyings with Certain People' rubs covers with the United States Newspaper Directory, and a commentary on the Old Testament is neighborly and shows no ill-feeling towards Ruskin, who stands near at hand in a red binding."
OPPOSITE, BELOW: The same pool table Twain kept in his study, but here in his later New York City home. A friend recalled: "He was never tired of the game. He could play all night. He would stay till the last man gave out from sheer weariness; then he would go on knocking the balls about alone." But he used the distractions of the game to help his concentration on his work, working out his ideas and phrasing. "The difference," he noted, "between the almost right word & the right word is really a large matter—it's the difference between the lightning bug and the lightning."

appended conservatory—a room that Twain himself cherished for "its delicious dream of harmonious colors, and its all-pervading spirit of peace and serenity and deep contentments." It was here he would read to himself—or to the children on his lap. The walls are lined with carved scrollwork bookcases, the tops of which were cluttered with bric-a-brac. Twain would use the objects to contrive stories to amuse his daughters. The room is dominated by a huge mantel that Twain brought back to the house in 1874 from Ayton Castle in Scotland. (It was removed when the house was sold in 1903, but was long after discovered disassembled in a barn and restored to the house in 1958.) The pierced brass fitting over the fireplace has inscribed in it a line by Emerson: "The ornament of a house is the friends who frequent it." Those friends staying overnight were put up in a sumptuous first-floor guest room, with an Eastlake-style mahogany

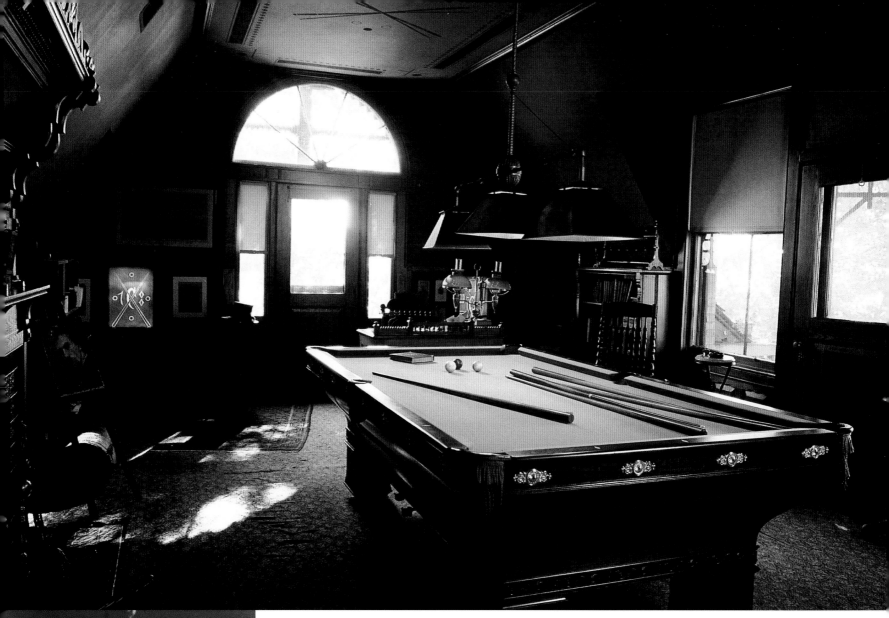

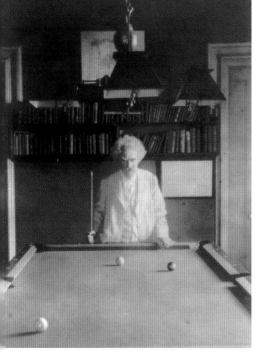

bed and dresser with inlaid Minton tiles. This arrangement afforded privacy both to guests and to the Clemens family upstairs.

Upstairs are rooms for the girls, whose wallpaper by Walter Crane illustrates the adventures of "Ye Frog He Would A-Wooing Go." Their dolls and tea sets, all the fragile and redolent stuff of memory, are still in place. Across the hall is their schoolroom, where the girls and their governess would tend to piano and violin lessons, history and literature, languages and dancing. The master bedroom is like a Victorian pond in the middle of which floats the author's magical island, the magnificently carved bed he brought back from Venice in 1878. He called it "the most comfortable bedstead that ever was, with space enough in it for a family, and carved angels enough . . . to bring peace to the sleepers, and pleasant dreams." Indeed, the carved angels he considered so sweet that he and Livy would sleep facing the head of the bed, for a better view of them; and the children liked them because they were detachable, and could be dressed up and played with.

The third floor was Twain's. Yes, his devoted African-American butler George Griffin had his room there too, but most of the floor is given over to Twain's study. It is stocked with what prompted his imagination or allowed him—since he wrote, he said, in "fits and starts"—both to relax and to concentrate. In the middle of the room is a fine billiards table where countless idle games might give him the chance to twist a plot or move a paragraph along. On rare occasions, too, he would bring a visiting friend—William Dean Howells, say, or Bret Harte—up here for a game. There is a balcony where he could string a hammock. A desk for correspondence and paperwork. And a writing table that faces his bookshelves, not the windows. He would pin notes to the walls in front of him—reminders, outlines, passages to be inserted later. After a huge breakfast (a whole chicken, for instance, with potatoes), he would come up to his study around 11 in the morning, and work all day until supper, taking the time then to read to his family what he had written during the day. It was then they heard the unfolding of such classics of American literature as *The Adventures of Tom Sawyer* (1876), *A Tramp Abroad* (1879), *The Prince and the Pauper* (1880), *Adventures of*

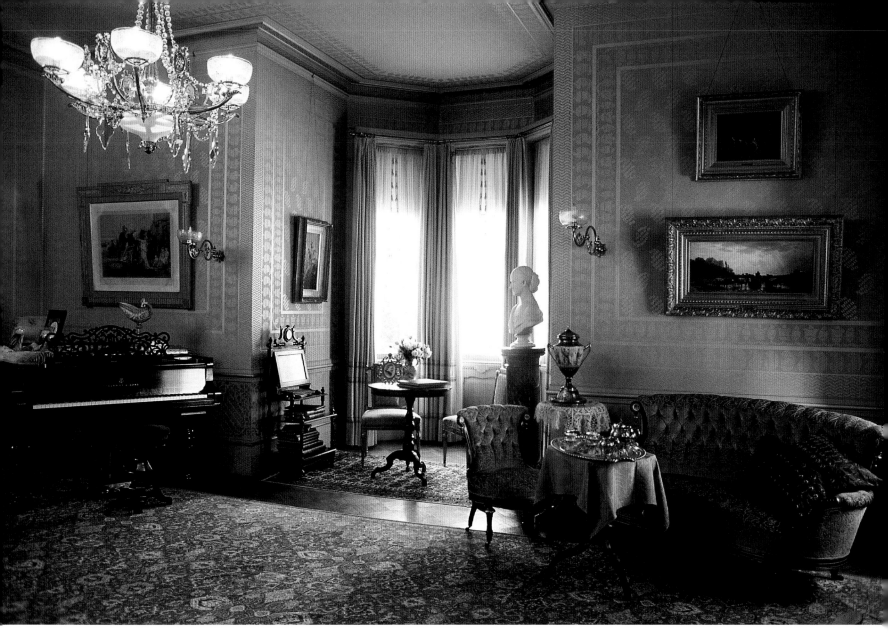

Huckleberry Finn (1885), and *A Connecticut Yankee in King Arthur's Court* (1889). Perhaps the most distinctive features of this room are the two translucent marble panels set in the wall behind Twain's desk. They were a gift to him from the architect, etched with the date of the house's completion, 1874, and a "C" for Clemens, along with depictions of things dear to the author's heart—a pipe, wine barrels, a stein, a champagne bottle, drinking glasses, billiard sticks and balls.

Twain saw to it that the house was equipped with the latest modern conveniences—burglar alarm, gas lighting, central heating, speaking tubes and bells, flushing toilets and hot showers, even a telephone. Ten years after he moved into his Hartford home, he wrote, "I am frightened at the proportions of my prosperity. It seems to me that whatever I touch turns to gold." But running the house was more expensive than he thought. There were seven servants, along with tutors and barbers, and Livy's extravagant ways resulted in weekly grocery and wine bills mounting to a lavish $100. Their yearly household

expenses ran to $30,000. Twain wanted to spoil his adored wife and give his children everything he himself had never had as a child. He decided that the best way to supplement his writing income would be to invest in a publishing company and in new inventions. In 1884, he put his young nephew-by-marriage, Charles L. Webster, in charge of his publishing enterprise, and the firm's first book, *Huckleberry Finn*, was a bonanza—the second book too, the *Memoirs* of Ulysses S. Grant. But these were the firm's only successes, and eventually the company went out of business. Undaunted, Twain invested huge sums in new-fangled steam generators and marine telegraphs. His greatest fiasco, though, was the money he sank—up to $5,000 a month—into the development of the Paige compositor, a typesetting machine he thought would revolutionize printing. The inventor kept insisting on refinements, and Twain kept backing him, at one point borrowing an additional $160,000 for that purpose. Nothing ever worked, and creditors hollered. Livy's health was delicate, and Twain's rheumatism prevented him from writing.

Fortunately, the house was in his wife's name, so it was safe from the crushing toll of his debts. Still, in 1891, the family decided to move to Europe to live more frugally, and to allow Twain's fame abroad to help him earn the money necessary to pay back his debts. In 1895, Twain was sixty years old, world-famous, and bankrupt.

As he slowly worked to restore his fortunes, he was hit with more heartache. His daughter Suzy, always his favorite, had returned to the United States and was visiting friends in Hartford, where she would go to the family's old home to practice on the piano. She soon developed a fever that was diagnosed as spinal meningitis. Delirious, she wandered about the house, then finally went blind, lapsed into a coma, and died at the age of 24, on August 18, 1896. Twain never recovered. For years, no holiday was ever celebrated. "God gives you a wife and children whom you adore," he wrote in an essay, "only that through the spectacle of the . . . miseries which He will inflict upon them He may tear the palpitating heart out of your breast and slap you in the face with it. . . . He can never hurt me anymore." But He did. Twain eventually returned to America, but neither he nor his wife could ever set foot in the Hartford house again. He passed by it once, during a trip in 1900, but couldn't go in. "I realized that if we even enter the house again to live our hearts will break." They finally sold it in 1903. By then, the neighborhood was unfashionable and the property brought only $28,000, just a quarter of its original cost. The next year, his beloved wife died, and Twain's remaining daughters, Clara and Jean, tried to look after him. But the volatile Clara was temperamental and strong-willed, and Jean eventually had to be sent to a sanitarium. He had always had a private understanding. "The secret source of humor itself," he wrote, "is not joy, but sorrow. There is no humor in heaven." But now his sorrows seemed overwhelming, and when Jean died of a heart attack at the age of twenty-nine on Christmas Eve, 1909, he wrote to a friend, "It is the end of my autobiography. I shall never write any more." The man who had enchanted millions, and whose family and home had been the source of infinite delight, toward the end could only think:

> There is no God and no universe; . . .
> there is only empty space, and in it a lost
> and homeless and wandering and
> companionless and indestructible Thought.
> And . . . I am that thought. And God,
> and the Universe, and Time, and Life,
> and Death, and Joy and Sorrow and
> Pain only a grotesque and brutal dream,
> evolved from the frantic imagination
> and that insane Thought.

His only peace came at the end. When he died in 1910, thousands of mourners passed his open casket at the Brick Presbyterian Church in New York City. One of them was the Reverend Joseph Twichell, Twain's closest friend, the man who had married Twain and Livy and presided over the funerals of his wife and children. "I looked a moment at the face I knew so well," he recounted, "and it was patient with the patience I had so often seen in it: something of a puzzle, a great silent dignity, an assent to what must be from the depths of a nature whose tragical seriousness broke into laughter which the unwise took for the whole of him. Emerson, Longfellow, Lowell, Holmes— I knew them all and all the rest of our sages, poets, seers, critics, humorists; they were like one another and like other literary men; but Clemens was sole, incomparable, the Lincoln of our literature."

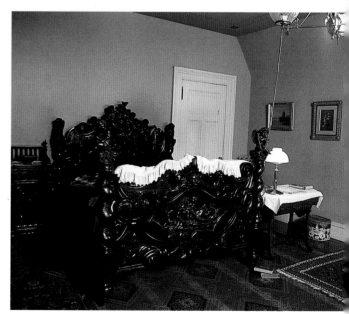

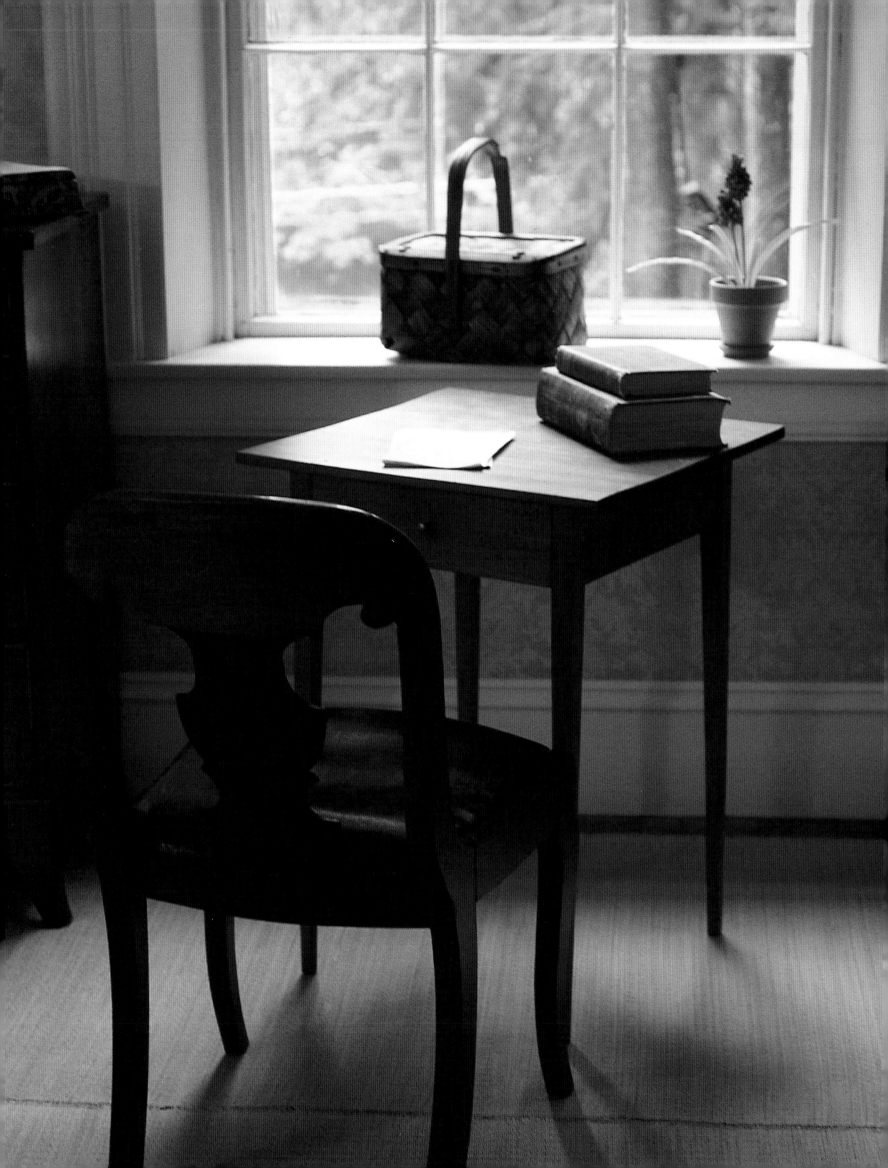

Emily Dickinson

1 8 3 0 – 1 8 8 6

OPPOSITE: The writing table in Dickinson's bedroom. Her bedroom was at the front of the house, and she could look out onto the street, but she rarely ventured out of the house and eventually preferred to stay in her room. It is hard to say how often she wrote, but there seem to have been distinct waves, a few years at a time, when poems poured forth. The most astonishing of these occurred in 1862–63, when hundreds were composed.

ABOVE: Dickinson at 16, a daguerreotype made by William C. North in 1847. It is the only authenticated photographic image of the poet.

RIGHT: Main Street, Amherst. In the left background The Evergreens, the house belonging to Dickinson's brother Austin, and on the right the Dickinson Homestead itself.

Anyone moving to Amherst at the time would hear, soon enough, about that woman living on Main Street, a recluse famous for her eccentricity, and known locally as "the Myth." Emily Dickinson was well known in her own day, not for her poems (she published only ten of them in her lifetime, all anonymously), but for her odd behavior. She was the sweet spinster cracked with moonlight, a white witch who let gingerbread down on a string from her bedroom window for the neighborhood children. Townsfolk had no idea what else went on in that bedroom, where at a small writing table in the corner Dickinson wrote the eeriest poems any American ever imagined. With Walt Whitman, she remains one of the two progenitors of American poetry, all of it born of his soulful, sprawling vision and her ecstatic hymns to unbelief. Whitman did his best to make himself known—he had dozens and dozens of publicity photographs taken. Of Emily Dickinson, we have just one daguerreotype, taken by an itinerant photographer when she was only sixteen.

What wasn't known about her gave rise to distorting stories. After her death, when the first collections of her poems were gathered up and published, she was portrayed as a delicate curiosity whose "bolts of melody" had been stitched together like a homemade sampler. It was not until 1955, seventy years after her death, that an accurate and comprehensive edition of all her 1775 poems appeared; a popular reading edition followed in 1961, a serious biography in 1974. Only in the short decades since has her true power at last, and almost abruptly, been revealed. The Dickinson myth—again adjusted, this time to her position as one of the language's great poets—has become an industry, and her story has been rewritten to include absurd melodramas from abortions to lesbian affairs,

and her role in the culture been changed—now anti-war crusader, now feminist pioneer. Each time, she slips free, of biographical nonsense or of any other reductive classification. Her life remains a puzzle, at once demurely conventional and powerfully estranged. And her poems remain a mystery, plain as a daisy and as cryptic as any heart.

Emily Dickinson was born on December 10, 1830, in the large brick Federal house her grandfather, Samuel Fowler Dickinson, had built in 1813, three blocks from the Amherst town green. Financial losses forced him to sell the house in 1826, and his son Edward Dickinson, his wife, and their three children—Austin, Emily, and Lavinia—lived as tenants in the eastern half of the house until 1840 when they moved to a wood-frame house on North Pleasant Street. It was there, across the street from the cemetery where she is now buried, that the poet passed

of the original furniture remain in the house; most were dispersed to family and friends over the years. (At Harvard's Houghton Library, which now owns most of Dickinson's manuscripts, there is an Emily Dickinson Room which preserves the family portraits and piano, along with other furniture, including the poet's writing table and her bedroom chest of drawers, where her sister found the bundles of her poems after her death.) Though there was a devoted Irish servant, Emily and Lavinia liked to help run the household and work in the garden. Though at first she would visit her brother and sister-in-law at The Evergreens, Dickinson grew increasingly nervous in public and withdrew more and more, eventually unwilling to leave the house, and usually loathe to see any company. So it is the rooms upstairs in the Homestead that have the most interest. Dickinson's own

LEFT: Flowers in the garden today. RIGHT: An 1856 print of the Dickinson Homestead by John Bachelder. A childhood friend of Dickinson, later Mrs. Gordon L. Ford, left an account of the younger Emily: "I think the friendship was based on certain sympathies and mutual admirations of beauty in nature and ideas. She loved the great aspects of nature, and yet was full of interest and affection for its smaller details. . . . She knew the wood-lore of the region round about, and could name the haunts and the habits of every wild or garden growth within her reach. Her eyes were wide open to nature's sights, and her ears to nature's voices."

her formative years, from age nine to twenty-four. In 1855, when the owner of the Homestead died, Edward Dickinson, then a congressman, bought the house back, with its fourteen acres, eleven of them across the street and known as the Meadows. The previous owner had enlarged the structure in the Greek Revival style, and Edward Dickinson wanted to make his own "great repairs." The fashion of the day was the Italianate style, so a conservatory and cupola were added on, a parapet was built on top of the portico; the two west parlors were combined into a double-parlor, with a fireplace of Italian marble and a veranda; the original brick was painted ochre. A year later, when Austin married Susan Gilbert, Edward Dickinson had built for them next door to the Homestead a classic Italian villa called The Evergreens, which soon became an intellectual and social center of Amherst life.

Inside the Homestead the rooms are spacious. The ornamental moldings around the windows and doors were painted a dark brown—so that the wood would resemble wood—to offset the floral wallpaper. Few pieces

bedroom is at the front, looking—through the pots of forced hyacinth she kept on the windowsills—past the hemlock hedge at Main Street on one side, and on the other toward The Evergreens, suggesting a woman who remained above all she surveyed. Her narrow bed has an austere air, enlivened by the paisley shawl outspread over it. The room behind her bedroom is nowadays dominated by an eerie presence. Dickinson's sister, after the poet's death, gave to her cousin as a memento one of the white house-dresses Dickinson wore; that cousin's sister eventually gave it to the Amherst Historical Society, which has it to this day. Because of its fragility a replica was made in machine-stitched cotton with pearly buttons down the front (the seamstress's twelve-year-old son posed for the mannequin), which stands now, inside a glass case, the ghost in the house. How tiny and plain the dress, how huge and startling the poems.

Dickinson was a middle child. Her mother, after whom Emily was named, was a meek, unhappy, and resigned woman. Her father dominated family life, the remote puritanical God of

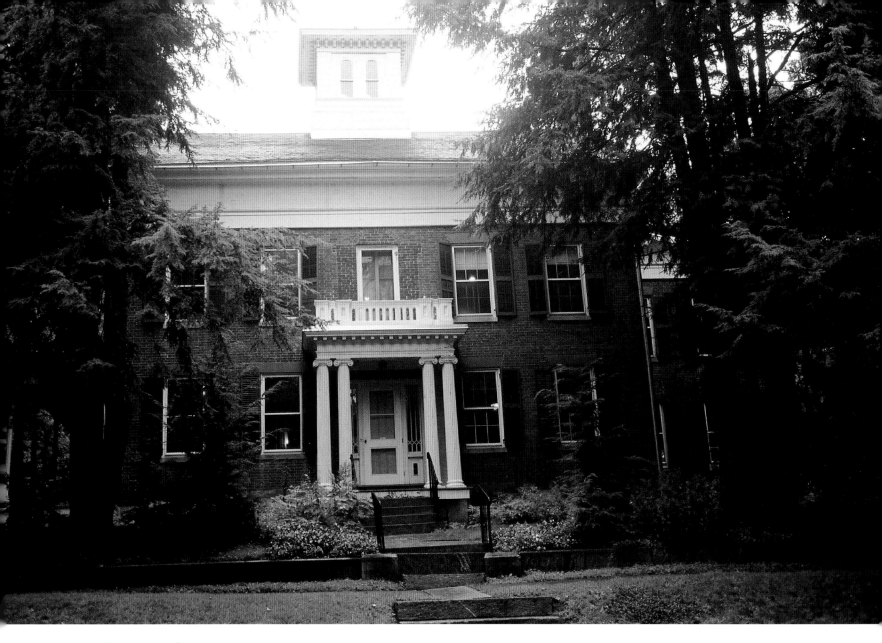

The front entrance of the Homestead. When the man she called her "savior," the literary critic Thomas Wentworth Higginson, first visited Dickinson, he asked "if she never felt any want of employment, not going off the grounds, and rarely seeing a visitor." To which she replied, "I never thought of conceiving that I could ever have the slightest approach to such a want in all future time."

her Eden, after whose death Dickinson wrote, "His heart was pure and terrible." In truth, she was alone, and her earthly paradise was language. "My Lexicon—was my only companion," she later wrote. "My Mother does not care for thought," one of her letters, with her characteristic dashes, recalls, "—and Father, too busy with his Beliefs—to notice what we do—He buys me many Books—but begs me not to read them—because he fears they joggle the Mind. They are religious—except me—and address an Eclipse, every morning—whom they call their Father." She was given a superior education— rigorous studies in mathematics, science, philosophy, music, and logic—but before all else came religion. Amherst, though a college town, was a staunchly Puritan community. The air rang with themes of death and salvation; ordinary events were emblems of states of soul, the world merely a text to be deciphered for God's intentions. Religious revivals periodically swept through town. As a young woman, Dickinson both yearned for and resisted the sometimes harrowing call to conversion. "Christ is calling everyone

here," she wrote to a friend in 1850. "All my companions have answered. . . . I am standing alone in rebellion and growing very careless." At the Mount Holyoke Female Seminary she was put with the no-hopers, determined to preserve her identity and cultivate her intelligence. "The shore is safer," she wrote at twenty, "but I love to buffet the sea—I can count the bitter wrecks here in these pleasant waters, and hear the murmuring winds, but oh, I love the danger!"

She read the books in her father's library, cherished a series of passionate, anxious friendships, and watched as her friends married or died young. "Parting is all we know of heaven," her famously bleak poem has it, "And all we need of hell." Abandoned to a daughter's duty, but choosing the terms of seclusion necessary to her genius, she retired into a homebound world of words. "Because I could not say it," she wrote once, "I fixed it in Verse." Words became her source of empowerment, her sense of self, her means to wrestle with the demons of faith or the seraphic exultations of solitude, her way to both preserve and parse her perceptions. "Sometimes

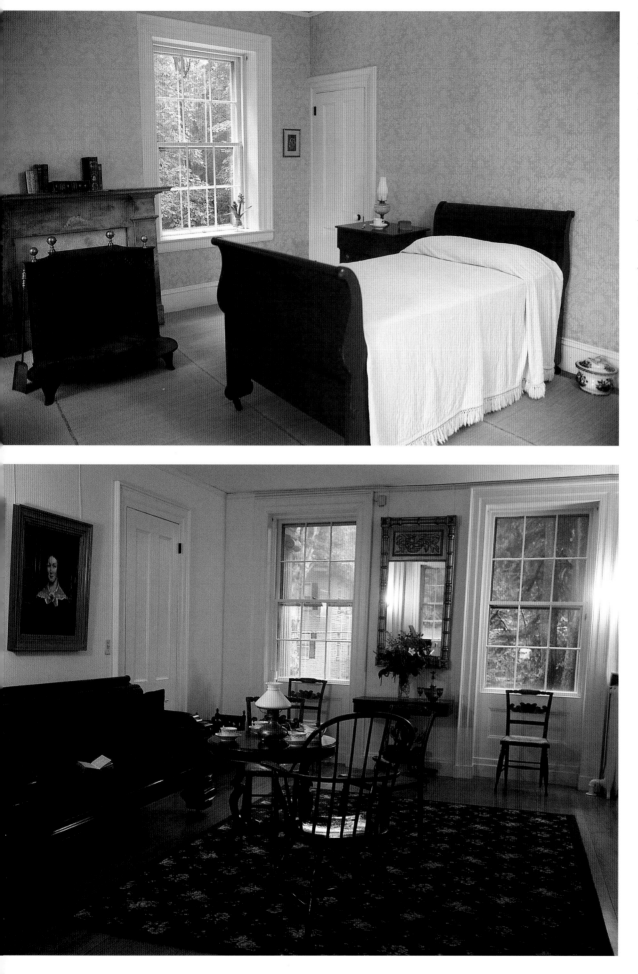

LEFT: The poet's bedroom. What his cabin at Walden Pond was for Thoreau, this room was for Dickinson—a refuge from the world's business and a lens through which to study nature and the soul more intently.

BELOW, LEFT AND OPPOSITE: The parlor at the Homestead. The room's comfortable, sociable ambience is in sharp contrast to the austerity of Dickinson's bedroom upstairs.

BELOW: One of Dickinson's dresses, thought to have been worn by the poet in the late 1870s or early 1880s. In her later years, she would wear only white, and as she grew more reclusive, dressmakers fitted her garments to her sister Lavinia.

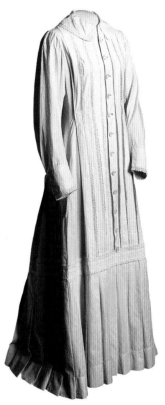

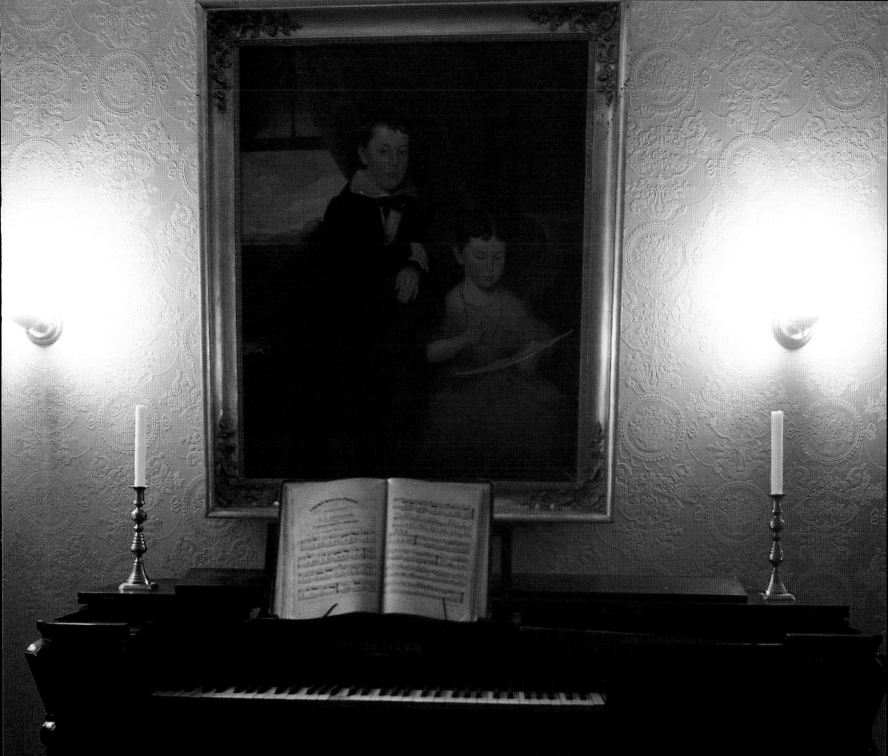

I write bone," she once said of words, "and look at his outlines till he glows as no sapphire." But from the start, she realized that the gem has a cutting edge, that she could use "words like Blades . . . / And every One unbared a Nerve / Or wantoned with a Bone." Gem and blade can both be seen in that "certain slant of light" her poems cast, and by means of which she discovered for herself a vocation higher than any calling, an inspiration that entitled her to eternity:

> *For this—accepted Breath—*
> *Through it—compete with Death—*
> *The fellow cannot touch this Crown—*
> *By it—my title take—*
> *Ah, what a royal sake*
> *To my necessity—stooped down!*

Precisely when and why she began writing poems it is impossible to say, as it is about any poet. By the late 1850s she was copying out her poems and binding them into packets—four or five sheets of folded and threaded writing paper, called fasicles. Nearly fifty of these booklets were found in her bureau. During the last two decades of her life, she wrote little. The flood-tide was 1862–63, when hundreds of poems, and many of her greatest, were written. Some critics suggest a nervous crisis; others a surge of confidence. It was just at this time, in fact, aware of her power but uncertain of its possibilities, that she turned to someone for help. Encouraged by a sympathetic essay, "Letter to a Young Contributor," she read in the *Atlantic Monthly* in April 1862, she sent its author, the critic Thomas Wentworth Higginson, four of her poems and a letter asking him to say "if my Verse is alive." His reply was respectful, but he judged the poems "not for publication." She wrote back to thank him "for the surgery—it was not so painful as I supposed," and enclosed three more poems. Again, Higginson wavered, finding the poems "remarkable, though odd." Again, Dickinson's reaction had a proud, sardonic edge: "If fame belonged to me, I could not escape her—if she did not, the longest day would pass me on the chase and the approbation of my Dog, would forsake me You think my gait 'spasmodic'—I am in danger—Sir—." Her fourth letter to him, a month later, is bolder in its declaration of her ambition: "Perhaps you smile at me. I could not stop for that—My Business is with Circumference—An Ignorance, not of Customs, but if caught with the Dawn—or the Sunset see

Executed by Charles Temple, a native
of Smyrna.
1845

Emily E. Dickinson

me—Myself the only Kangaroo among the Beauty." By the word "circumference," Dickinson means she locates herself on the edge of things, a God's-eye view, looking back at worldly life and outward to cosmic matters.

"Something in the sight / Adjusts itself to Midnight," one poem avows. God's withdrawal from the land—"so huge, so helpless to conceive"—is an abiding theme of hers:

> Much Gesture, from the Pulpit—
> Strong Hallelujahs roll—
> Narcotics cannot still the Tooth
> That nibbles at the soul.

Reluctant to doubt the principle of God's existence, she was at the same time eager to undermine complacent or oppressive myths about our Father and his "House of Supposition." And though she wrote with a naturalist's eye about the New England landscape—the apple bough beyond the window, the bee at its flowery task, the sowing of days and harvest of season— she treats Nature as she does Divinity, as a metaphor for the self. What her poems regard continually, and with a restless moral scrutiny, is the soul's abyss, the experience of human isolation, the threatened, vulnerable self "homeless at home" in this world.

When Higginson—who she once said "saved my Life" by his interest in her work—asked her for a photograph of herself, Dickinson demurred, and described herself as "small, like a Wren, and my Hair is bold, like the Chestnut Bur—and my eyes, like the Sherry in the Glass, that the Guest leaves." The woman's self-effacement disguised the poet's bold strategies. She stayed in her room, dressed in white, like a page on which the universe would inscribe its secrets. At her funeral, Higginson looked at her, in her white dress, in a white casket, and marveled that she had "not a gray hair or wrinkle, & perfect peace on the beautiful brow." But when he had first visited her years earlier, after their correspondence, he wrote of her "excess of tension . . . She was much too enigmatical a being for me to solve in an hour's interview." "I was never with any one," he wrote to his wife, "who drained my nerve power so much. Without touching her, she drew from me." His experience in the Amherst parlor was the same as any reader's today with her poems. She draws from us the very mystery of selfhood. She draws us on toward "the Glimmering Frontier that skirts the Acres of Perhaps."

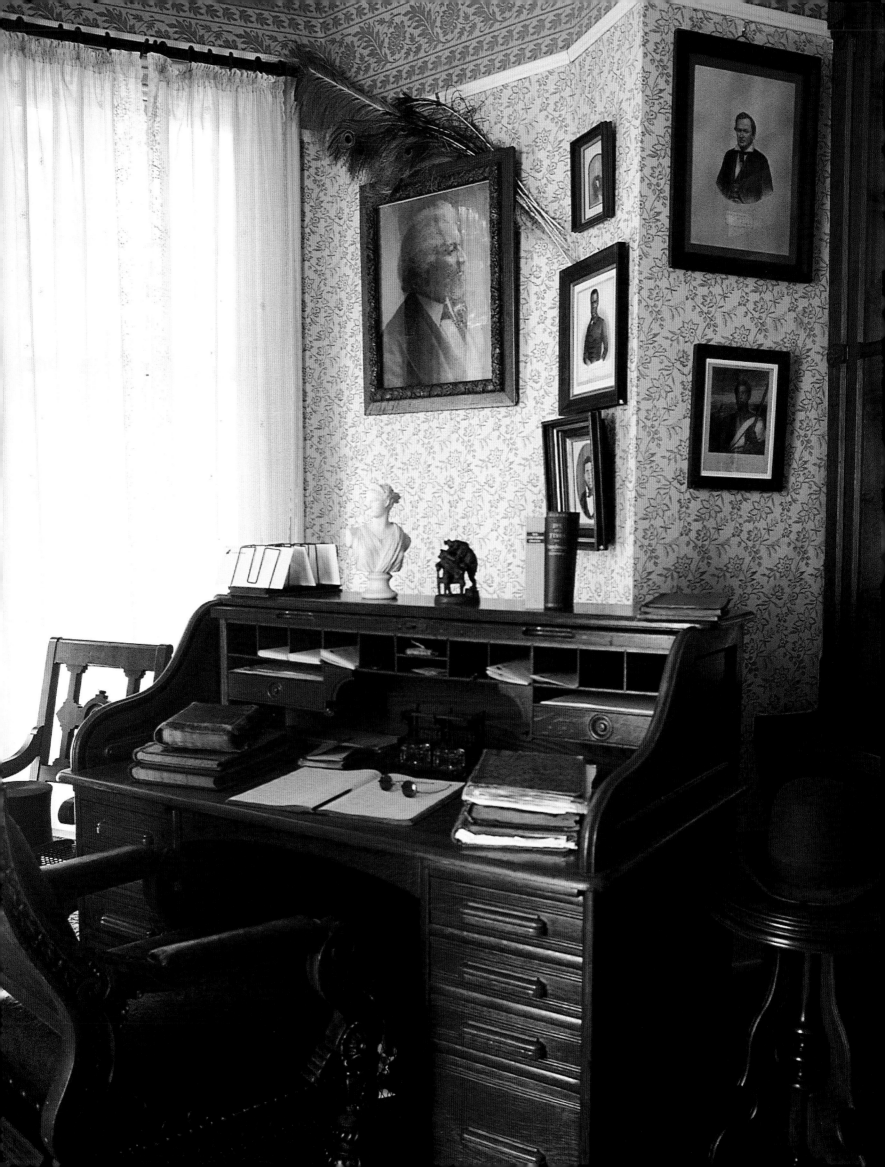

Frederick Douglass

1818 – 1895

OPPOSITE: Douglass's desk in his study at Cedar Hill. His library of over 2,000 volumes was nearby, and portraits and busts of his intellectual heroes surrounded him as he worked. It was here that he wrote the two expanded versions of his autobiography, as well as the many speeches and essays that roused the nation's sense of justice after the Civil War, just as his fiery anti-slavery speeches had shaped the North's thinking before the conflict. In 1892, he wrote: "Contemplating my life as a whole, I have to say that, although it has at times been dark and stormy, and I have met with hardships from which other men have been exempt, yet my life has in many respects been remarkably full of sunshine and joy."
RIGHT: Frederick Douglass working at his desk, c. 1890.

There are times, it has been said, when the events before a writer's eyes are so intense that the imagination isn't needed. Simple consciousness takes its place, and witness rather than fiction is called for. Aleksandr Solzhenitsyn writing about the gulag or Primo Levi writing about the concentration camps testify to the enormous power of such witnessing—a power that haunts the imaginations of their readers, charges their memories, and transforms their souls. It has also been said that the whole African-American literary tradition grew out of slave narratives, those harrowing accounts of damnation and redemption, of bondage and freedom. The greatest of them is the autobiography of Frederick Douglass, and the witness he bore has inspired generations. But Douglass also takes a prominent place in a line of celebrated American autobiographers, from Benjamin Franklin to Ulysses S. Grant to Henry Adams—and probably also including Gertrude Stein for her *Autobiography of Alice B. Toklas.*

It may be, as Willa Cather wrote, that "there are only two or three human stories, and they go on repeating themselves as fiercely as if they had never happened before." Douglass's story was that of thousands of others, yet he made it powerfully his own. At the same time, he felt trapped in it. As he wrote to a friend, "I shall never get beyond Frederick Douglass the self-educated fugitive slave." And yet, it was a figure he created as surely as Melville created his Ahab or Faulkner his Sutpen. And he created it over and over again. Douglass published his *Narrative of the Life of Frederick Douglass, an American Slave, Written by Himself* in 1845. Ten years later, he published *My Bondage and My Freedom.* Then in 1881 there appeared *Life and Times of Frederick Douglass,* which he later revised, expanded, and re-published in 1893. In that first book, he

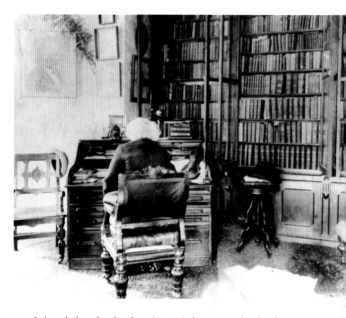

explained that he had written it because he had been accused of being an impostor and "I was induced to write out the leading facts connected with my experience in slavery, giving names of persons, places, and dates—thus putting it in the power of any who doubted, to ascertain the truth or falsehood of my story of being a fugitive slave." To have revealed such facts, he knew, risked his freedom, since he would be liable to capture and return. Soon after the book appeared, in fact, he left the country to lecture in the British Isles, and learned while abroad that his slave master had vowed to seize him if he ever returned. (A few months later, his English friends raised the money to buy Douglass's freedom. His manumission cost $711.66.) But the fact that he kept returning to his autobiography, first to sharpen its moral edge, and later to piece together more and more details of his past, shows his obsession not just with the facts of history, but with the shape and force of his story.

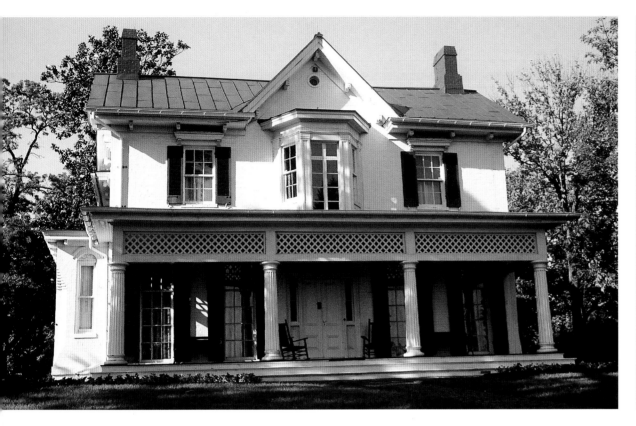

But from the very beginning he had been forced to make himself up. He was born Frederick Augustus Washington Bailey, the son of a slave, Harriet Bailey, who was forced to give him up to be raised by relatives, and of a white father, rumored among fellow slaves to have been his master. He was listed on the estate's inventory of property along with mules and bags of meal. But as a boy he learned to read and write, even though for obvious reasons, it was imperative that owners keep their slaves from doing so. The ability to communicate and organize would, the owners thought, lead inevitably to rebellion. A sympathetic mistress, the owner's children—Douglass begged everyone he dared for help in learning. Later, working on the wharves in Baltimore, he watched carpenters mark pieces of wood with an "S" or an "L" to designate which part of the ship they were destined for. White playmates taught him the other letters, and before long he was copying from Webster's spelling-book. Learning was in a crucial sense an escape, but with a bitter irony it also led him to realize the miserable depth of his condition. Still, he used his hard-won knowledge, trying to educate other slaves and later organizing debating societies. Nothing, though, could remove the shackles of slavery but a real escape, and in 1838 he fled north. At first, he used Johnson as his last name to avoid detection, but when that seemed too common a name, he chose Douglas, the name of a lord in Sir Walter Scott's poem *The Lady of the Lake*, and added an extra *s* as a flourish.

Hearing the fiery speeches of abolitionists like William Lloyd Garrison inspired him to speak and write. He traveled across New England, preaching his anti-slavery message, and before long was doing so in England and Ireland as well. In a larger sense, his work on behalf of women's suffrage and of Chinese immigrants shows that he was an advocate of human freedom. It is no wonder that when news of Douglass's death reached Theodore Roosevelt, he praised Douglass for having taught "the lesson of truth, of honesty, of fearless courage, of striving for the right; the lesson of disinterested and fearless performance of civic duty." It was a tumultuous life, lived against the violent panorama of the national struggle over slavery. The eloquence of his lectures gripped the imagination of everyone who heard him, and after the Civil War he fought just as hard for justice during Reconstruction. As a writer and a newspaper editor as well as an orator, he was tireless in pursuit of his goals. Beaten and ridiculed, he pressed on. But when arsonists burned down his house in Rochester in 1872, he was fearful for his family's safety. It was time to settle elsewhere.

Douglass had moved to Washington two years earlier, in 1870, appointed by President Grant to be assistant secretary to the commission investigating the possible annexation of the Dominican Republic. It was the first of several government posts he held: U.S. marshal for the District of Columbia, recorder of deeds for the District, and Consul General to Haiti. When he

For a man who had grown up in slavery, Cedar Hill must have represented a singular turn of fortune, seeming to embody in its spacious dimensions and elegant setting the very idea of the master's Big House that was a fixture of his childhood. From 1824 until 1826, Douglass had lived as a slave child at the Lloyd plantation on the Wye River on the Eastern Shore of Maryland, and he wrote of its Great House Farm: "Few privileges were esteemed higher, by the slaves of the out-farms, than that of being selected to do errands at the Great House Farm. It was associated in their minds with greatness." Greatness, Douglass soon learned, was a property of the spirit, and he never took for granted the comfort he came to find at Cedar Hill, but used it to work tirelessly on behalf of the downtrodden.

help. He named the house "Cedar Hill" to acknowledge both its lofty prospect and its signature trees, which far outnumber the walnut, tulip, and oak elsewhere on the grounds. Over the years, he added both to the property and to the house itself, attaching a clapboard extension onto the original brick structure. And to the outbuildings he added a growlery. It is a small stone hut, with its own fireplace, bed, and desk, and was meant to accommodate what its name implies: Douglass in his moody moments.

The house's east parlor was the public room. A visitor would hand the butler his card, and Douglass would decide to accept or decline the visit. If he had the time and inclination, he would receive his visitors in this room, with its bay windows flanking the marble fireplace and gilded mirror. An imposing portrait of Douglass and pictures of his two wives stare from the walls. The room yields to Douglass's study, a room which to this day has the aura of intensity. Its bookcases held over a thousand books, and at the roll-top desk he wrote the speeches he was constantly giving and dealt with his voluminous correspondence. It was here too that he wrote the final version of his autobiography. Nearby are a small stove and a letterpress, busts of philosophers and photographs of abolitionists and suffragists—as well as a portrait of Cinqué, who led the 1839 *Amistad* mutiny. His favorite reading chair, originally made for use in the House of Representatives and purchased by Douglass for $10 at a second-hand shop, faces the desk, and animal skins are laid over the carpet. A music stand and his violin case are at the rear, a reminder of his interest in music. Close by is a collection of his walking sticks. Not one he would use but by far the most treasured of them was the horn-handled stick owned by Abraham Lincoln and given to Douglass by Mrs. Lincoln after the president's assassination in recognition of all Douglass had done for and meant to her husband. Another cane is carved from wood taken from John Brown's house. In 1859, Brown had tried to enlist Douglass's help in his plot to seize the arsenal at Harpers Ferry, but Douglass refused, arguing that the plan was doomed to fail. He insisted that passionate eloquence rather than violence would win the day, and it was with this eloquence that he pressed a hesitant Lincoln on the fraught issue of emancipation during the Civil War: "The iron gate of our prison stands half open. One gallant rush from the North will fling it wide open, while four millions of our brothers and sisters shall march out into liberty. The chance is now given you to end in a day the bondage of centuries. . . ."

Across the hallway and through the sliding double doors, the west parlor was reserved for the family's use. Again, his favorite instrument,

decided to move his wife and children to the city with him, he first bought two townhouses on A Street and joined them. But in 1877, defying a "whites only" covenant, he purchased for $6,700 a house and a ten-acre property in Anacostia, which at the time was farmland about five miles from the Capitol. The house had been built in the late 1850s by John Van Hook, a real estate developer who was building Uniontown for people working at the Navy Yard. Van Hook's house, which served as his office as well, was on a hill overlooking the construction. But the project foundered, and Van Hook was forced to sell. For Douglass, who grew up with nothing, often went hungry and slept on a dirt floor, endured beatings and humiliations at the hands of cruel overseers, this must have seemed an eerie version of "the great house" he looked up to as a boy. He was now truly his own master. He could look out from his veranda over the city of Washington, the Capitol dome in the distance, and survey as well his own good fortune. There was livestock, an orchard, and vegetable gardens. He and his wife kept a maid, a butler, and a driver, plus yard

The small desk in the dining room where Douglass's wife, Helen, worked, keeping the house accounts and helping her husband with his correspondence. Helen Pitts, born in 1838, had graduated from Mount Holyoke Seminary (where Emily Dickinson had been a student). During the 1860s, she taught at Hampton Institute and was eventually hired by Douglass to work in the Recorder of Deeds office. All her life she was active in the women's rights movement and served on the board of managers of the Home for Colored Orphans. She endured criticism for marrying an African-American, but her devotion to Douglass and to his cause was unwavering. Near her death in 1903, in words echoing Lincoln, she wrote: "I do not wish this to be understood to be a colored movement, a movement by the colored people, but a movement by the people, for the people, regardless of color."

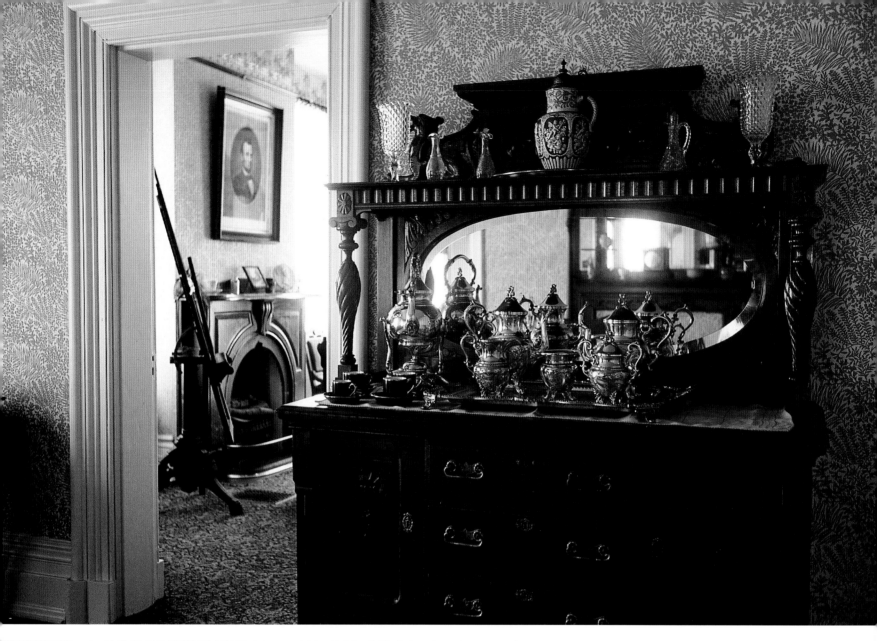

ABOVE: The mirror-backed sideboard in the dining room, looking through to the family parlor.

LEFT: His wife Helen's bedroom. Douglass's first wife, Anna, had died in 1882 from complications of a second stroke. He remained devoted to her memory and kept her bedroom as a shrine. His second wife was given a new bedroom next to Anna's. During the Victorian era, it was not just a sign of wealth but also of etiquette that each family member be provided with a private bedroom.

OVERLEAF: The west parlor, used by the family in the evening, when a musicale was often in order.

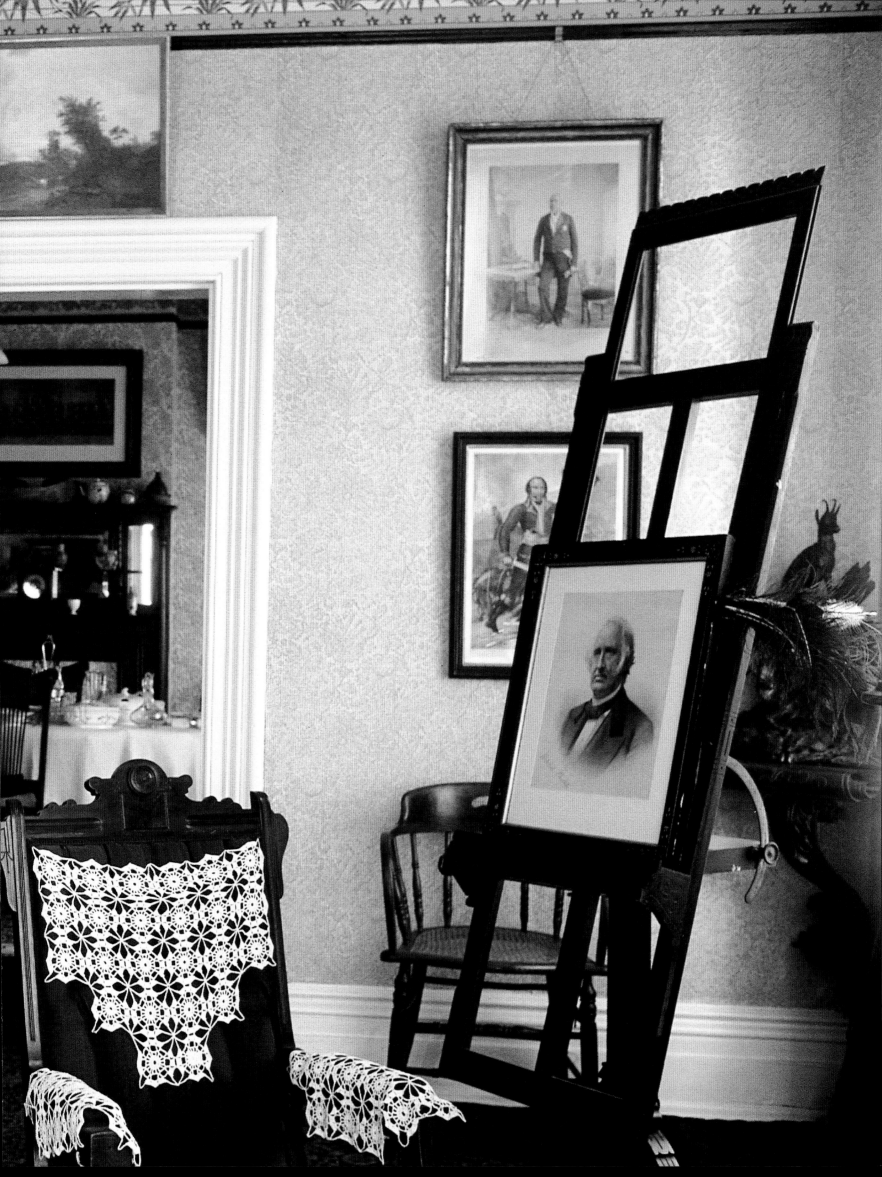

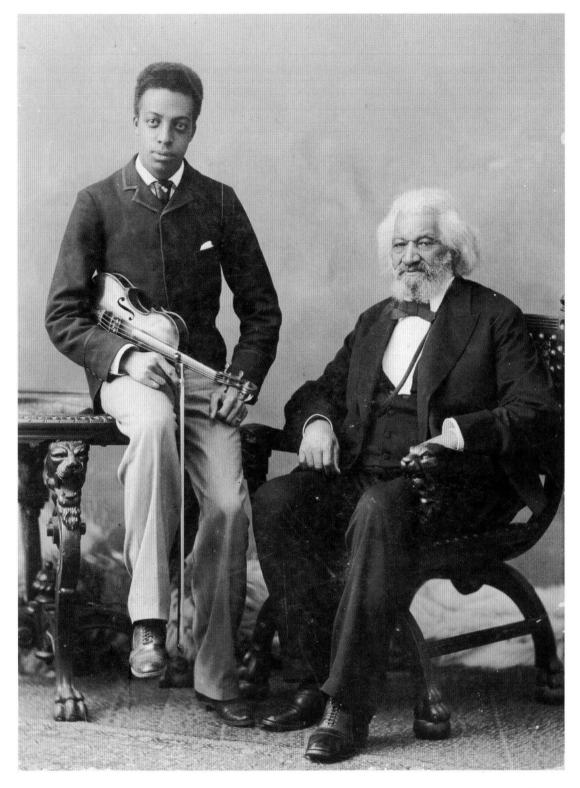

the violin, rests on top of an upright piano. In the manner of the day, there are photographs and engravings, and Greco-Roman statuary. A leather rocking chair, a gift from the people of Haiti, stands out, and in one corner is propped an elaborately carved cuckoo clock. This was a gift from his German admirer Ottilia Assing. A translator of his work into German, Assing devoted herself to him and in 1884 committed suicide in Paris when she learned that Frederick Douglass had married Helen Pitts.

Nonetheless, she bequeathed him her library and a trust fund.

Upstairs, on either side of the hall where Douglass kept the desk of the late Charles Sumner, the golden-tongued senator from Massachusetts, are the bedrooms, his own and those of his two wives. His first wife, Anna Murray, a free black woman born to slave parents about 1813, was working as a housekeeper when Douglass met and fell in love with her in 1837. She was the mother of his five children,

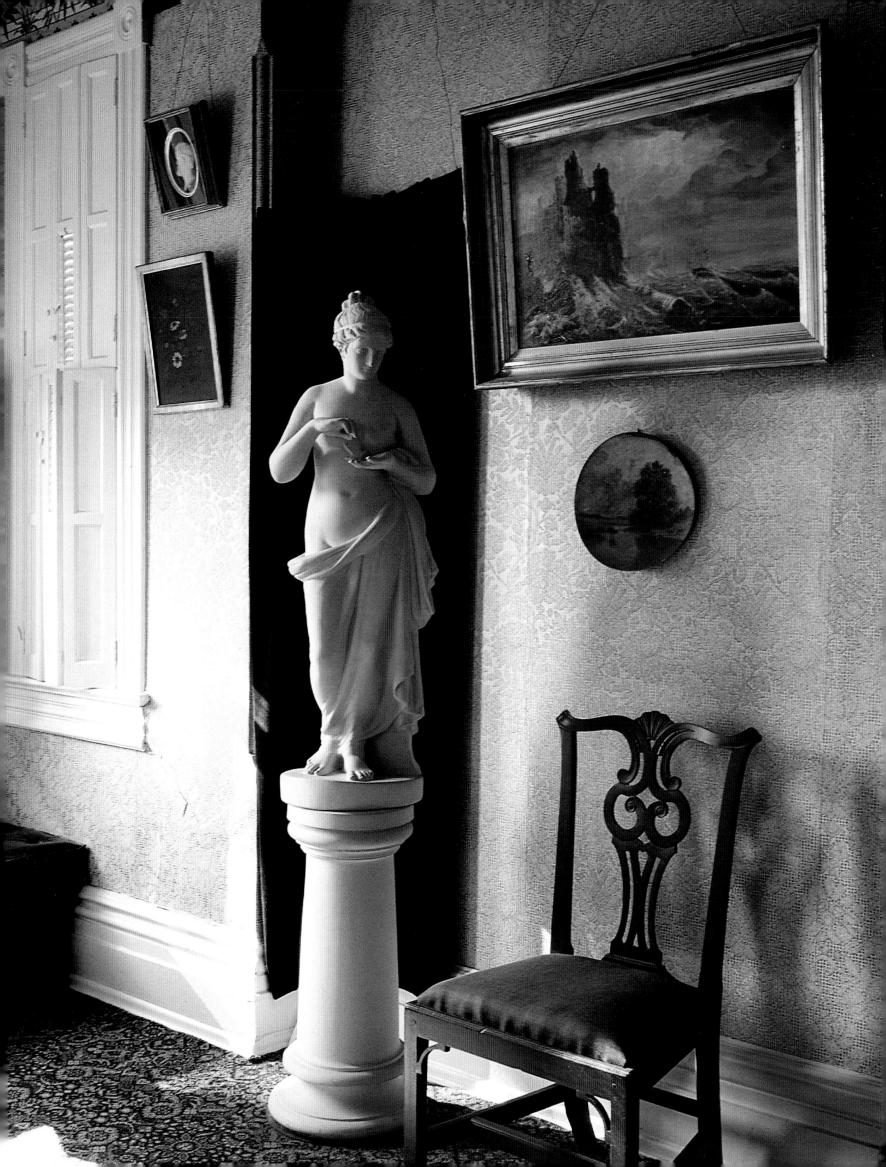

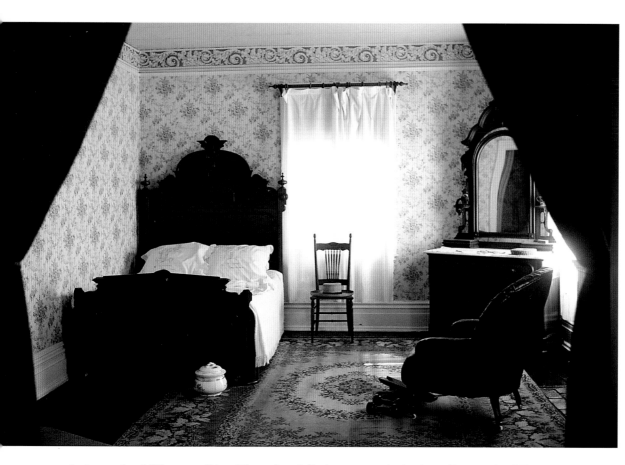

but remained illiterate all her life and took little interest in her husband's career. With the busy Douglass constantly on the lecture circuit, their marriage grew distant. But after her death in 1882, he was stricken with grief, and ever afterward kept her bedroom, across the hall from his own, as a memorial shrine. When, two years later, he married Helen Pitts, whose abolitionist parents he had known, she took another room as her own. Because she was white, and nearly the age of his daughter, Douglass's marriage to Helen was severely criticized at the time by whites and blacks alike. Her own father refused to admit Douglass into his home, and vicious mail arrived daily. But the couple persevered,

were invited to dine at the White House, and toured Europe together. It was a happy marriage, Helen the constant and true companion in Douglass's last years. She supervised the household, and tended to visiting grandchildren. There is a typewriter in her bedroom, and in the dining room downstairs is the small table where she kept the house accounts and wrote checks. This room, with its large table where she presided over parties for twelve, its sideboards with their china tureens and silver tea set, is where the two of them were sitting on the evening of February 20, 1895. Earlier that day he had addressed a meeting of the National Council of Women, and had been escorted to the platform by his old friend Susan B. Anthony. A British delegate in the audience that afternoon commented on Douglass's "commanding figure six feet high, a splendid head with large and well-formed features, soft, pathetic eyes, complexion of olive-brown, flowing white hair." He was about to leave for yet another meeting, and was regaling Helen with the events of the afternoon, mimicking the speakers. Suddenly, he felt unwell and made to go upstairs to his room. His bedroom is a simple room, with a double bed and dresser; his clothes and shoes are still laid out on a chair, and a set of dumbbells is on the floor. But that evening, he never made it upstairs. He slouched to the floor in the hallway, dead at 77.

ABOVE, LEFT: Frederick Douglass's bedroom. The simplicity of this room is telling, as if it were merely a necessity rather than a pleasure to be here. Always restless, Douglass worked incessantly in his study. Sleep and exercise—he kept a pair of weights by his chair (below)—enabled him to devote his waking hours to the causes he championed. To the end of his life, he was a passionate orator. In 1894, his last great speech, "The Lessons of the Hour," was delivered at the Metropolitan African Methodist Episcopal Church in Washington. ABOVE, RIGHT: A portrait of Douglass in the east parlor, used for receiving visitors to Cedar Hill.

Douglass was more relaxed with women than with men. He liked to read and talk about books with women, and he embraced their political cause with rare fervor. Susan B. Anthony was an old friend of his, but there was sometimes tension between them as each campaigned for voting rights, the one for women, the other for African-Americans. Declining to attend a women's suffrage meeting in 1868, Douglass wrote to its sponsors: "The right of women to vote is as sacred in my judgment as that of man, and I am quite willing at any time to hold up both hands in favor of this right. . . . I am now devoting myself to a cause [if] not more sacred, certainly more urgent, because it is one of life and death to the long enslaved people of this country, and this is: negro suffrage."

"Agitate, agitate" had been his motto. His eye vigilantly on the future, he urged political activism, holding both the law and the citizenry to the highest moral standards. But there was another side to his character, the literary side that was continually looking backward. In 1877, he returned as "the most famous black man in the world" to the Eastern Shore of Maryland, forty years after he had worked on the wharves there. While in St. Michaels, in a gesture much criticized by African-Americans, he visited the house of Thomas Auld, his old master and now a dying man. "Captain Auld," Douglass began. "Marshal Douglass," Auld replied, calling him by his title. "Not *Marshal*, but Frederick to you as formerly." They spoke for twenty minutes, Douglass always in search of information about his past. When he left, Douglass realized "we had both been flung, by powers that did not ask our consent, upon a mighty current of life, which we could neither resist nor control. By this current he was a master, and I a slave; but now our lives were verging towards a point where differences disappear, where even the constancy of hate breaks down and where the clouds of pride, passion and selfishness vanish before the brightness of infinite light." A year later, on another visit to Maryland, he sought out the sheriff who had arrested him decades before, and sought to locate the exact spot where his slave cabin had stood on the Tuckahoe Creek. He took a handful of soil back with him to Cedar Hill. It is this turn of mind that brought him, as a writer, back again and again to his autobiography, and it gives his

Life and Times a stunning immediacy. Here, for example, he describes in haunting detail the hunger he experienced as a boy:

I have often been so pinched with hunger as to dispute with "Nep," the dog, for the crumbs which fell from the kitchen table. Many times have I followed, with eager step, the waiting-girl when she shook the table-cloth, to get the crumbs and small bones flung out for the dogs and cats. It was a great thing to have the privilege of dipping a piece of bread into the water in which meat had been boiled, and the skin taken from the rusty bacon was a positive luxury.

The vivid details and narrative poise of *Life and Times of Frederick Douglass* give it an important literary status. But, as historian William McFeely has pointed out, the book had a deeper message—that the epic of slavery should not be erased from the nation's memory. "White America wanted to hear no more of the subject; emancipation had taken care of it. Many black Americans, reacting to this weariness, had become almost apologetic about their slave past. His friend Harriet Beecher Stowe had once awakened the nation with a great saga of slavery. Now his story might rouse people to the plight of the former slaves who were not fully free. He saw his life as a metaphor for a second emancipation." It is a metaphor that resonates today, and a book that defines brave witness.

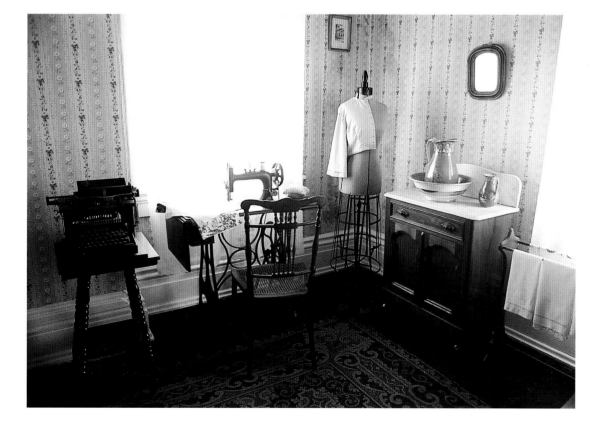

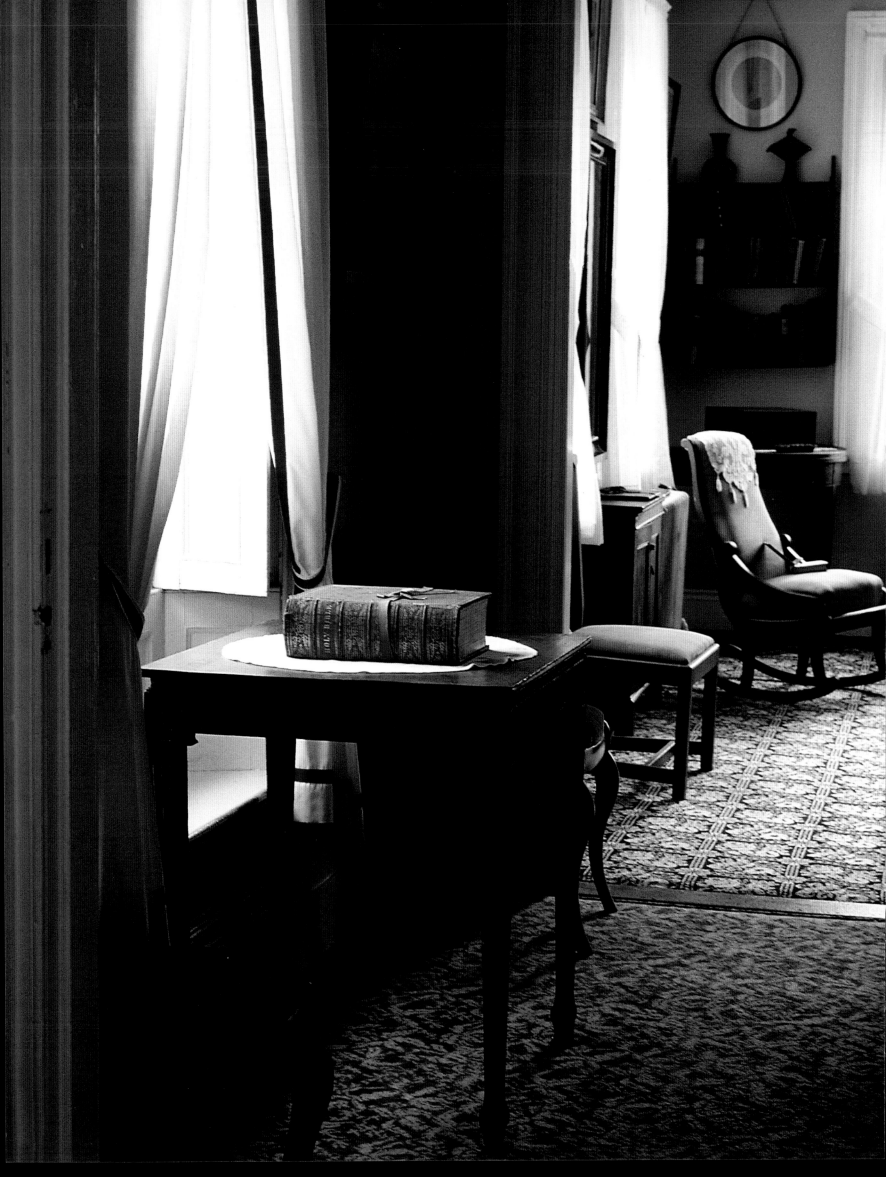

Ralph Waldo
Emerson
1 8 0 3 – 1 8 8 2

OPPOSITE: A view from the second-floor hallway into Edith's bedroom, the original master bedroom before the addition to the house was finished. Edith Emerson (1847–1929) was Emerson's second daughter, later married to Colonel William Hathaway Forbes, who had distinguished himself in the Civil War. The rocking chair belonged to her mother, Lidian, and the two pottery vases were brought from Egypt in 1872. The table on which the Bible rests was a gift from Ellery Channing to Edith's sister Ellen, and the portrait in the hall is of Massachusetts senator Charles Sumner, the influential abolitionist and friend of Emerson.

On April 18, 1775, Paul Revere made his storied midnight ride. The next day, the Battle of Concord began the American War of Independence. From the windows of his home on the banks of the Concord River, the Rev. William Emerson, the patriot preacher, heard the musket fire, and two weeks later he wrote in his journal, "This Month remarkable for the greatest Events taking Place in the present Age." Sixty-two years later, in 1837, the town of Concord unveiled its North Bridge Battle Monument on July 4th, and asked William Emerson's grandson, Ralph Waldo Emerson, to deliver some verses on the occasion. One stanza stood out memorably:

By the rude bridge that arched the flood,
Their flag to April's breeze unfurled,
Here once the embattled farmers stood
And fired the shot heard round the world.

No other writer discussed in this book is so much the embodiment of the American spirit, or has so deeply influenced its history, as Emerson. How we understand ourselves at our best—our hopes and ambitions and projects—has everything to do with Emerson's original formulations of the American character. Self-reliance can become arrogance, and Emerson has been criticized for having encouraged Americans to a dangerous grandiosity, as when he writes of a citizen, "It becomes him to feel all confidence in himself, and to defer never to the popular cry. He and he only knows the world." But when, a few sentences later in his famous 1837 oration "The American Scholar," he describes his ideal American it is impossible not to recognize a new race—peculiar, practical, solitary, admirable, original:

In silence, in steadiness, in severe
abstraction, let him hold by himself;

add observation to observation, patient of
neglect, patient of reproach; and bide his
own time,—happy enough if he can satisfy
himself alone, that this day he has seen
something truly. Success treads on every
right step. For the instinct is sure, that
prompts him to tell his brother what he
thinks. He then learns, that in going down
into the secrets of his own mind, he has
descended into the secrets of all minds.

He delivered this speech—sometimes called the American "intellectual Declaration of Independence"—at Harvard, as the college's Phi Beta Kappa address, a month after he had recited his poem at Concord. Already he was being toasted as "the Sage of Concord" who "makes us all of One Mind." But of course his point all along was that each of us be of a different mind, each of us find a private way through nature and society to an understanding of a higher purpose. "The day is always his," he urged his countrymen, "who works in it with serenity and great aims." Likewise, "he who has put forth his total strength in fit actions has the richest return of wisdom." For that it would be more appropriate to name him the Sage of America.

One of his English ancestors had founded the town of Concord in 1635, but Emerson moved there only in 1834. He had, of course, often come out from Boston to visit his grandmother, and perhaps that is why the family home, later named by Nathaniel Hawthorne "The Old Manse," seemed a refuge for him after the emotional tumult of the past few years. As a young man he had been a teacher until he decided to follow the example of his father and grandfather and join the ministry, despite his doubts about orthodox views. He rose through the ranks, became chaplain of the state senate and junior pastor of Cotton Mather's old church, and at the same

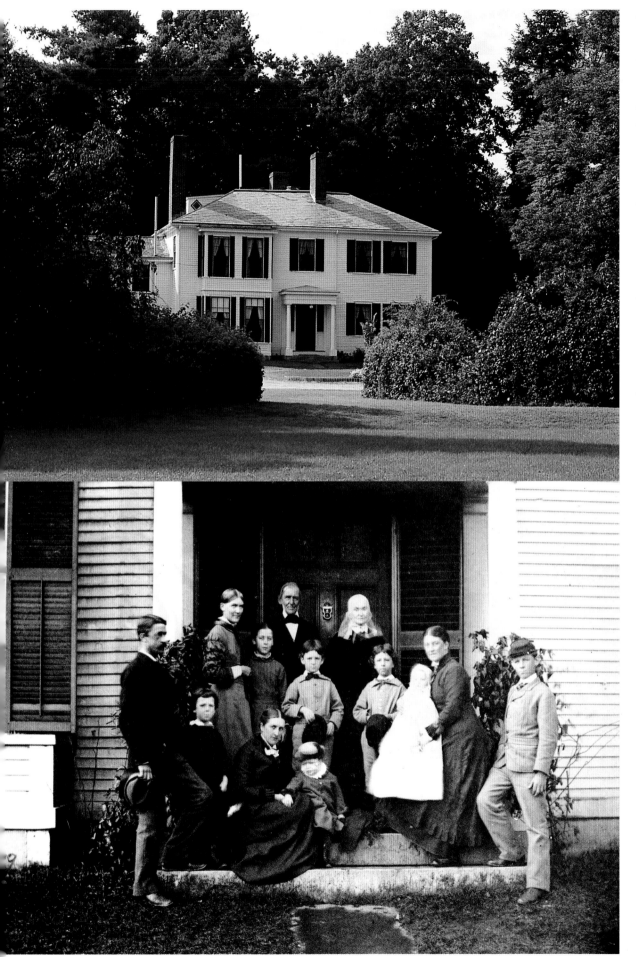

ABOVE: In his lifetime, the Emerson House was named Bush. There was a white fence around it, and when he returned home Emerson used to balance his half-smoked cigar on the lower rail. In addition to his family ties to Concord, he was drawn to what he called the "lukewarm milky dog-days of common village life."

BELOW: An 1879 photograph of Emerson and wife, Lidian, with their children and grandchildren. His son Edward later wrote: "He had the grace to leave his children, after they began to grow up, the responsibility of deciding in more important questions concerning themselves, for which they cannot be too grateful to him; he did not command or forbid, but laid the principles and the facts before us and left the case in our hands."

OPPOSITE, ABOVE: A grape arbor in the gardens.

OPPOSITE, BELOW: At the rear of the spacious main hallway downstairs, Emerson and his guests would leave their hats and walking sticks.

time married Ellen Tucker, who died of tuberculosis at the age of nineteen, after just five months of marriage. "God be merciful to me a sinner & repair this miserable debility in which her death has left my soul," he wrote. Every morning he visited her tomb, his health deteriorated, and his religious doubts increased. Convinced that "in an altered age we worship in the dead forms of our forefathers," he felt he must resign his post, and traveled to Europe, absorbing its culture and meeting Thomas Carlyle, John Stuart Mill, Samuel Taylor Coleridge, and William Wordsworth. By the time he returned, he had vowed "not to utter any speech, poem, or book that is not entirely & peculiarly my work." It was at that moment he set out for Concord and began his first book, *Nature*, which begins by staring at "the sepulchres of the fathers" and asking the seminal questions at the heart of his thought: "Why should not we also enjoy an original relation to the universe? Why should not we have a poetry and philosophy of insight and not of tradition, and a religion by revelation to us, and not the history of theirs?"

After a year in Concord, he made two crucial decisions. First, he remarried. His new wife was Lydia Jackson of Plymouth, Massachusetts, an attractive woman a year older than Emerson with strong emotions and a poetic sensibility.

(He changed her name to the euphonious Lidian for fear that the Yankee dialect would make it Lydiar.) And with a part of the inheritance left him by his first wife he bought a house for $3,500. He lived in it for the rest of his life.

His family referred to the house as "Bush," and it didn't take long for it to become a shrine. Looking back in 1882, Louisa May Alcott wrote: "The marble walk that leads up to his door has been trodden by the feet of many pilgrims from all parts of the world, drawn thither by their love and reverence for him. In that famous study, his townspeople have had the privilege of seeing many of the great and good men and women of our time, and learning of their gracious host the finest lessons of true courtesy." It had been Emerson's intention from the beginning to "crowd so many books & papers, &, if possible, wise friends, into it that it shall have as much wit as it can carry." He began by moving his mother and two maids into the house, and then planned to make an apartment on the second floor for his brother Charles and his fiancée when they married. Before that could happen, though, his brother died of tuberculosis, as another of his younger brothers had two years earlier. Death stalked Emerson's family, as it did so many families in the nineteenth century. Perhaps the most poignant loss occurred in

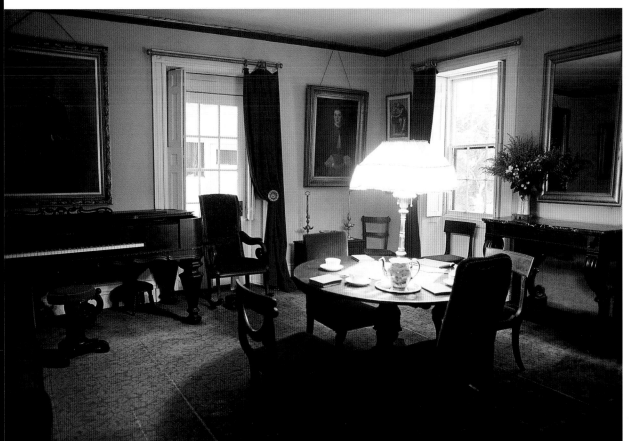

LEFT: The parlor. A Chickering piano is on the wall opposite the room's marble fireplace. Much of the best furniture in the house, including the sofa in this parlor, was brought by Lidian from her home in Plymouth.

BELOW AND OPPOSITE, ABOVE: Emerson's study.

OPPOSITE, BELOW: An 1879 photograph taken by A. H. Folsom of Emerson in his study. It was in this room, he said, that he listened for "the voices which we hear in solitude" that "grow faint and inaudible as we enter into the world." Emerson's children, on the other hand, had memories of the room as an enchanted treasure. They were carried around the room by their father, who told them the stories behind objects and pictures, then given pencils and letter-backs to draw with.

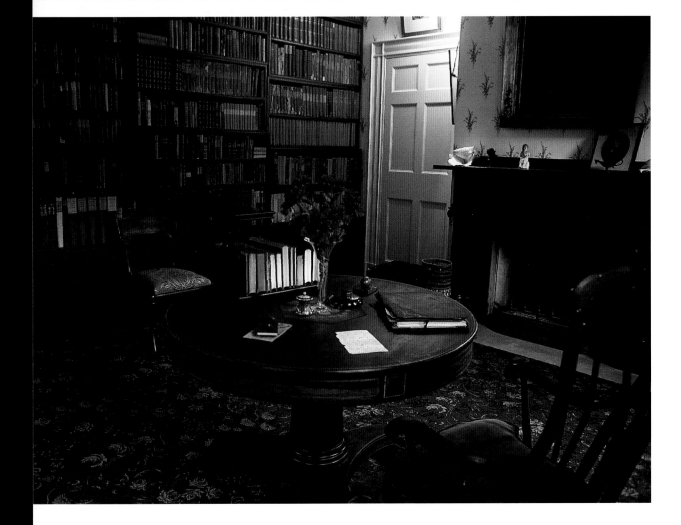

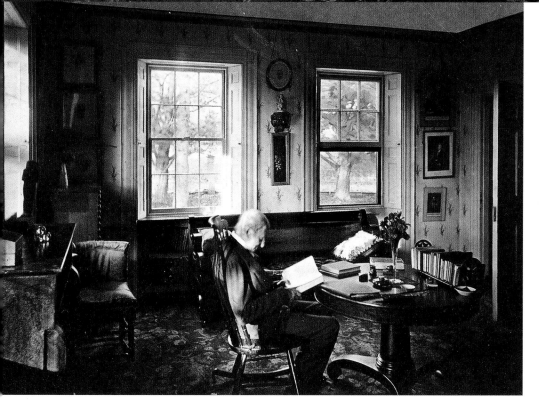

1842, when his five-year-old son Waldo came down with scarlatina and died: "Yesterday night, at fifteen minutes after eight, my little Waldo ended his life. . . . He gave up his little innocent breath like a bird." At times, such losses make it more difficult to comprehend Emerson's relentless optimism. The individualism and self-reliance he urged can seem frail barriers against grief. Yet properly understood, his insistence that "nothing can bring you peace but yourself" calls for a kind of stoic detachment from the self's preoccupations and sorrows. He and his fellow Transcendentalists trusted to an inner light, that spark of the eternal born in each of us, enabling us to discover the true and beautiful and giving us the moral strength to conduct our lives in their service.

The house Emerson bought in Concord had been built in 1828 by a Boston merchant named J. J. Coolidge as a summer home, and it was large enough to be known as "Coolidge Castle." Indeed, the effect is spacious, starting with the grand entrance hall and stairway. It is odd that the two rooms off the main entrance are, to the

left, a guest bedroom or sick room and, to the right, Emerson's study, making him a victim of the front door. The parlor is at the back of the house, under the master bedroom—a section of the house Emerson built on later. It was here that he and Lidian were "at home" on Sunday evenings. Perhaps the Chickering cabinet piano was played. The sofa had belonged to Lidian's family, and surrounding it are duck-foot chairs, a center table, a whatnot filled with gifts from friends. Friends, too often, gave them steel engravings, and the house is filled with them. In the parlor are reproductions of Correggio's *Madonna* and Raphael's *Sibyls*. Over the sofa is Thomas Carlyle's gift of an engraving of Guido Reni's *Aurora Bringing in the Dawn*, and under it a bronze medallion of Apollo. Across the hallway, where hang pictures of Emerson's parents and of his son Edward, near a coat rack that still holds his canes and hats, is the dining room. The marble fireplace here stands between two china closets, and over it hangs an engraving of Raphael's *School of Athens*. The table and, to one side, Lidian's card table seem overwhelmed

by the room's walls, festooned with engravings and photographs, including Julia Margaret Cameron's well-known photograph of Carlyle (a gift from the sitter) and several shots of Mt. Shasta and Yosemite, where Emerson had visited and met with John Muir. Every morning at seven, Emerson summoned his family and the servants here for a reading from the Bible and a prayer. One can go from this room either to the kitchen and servants' quarters at the rear, or toward the front to a hallway off the side door to the house, used by the family and guests arriving by horse-drawn carriages. One of Emerson's gardening hats (he was an avid purveyor of pears, and even used his desk drawers to ripen them) is on a peg here, in rather plain relief to the wallpaper under it, known in the family as "Miss Ellen's pineapples," in honor of Emerson's eldest daughter, though it fact it is a Morris design based on thistles.

The deep staircase rises past many portraits. At the top, to the left, is the room his mother used until her death, and was afterward used by his daughter Ellen, who eventually managed the household. Across the hall, the original master bedroom was his daughter Edith's room, and farther back is the nursery, where the children, when they were young, and their nurse slept. The rocking horse belonging to his youngest son, Edward, still guards the old toys and tiny books. Across the hall is the master bedroom, largely

Lidian's domain. Twin alcoves flank the fireplace; in one is an impressive tallboy from Plymouth, once owned by Lidian's family. In the other hang two of Emerson's favorite articles of clothing—his lecturing robe, and the dressing gown he wore over his clothes in the early morning as he wrote in the still cold house.

Emerson's journal entry for July 24, 1872, says starkly, "House burned." A newly hired servant was snooping in the attic when she upset her kerosene lamp. Emerson gathered his family outside and shouted to the neighbors for help. They tried to save as much as they could from the house. Teenaged boys, with wet handkerchiefs tied around their faces, formed a relay line to pass books and papers out the study window. The roof was gone and the house uninhabitable, but most things were saved. The shock, though, fell heavily on Emerson and affected his health. The family left for Europe and Egypt, and stayed away for a year. When they returned, they found that the people of Concord had restored the house down to the smallest detail. A brass band played "Home, Sweet Home" as his friends and townsmen escorted them from the train station, and when they reached the house they found that a floral triumphal arch had been constructed over the gate.

As time went on, his memory failed. He could not remember the names of his friends or of the

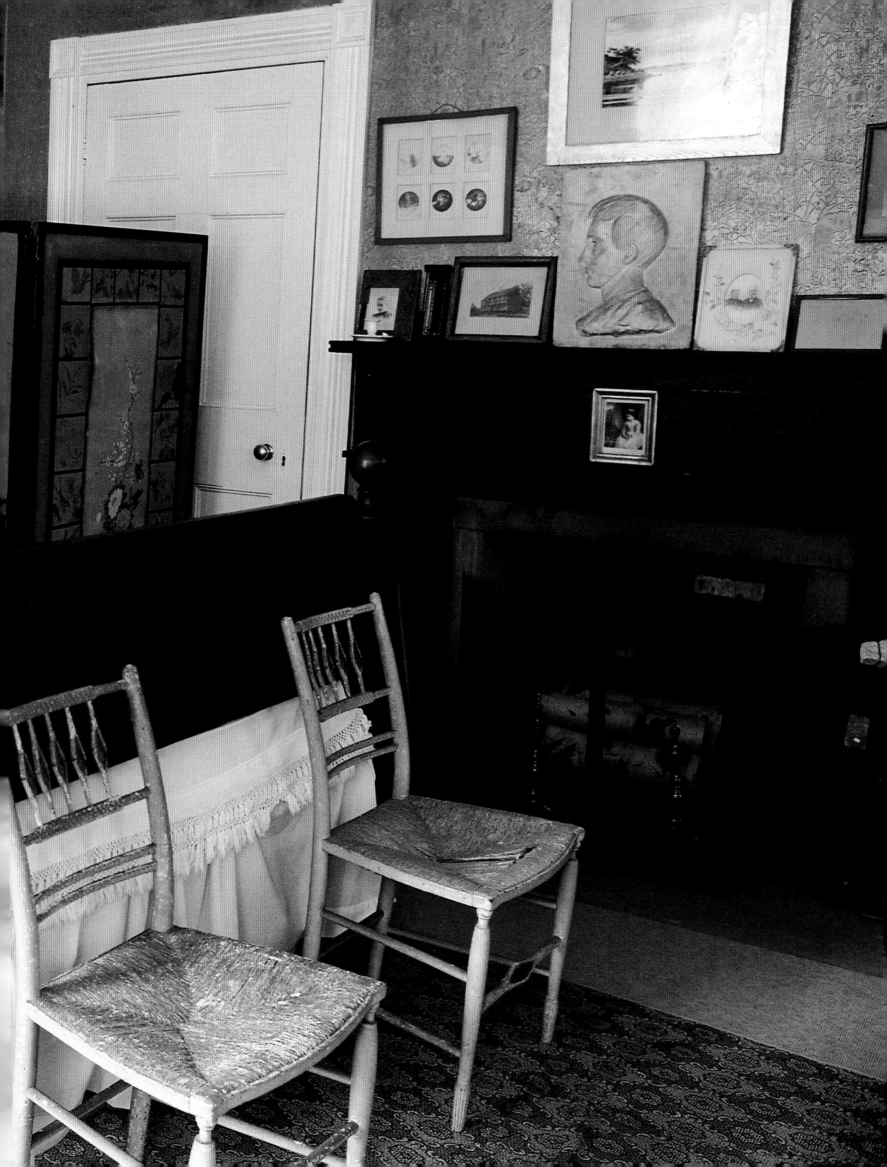

books he had written. He continued to give lectures, but they were old ones and he needed Ellen's help to deliver them. After 1875, he no longer wrote in his journal. But every day he would sit in his study. Few rooms in American history have ever been so important. He sat at the round table in the middle of the room, a desk he could rotate to facilitate the opening of drawers, and that, like the bookcase, once belonged to Lidian's family. His papers were kept in a leather-bound portfolio he wrote in as well. On the table are inkwells and a blotter and a small collapsible bookrack. He kept about twelve hundred books on the bookshelves against one wall, and that many again elsewhere in the house; he gave those he didn't wish to keep to the Concord Free Public Library, whose new building he was instrumental in founding. The wallpaper is a gold-on-cream pattern of lilies-of-the-valley, a motif his daughter thought would remind him of humility; on the floor is a red wall-to-wall Brussels-weave carpet with roses and marguerites. Over the fireplace is a copy of Francesco Salviati's painting *The Three Fates*, which he had first seen in the Pitti Palace in Florence and admired. (It was thought at the time to have been painted by Michelangelo.) There is an Aeolian harp and pictures on his walls of Dante and Pindar, Coleridge and Newton, Cromwell and Tennyson, William Godwin and Lord Herbert of Cherbury. There is a Flaxman statuette of Psyche and a small bronze Goethe. There are souvenirs everywhere of his travels, from Vatican prints to the small sarcophagus, the figures of Osiris and Mut, and the mummy cloth he brought back from Egypt. He would use these as educational introductions to culture and ideas whenever children—his own or those of friends—would romp in his study.

On April 18, 1882, he went out for a walk and returned home soaked with rain. The next day, he was ill—pneumonia had set in—and he said haltingly to his daughter, "I hoped it would not come this way. I would rather fall down cellar." But he insisted on dressing and going to his study as usual. A week later, he was dead. His grave is on a ridge in Concord's Sleepy Hollow Cemetery. He is buried near some of his closest friends— Thoreau, Hawthorne, Alcott. But even in death, he seems to tower over them. The graves of the others are marked with demure tombstones. Over Emerson's body was placed a huge, craggy boulder of quartz marble. It remains an apt symbol: whatever beautiful thing could be made of this glistening stone is here in its rocky mass: everything is potential. He was the man who pitted sublime reason against mere common sense. Where most saw commodity, he knew we could see the alphabet of divinity. On the bronze plaque embedded in the boulder, under his name and dates, are two lines that can strike the passerby as modest until one realizes they dramatize the grip of here and beyond, the grand scheme of moral idealism:

THE PASSIVE MASTER LENT HIS HAND
TO THE VAST SOUL THAT O'ER HIM PLANNED.

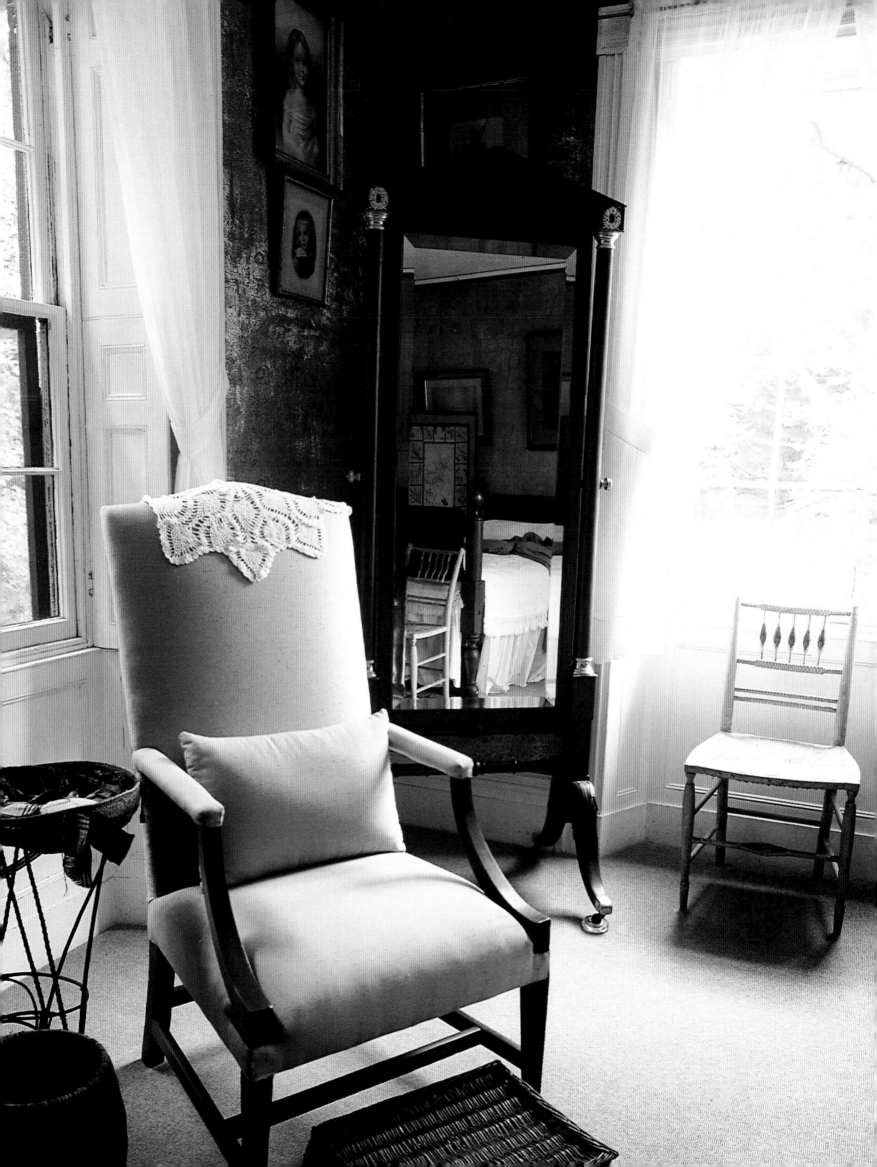

William Faulkner

1 8 9 7 – 1 9 6 2

Opposite: The desk in Faulkner's original study at Rowan Oak. When he received word in 1950 that he had won the Nobel Prize, he told a Swedish reporter: "I won't be able to come to receive the prize myself. It's too far away. I am a farmer down here and I can't get away." Then he drove his daughter to school and in the afternoon chopped wood. In the end, he was persuaded to go to Stockholm where, in a rented dress suit, he gave a memorable acceptance speech which in part said, "I feel that this award was not made to me as a man, but to my work—a life's work in the agony and sweat of the human spirit, not for glory and least of all for profit, but to create out of the materials of the human spirit something which did not exist before."

He was born William Cuthbert Falkner, and added a "u" to the name, perhaps trying to make it sound more English, when he joined the Royal Air Force in 1918. Ironically, by doing so, he restored the family name to its original spelling. It was his great-grandfather, William Clark Falkner, lawyer, slave-owning planter, and colonel in the Confederate Army, who had first changed his name so that people wouldn't confuse him with "some no-account folks." The statue of Col. Falkner atop his grave in the Ripley, Mississippi, cemetery is missing three fingers of its outstretched right hand. Legend had it that they were shot away, after a bout of heavy drinking, by relatives of his former business partner, Dick Thurmond. Thurmond had fought with Falkner over the Ripley Railroad they co-owned, later shot him to death, and was acquitted at his 1891 trial. In his lifetime, Col. Falkner had written several books, including a successful romance, *The White Rose of Memphis*, and part of his cemetery statue is a pile of the books he wrote. It is not as an author, however, that he is remembered today, but as a character—his great-grandson's Col. John Sartoris.

When Faulkner was five, his father moved the family from New Albany forty miles southwest to Oxford, seat of Lafayette County. It was a town and a county he grew to know intimately. After an apprenticeship spent writing wispy poems and two promising novels, he came to realize that his best chance for success as a writer lay in taking as his subject his "own little postage stamp of native soil," and so he transformed Oxford into the town called Jefferson and Lafayette County into his fictional Yoknapatawpha County, an imaginary place with real lives and blasted dreams in it. From *Sartoris* (1929) on, Faulkner used his own family's history as the basis for his fiction, the prototype of the labyrinth of a threatening and irrecoverable past. The dark legacy of Southern history, its harsh traditions of violence and gentility and corruption, when combined with Faulkner's lush and sometimes experimental fictional technique, acquire a unique grandeur, at once alluring and grotesque. How he stared down the past is the story of his profound art, but in the library of his home in Oxford is a curious emblem of the process. There are two oil portraits on the wall there, both by Faulkner's mother, Maud. One is of Faulkner himself. That portrait stares out at another. It is of his great-grandfather, the old Colonel. Day after day, seated between the portraits, Faulkner wrote of the burden of the past.

Ruined greatness fascinated Faulkner from the start. Even as a child growing up in Oxford, he knew the old Bailey Place, once reputed to be a "mansion" but long since a dilapidated ruin. When the chance came to buy it in 1930, Faulkner leapt at it, promising the owners to restore the place. Having published *The Sound and the Fury* a year earlier, it suited his new sense of self-confidence; and having recently married his sweetheart Estelle Oldham, herself recently divorced and now the mother of two, he needed a place large enough for them all to live and as impressively as possible. For $6,000 he bought the house and four acres, though the owners kept the deed of trust, allowing Faulkner to pay them $75 a month. It took him six years to pay off the place, and over the next two years he added an additional twenty-nine acres to the property. By 1938, then, the house and grounds were as we see them today. But it had taken a great deal of work—like Thomas Sutpen in *Absalom, Absalom!* creating his baronial manor in the wilderness.

The house was originally built around 1844 by Col. Robert Sheegog, an Irish planter who

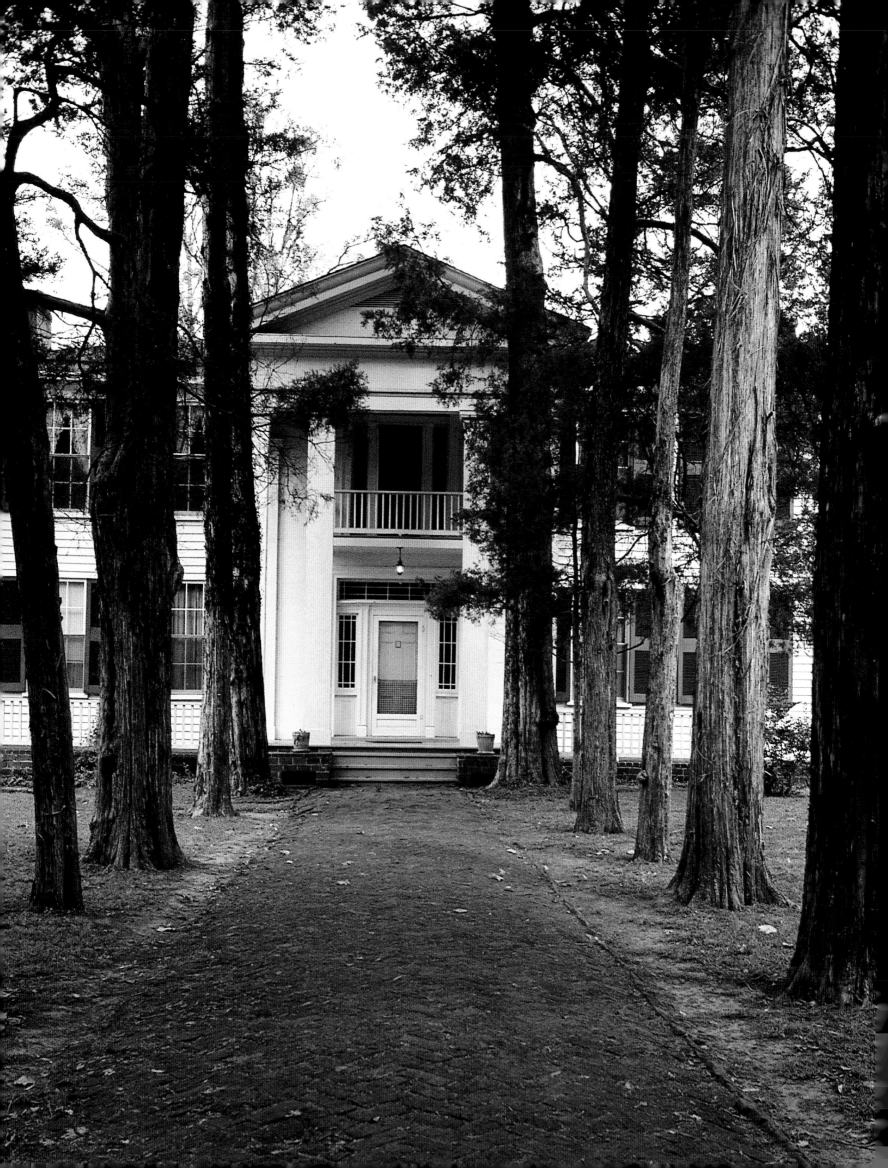

OPPOSITE: The approach to Rowan Oak. The first party the Faulkners gave here, in 1930, was a Halloween party for the neighborhood children. Faulkner entertained them by telling a ghost story, all hopeless love and rattling chains, about a former owner of the house—and terrifying the children.
BELOW: Faulkner and his wife, Estelle in May 1955.
RIGHT, ABOVE: The back entrance, with Faulkner's new study to the right. After an afternoon on horseback, Faulkner would hang his riding gear here.
RIGHT, BELOW: The telephone in the pantry where he received word of his Nobel Prize. Visible on the walls are scrawled names and numbers.
OVERLEAF: Faulkner's original study. Hanging over the fireplace is the portrait of him by his mother.

had migrated from County Down and by the time of his death in 1860 owned more than six thousand acres and ninety slaves. The architect—more likely a master carpenter—was William Turner, who had built several other houses in the area and favored the then popular Greek Revival style. From the Sheegog family, it passed to the Baileys, and eventually to tenants as the place fell further into disrepair. Still, Faulkner could look past the wreck—or into it. With its imposing facade, a curved driveway and cedar-lined brick front walk, its antebellum maze garden and gloomy aspect, it may well have reminded him of his great-grandfather's life in Ripley. Above all, he liked the privacy. The property is shaded by dogwood, magnolia, and cedar (thought to protect from yellow fever), and Faulkner himself planted camellia, English tea roses, box, and ornamental pear and apple. The two trees not in evidence are the rowan and the mighty oak. But he named his house for a tree he remembered and a tree he'd read about. The water or "inspiration" oak he remembered from his days in Louisiana, and he knew the tree symbolized virtues he sought in his new home, solidity and security. The rowan tree, native to Scotland, he had read in Frazer's *The Golden Bough*, could ward off evil spirits, and to Faulkner that meant reporters, students, and autograph seekers. So he combined the two trees, and set to work on restoring the house and his dreams—and at the same time, it was said, he dug extra potholes in his driveway to discourage visitors' cars.

When Faulkner bought Rowan Oak, it had no central heating, no electricity, no plumbing. The roof needed shingling, nothing had been mended or painted for years. With a remarkable patience, he made all the repairs and improvements himself, assisted only by the occasional day laborer. He also added balustraded brick terraces to both sides of the front portico and remodeled the grounds, adding a rose garden and scuppernong arbor. He built a porch off the dining room, a porte cochere for the side entrance, and a new upstairs bedroom. In the early 1950s he plastered in the porches, upstairs and down, making a study for himself on the ground level and a storage area upstairs. The outbuildings—which included at the start a kitchen and an outhouse—were also repaired. There was a tenant cottage for domestic help. Faulkner's childhood nurse, Caroline Barr, known as "Mammy Callie," who had been born in slavery and to whom Faulkner was devoted all his life, first lived in the cottage, and after her death, it was occupied by Mr. and Mrs. Price, who looked after the house and grounds. There was also an oak barn, but Faulkner built a new

stable. He and his daughter, Jill, loved riding and kept four horses in the stable. Faulkner's own were named Tempy and Stonewall.

Faulkner wanted the life of a country squire but without undue pretension. A certain simplicity went with the privacy he craved. Estelle, on the other hand, had designs on the house. The parlor was done up with a Chickering baby grand and her antiques. There is a cabinet with a Geisha doll on display and Chinese wall hangings, reminders of the years she lived in Shanghai during her first marriage. The oil painting over the fireplace is flanked by cranberry glass vases. It seems a room used mostly on formal occasions. The last such occasion was Faulkner's wake—held in this room, as was his beloved mother's and Caroline Barr's. The dining room is similarly furnished, with its china cabinet and sideboard,

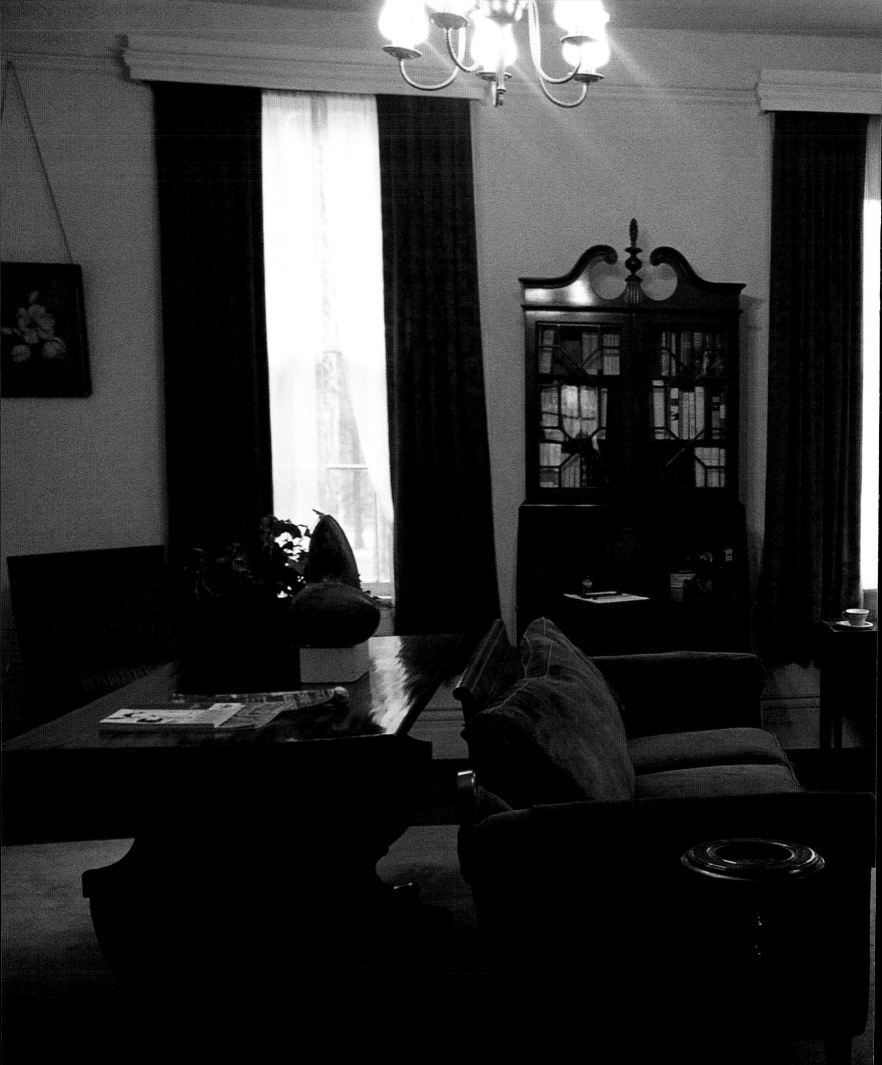

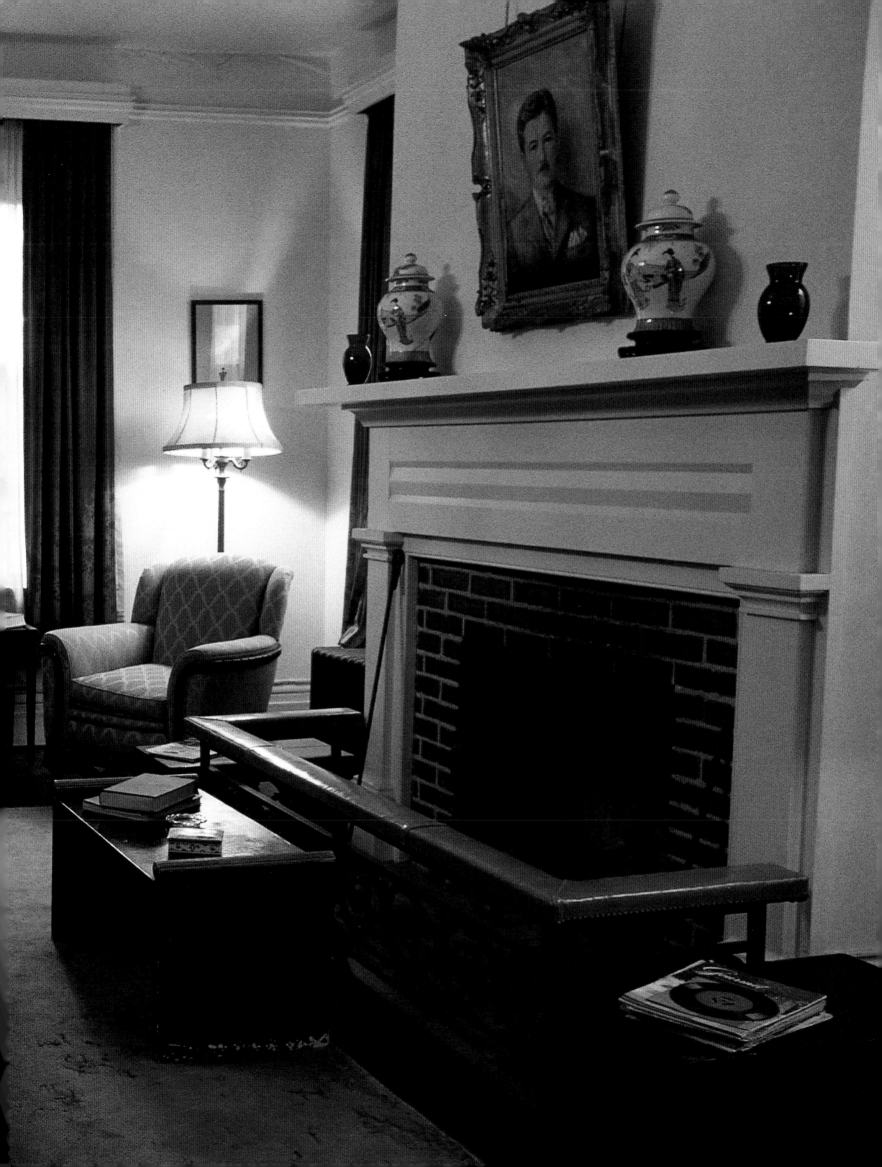

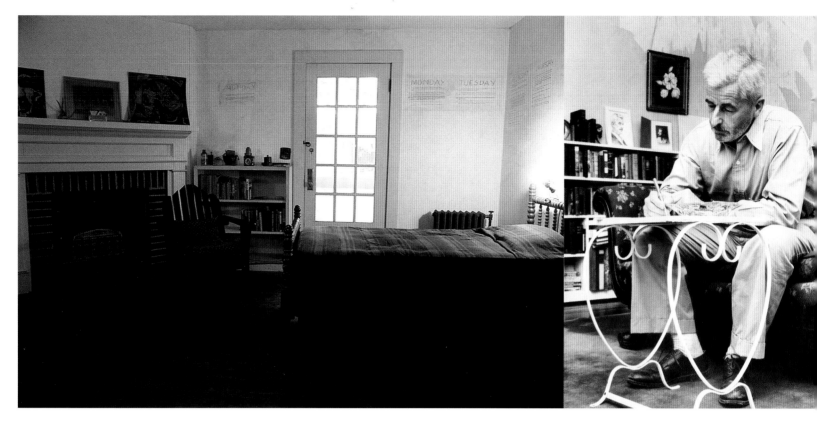

and its Oriental prayer rug on one wall. A large pantry and the kitchen are beyond, and a back hall known in the family as "the music room." They often retired there after dinner, Faulkner to read, his wife to play on her spinet. Faulkner wouldn't allow a radio in the house or, when it became available, a television. And despite the blistering summer heat, he forbade an air conditioner as well, complaining that "they're trying to do away with weather." Today, though, one notices a huge old air conditioner in what was Estelle's bedroom. The receipt for its purchase is dated two days after her husband's death. So wary was he of interruption that he barely tolerated the presence of a telephone. The only one allowed is on a tiny shelf in a corner of the pantry. On the pantry walls is a constellation of scribbled notes in several hands—names and numbers: *Jimmy 2250. Chester McL. 1332.* It was this telephone that rang early on the morning of November 10, 1950. It was the New York correspondent for a Swedish newspaper, wanting to know how he felt about having just won the Nobel Prize—news that Faulkner himself hadn't yet heard.

It was in the library across the entrance hall from the parlor where, at a small writing table, Faulkner wrote most of the novels and stories that created the saga of Yoknapatawpha, from *Light in August* (1932) to *Absalom, Absalom!* (1936), along with many later works as well, including the Snopes trilogy. Together they constitute a dramatic—at times scandalous—rendering of "the passions of the hope, the beauty,

the tragedy, the comedy of man, weak and frail but unconquerable." Neither money-making stints as a scriptwriter in Hollywood nor his frequent and near fatal drinking binges could deter Faulkner from his work. Debts sometimes threatened his hold on Rowan Oak; in 1940, he wrote, "It's probably vanity as much as anything else which makes me want to hold onto it. I own a larger parcel of [property] than anybody else in town and nobody gave me any of it or loaned me a nickel to buy any of it with and all my relations and fellow townsmen including the borrowers and frank spongers, all prophesied I'd never be more than a bum." When sales of his books were discouraging or all of his work went out of print, still he pressed on. The bookshelves that circle the room are crammed with volumes, including editions of the books that he once told a class at the University of Mississippi had most influenced him: the Old Testament, Melville, Dostoevsky, and Conrad.

In 1952, Faulkner enclosed the rear porch and made a new study across the side hallway from his library. He used it to write in, but also as a business office and, toward the end of his life when he found it difficult to climb stairs, as a bedroom. He guarded this lair ferociously. In his library, he was too close to the front door, and it was like Faulkner to keep moving back—into his house, as into his history—to find the stillness he required. Once when he returned from a trip to discover the room had been "straightened up," he resolved to take the doorknob with him on future trips to foil busybodies. It is a simple

ABOVE, LEFT: The new study that Faulkner built onto the back of Rowan Oak. On its walls is his written outline of his novel *A Fable*. In his later years, when it was difficult to climb up to his bedroom, he would use this bed to sleep downstairs.

ABOVE, RIGHT: A photograph of Faulkner taken May 6, 1955. He is writing at a table given to him by his mother. He would often take it outside to continue working.

OPPOSITE: His writing table in the new study. For an interview in *The Paris Review*, he said, "I like to think of the world I created as being a kind of keystone in the Universe; that, as small as that keystone is, if it were ever taken away, the universe itself would collapse. My last book will be the Doomsday Book, the Golden Book, of Yoknapatawpha County. Then I shall break the pencil and I'll have to stop."

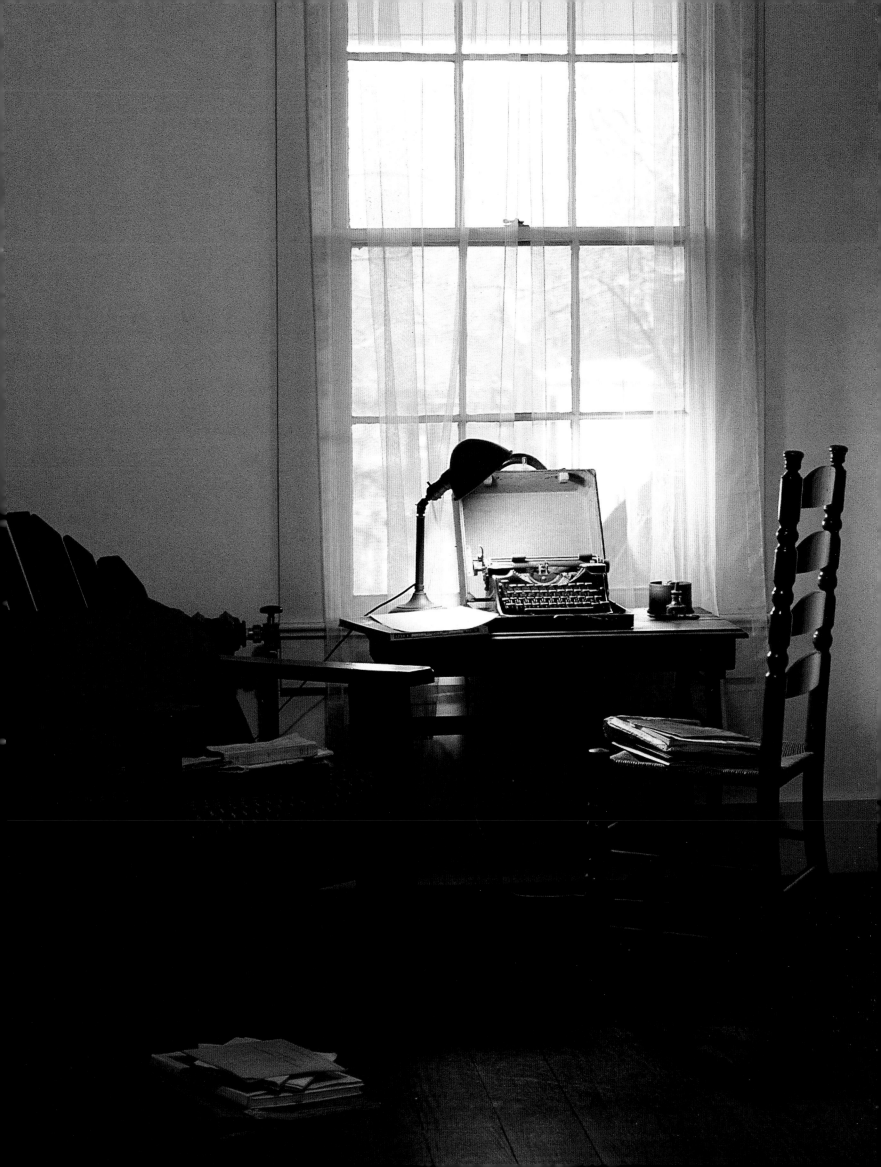

room: bookcases, writing table, fireplace, two Adirondack chairs. On the walls of this room he famously worked out the plot of his 1954 novel *A Fable*. Its complex and rather opaque allegory, that transpires over Holy Week during World War I, was plotted by Faulkner, day by day, around the walls of the room. The first outline was painted over, and when he began another, he started again with the Monday—so that now there are two. The first installment, with its military time, reads: "06.00 The French Regiment mutinies, refuses to leave the trench to make an attack, is drawn out, disarmed, put under arrest and sent to the rear." Following Sunday is the final entry, marked *Tomorrow*: "The body of the old Generalissimo is brought in state to the Arc de Triomphe for a final ceremony. The Runner bursts out of the crowd, interrupts the ceremony by flinging the Corporal's medal at the casket."

At the front of the house upstairs are Jill's room and a guest room. Estelle's bedroom is at the rear, and Faulkner's in the middle. Its drabness—plain bed, dresser, rocking chair, and bookshelf—reminds one that his peace and his restless dreams all took place downstairs, at his desk, with its pens and Underwood portable. He rose early every morning and made his own breakfast, and worked from 7 until 2 every day. He wrote in longhand on specially made paper with wide margins for his revisions. In the afternoons he walked into town for his mail, and then might ride or sail on the nearby Sardis Reservoir. And there were always chores to do. Evenings were a more formal time, and Faulkner loved to pour fine wines for his guests. After dinner, with some sipping whiskey, he might retire to a favorite chair with a murder mystery, his wife in a chair on the other side of the room. His marriage had been first a romantic and later a chilly affair, but despite his several long liaisons with younger women and Estelle's offer of a divorce in 1957, they endured to the end. That she had been able to stop drinking and turn to mysticism apparently helped.

In the end, it was a fall from his horse that occasioned Faulkner's death, though his drinking and weak heart were undoubtedly its cause. Novelist William Styron attended the funeral in Oxford, and wrote of driving with the cortege through Courthouse Square: "I am deep in memory, as if summoned there by a trumpet blast. Dilsey and Benjy and Luster and all the Compsons, Hightower and Byron Bunch and Flem Snopes and the gentle Lena Grove—all of these people and a score of others come swarmingly back comically and villainously and tragically in my mind with a . . . a sense of utter reality. . . . Suddenly, as the watchful and brooding faces of the townspeople sweep across my gaze, I am filled with bitter grief." Years before, Faulkner himself had written of such a moment: "the moment, instant, night: dark: sleep: when I would put away forever that I anguished and sweated over, and it would never trouble me anymore." It should be added that the day he died, July 6, 1962, was in fact the very birthday of his great-grandfather, the old Colonel.

ABOVE: The dresser in Faulkner's bedroom.

BELOW: A hunt breakfast at Rowan Oak in 1938. Venison and quail were served, resplendent riding clothes were required, and Faulkner greeted his guests with a blast at the hunting horn around his neck. Jiggers of bourbon were served every fifteen minutes. Faulkner, his wife, and young daughter Jill are in the back row.

OPPOSITE: The vanity table in Estelle's bedroom. She was a year and a half older than Faulkner, who had met her in 1911, when he awkwardly danced with her at parties and showed her his first poems. She was "ready to elope" with him in 1918, but her family opposed the marriage, and she wed another man. Only after her divorce were they free, and they married in 1929. Their troubled honeymoon foretold many future difficulties.

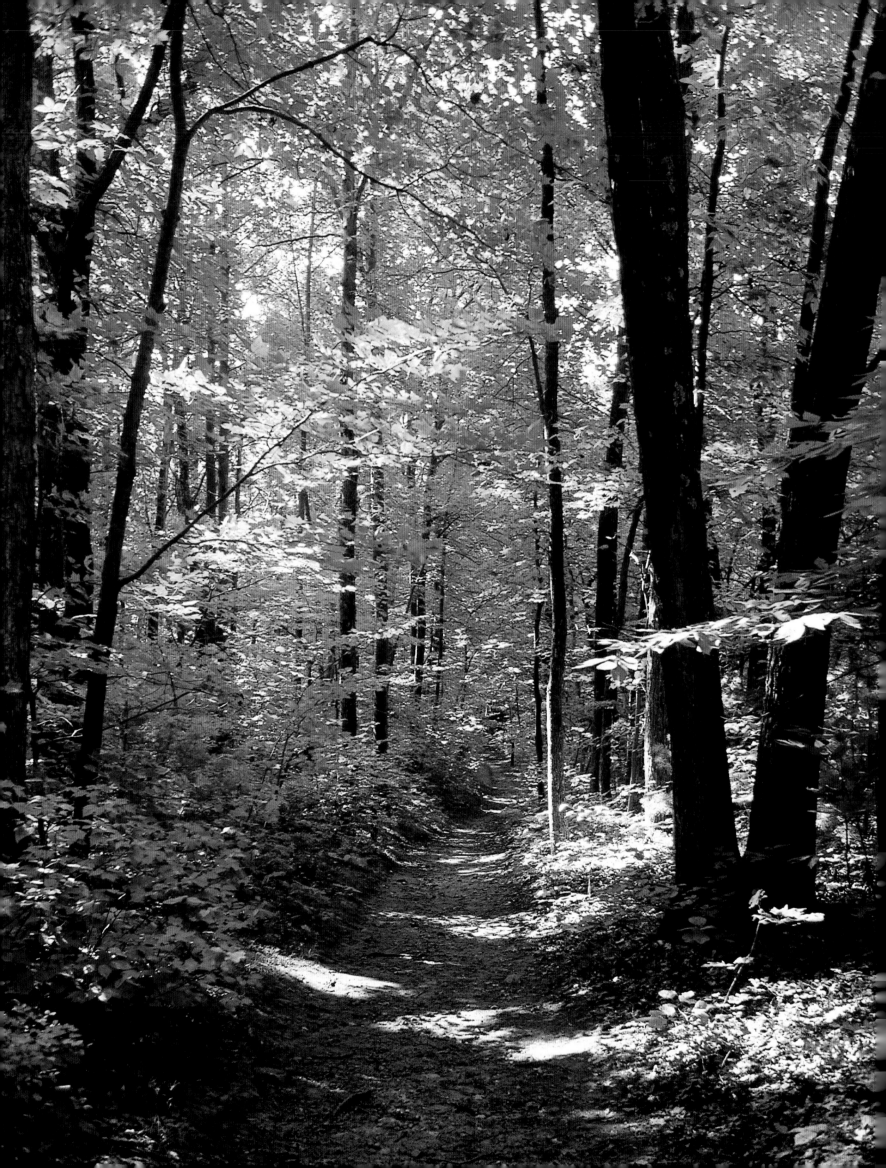

Robert Frost

1 8 7 4 — 1 9 6 3

OPPOSITE: A woodland path on the property of Frost's Derry farm. He loved to take his young children on nature walks, but loved even more his solitary rambles. One of his most famous early poems is called "The Road Not Taken," and it ends, "Two roads diverged in a wood, and I— / I took the one less traveled by, / And that has made all the difference."

RIGHT: The Morris chair in which Frost wrote in the evenings, a board on his lap. "There is a danger," he once said, "of forgetting that poetry must include the mind, as well as the emotions. . . . The mind is dangerous and must be left in. . . . The poet can use the mind in fear and trembling. But he must use it."

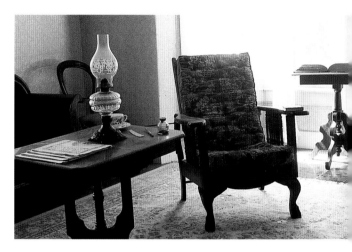

There are several Frost Houses. They can be visited in Ripton, Vermont, in Key West, Florida, and in Franconia, New Hampshire. In South Shaftsbury, Vermont, there is the stone house where on a hot June morning in 1922 he wrote "Stopping by Woods on a Snowy Evening" at the dining room table, and it is not far from the Old First Church in Bennington, where he and his wife are buried. There are residences to be pointed out in Amherst and Cambridge. But when, in 1949, Frost was asked where he had been the happiest, he replied, "The happiest? Oh, I guess it was when I lived in Derry, New Hampshire. It was the only piece of real estate I ever owned." But it wasn't just pride of ownership that occasioned, at least in retrospect, Frost's happiness—in fact, he didn't quite *own* the farm—but the fact that his years in Derry were the seedbed for his career as a poet. It was this farm, its topography and routines, that gave him a subject matter, and the time to work it into lines. Half a century later, in a 1952 letter, Frost wrote to an inquiring stranger:

You might be interested to know that during my ten years in Derry, the first five of them farming altogether and the last five mostly teaching but still farming a little, I wrote more than half of my first book, much more than half of my second, and even quite a little of my third, though they were not published till later. I might say the core of all my writing was probably the five free years I had there on the farm down the road a mile or two from Derry Village toward Lawrence. The only thing we had plenty of was time and seclusion. I couldn't have figured on it in advance. I hadn't that kind of foresight. But it turned out as right as a doctor's prescription.

Frost was one of America's famously slow-starting writers. Like Walt Whitman and Wallace Stevens, he had a long, fractured apprenticeship. He was thirty-nine years old before his first book appeared, and he had to go to England to find a willing publisher. The years before that he drifted. He'd studied at Dartmouth and Harvard, but never completed a degree. He worked in a factory and on a newspaper, he taught school, he studied and wrote desultorily, and continually fell ill. The only constants in his life were the high-school sweetheart he had married in 1895, Elinor White, and the financial support of his grandfather. In 1899, when a doctor told him that his sedentary ways would ruin his fragile health, Frost tried poultry farming—and, to his surprise, enjoyed it. But tragedy hounded him. His mother developed terminal cancer, his four-year-old son Elliott died of cholera, his wife sank into depression, and Frost himself suffered from chest pains and nightmares. His grandfather, persuaded that a change of scene would help Frost put his life right, agreed to put up the money for a thirty-acre farm in Derry, a small town between Salem and Manchester in southern New Hampshire. There was a relatively new

farmhouse and barn, orchards, a horse and cow, 300 chickens, all for $1700. He even covered the wages of a hired man. Frost, his wife, and their baby daughter Lesley, moved in on October 1, 1900. The *Derry News* reported the event: "R. Frost has moved upon the Magoon place which he recently bought. He has a flock of nearly 300 Wynadotte fowls."

Frost's grandfather died a year later, and his will stated that Frost was to have "free use and occupancy" of the property for ten years, after which time it was to be his. His gift was a handsome one. The white clapboard farmhouse is amply proportioned, facing west across the dirt road toward two fields where he'd pasture his cow. To the north were apple and peach orchards and a vegetable garden, a sizable portion of which was given over to root vegetables, good for putting up in the cellar for wintertime. To the east was a hayfield stretching back to a hardwood grove, and to the south were alders, a brook, and a small cranberry bog. When the house was purchased by the state of New Hampshire, Frost's eldest daughter, Lesley, who had lived there until she was eleven, returned to New Hampshire and spent several years scouring the countryside for furniture and wallpaper, trimmings and kitchenware similar to what she remembered in the house at the turn of the century. Frost's own writing chair—a reclining Morris chair stuffed and upholstered with horsehair—was found in an attic corner, and it dominates the parlor. The poet would write there, a board across his lap, and when he was working the doors were shut against any disturbance. There are bookcases as well; it was a family that prized books, and all the children (three more were born there) were started early on the classics. On social calls, Frost would often bring his host a book and admonish him to "put it down,

but don't put it away." Beyond the parlor is a spacious dining room, with a round-fronted stove, and off to one side a small sewing room also used for childbirth and as a place to isolate a sick child. In the kitchen, by the stove, was a rocking chair where Elinor read to the children. She prided herself on her Royal Dalton china set and her wall phone, but she was also a thrifty housekeeper. The burlap bags that potatoes and animal feed came in were used to make blankets, and the cotton bags that salt or sugar or cornmeal came in were fashioned into clothes for her children. Behind the kitchen is a laundry room (to which the stove was moved in the summer), a wood room, and a privy. There was no refrigeration; milk would keep in the basement for a couple of days, and root vegetables and apples were stored down there too. In the master bedroom upstairs are the standard features of old American houses—a double bed, a stove, and a crib.

ABOVE: Derry, 1907. The Frost children: Marjorie, Lesley, Irma, and Carol.

BELOW: The farmhouse and field. In a letter written in 1915, Frost confessed, "I kept a farm, so to speak, for nearly ten years, but less as a farmer than as a fugitive from the world that seemed to me to 'disallow' me. It was all instinctive, but I can see now that I went away to save myself and fix myself before I measured my strength against all creation. I was never fully out of the world for good and all. I liked people even when I believed I detested them."

OPPOSITE: The back entrance to the house, looking through the pantry (used also as a summer kitchen) toward the kitchen from the woodshed.

OVERLEAF: The kitchen. It was here that his wife, Elinor, would sit and read to their children.

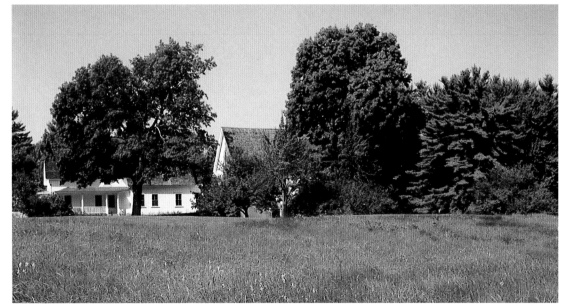

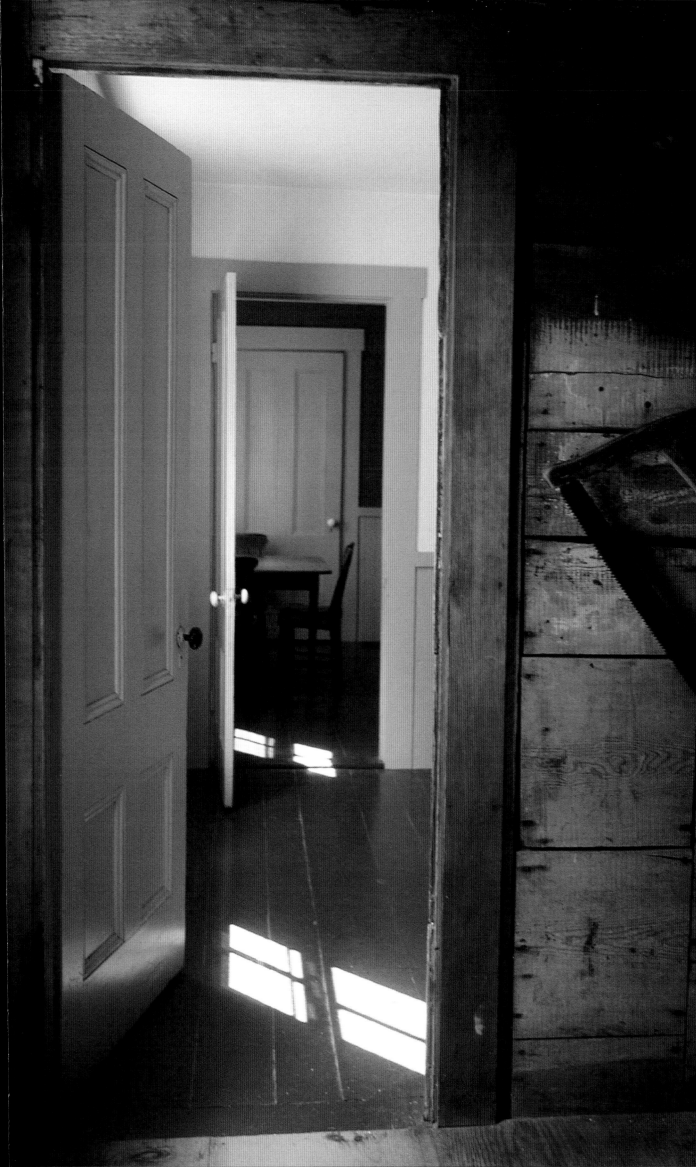

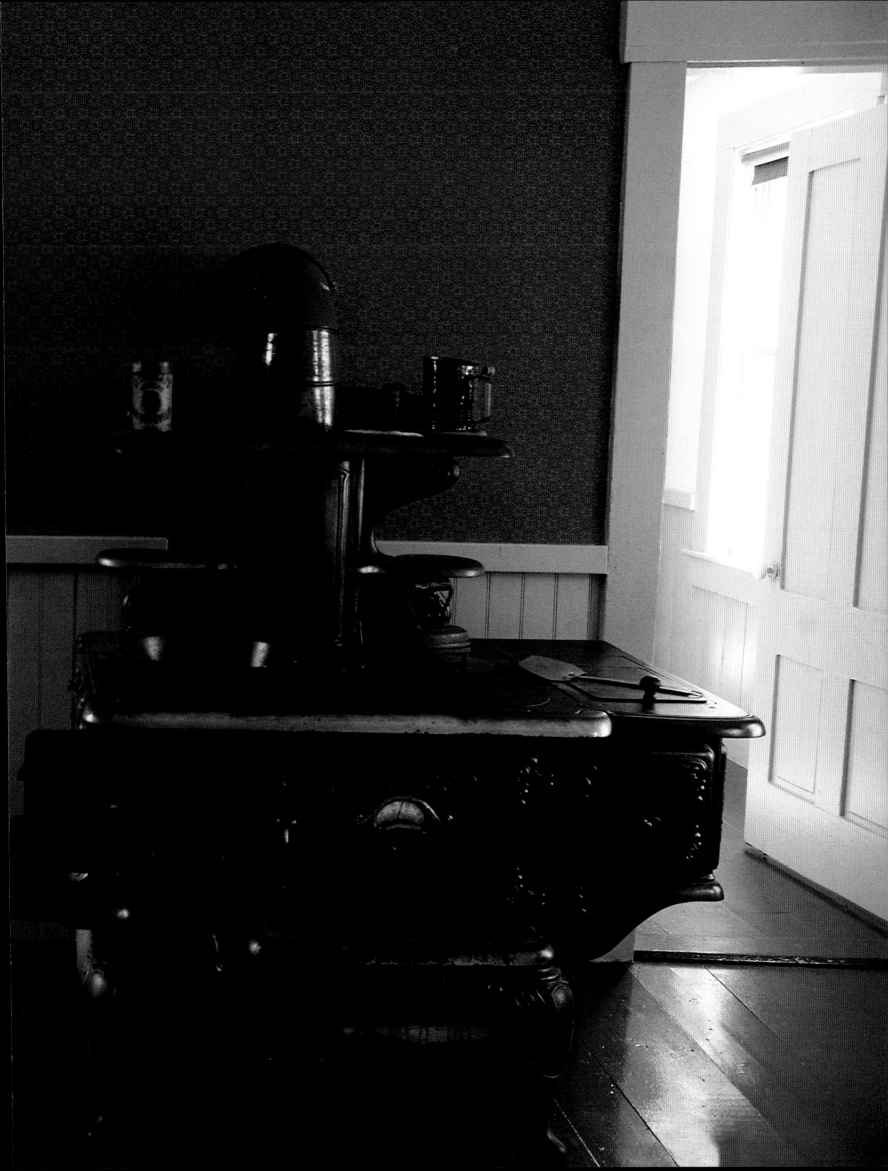

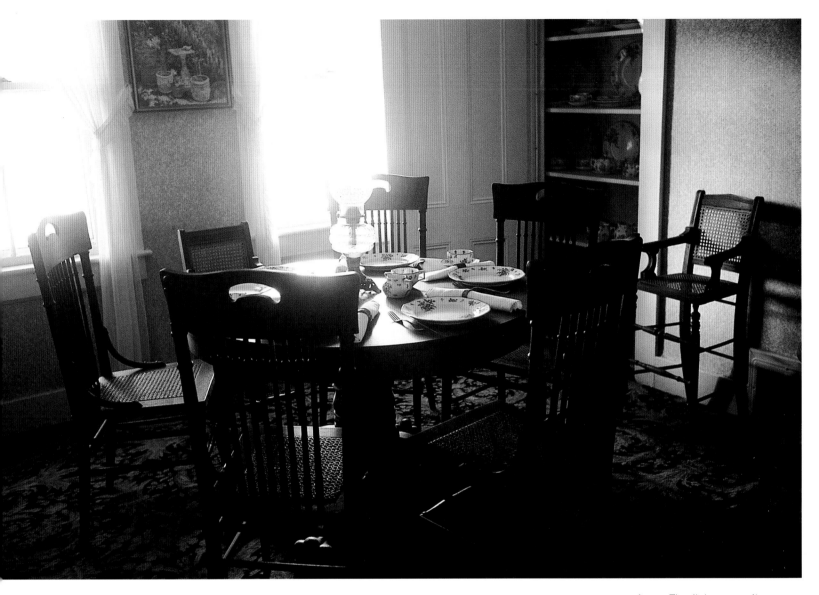

Frost's neighbors thought him odd. He did things in his own way, and at his own pace. He milked the cow at noon and midnight because he didn't like to get up early in the morning. Because it was time to cut hay didn't mean he'd cut it. But he always had time to talk about poetry, and he would invite boys from nearby Pinkerton Academy to stop by after dinner and listen to his thoughts on the Latin masters or Shakespeare or Keats.

What he liked above all was to walk. Lines of poetry are measured, of course, in *feet,* and the rhythms of walking have been a part of many poets' lives. Frost would take his children along with him to explore the farm. Lesley, in fact, kept a diary during her years in Derry. In an entry dated April 9, 1908, for instance, the eight-year-old writes: "Our farm has interesting places to travel to, just like the world, though you do not have to journey so far as in the world. We go to some place almost every day." Frost, too, could see the world in his back yard, and explore it. He could involve

his children in his stories, as when he wrote for Lesley a poem called "The Last Word of a Bluebird," which begins

> *As I went out a Crow*
> *In a low voice said, 'Oh,*
> *I was looking for you.*
> *How do you do?*
> *I just came to tell you*
> *To tell Lesley (will you?)*
> *That her little Bluebird*
> *Wanted me to bring word*
> *That the north wind last night*
> *That made the stars bright*
> *And made ice on the trough*
> *Almost made him cough*
> *His tail feathers off . . .'*

But his solitary walks yielded something more. Over his own acres and on to Guay's Woods, Berry's Pasture, Mrs. Upton's property, Nat Head's Woods. . . .

ABOVE: The dining room. It was here that Frost began daydream discussions with his family about the possibility of abandoning farming and traveling to exotic countries. They moved to Plymouth, New Hampshire, in 1911, after Frost had accepted a teaching position there, but a year later, on impulse, they moved to England, where finally he was recognized as a poet and his first two books were published.

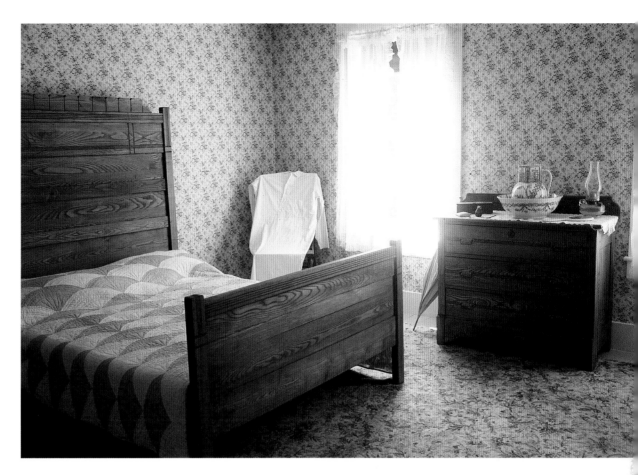

ABOVE: Robert and Elinor's bedroom. After her death in 1938, Frost wrote to his son from Florida, "After the funeral we can all drive over to Derry and scatter the ashes out in the alders on the Derry farm if the present owner will let us. By all I mean just the family and perhaps one or two of our closest friends." In fact, when he visited the farm to inquire of the owner if this plan was possible, he sensed the owner's unease and decided to keep the urn of ashes, which in 1941 was buried in the graveyard behind the Old First Church in Bennington, Vermont, alongside those of their son Carol, who had killed himself a year earlier. In June, 1963, the urn of Frost's own ashes was buried beside them. BELOW: A child's crib.

Out through the fields and woods
And over the walls I have wended;
I have climbed the hills of view
And looked at the world, and descended.

The woods on the Derry farm are eastern white pine and oak, alder, birch, and sugar maple. The forest floors are filled with sweet fern, skunk cabbage, and orchis, and the fields abundant with meadow sweet, dandelion, and milkweed. Stone walls—in need of annual "mending" to replace stones felled by frost heaves or gravity—mark both the property lines and the border of field and forest. (It was Frost's neighbor Napoleon Guay—with his "good fences make good neighbors"—who insisted on the tradition of their walking together to repair the walls that divided and joined them, a task Frost wryly mocks in his famous poem "Mending Wall.") Frost took with him on his walks the despair that suffused his emotional life and the professional disappointments that hindered his way, and he looked to nature at times to restore his spirit and at times to echo his dark feelings. Always, though, he was a keen observer, not just of nature's quirks and plenty but of the quizzical relationship between man and the world. Few poets have written so well about work on the land. Frost once said that his favorite tools were the scythe and the pen, and a poem written at Derry, "Mowing," captures

perfectly—the rhythms of the curved blade and the poem's long lines moving in tandem—the eerie stillness of an afternoon:

There was never a sound beside
the wood but one,
And that was my long scythe whispering
to the ground.
What was it it whispered? I know
not well myself;
Perhaps it was something about the heat
of the sun,
Something, perhaps, about the lack
of sound—
And that was why it whispered and
did not speak. . . .

Frost was as keen an observer of his neighbors as of his farm, and if the lyrics in his first book, *A Boy's Will*, derive from farm life in Derry, the dramatic narratives in his second book, *North of Boston*, are a result of his encounters with nearby farmers and odd locals, to whom he listened intently. Their picturesque vocabulary and rhythms of speech became the basis for his insistence that poetry be vernacular rather than literary. His term was "the sound of sense," poems adjusted to the actualities of human speech, the better to catch the drift of human feeling.

He never could make a success of farming, and years later attributed that fact to his laziness. (Laziness! He was all the while writing poems that are now among the best known and beloved in the English language.) By 1906, in need of money for his growing family, he decided to start teaching at Pinkerton Academy, in Derry village. Even that job came to him through poetry. One day the minister at the Derry Congregational church read out Frost's poem "The Tuft of Flowers" from the pulpit. Several teachers from Pinkerton were in the church, and came up to congratulate the embarrassed poet. One of them suggested he teach. Frost loved teaching, and eventually gave up the farm to move to town and be nearer Pinkerton. His success attracted attention across the state, and in 1911, when his grand-father's will permitted him to sell the farm, he did. He moved to Plymouth, New Hampshire, and to new teaching duties, but he was nearing forty and was at a crisis point in his career. He felt he had to make a break and devote himself exclusively to his poetry. He wanted to move to Canada, his wife preferred England. They flipped a coin, and England won. In the summer of 1912, the family set sail. He was headed for fame.

He once said that a teacher's job is to make something understood and, he added, that is the poet's job as well, "a clarification of life." That illumination sometimes involved a darkness. A haunted poem like "Desert Places" confronts the emptiness without and the emptiness within, each a sullen echo of the other. Frost's own emotional life was difficult, in ways he himself created, but at its heart was what Randall Jarrell once called a "stubborn truthfulness." In one of the very last letters he wrote, sent just a week before his death, he was puzzling "how can we be just in a world that needs mercy and merciful in a world that needs justice." The claims of the heart and of the mind are what his poems explored, and they gave eloquent voice, as few in our literature have, to the punishing, pleasureful world and man's place in its schemes. And that lifelong pursuit of the truth began at his farm in Derry.

ABOVE, LEFT: The series of sheds connecting the house and barn had many purposes. ABOVE, RIGHT: The pantry adjoining the kitchen served as a washroom.

OPPOSITE: This unfinished room, behind the family bedroom, would sometimes be used to put up guests, but when the Frosts first lived at the farm it was used by the handyman, Carl Burrell, whom Frost's grandfather had hired to help Frost with farming chores. One famous poem written at Derry, the dramatic narrative "The Death of the Hired Man," is a chilling account of a hired man returning to die at the farm he once worked. "I made the bed up for him there tonight. / You'll be surprised at him—how much he's broken. / His working days are done; I'm sure of it." The story is not Burrell's, but local legend.

Nathaniel
Hawthorne
1804 – 1864

OPPOSITE: While working on *The House of the Seven Gables* in Lenox, Hawthorne wrote to his publisher that many passages of the novel "ought to be finished with the minuteness of a Dutch picture." This view of The Old Manse has precisely that Dutch quality of intriguing perspectives and ghostly emptiness—as if the people who live there had just left the room. Houses and rooms, at once revealing and constricting, fascinated Hawthorne throughout his career. He was himself an isolated and reticent man, who favored solitude and silence.

While an undergraduate at Bowdoin College in the 1820s and looking to join a literary society, Nathaniel Hawthorne chose the Athenean, which was the more "nativist" of the two societies. His choice echoed a debate that raged in the early decades of the nineteenth century between those who favored genteel British literary models for aspiring American writers and those who sought to reject the established ways and concentrate instead on what was distinctly American—the landscape, temperament, history, and idiom of their native land. From the start, Hawthorne was fascinated by "the matter of America," especially its Puritan origins, and he immersed himself in the study of old records and musty histories, whatever he could get his hands on, the better to understand how America had come to be. If his earliest stories seem derivative of Sir Walter Scott's gothic manner, Hawthorne as he matured changed into the gloomy master of the haunted Calvinist heritage that defined—indeed still defines— much of the American character. He was fascinated by the Puritan strain in our culture—its sense of purpose sometimes devout and resolute, sometimes maniacal or hypocritical. His stories explore its cost and curse, and his best-known novels, *The Scarlet Letter* (1850) and *The House of the Seven Gables* (1851), with their psychological depth and chilling precision, probe its struggle within the individual human heart. At the center of *The House of the Seven Gables*, as Hawthorne explained in his preface, is the truth that "the wrongdoing of one generation lives into the successive ones, and, divesting itself of every temporary advantage, becomes a pure and uncontrollable mischief." Greed and guilt tumble forward, forever bound together. And Hawthorne knew why. In fact, he was writing about his own family. Hawthorne's ancestor, the cruel Colonel John Hathorne, had been a judge in the Salem witch trials, and was sitting on the bench when Sarah Good cried out at her prosecutor, "I am no more a witch than you are a wizard. And if you take my life God will give you blood to drink!" The curse that Matthew Maule, in the novel, screams at Colonel Pyncheon, who has condemned him for witchcraft and seized his property, is "God will give him blood to drink!" In effect, though, Hawthorne is not just dramatizing the ancestral story. Nor is he concocting another allegory about original sin. He is writing the American romance—the restless story of a nation driven to dark deeds by innocence, and justifying its innocence by murder.

Hawthorne's fame was slow to accumulate, and his early career was marked by difficulty and rejection. At one point, Edgar Allan Poe called him "the example, par excellence, in this country, of the privately-admired and publicly under-appreciated man of genius." He began writing while still in college, and as a solitary young man lived with his mother and sisters in the Salem home of relatives, sticking to his room "under the eaves" and composing stories and sketches. So discouraged was he by their poor reception that he burned his manuscripts. His first book was published at his own expense in 1828, but he destroyed his own copy and never discussed it again. Slowly, however, his tales attracted notice when they appeared in local newspapers, and finally in 1837 his collection *Twice-told Tales* was published (anonymously underwritten by a friend) and was praised in the *North American Review* by his Bowdoin classmate Henry Wadsworth Longfellow, who declared Hawthorne "a new star" and said of the book that it "comes from the hand of a man of genius." Now something of a literary star in Boston, he met the three Peabody sisters:

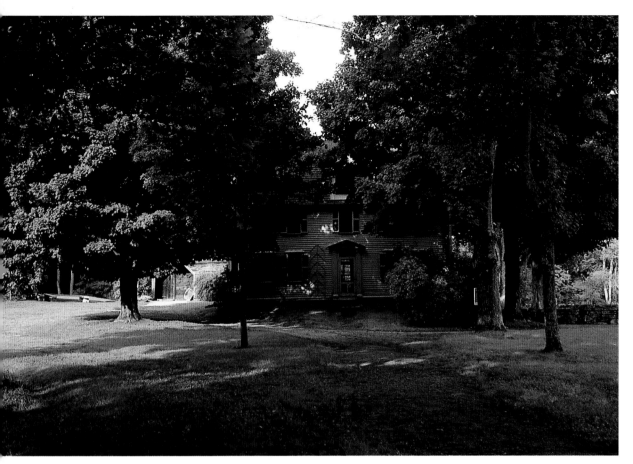

Elizabeth, a friend of Emerson and later the publisher of *The Dial*; Mary, who married educator Horace Mann; and their frail youngest sister, Sophia, with whom Hawthorne fell in love. In 1838, they were engaged, but secretly, because his lack of prospects would have caused a small scandal in her family. He tried his hand first at work in the Boston Custom House and then at Brook Farm, a utopian community of Transcendental artists and writers, but nothing he tried was adequate to support a wife. Still he was in love and determined, so on July 9, 1842, at the age of thirty-eight, he married Sophia. The couple went directly from their wedding in Boston to Concord, where for their honeymoon they had arranged to rent, for $100 a year, the ancestral home of the Emersons. (Ralph Waldo Emerson had earlier completed the first draft of his essay "Nature" while living there.) The Hawthornes stayed for three years and called it their little Eden. In later years, they said they were never again so happy as they were there. In the front of the house, Henry David Thoreau had planted a vegetable garden for the couple as a wedding present, and their orchards and gardens provided all the food they needed beyond meat and milk. Hawthorne himself became a member of the circle of Concord Transcendentalists that included Emerson, Thoreau, Bronson Alcott, Margaret Fuller, and Ellery Channing. His work flourished. Sophia, a

talented painter, sketched in her studio. Their daughter Una was born in 1844. He brought Sophia lilies from the river and flowers from the garden. She called Hawthorne her Apollo, her Adam, her lord. "Before our marriage," she wrote, "I knew nothing of its capacities & the truly married alone can know what a wondrous instrument it is for the purpose of the heart." Embarrassed, she once asked her husband to destroy a letter she had written to him about the sexual happiness they shared, but he refused, and declared, "I cannot do it, and will not. . . . I verily believe that no mortals, save ourselves, have ever known what enjoyment was."

The stories Hawthorne wrote in these years are among his very best—"Rappaccini's Daughter," "The Birth-mark," and "The Celestial Rail-road" among them. When he came to collect them in 1846, he called the book *Mosses from an Old Manse*—the name he had by then given to the house he had rented. (Since so many ministers had lived in it, the term for a parson's home seemed appropriate to him.) To introduce the book, he wrote an essay, "The Old Manse," that drew on the journals he kept while living in Concord, and that remains a vivid picture of his days there. Hawthorne loved to garden, for instance:

An hour or two of morning labor was
all that it required. But I used to visit and

ABOVE: The Old Manse was set at the end of a long allée of Balm of Gilead trees and away from the public road so that, as Hawthorne wrote, it was not "so imminent upon the road that every passer-by can thrust his head, as it were, into the domestic circle." Also, the Old Manse from a stereoscopic photograph taken in 1875.
OPPOSITE, ABOVE: The Old North Bridge, northwest of the house, a two-minute walk away. This is where the first armed resistance to British rule took place on April 19, 1775, with about 100 British Redcoats on one side of the bridge, and 400 Minutemen on the other.
OPPOSITE, BELOW: The entrance hallway and staircase of The Old Manse. Hanging in the stairwell are leather water buckets. Each household joined a local fire brigade, and when an alarm sounded, they would rush with their readied buckets to help extinguish a blaze.

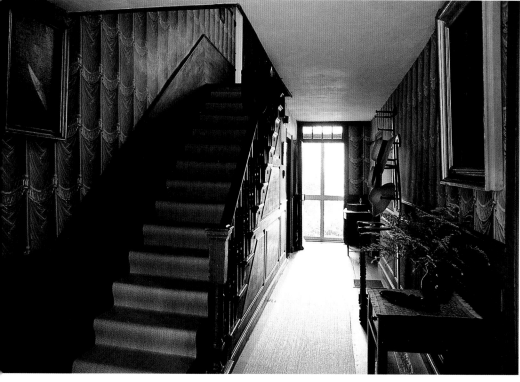

revisit it a dozen times a day, and stand
in deep contemplation over my vegetable
progeny with a love that nobody could
share or conceive of who had never taken
part in the process of creation. It was
one of the most bewitching sights in the
world to observe a hill of beans thrusting
aside the soil, or a row of early peas
just peeping forth sufficiently to trace
a line of delicate green.

The Concord River flowed at a slight distance
from the back of the house, but was easily to
be seen from Hawthorne's study. He purchased
Thoreau's boat, the *Musketaquid*, for $7—the
one used on Thoreau's famous excursion on
the Concord and Merrimack rivers—and
renamed it the *Pond Lily*. He used it to drift
lazily on the water:

*The river sleeps along its course and
dreams of the sky and of the clustering
foliage, amid which fall showers of broken
sunlight, imparting specks of vivid*

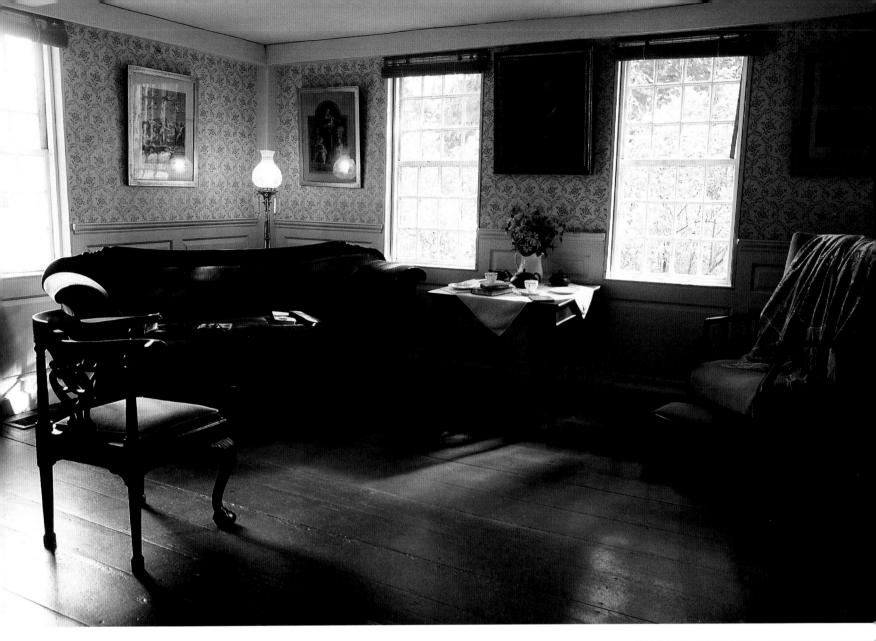

*cheerfulness, in contrast with the quiet
depth of the prevailing tint. . . . We glided
from depth to depth, and breathed new
seclusion at every turn. The shy kingfisher
flew from the withered branch close
at hand to another at a distance, uttering
a shrill cry of anger or alarm.*

Hawthorne also liked to skate on the river in
wintertime. Emerson and Thoreau occasionally
accompanied him. Sophia described the trio:
Emerson "evidently too weary to hold himself
erect, pitching headforemost," while Thoreau
did "dithyrambic dances and Bacchic leaps on
the ice," and her husband "wrapped in his cloak,
moved like a self-impelled Greek statue, stately
and grave."

At the back of the house, upstairs, was
Hawthorne's study, "the most delightful little
nook of a study," and as "The Old Manse" recalls,
when he first came upon the room:

*Its walls were blackened with the smoke of
unnumbered years and made blacker still*

*by the grim prints of Puritan ministers
that hung around. These worthies looked
strangely like bad angels, or at least like
men who had wrestled so continually and
so sternly with the devil that somewhat of
his sooty fierceness had been imparted to
their own visages. They had all vanished
now; a cheerful coat of paint and golden
tinted paper hangings lighted up the small
apartment, while the shadow of a willow
tree that swept against the overhanging
eaves attempered the cheery western sun-
shine. In place of the grim prints there was
the sweet and lovely head of one of
Raphael's Madonnas and two pleasant
little pictures of the Lake of Como.*

Those engravings of the Puritan divines—
one of them bizarrely cross-eyed—were rehung
on the second floor landing, and indeed the
room is bright, the western view streaming in
through its nine-over-nine windows. But
Hawthorne built a writing desk for himself that
faced away from the view—faced, indeed, the

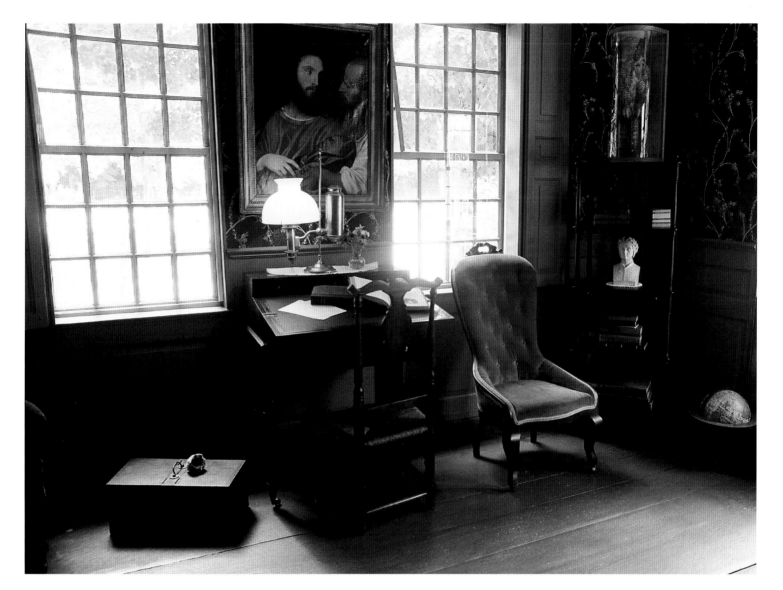

opposite wall, next to the fireplace. It is a board that can be raised or lowered by a brace set in scaled notches. He wrote there four hours every day, then walked into town to fetch his mail and read the newspapers. In the summer, he didn't write at all, though, and spent his time reading, gardening, rowing, and chopping wood. For all his happiness, his imagination still dwelt in dark passages. "The Birth-mark," for instance, is the story of Aylmer the scientist and his young wife, on whose cheek is a small red blemish that he feels mars her otherwise ideal beauty. Hawthorne turns the tale of the small stain into an allegory: "It was the fatal flaw of humanity, which Nature, in one shape or another, stamps ineffaceably on all her productions, either to imply they are temporary and finite, or that their perfection must be wrought by toil and pain." Aylmer resolves to make it vanish, and after several experiments, he succeeds, but in doing so he kills his exquisite bride. Here as elsewhere in his work he is obsessed with the question "Shall we never, never get rid of this Past?"

The most curious and touching details in this room are two of its small window panes, on which the couple inscribed messages with Sophia's rose-cut diamond engagement ring. Despite their sometimes serious cast, they stand as a testament to their romantic playfulness. At the top of one pane is "Man's accidents are God's purposes. Sophia A. Hawthorne, 1843." Under that, in a somewhat more unsteady script is "Nathaniel Hawthorne. This is his study, 1843." Then Sophia starts again, and one can suddenly picture them sitting there together, looking through their own thoughts at the twilight beyond them: "The smallest twig / Leans clear against the sky," and her husband interrupts with "Composed by my wife and written with her diamond." Squeezed to the bottom of the pane are Sophia's final comments: "Inscribed by my husband at sunset, April 3, 1843. On the gold light. S.A.H."

The Old Manse, a Georgian structure with a gambrel roof and saltbox lean-to, had been built in 1770, and from its rear windows the first owner, the Rev. William Emerson, watched as

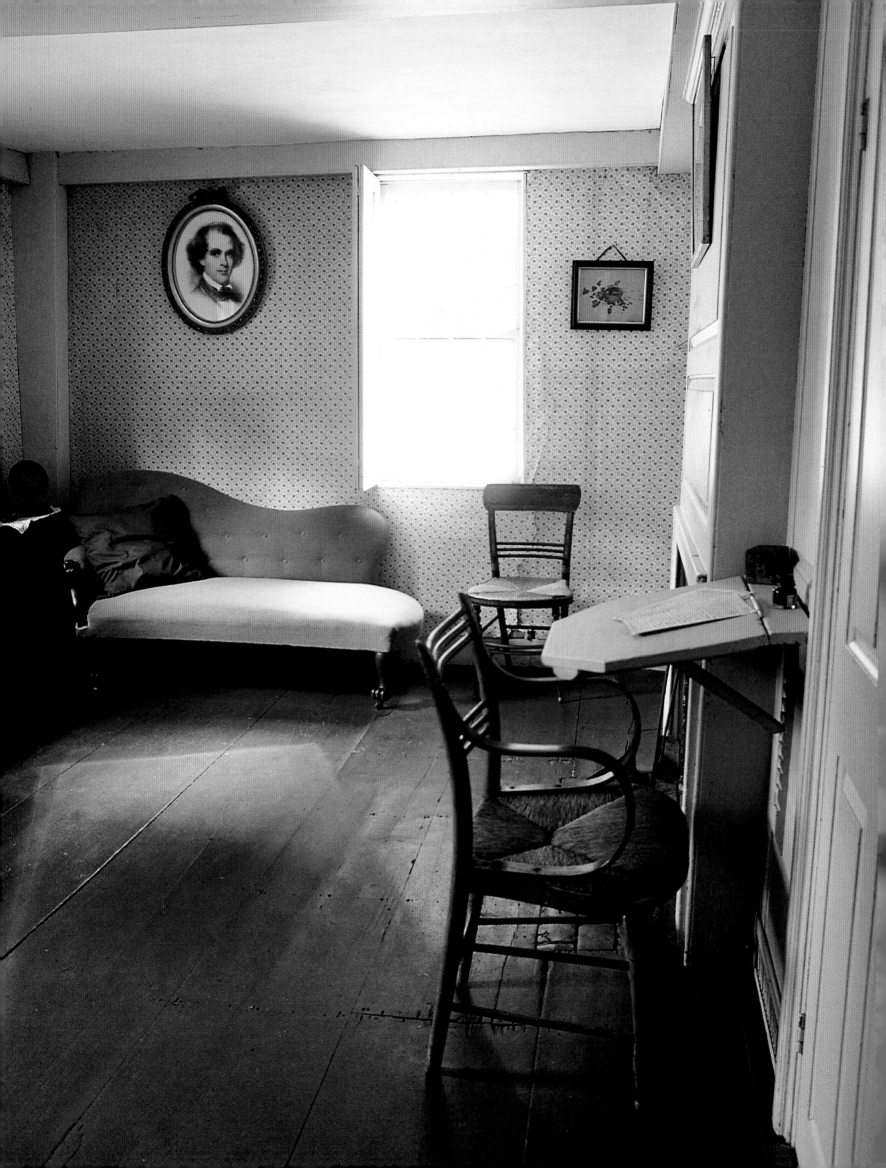

OPPOSITE: Hawthorne's desk. Rather than work at a desk facing the view toward the river at the back of the house, Hawthorne built for himself a writing table (just a board with a collapsible support) facing the wall. That it was next to the fireplace reminds one that in such old houses, writers were probably either too hot or too cold. Sophia never intruded on her husband's work: "I have made a law to myself never to ask him a word concerning what he is writing."

RIGHT: The master bedroom. On the wall is a portrait of Hawthorne's daughter Una, born on March 3, 1844, in this very room. Hawthorne wrote to his sister that the baby "came head-first into the world at $1/2$ past 9 o'clock this morning, after being ten awful hours in getting across the threshold. . . . We had a name already—Una! Is not it pretty? Una Hawthorne. Una Hawthorne!! It is very pretty." The portrait was painted by a Mr. Mills in England, where Una lived—and, at the early age of 33—died in 1877.

ABOVE: The kitchen. Sophia's parents, worried about her fragile health, hired a young Irish cook, Sarah, to work for the Hawthornes. RIGHT: The breakfast room. In the afternoons, Sophia would use this space to work on her watercolors.

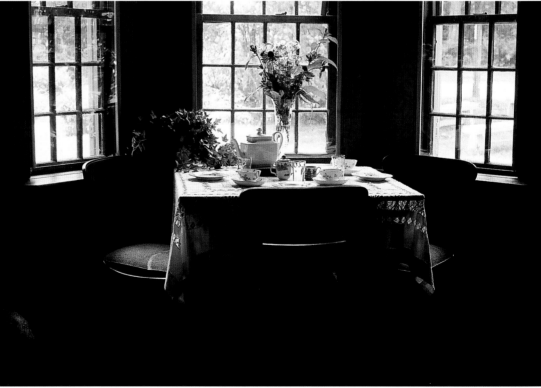

RIGHT: The master bedroom. Part of Sophia's dowry was a set of secondhand bedroom furniture, which unfortunately is no longer in the house. She repainted the bedstead and on its headboard painted a copy of Guido Reni's *Aurora*. When she moved in as a new bride, she wrote to her mother: "Everything is as fresh as in first June. We are Adam and Eve and see no persons round."

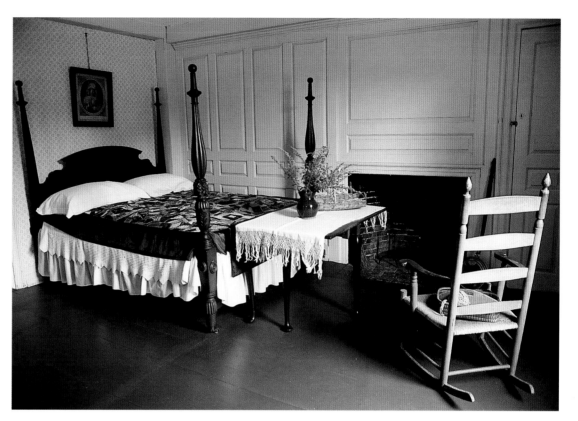

the British were driven back from the Old North Bridge in 1775. When the Hawthornes moved in, its front hallway was decorated with an 1810 French wallpaper called "Josephine," a trompe l'oeil pattern of swagged curtains. Suspended from the landing above the staircase are two leather fire buckets, to be used when the town alarm was sounded. The small parlor to the left, again with fancy French wallpaper, never pleased Sophia. The owners kept a stuffed great horned owl under glass on a table in the room, and she felt its eyes followed her around the room. So instead they used what had been a bedroom across the hallway as their parlor. It is a large room in a house of small ones. A square rosewood Steinway dominates, and the furniture is comfortable. At the rear of the house is the kitchen; the Hawthornes added a stove, and Sophia's family, worried that she couldn't manage housework, provided her with a maid. Also at the rear of the downstairs is a room that in the mornings they used as a breakfast room, and in the afternoons, Sophia used as her studio. The original master bedroom upstairs, they used as a guest room, and across the hall, Sophia decorated their new bedroom in bright golden-yellow paint; the bed, washstand, and dresser were similarly painted, so that the entire room glowed. On the headboard she painted scenes from classical mythology.

Their golden world, their Eden, crumbled in 1845. The house's owner, Samuel Ripley, wished to return, and Hawthorne himself, with a young child, felt he needed a steady income. He left to take up a position as surveyor in the Salem Custom House. Seven years later, however, and now a successful author, he returned to Concord and purchased Bronson Alcott's home, Hillside, for $1,500. (It was the house where Louisa May Alcott and her sisters grew up.) He renamed it The Wayside, and settled in. But the very next year, his friend Franklin Pierce became president, and in gratitude for the campaign biography that Hawthorne wrote, Pierce appointed him American consul in Liverpool. Hawthorne didn't return to The Wayside until 1860, when he oversaw the construction of additions to the house, including his own Tower Study, with a stand-up desk. But the words did not come. He was plagued by ill health, and by the gloom the impending Civil War spread. Events overwhelmed his instinct for fantasy. "The Present, the Immediate, the Actual, has proved too potent for me," he wrote. "It takes away not only my scanty faculty, but even my desire for imaginative composition, and leaves me sadly content to scatter a thousand peaceful fantasies upon the hurricane that is sweeping us all along with it." Several new projects were started and sputtered, as a wasting illness sapped his strength. At the very end of his life, despite the attentions of his devoted family, he feared the almshouse awaited him, and he died with just $120 cash on hand. But men don't die because they are poor. "Men die, finally," Hawthorne wrote, "because they choose not the toil and torment of struggling longer with Time, for mere handsfull of moments." His struggle with Time, and with the guilt it drags in its wake, still lives in his fiction.

Ernest
Hemingway

OPPOSITE: A wall of books and mementos in Hemingway's writing studio.

OVERLEAF: The main entrance, 907 Whitehead Street. In a 1932 letter to John Dos Passos, he wrote: "Am working hard. Cut a ton of crap a day out of the proofs and spread it around the alligator pears which are growing to be enormous. Second crop of limes. 3rd crop of Gilbeys."

Though born in the heartland—Oak Park, Illinois, a suburb of Chicago he once described as having "wide lawns and narrow views"—Ernest Hemingway didn't know much about America as a young man. His family didn't travel farther than Michigan's Upper Peninsula, and he never studied American authors in school. When he graduated from high school, he left home to work as a cub reporter in Kansas City, and soon after, eager to join the American forces which had finally entered the Great War in Europe but fearful his poor eyesight would bar him from active service, he joined the Red Cross. In an army uniform with full insignia, he was dispatched at once to an ambulance unit in Italy. Wounded in the legs by shrapnel from a trench mortar shell, he returned home a hero, already exaggerating his courage in a way that later became a hallmark of his fiction, with its exaltation of "grace under pressure." Determined to be a writer, and hearing from his first mentor Sherwood Anderson that Paris was the place to apprentice himself (cheaply), he landed a job as the Toronto *Star*'s first "European correspondent," and set out. Now married to Hadley Richardson, Hemingway plunged into the years he described so memorably decades later in *A Moveable Feast*. These were the years of the Lost Generation, disillusioned youth on a spree. His friendships with Gertrude Stein, Scott and Zelda Fitzgerald, Gerald and Sara Murphy, John Dos Passos, and with a whole colony of expatriates in search of a louche, adventurous life unthinkable at home, took him from the cafés of Paris to the ski slopes of Austria and the bull runs in Pamplona. All along, despite rejection slips for his stories, he persisted in writing. The example of Anderson and advice from Stein and Ezra Pound helped Hemingway hone his characteristic style—pared-down and intense, precise to the point of mystery,

dry and caustic and haunting. Within a few years, his hard work resulted in the stories of *In Our Time* that first announced his prodigious talent, and then in 1926 his first novel, *The Sun Also Rises*, that secured his fame. What he said of the matador Romero in the book—that he "had the old thing, the holding of his purity of line through the maximum of exposure"— describes as well Hemingway's own way with words, his taut characterizations, his spiraling of emotions and events. "All you have to do is write one true sentence," he once said. "Write the truest sentence that you know."

As his career took off, his marriage sputtered. Hemingway was restless, and his first-born son seemed as much a nuisance as a joy. His roving eye lit on svelte, bobbed, flashy Pauline Pfeiffer from a rich family in Piggott, Arkansas, who with her sister had swept down on Paris and soon set her eye on Hemingway. Before long, Pauline, Hadley, and Hemingway had established—to Hadley's chagrin—a sort of ménage, and the balance began to tip. Separate residences in Paris ensued, ultimatums and tears, but Hadley finally relented; the pair were divorced, and Hemingway and Pauline married on May 10, 1927. Two events then conspired to disrupt things. First, Pauline became pregnant and wanted her child born in America. Then Hadley, having found a new lover, decided to move back to Paris with him. The city was suddenly uncomfortable. Some of his friends had already left Paris; others had been offended by his portraits of them in *The Sun Also Rises*. It seemed a good time for Hemingway to decamp. Realizing how little he knew of his native land and its attractions—from fishing in Florida to hunting in the Rockies—he decided to head back. Late in March of 1928, they sailed on the *Orita* for Havana, and from there crossed the ninety miles to Key West. Augustus Pfeiffer— Pauline's Uncle Gus—was their financial angel

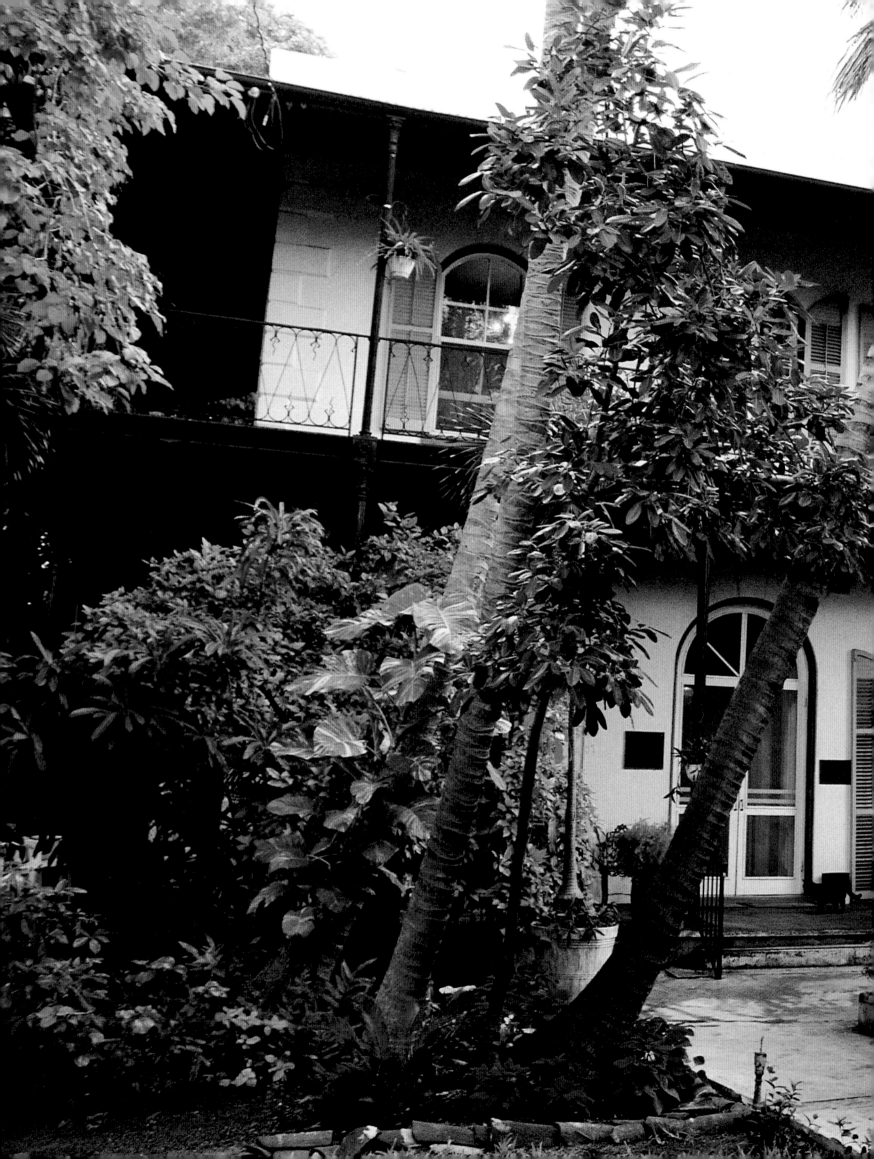

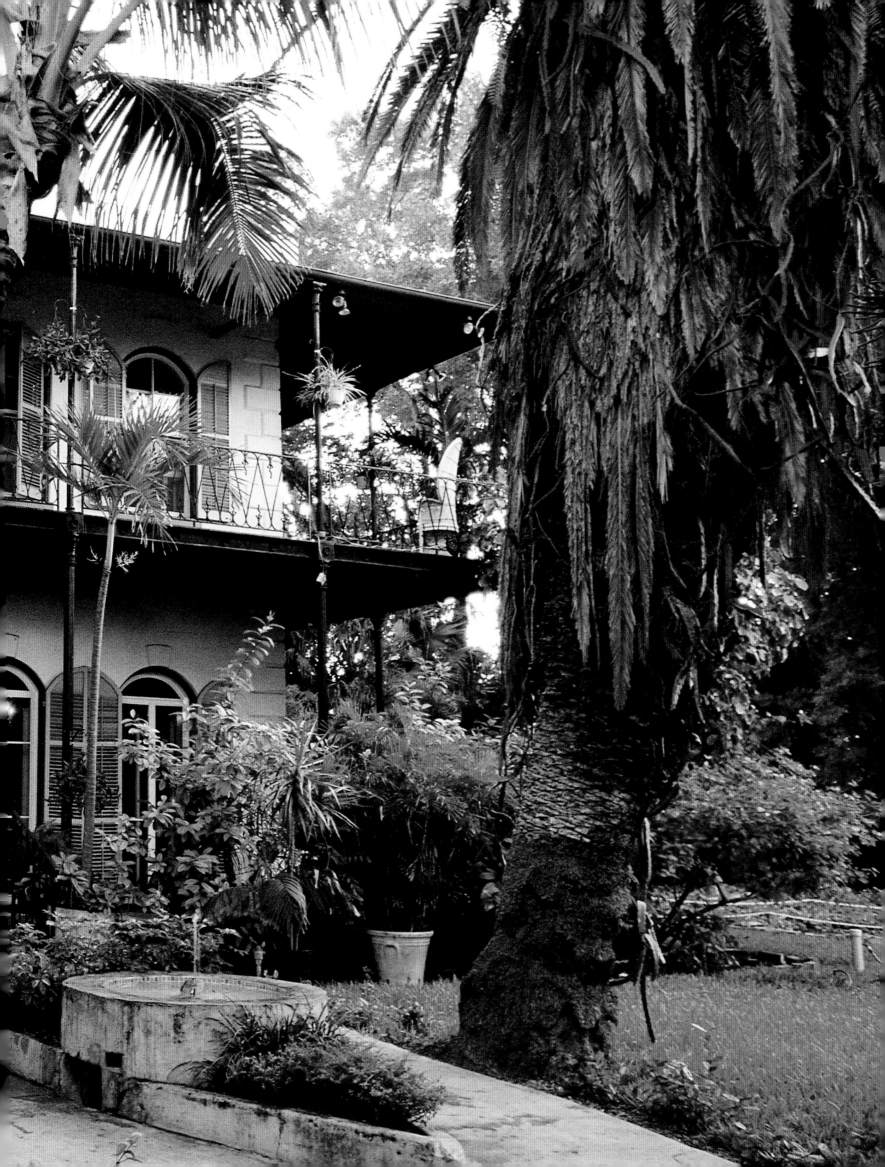

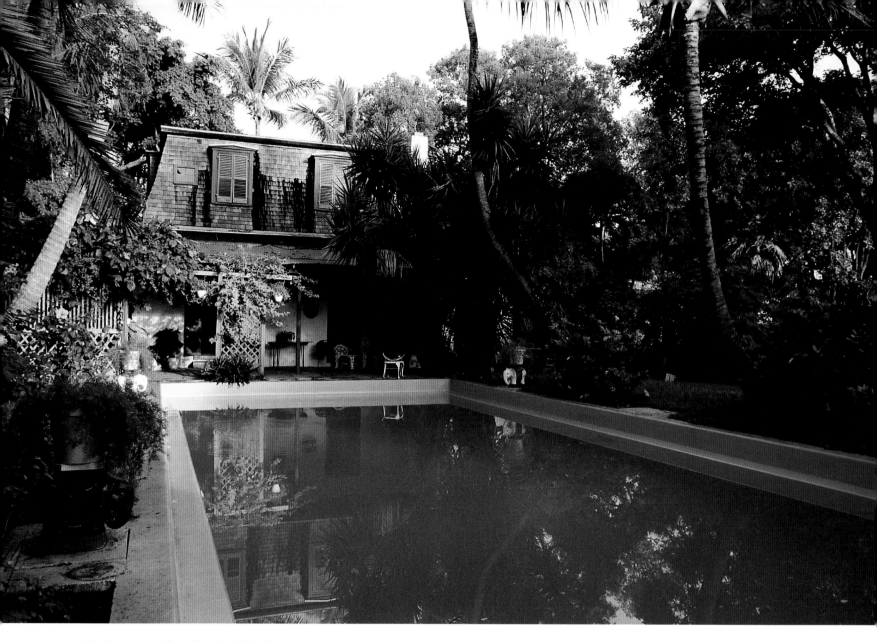

and had a new yellow Model A Ford waiting for them. It was, at first, quite the snazziest thing in Key West.

Key West was seedy, and worse in the Depression years to come. The population was just ten thousand; there was a naval station and a lighthouse, but the days of prosperous wreckers and cigar factories were long over. Still, there was a charm that Hemingway immediately sensed in its lanes shaded with bougainvillea and oleander, its Bahamian shacks with their gabled tin roofs and lacy gingerbread trim, its bars and coffee shops. They rented rooms on Simonton Street, and Hemingway went right to work on the two manuscripts he'd brought with him. One was a long novel named *Jimmy Breen*, which he soon abandoned. The other was a promising short story which kept growing; four months later is was the first draft of *A Farewell to Arms*. Hemingway found he could work well in Key West. Better yet, he made a new group of friends. With the closest of them, Charlie Thompson, he'd fish constantly, out on the green Gulf Stream for tarpon and marlin. And

there were others—Joe Russell, who owned Hemingway's favorite hangout, Sloppy Joe's bar on Duval Street, and Eddie Sanders, Earl Adams, and Sully Sullivan. He liked what he called his "Mob," their company and their yarns. In his stained pullover, canvas walking shorts, and old tennis shoes, he fit in on the docks and at the speakeasies. He relished the raw conch salad made with Key lime and salt brine sauce; he downed the rum and beer. This first visit to Key West lasted six weeks. The couple went off to Kansas City where Pauline would have her baby, and later returned to Europe. But they would return for winter visits in Key West over the next two years, and in 1930 moved there for good. A year later they found the house they wanted, and for $8,000 Uncle Gus made them a present of it. It needed work, but Hemingway was delighted. "This is a grand house," he wrote to a painter friend. "Do you remember it across from the lighthouse? One that looked like a pretty good Utrillo, somewhere between that and Miro's Farm."

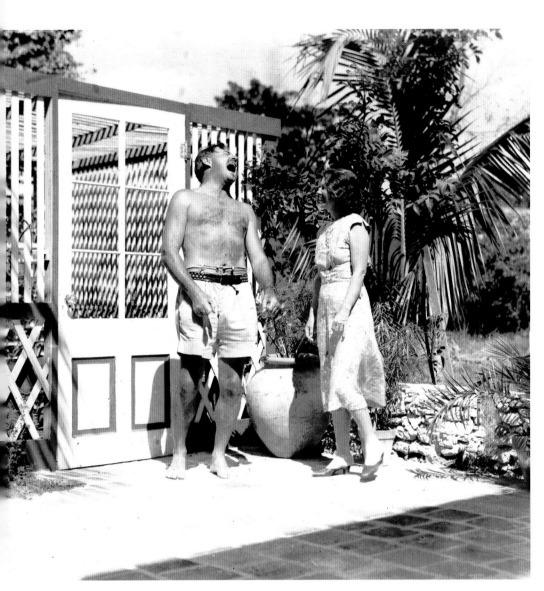

The house had been built in 1851 by Asa Tift, a local merchant and salvage wrecker who knew enough about hurricanes to insist on a solid house. It was built on a low hill and its limestone had been quarried from the site itself, so that there is a nine-foot-deep basement under the house, a rarity in south Florida. (Hemingway made it his wine cellar.) By Key West standards, the Spanish colonial-style house is an imposing one, on a spacious lot, eventually enclosed, that is lushly planted with bamboo, banyan, weeping fig, dragon tree, poinciana, chenille, and many varieties of palm—Christmas, thatch, Washingtonia, green sago, and more. Verandas surround the exterior on both levels, and all the rooms have large windows giving onto the view. Pauline oversaw the refurbishing. The walls were replastered, the wiring and floors redone. Ceiling fans were replaced with chandeliers. The original outdoor kitchen was moved inside, its counters built extra high to accommodate Hemingway when he wished to clean fish or cook. The upper floor of a large outbuilding behind the house, once a carriage house and servants' quarters,

was converted into a writer's studio, at first connected to the house by a catwalk. Pauline fashioned a comfortable working area for a writer, its walls lined with bookshelves over which were hung antelope heads and a tarpon. There is a reading chair and a round writing table. The chair pulled up to it once belonged to a Cuban cigar-maker. Hemingway's old Royal portable typewriter is on the table, though in truth he preferred to write in longhand and have someone else (often Pauline or his younger sister Sunny, who later moved to Key West) type his manuscripts. Despite his travels and accidents and drinking binges, he was a disciplined artist, was at his desk at 8 every day and wrote all morning. A good day's work he described as "a seven-pencil morning." Some of Hemingway's very best work was written in this room. The first two books he wrote there had in fact nothing to do with where they were written. *Death in the Afternoon* (1932) is his homage to bullfighting: in the corrida's theater of bull and matador he found the noble myth of death defeated. His next book, *Green Hills of Africa* (1935), recounts his

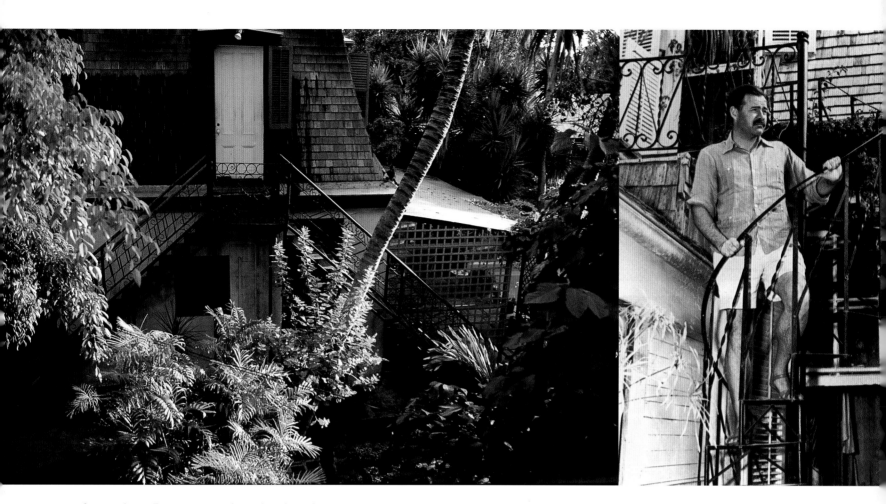

safari exploits. But two years later, his three long Harry Morgan stories, published as *To Have and Have Not*, offer a vivid portrait of smuggling, hurricanes, greed, and murder. (The screenplay of the film version was co-written by William Faulkner.) *For Whom the Bell Tolls* was begun here, and in this room he also wrote some of his most celebrated short stories, including "The Snows of Kilimanjaro" and "The Short Happy Life of Francis Macomber."

Pauline was a fastidious woman. Exquisitely dressed and perfumed, she was often seen on the docks greeting Hemingway's fishing boat, the *Pilar*, after its days at sea, and embracing the grimy author. Her fine taste—she had been an editor at Paris *Vogue* and later began an interior decorating company in Key West—dominated the look of the house. She had shipped from Paris the pieces she had been collecting over the years, Spanish antiques and hand-blown Venetian glass. The long living room, with Pauline's writing desk, a seventeenth-century Spanish chest-on-chest of Circassian walnut, runs the depth of the right side of the house. The hall and dining room are on the left. A heavy Spanish dining table and chairs take up the middle of the narrow room. There is a fireplace and sideboard, and to complement Pauline's delicate Murano-glass chandelier is a mounted wildebeest head contributed by Hem. Behind the dining room is a breakfast room,

where the Hemingways' two young sons, Patrick and Gregory, would have their dinner, out of the sight of company. Beyond is the kitchen.

At the top of the stairs, over the living room, is the master bedroom. Over its huge custom-made bed, its headboard once the gate of an old Spanish monastery, hung Joan Miro's "The Farm." Two small chairs in the room are Spanish antiques, a midwife's chair and a birthing chair. A large Mexican chest, inlaid with ceramic tiles, is nearby. On top of it once stood a small cat sculpture by Picasso, given to Hemingway and his first wife by the artist. The bathroom is large and elegant. The effect of the whole suite is airy. Its walls are mostly windows, and from the veranda, one looks over a green tapestry directly at the Key West lighthouse, as if from the prow of a ship. On the other side of the hallway is the boys' room, and behind it, a small room with fireplace for Ada Stern, their nanny, that was also used as a sewing room when the boys were at school. The bathroom off this room was, at the time, the only working second-floor bathroom in south Florida. Running water didn't come to Key West until 1944, but the Hemingways had a five-hundred-gallon rainwater cistern on the roof, and to complete the luxury-effect Pauline had the floor covered in Art Deco tiles, a stylized pattern of fish and ducks in yellow, black, and white.

LEFT: A view from the house toward Hemingway's writing studio, fashioned by Pauline above the poolhouse. Originally there was an iron walkway that led directly from the balcony off his bedroom to the study door.

RIGHT: Hemingway, c. 1930, standing on the spiral staircase leading up to his studio.

OPPOSITE: From the side balcony off the bedroom, a view of the Key West lighthouse. The lushly planted property, at the time the largest private residence in Key West, included fountains and tropical greenery, its effect quite the opposite of the spare, elegant economy of Hemingway's prose.

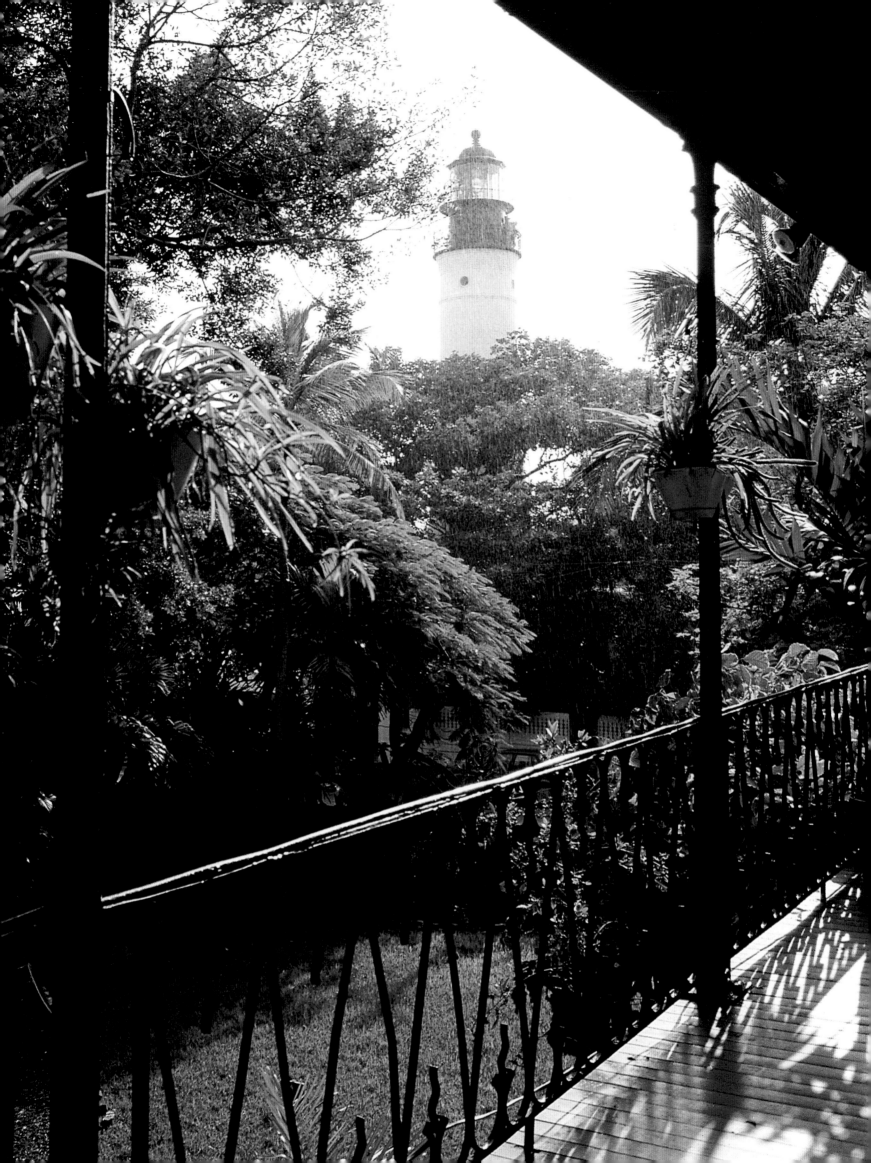

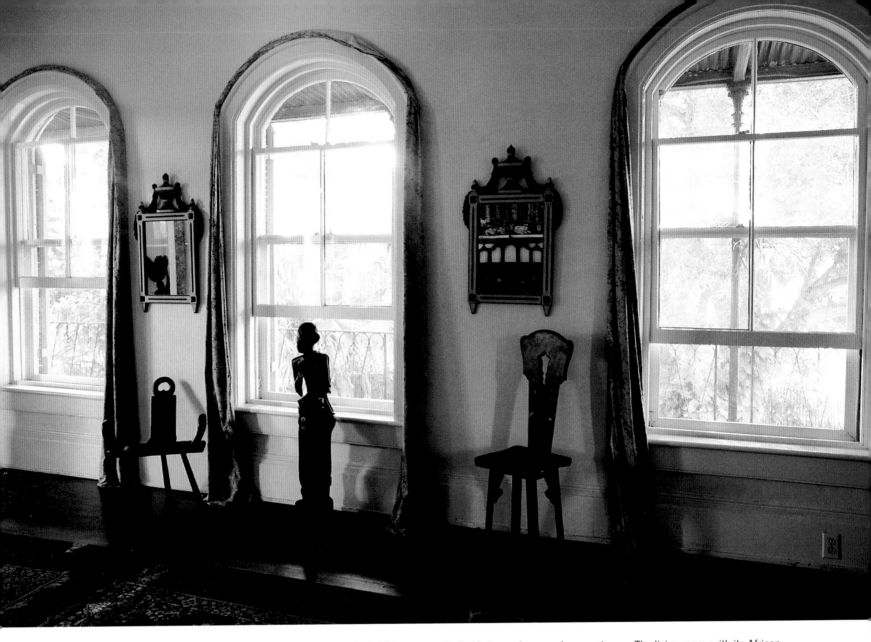

To reach the rear of the house, there is a walkway built with bricks shipped from Baltimore that were used to pave city streets. Hemingway purchased enough of them that in 1935 he had the property enclosed with a brick wall both to protect his privacy and to keep his young sons from roaming. A concrete patio covers the primary rain cistern, and the cat tracks still visible in the concrete come from the famous six-toed cats he kept around the property. At one end of the patio, in fact, is a drinking fountain for the cats. The water flows from the top of a large Spanish olive urn brought from Cuba into what was once a urinal in Sloppy Joe's. For discretion's sake, Pauline had it tiled. In fact, Pauline kept covering over as best she could the widening rifts in their marriage. She kept herself blond and boyish, and threw money at what problems she could. Once, while her husband was in Spain covering the civil war and already infatuated with another woman, she had built adjacent to his writing studio a salt-water swimming pool, the first ever constructed in Key West. The story goes that on his return, astounded by the pool's cost (a whopping

$20,000, two and a half times the purchase price of the house itself), he took a penny out of his pocket and tossed it on the ground, telling Pauline, "you might as well take my last cent." She was clever enough to embed the penny in the cement where it fell, and cover it with glass—not least, perhaps, to remind herself that it was her family's money that had paid for everything.

In the end, of course, the money didn't help. One day late in 1936, sitting in Sloppy Joe's, he spotted a tourist. She was strikingly attractive, with golden hair, high cheekbones, and a husky voice. Her name was Martha Gellhorn. The bartender later said the pair reminded him of beauty and the beast. But that night, Hemingway never went home for dinner. Gellhorn was a novelist and gifted journalist, a friend of Eleanor Roosevelt and H. G. Wells, and when, the next spring, Hemingway shipped out to Spain as a war correspondent, she joined him. For nearly two years, he shuttled between the two women. Certainly his young sons kept him attached to Pauline longer than he would have wished. Finally, in 1939, Gellhorn rented a villa outside

The living room, with its African motifs. In 1933, Hemingway, along with Pauline and their Key West friend Charles Thompson, visited Africa for the first time. It was then he met the legendary Philip Percival, once Theodore Roosevelt's white hunter, who served as the novelist's guide on this and subsequent hunting safaris. The bloodletting sickened Pauline, and dysentery felled Hemingway, but his exuberance and skill were undaunted.

RIGHT: The writing studio. Some years earlier, when he sent a copy of *The Sun Also Rises* to his difficult mother, who didn't care for it, he wrote to her: "I *know* that I am not disgracing you in my writing but rather doing something that some day you will be proud of. . . . You could if you wanted be proud of me sometimes—not for what I do for I have not had much success in doing good—but for my work....You cannot know how it makes me feel for Mother to be ashamed of what I know as sure as you know that there is a God in heaven is *not to be ashamed of*."

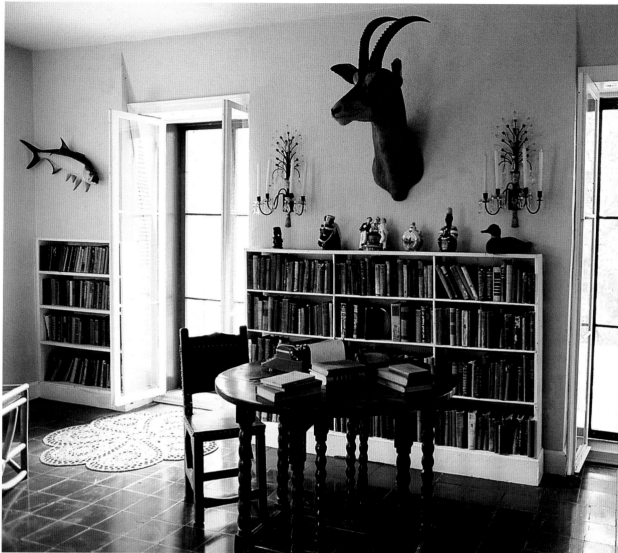

Havana, the Finca Vigía, or Lookout Farm, and Hemingway moved in with her there. The whole while, Pauline wrote him cheerful letters, as if nothing was wrong. But one day, her son Patrick remembered, having joined her husband at a friend's Wyoming ranch, feeling unwell and starting to unpack, she discovered the wax buttons on one of her favorite outfits had melted and run into the fabric. She began to cry. She couldn't stop. Nothing young Patrick tried could console her. She was still weeping when the annoyed Hemingway telephoned to make arrangements to have her and the boys driven back East and for Martha to join him. He and Pauline were divorced on November 4, 1940, two weeks after the publication of *For Whom the Bell Tolls*, which he had dedicated to Martha, whom he married two weeks later.

Hemingway, with his bloated, alcohol-smeared ego, treated all his wives and most of his friends badly. No one measured up, and he had so often to prove his manhood that his motives have been questioned by some. Once, hearing that at a party in Key West the poet Wallace Stevens

had called him a sap, he rushed through the rain to the party and found Stevens just leaving the group. Blows were exchanged and Hemingway knocked the poet into a puddle. Stevens recovered long enough to land a punch on Hemingway's jaw, but in doing so broke his hand in two places. The writers made up the next day, but the anecdote says a good deal about how Hemingway butted against the world to keep his myth of *machismo* polished. The older he got, the fewer friends he had, and the more hangers-on. One of the few constants in his life, however, was his home in Key West. He never sold it and continued to visit. Even after Pauline's death, he brought his fourth wife, Mary Welsh, to visit. In the two decades left him, he never again wrote so well as he had in Key West. His life there had steadied and achieved a balance between work and pleasure. The citation that accompanied the Nobel Prize awarded him in 1954 paid tribute to his "powerful, style-making mastery of the art of modern narration." In the acceptance speech he sent to Stockholm, he spoke of the other side of mastery. "Writing, at its best, is a lonely life."

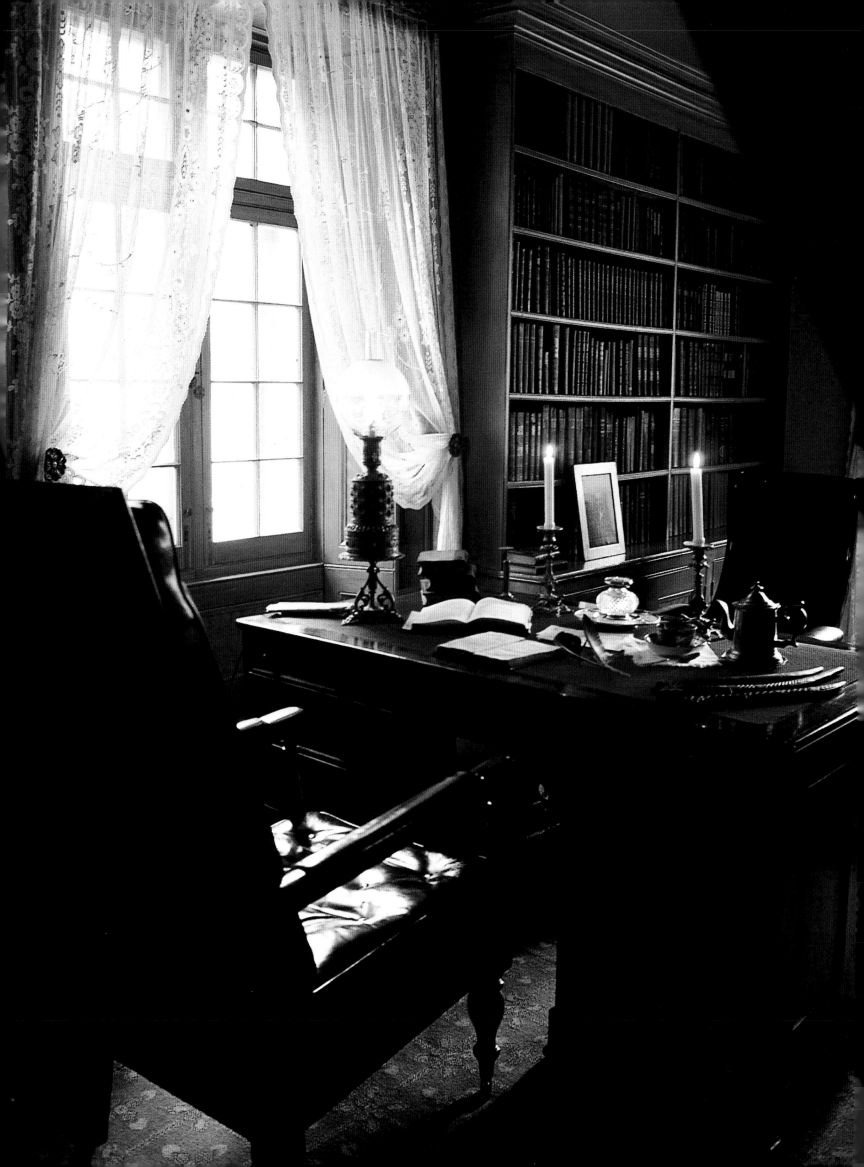

Washington
Irving

1 7 8 3 – 1 8 5 9

OPPOSITE: Irving's study. In the mid-nineteenth century, this room had become a shrine, and engravings of Irving at his desk were popular. The desk had been presented to the "Squire of Sunnyside" in 1856. His nephews, working as his literary assistants, would sit at it opposite him. Irving kept a set of Moorish daggers on the desk, a remembrance of his years in Spain. In 1828, he had written to a friend: "For my part, I know no greater delight than to receive letters; but the replying to them is a grievous tax upon my negligent nature. I sometimes think one of the great blessings we shall enjoy in heaven, will be to receive letters by every post and never be obliged to reply to them."

RIGHT: The writer's desk in his study.

Washington Irving was born in New York City in 1783. That was the year the Treaty of Paris ended America's War of Independence. George Washington resigned as commander-in-chief, the Continental Army was disbanded, and the British evacuated New York. In that same year, the first map of the United States was made, the first American daily newspaper began publication, and Noah Webster finished his influential *American Spelling Book*. The new nation's population was estimated at 2.4 million, and it took Thomas Jefferson five days to travel the ninety miles from Philadelphia to Baltimore.

Irving was named in honor of the great man of the day, and the story goes that, at the age of six, on a walk with his Scottish nanny in Manhattan, he encountered George Washington in a book-shop. The nanny took the child over to the tall, imposing figure and spoke up, "Please, your honor, here's a bairn was named after you." Washington put his hand on the boy's head—this was the same year that he was inaugurated as the country's first president—and wished him well. It proved to be as much an omen as a blessing.

The intellectual life of the fledgling American republic flourished in the years following the Revolutionary War. Joel Barlow's mighty epic poem *The Vision of Columbus* appeared in 1787 and was admired by both Washington and Louis XVI. Artists, writers, inventors, and explorers abounded. But their models were consistently European, and their efforts ignored by their Continental masters. As late as 1820, an English critic could sniff: "In the four quarters of the globe, who reads an American book?" Ironically, it was in that very year that the world sat up and paid attention to an American book. Washington Irving's *The Sketch Book of Geoffrey Crayon, Gent.*, a miscellany of tales and essays, and often considered the origin of

the short story as a genre, was published in both America and England. It was enthusiastically reviewed and widely read. Irving, living at the time in London, was the toast of the town, invited to all the fashionable salons. Everyone, it seemed, wanted to meet the creator of Rip Van Winkle and Ichabod Crane. And so Irving came to be hailed as the first American man of letters.

He was born as the War of Independence ended, and died as the Civil War was about to begin. But it was the War of 1812 that determined the course of his life. He had been the spoiled youngest of eleven children. His father and brothers ran the family importing business, P. & E. Irving, with offices in New York and Liverpool, but when the 1807 embargoes disrupted shipping, business declined, and the war itself then greatly diminished American interest

LEFT: Irving wanted the picturesque landscape that looked untouched by human hands.
BELOW: The photograph of Irving seated in the entryway at Sunnyside was taken in 1856, when he was 73. He had planted the wisteria, then an exotic plant, in the late 1840s, and the benches had been made by Gouverneur Kemble. Irving also had planted, on the east side of the house, English ivy that had been transplanted from Melrose Abbey in Scotland.
OPPOSITE, ABOVE: The front view of Sunnyside, showing both its mélange of architectural styles and later additions to the main house.
OPPOSITE, BELOW: The side piazza, or veranda, where the author and his guests sat to view the majestic Hudson River.
OVERLEAF: The kitchen. Nearly three dozen servants, most of them Irish immigrants, worked at Sunnyside between 1836 and 1860. The full-time employees lived in the house; others worked as day laborers.

in English exports. So in 1815, Irving was sent to England to rescue the family firm and restore its good name. He had been abroad before. Ten years earlier, his brothers, worried about his health and sensitive to his literary refinement, had financed a European tour for him, during which he indulged his passion for history and theater. He had earlier still trained as a lawyer, and was already contributing articles to newspapers. By the time he returned he realized he didn't have the stomach for the law, and was persuaded instead to write a satirical historical guidebook to New York. *A History of New York* by the pseudonymous Diedrich Knickerbocker appeared in 1809, was an instant success, and invented a moniker New Yorkers have been using ever since. During his years in Manhattan, he would visit friends in the Hudson Valley, where as a boy he had learned to hunt for squirrels and tramp through the woods. Years later, he declared his luck in having been born on the banks of the Hudson River, though he meant its wharves, thronged with sailing ships, in lower Manhattan. Still, the river was in his blood from the start, and when he returned in 1832 after seventeen years abroad, it wasn't long before his thoughts drifted back to the Hudson. His years in Europe had been busy ones. He devoured languages and history; he tried his hand at playwriting, and undertook new stories and histories. Spain particularly inspired him, its rich literary heritage as well as its landscape. His *Life and Voyages of Columbus* (1828), *Conquest of Granada* (1829), and *The Alhambra* (1832) all testify to his immersion in

Spanish history and legend. And all the while he held diplomatic posts at American legations, gaining important political experience and connections. Even while abroad, he played a decisive role in American literary history. When in London in 1846 he heard the manuscript of Herman Melville's first novel, *Typee*, read aloud, he helped arrange for its publication, and later he sponsored William Cullen Bryant's collected poems. He persuaded John Jacob Astor to establish the New York Public Library, and in Spain received the young Henry Wadsworth Longfellow, who wrote home to his brother in 1827 that Irving "is one of those men who put you at ease with them in a moment. He makes no ceremony whatever with one—and of course is a very fine man in society—all mirth and good humor. He has a most beautiful countenance—and at the same time a very intellectual one—but he has some halting and hesitating in his conversation—and says very pleasant, agreeable things in a husky—weak—peculiar voice."

By 1831, his literary fame secure, he began hearing rumors from home that he had abandoned his native land. Stung, he sailed back. As if to prove himself, he dined with President Andrew Jackson and his good friend Martin Van Buren, then traveled west to Indian country, hunting buffalo and eating skunk. On his return, Van Buren asked him to serve as an advisor, and he enjoyed another success with *A Tour on the Prairies*. But at the age of fifty-two, plagued by congestive heart problems and asthma, wearying of his restless travels and literary labors, he felt the need to settle down, and once again turned

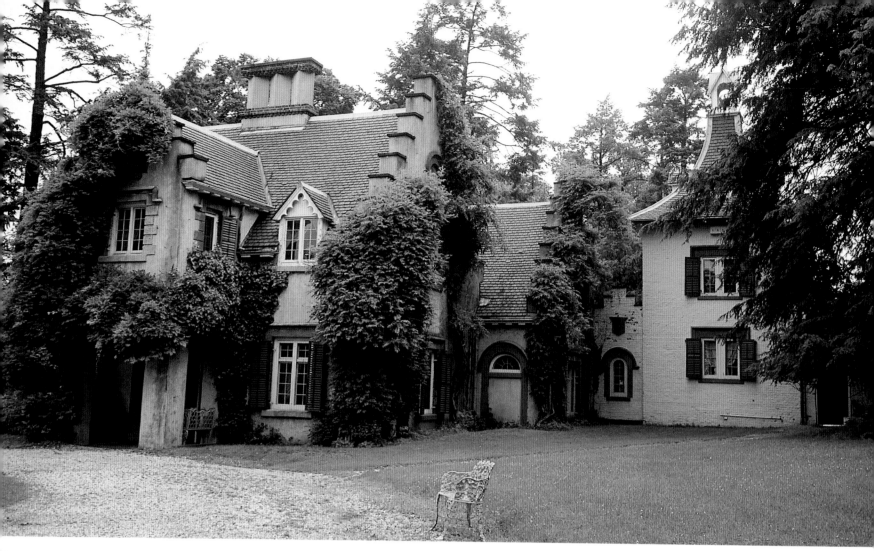

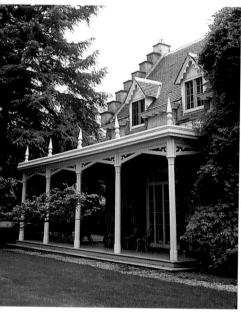

to the Hudson River Valley. "I have always been something of a castle-builder," he had written, "and have found my liveliest pleasures arise from the illusions which fancy has cast over commonplace realities." In 1835, he bought a humble two-room cottage and ten acres in Tarrytown. The house belonged to a wheat farmer named Benson Ferris, and Irving paid him $1,800.

The narrator of "The Legend of Sleepy Hollow" comments playfully on the name Tarry Town: "The name was given, we are told, in former days, by the good housewives of the adjacent country, from the inveterate propensity of their husbands to linger about the village tavern on market days." In fact, Tarrytown derives from the Dutch word for wheat, *tarwe*, and wheat was probably brought there to be sold. A vast corridor along the Hudson, more than 52,000 acres, was planted with wheat at one time, and the cottage Irving bought was one of many tenant farmhouses on what was originally the Philipsburg Manor. "It is a beautiful spot," he wrote, "capable of being made a little paradise." To that end, he hired architect George Harvey, and together they worked up a scheme to transform both the cottage and the land around it. He was spurred to enlarge the house by the fact that his brother Ebenezer, a recent widower with five daughters, asked to move in with Irving.

A lifelong bachelor—it was said he never recovered from the death at seventeen of his fiancée, Matilda Hoffman—Irving relished the idea of presiding over a family.

In one sense, the house, named Sunnyside when he and Harvey had finished with it, resembled the author's own past. It was a congeries of European motifs and pure American whimsy. The chimney is English Tudor, the roof has stepped parapet gables in the Dutch manner, the arch at the front door is Romanesque. There is a Spanish monastic tower (added in 1847), an Italian piazza, and French doors. On the west side of the house, he had a wrought iron date embedded in the stucco: 1656. One supposes it was merely to proclaim his nostalgia. But that too is a part of his romantic temperament. Having been steeped in European romanticism during his long residence abroad, he sought to replicate its mysterious surprises at home. Nowhere can that be better seen than in the grounds of Sunnyside. The native trees—hemlock, sycamore, spruce, horse chestnut—are plentiful, but the advent of the Erie Canal allowed people to order from seed catalogues and to import exotic species. Irving had tulip trees and viburum and even bamboo planted. He moved earth and water: a lawned berm was added for dramatic effect near the house, and farther away, a

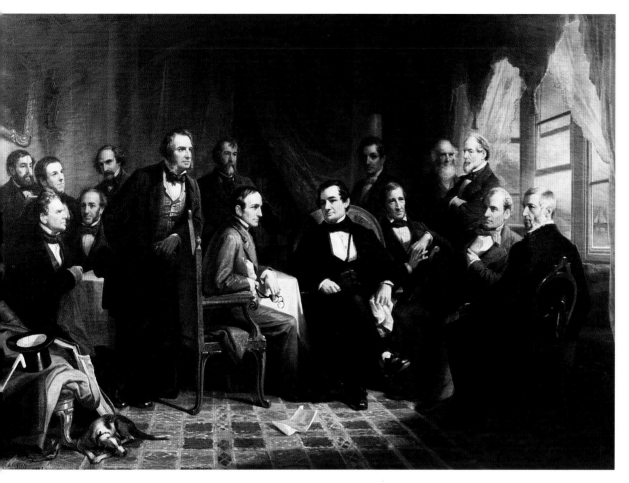

pond was widened and a cascade added. Irving wanted the property to be a series of "outdoor rooms," and as one strolled the grounds, the mottled sunlight on pathways, the shifts of perspective, the sound of streams or wind, a sudden view of the majestic river with its cargo of light or mist, each would have struck the visitor as an instance of Nature's wild sublimity.

The grandest of all views, of course, is that of the Hudson itself. Irving's parlor and dining room, his bedroom—the best rooms in the house—all looked out on the river. On the side piazza, or veranda, he and his guests would sit after a meal, and they could watch the expanse of the Tappan Zee, where the Hudson widens and its currents swirl. What they gazed at in the mid-nineteenth century is best described in "The Legend of Sleepy Hollow," written years before Irving moved to Tarrytown and based on his idealized memories of the area's riverscapes and cloudscapes, but still remarkably precise. A visitor to Sunnyside today, schooled in the luminous paintings of the Hudson Valley School, will see the same.

The wide bosom of the Tappan Zee lay motionless and glassy, excepting that here and there a gentle undulation waved and prolonged the blue shadow of the distant mountain. A few amber clouds floated in the sky, without a breath of air to move them. The horizon was of a fine golden tint, changing gradually into a pure apple green, and from that into the deep blue of the mid-heaven. A slanting ray lingered on the woody crests of the precipices that overhung some parts of the river, giving greater depth to the dark-gray and purple of their rocky sides. A sloop was loitering in the distance, dropping slowly down with the tide, her sail hanging uselessly against the mast; and as the reflection of the sky gleamed along the still water, it seemed as if the vessel was suspended in the air.

It is not difficult to sympathize with Irving's heartache when the first letter arrived from the State of New York, asserting its eminent domain over the narrow strip of land between Sunnyside and the Hudson in order to lay down tracks for a new rail line between New York City and Poughkeepsie. He ignored the first letter. And the second. The third, more threatening, he answered. It had asked what compensation he wanted. In the end, he was paid $3,500, but at the time he said that no sum could make up for what the state was taking away from him. The racket of a steam locomotive now roared through the house on its own schedule; he was forced to move his bedroom from the front of

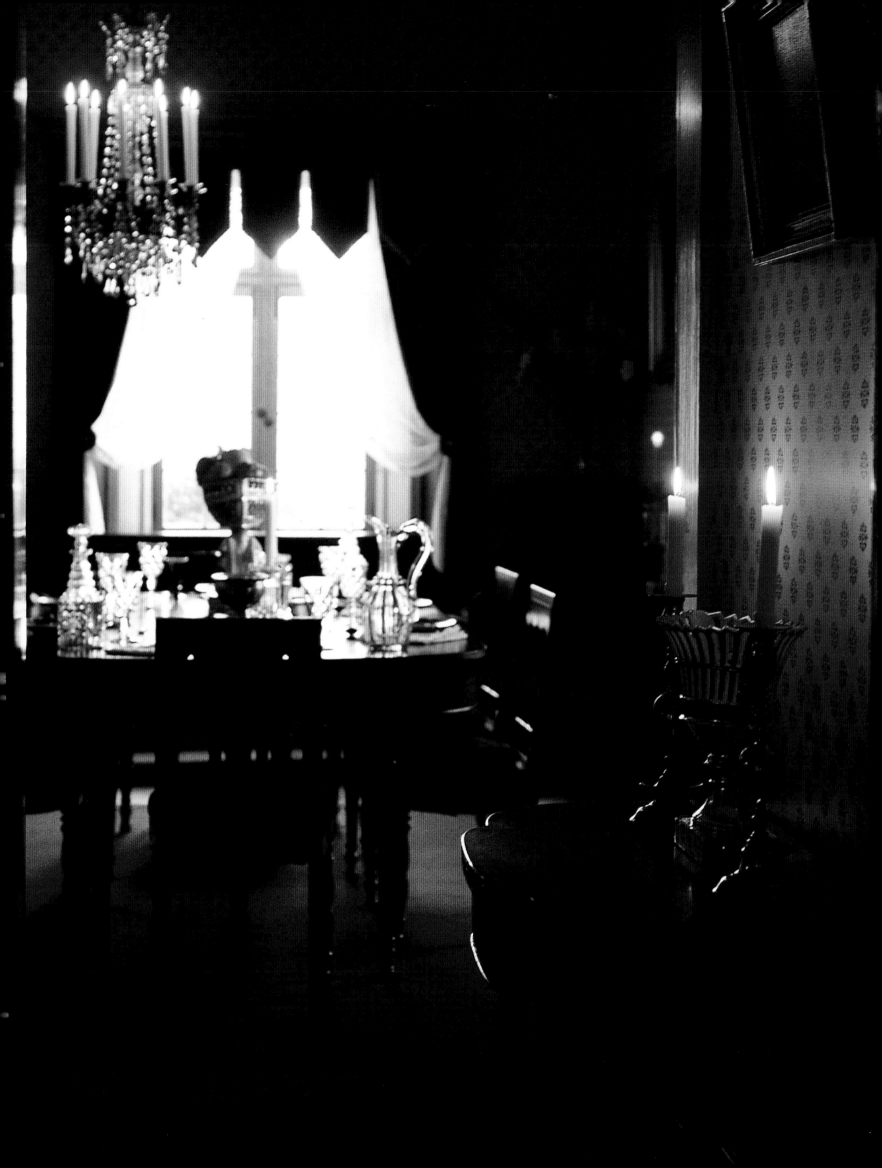

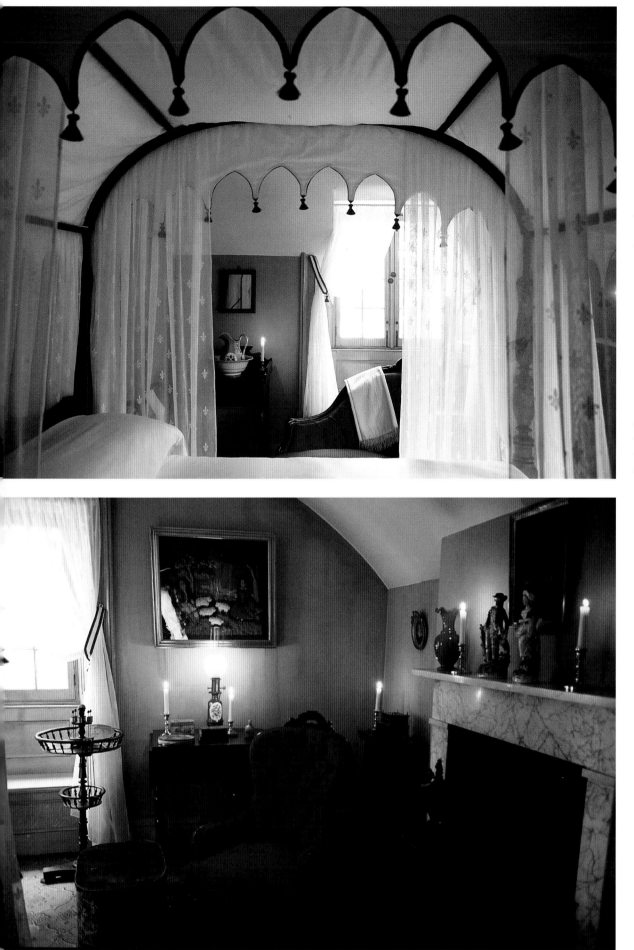

Nieces' room. Catharine and Sarah Irving, two of the five daughters of Irving's brother Ebenezer, served as the female heads of the household for the bachelor writer. "Uncle Wash" adored them. Evidence of their handiwork—crepe and ribbon work, quilting, netting, and berlinwork—is everywhere to be seen in the house. When another niece, Sarah Paris, moved to Europe, Irving was melancholy: "She is especially identified with the cottage and all its concerns, having been in all my councils, when building and furnishing it, and having been the life of the establishment ever since I set it up. How I shall do without her I can not imagine, or how I shall reconcile myself to her entire absence from a place where every path, tree, shrub and flower, is more or less connected with her idea. Thus you see, though a bachelor, I am doomed to experience what parents feel, when their children are widely separated from them by marriage."
OPPOSITE: A guest room.

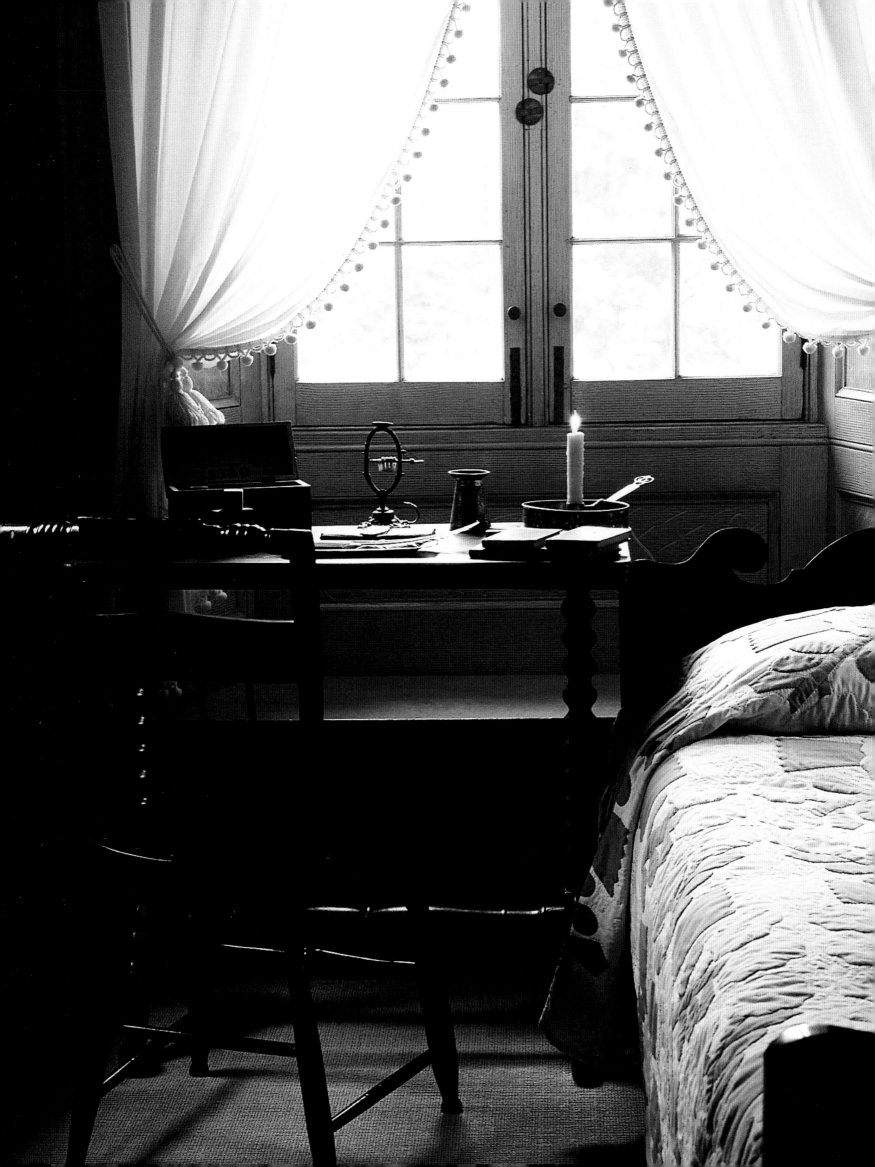

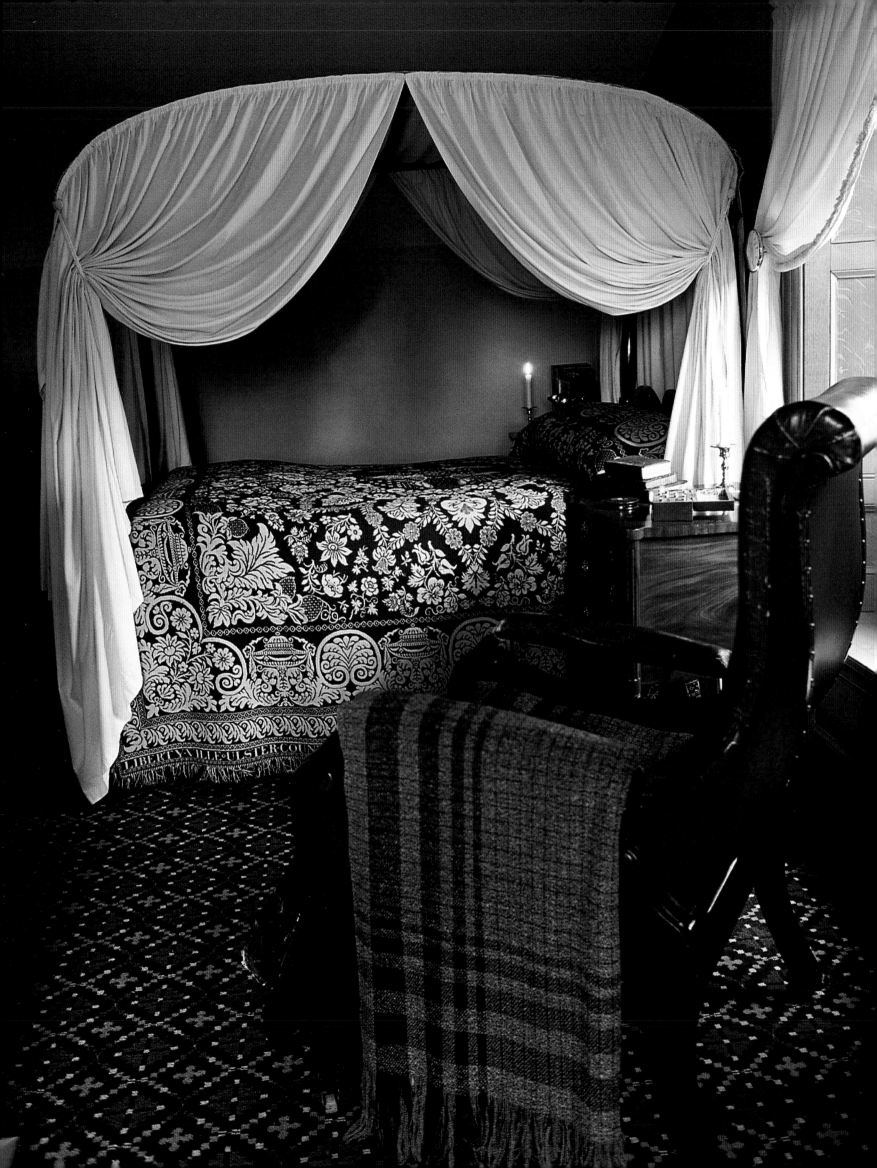

the house to the rear. His nostalgia, "the illusions which fancy has cast over commonplace realities," was forever shattered.

Except for another stay in Spain from 1842 until 1846, when President Tyler appointed him United States minister, Irving lived the last quarter century of his life at Sunnyside. His two nieces, Catharine and Sarah, served as hostesses for "Uncle Wash" while, despite his sometime precarious health, he worked hard to support the household. His masterpiece in those years—bringing his life full circle—was his five-volume *Life of Washington*. The study in which he wrote it is just to the right of the entrance hallway. One visitor called it a "labyrinth of books and manuscripts and tender associations." Irving worked at an oak partners' desk given to him by his publisher, G. P. Putnam. Constantly sipping coffee or tea, he liked to write in the early morning, when the light was better. Here is the heart of the house he called his "little snugglery." There are Cruikshank sketches on the walls, and one of his favorite Voltaire chairs. A book-lined alcove at the rear is where he would sleep if he had to give up his bedroom to guests, or when he had trouble climbing the stairs. Opposite is the formal dining room where the family and their guests would gather at three in the afternoon for their main meal, five or six courses over several hours, during which the river outside would shimmer or doze. The gilded wallpaper, cut-glass chandelier, Gothic Revival chairs, and French porcelain lend the room a stately air. The gentlemen would stay behind here for cigars and political talk while the ladies went on to the rear parlor. Whist or dominoes would be played here, and there is a rosewood pianoforte on castored wheels, so that it could be taken out to the veranda on summer evenings. Farther on is Irving's picture gallery, and a bathroom with a zinc-lined tub. The kitchen, pantries, and laundry, once bustling with Irish maids, are farther back, all with the then latest conveniences, including hot and cold running water and a cast-iron stove.

Upstairs are bedrooms for Ebenezer and the nieces and guest rooms with painted cottage furniture. The striped wallpaper was said to remind Irving of garrets in Paris, and he kept here his books in foreign languages. His own room is dominated by a canopy bed that had belonged to his parents, a Grecian-style wardrobe, and a mechanical chair where he could rest his swelling legs. It was in this room that he died on November 28, 1859. He was preparing for bed, and said to his nephew, "When will this ever end?" Then he clutched his side and sank to the floor. Four years earlier, when he had completed the first two volumes

of his monumental *Life of Washington*, he exclaimed, "If I can only live to finish it, I would be willing to die the next moment." He did finish the book, collapsed almost at once, and never recovered. By then, every honor had been bestowed, and Sunnyside had become, as Oliver Wendell Holmes remarked, "next to Mount Vernon, the best known and most cherished of all the dwellings in our land." Just as his stories helped domesticate for America that kind of English Christmas we now recognize—all peace and good will, mistletoe and St. Nick—so too his writing gained literary respect for his country in England. Back in 1819, declining the offer of a job with the Navy Department and determined to pursue a writing career, he wrote in a letter to his brother, "Should it not succeed—should my writings not acquire critical applause, I am content to throw up the pen and take to any commonplace employment. But if they should succeed it would repay me for a world of care and privation to be placed among the established authors of my country, and to win the affections of my countrymen."

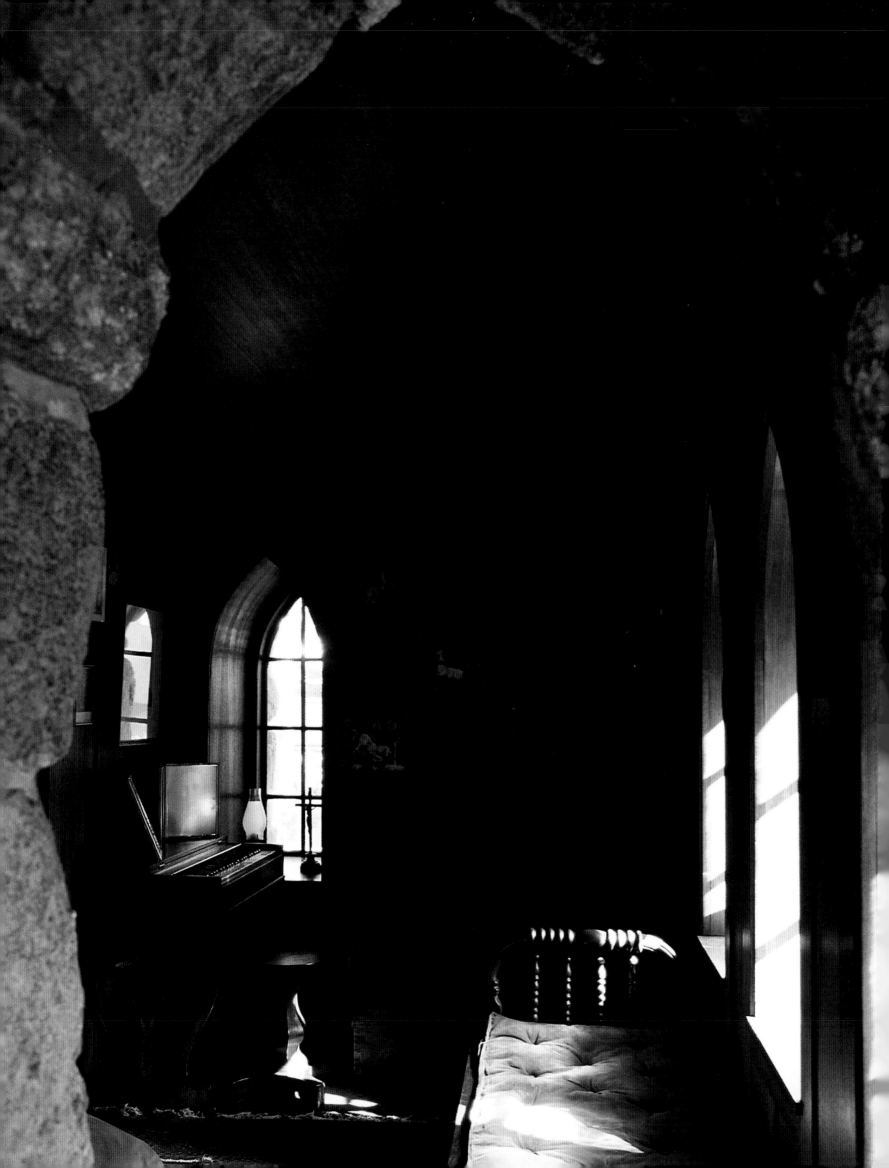

R o b i n s o n
Jeffers

1 8 8 7 – 1 9 6 2

OPPOSITE: A room in Hawk Tower. The tower was modeled in part on Carl Jung's Bollingen in Zurich and on William Butler Yeats's Thoor Ballyllee. Because of its romantic associations, it would seem likely that Jeffers wrote his turbulent, elemental poems in the tower, though in fact he worked in the house, in his upstairs bedroom, at a table that faced away from the ocean. Hawk Tower was entirely Una's domain, and in Jeffers' mind his homage to her devoted spirit.

Robinson Jeffers appeared on the front cover of *Time* magazine on April 4, 1932, at the height of his fame. The photograph shows his handsome, brooding profile above an open shirt and jacket. Many people were intimidated by his stern looks. He spoke little, and in a low, exact voice. One friend found his blue-gray eyes difficult to look into, "for in some unconscious way his eyes look through and beyond one. When it happens, it is fearsome and disturbing because one feels so *alone* afterwards, so stripped. He seems so distant and *apart* from all of us." Once, when called for jury duty in a homicide case, he was rejected by the defense attorney because of the suggestion of cruelty in his countenance. *Remote* rather than *cruel* would be the right description, however. "I have never encountered a man," recalled Loren Eisley, "who, in one brief meeting, left with me so strong an impression that I had been speaking with someone out of time, an oracle who would presently withdraw among the nearby stones and pinewood."

Behind Jeffers, in the *Time* photograph, are a few of the massive granite stones with which he built Tor House. It was a task that had defied both custom and nature, and in the end it gave him not only a home but his true poetic voice. He had always wanted to be a poet, but was a long time finding his way, and his first book of poems, *Flagons and Apples*, published at his own expense in 1912, was fusty and derivative. Then, in 1914, he and his wife, Una, came to Carmel. "When the stagecoach topped the hill from Monterey," he later wrote, "and we looked down through pines and sea-fogs on Carmel Bay, it was evident that we had come without knowing it to our inevitable place." That inevitable place was as much literary as it was physical and spiritual. Five years later, they finally bought land on a bluff facing the sea (it

was originally three-quarters of an acre, to which they added over the years four acres more), and it was there that Jeffers decided to build his own house with his own hands. A local stonemason was hired, and Jeffers apprenticed himself to the man, learning how to haul the stones and place them, how to mix and apply mortar. "As he helped the masons shift and place the wind- and wave-worn" stones gathered from the rocks below and pushed up to the site, Jeffers realized a kinship with the granite, his wife wrote in a letter, "and became aware of strengths in himself unknown before." In that kinship, he discovered primal forces of nature that corresponded to poetic energies he began to tap. His poems turned toward human dramas of violent sexuality and tragic grandeur. *Tamar* (1924) announced his thunder, *Roan Stallion* (1925) and *Cawdor* (1928) echoed it. Eventually—despairing of humankind—he was consumed with still larger concerns for his poems, with what he called "permanent life." Living a life or building a house—these were as nothing, he knew, in the fullness of cosmic time:

> *Before the first man*
> *Here were the stones, the ocean,*
> *the cypresses,*
> *And the pallid region in the stone-rough*
> *dome of fog where the moon*
> *Falls on the wets. Here is reality.*
> *The other is a spectral episode; after*
> *the inquisitive animal's*
> *Amusements are quiet: the dark glory.*

He even came to advocate what he called "inhumanism," which he defined as "a shifting of emphasis from man to not-man; the rejection of human solipsism and recognition of the trans-human magnificence." As one poem says, "Humanity is the mould to break away from, the

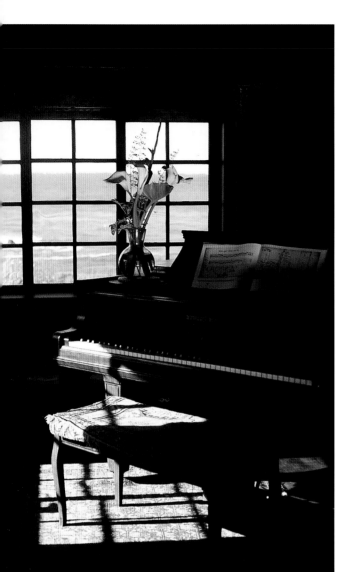

too, about a married woman he met first in 1906—Una Call Kuster—whom he sensed was his soulmate. It took seven years of desperate separations and legal difficulties before the couple could be married. Though their marriage was to be tested by his infidelities and her violent jealousies (she once attempted suicide to secure his loyalty), it persisted as the basis of the poet's life and work. "My nature is cold and undiscriminating," Jeffers once wrote, "she excited and focussed it, gave it eyes and nerves and sympathies. . . . She is more like a woman in a Scotch ballad, passionate, untamed and rather heroic,—or like a falcon—than like an ordinary person."

Before he and Una moved to Carmel, the spot had attracted other writers. Robert Louis Stevenson had lived there for a time (and is said to have taken details from the beaches at

crust to / break through." He had turned from Romantic poet to thundering prophet, and his emblem was the hawk:

> . . . *bright power, dark peace;*
> *Fierce consciousness joined with final*
> *Disinterestedness;*
>
> *Life with calm death; the falcon's*
> *Realist eyes and act*
> *Married to the massive*
>
> *Mysticism of stone,*
> *Which failure cannot cast down*
> *Nor success make proud.*

Despite their implacability, these are the words of a passionate man. Jeffers was passionate for literature and learning; he was educated in Switzerland and Germany, and after graduating from Occidental College at the age of seventeen, pursued graduate studies in Old English and German, then enrolled in medical school, and later in forestry school. And he was passionate,

Carmel for *Treasure Island*), as had Jack London (who built a house there, which almost immediately burned down), and in Jeffers's time there was a colony of artists. But Jeffers—supported by a small trust fund left by his father—kept himself isolated as much as possible, a part of and alone with the elements of nature around him. By his own account, Jeffers said that for the first time in his life "I could see people living—amid magnificent unspoiled scenery—essentially as they did in the Idyls or the Sagas, or in Homer's Ithaca. Here was life

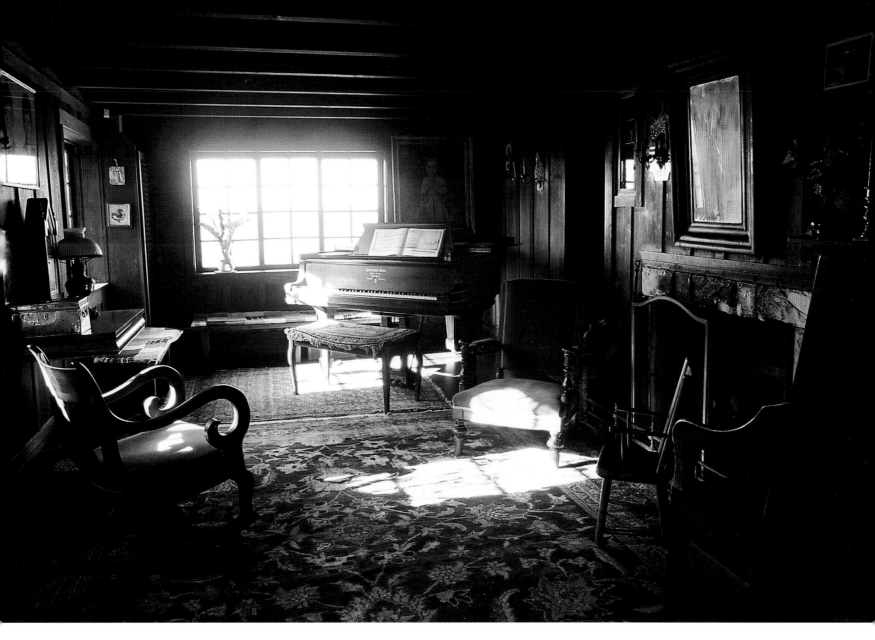

ABOVE: The living room at Tor House. The room was paneled with redwood and fir, much of it smoke-darkened by the constant use of the fireplace, the only source of heat. Writer Stewart Brand once noted, "Tor House is a poem-like masterpiece. It may express more direct intelligence per square inch than any other house in America."

purged of its ephemeral accretions. Men were riding after cattle, or plowing the headland, hovered by white sea-gulls, as they have done for thousands of years, and will for thousands of years to come." The house he and his wife, along with their twin sons, Garth and Donnan, moved into had running water, but it wasn't heated. The family all took baths on Saturdays, with pots of hot water carried to the tub from the stove. But there was no electricity, gas, or telephone. The routine was unvarying. The entire family slept in an upstairs loft, and it was here too—his back to any view of the Pacific—that Jeffers wrote every morning. After a big hot lunch, he would work on the house and grounds. Over time he planted some two thousand trees on the property—eucalyptus, Monterey pine, and cypress. And he continued to extend the house, first building a garage (storms blew its roof off at once, and he realized he needed to use buttresses), a large dining room, the start of a second house, and, most famously, Hawk Tower. As he worked—and it was hard and exacting work, three or four large

stones a day was progress—Una tended the garden she kept in the house's courtyard. As Anglophiles, they preferred a wild garden, with old-style roses and fragrant plants like lavender, rosemary, and scented geraniums. After supper, when the boys had been sent up to bed, Una and Robin (as he was called) would sit in their parlor reading poetry and sipping their home-made orange wine.

As one would expect in a house abutting a storm-wracked ocean and heated by one fireplace, the rooms in Tor House are snug. The sitting room is paneled with smoke-darkened red-wood and fir, its floors covered in worn kilims. The fireplace is of locally quarried sandstone. The room is dominated by a Steinway piano, and on its walls hang a portrait of Una as a child, family portraits, icons, and an old map of Ireland. The effect is of the Craftsman-style house already common in Carmel at the time. Here their guests included Edna St. Vincent Millay, Dylan Thomas, Sinclair Lewis, Langston Hughes, George Gershwin, Martha Graham, and Charles Lindbergh. In an alcove is a desk for

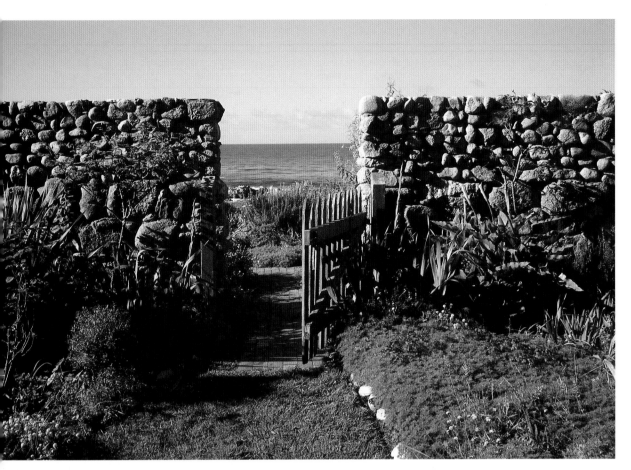

LEFT: The gate to the sea from the herb garden at the rear of the house. "There is in me," he once wrote, "older and harder than life and more impartial, the eye that watched before there was an ocean." And addressing the sea, he says of that eye that it "watched you fill your beds out of the condensation of thin vapor and . . . saw you soft and violent wear your boundaries down, eat rock, shift places with the continents."
BELOW: Robinson Jeffers and poet Edna St. Vincent Millay in front of Hawk Tower, 1930.
OPPOSITE: At one end of the living room was a nook for Una. This is her desk, with its portrait of her favorite poet, William Butler Yeats.
OVERLEAF: The Great Room, added to the house in 1930, and intended to serve as both a dining room and a room in which entertainments could be arranged. To that end, there is a small musicians' loft and a wind-up Victrola.

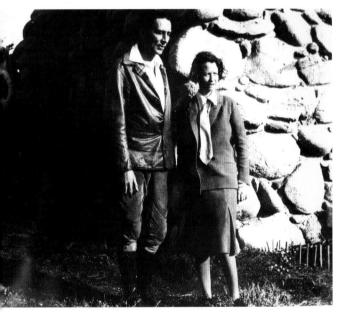

Una, near which is a photograph of her favorite poet, William Butler Yeats. The kitchen has a kerosene stove and cooling cabinets. On the bathroom door is painted *Prest d'Accomplir* (Quick about your business), and many other cabinet doors in the house have texts painted on them, usually medieval poems. There is a great dining room, used for entertaining, that Jeffers added on in 1930. It is an open, inviting room with a broad sea-window, a musician's loft, and articles as vivid as a spinning wheel

and a narwhal tusk. At its peak, embedded in the wall, is a stone from the Great Pyramid of Cheops. One other room deserves mention—the small guest bedroom off the parlor. There is a simple bureau, a chair and cradle, and a large bed with a turned-wood bedstead. The window is placed so that a reclining head can view the coastline out to Point Lobos, the fogbank and the restless waters beyond. When guests were not staying there, Robin and Una would some-times make love on the bed before retiring upstairs to join their already sleeping sons. But the room was deliberately meant for a darker purpose. The bed was always intended as a deathbed, and, in fact, Una died there in the poet's arms on September 1, 1950. A dozen years later Jeffers died in the same bed. On the beam above the bed are painted lines from Edmund Spenser's *The Fairie Queen*: "Sleepe after toyle, port after stormie seas, / Ease after warre, death after life, does greatly please."

Almost more famous than the house itself is the forty-foot tower Jeffers built next to it. He began construction in 1919, finished five years later, and called it Hawk Tower. Towers have always had a romantic appeal, and modern writers Jeffers admired such as Jung and Yeats had built them. Jeffers' fascination with medieval literature and heroic tales must also have inspired him. But it was finally to be his monu-ment to Una. Many people think Jeffers wrote his

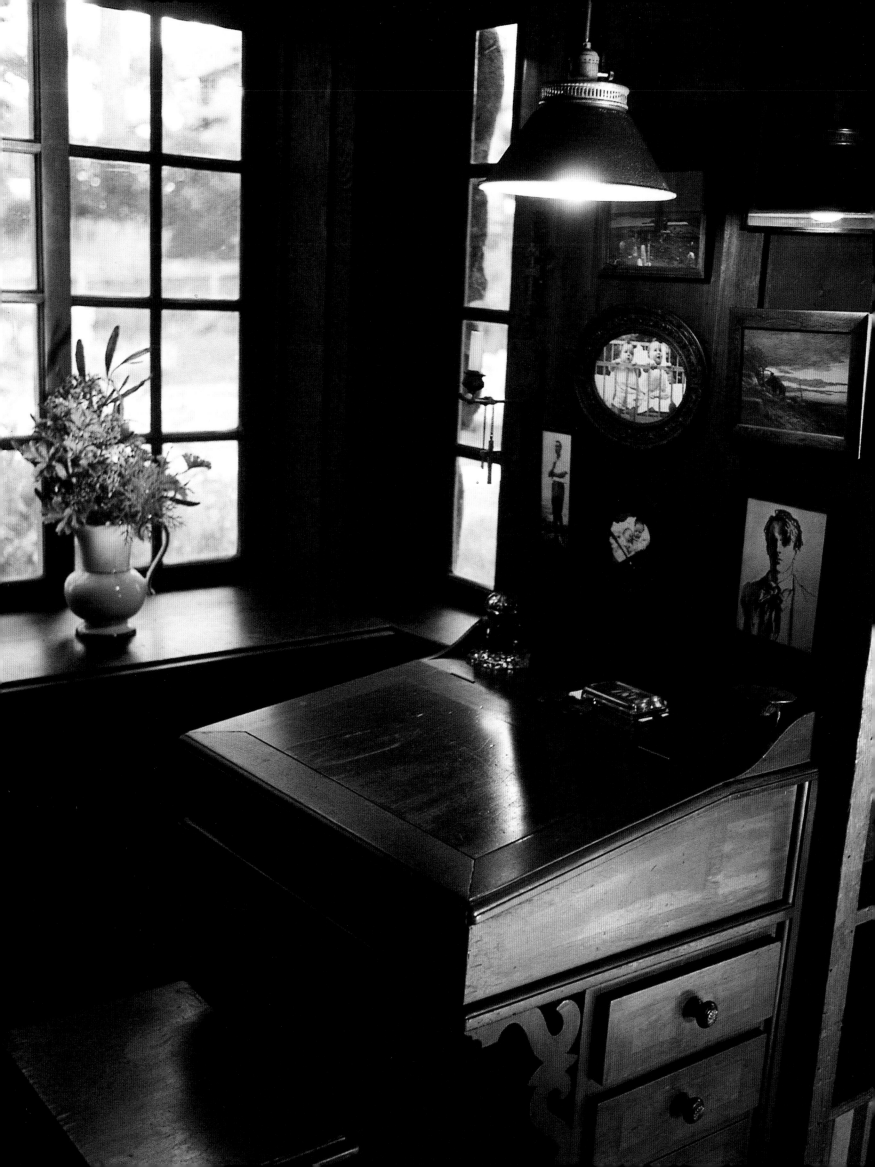

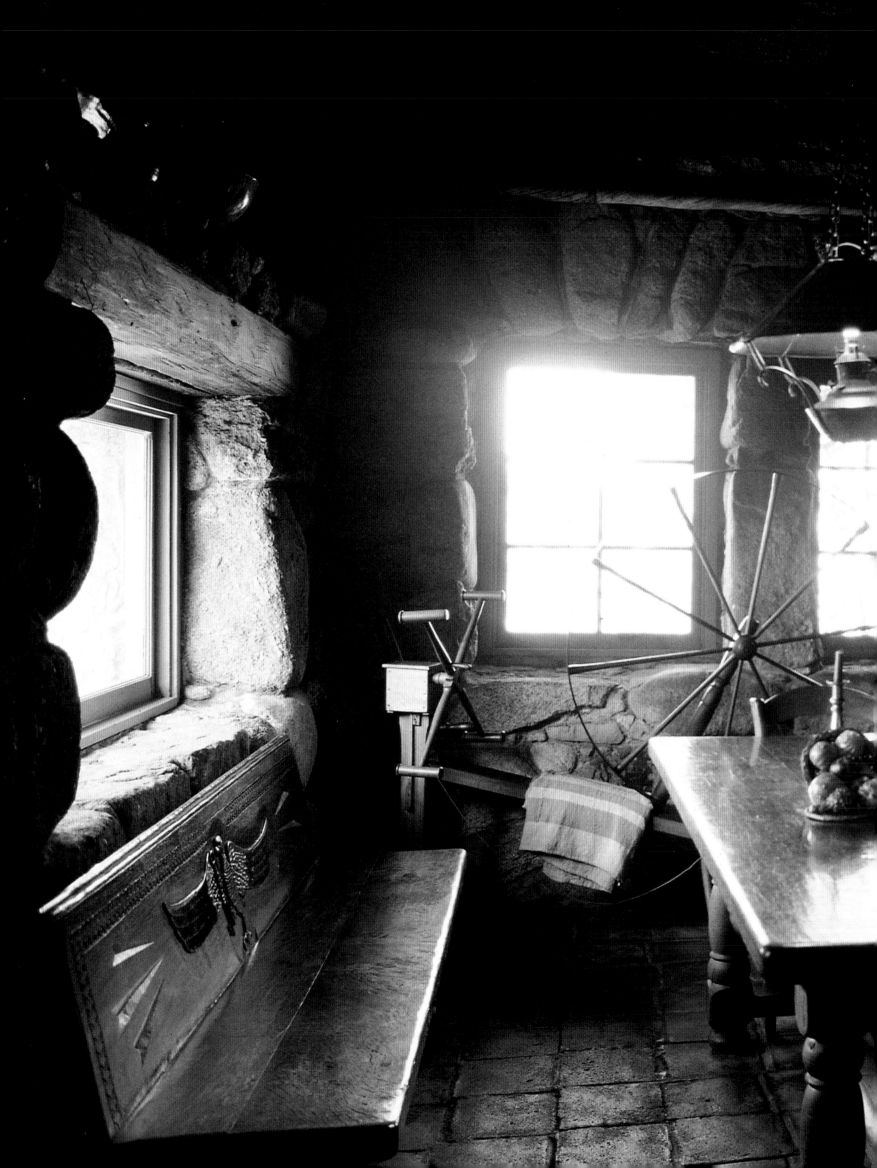

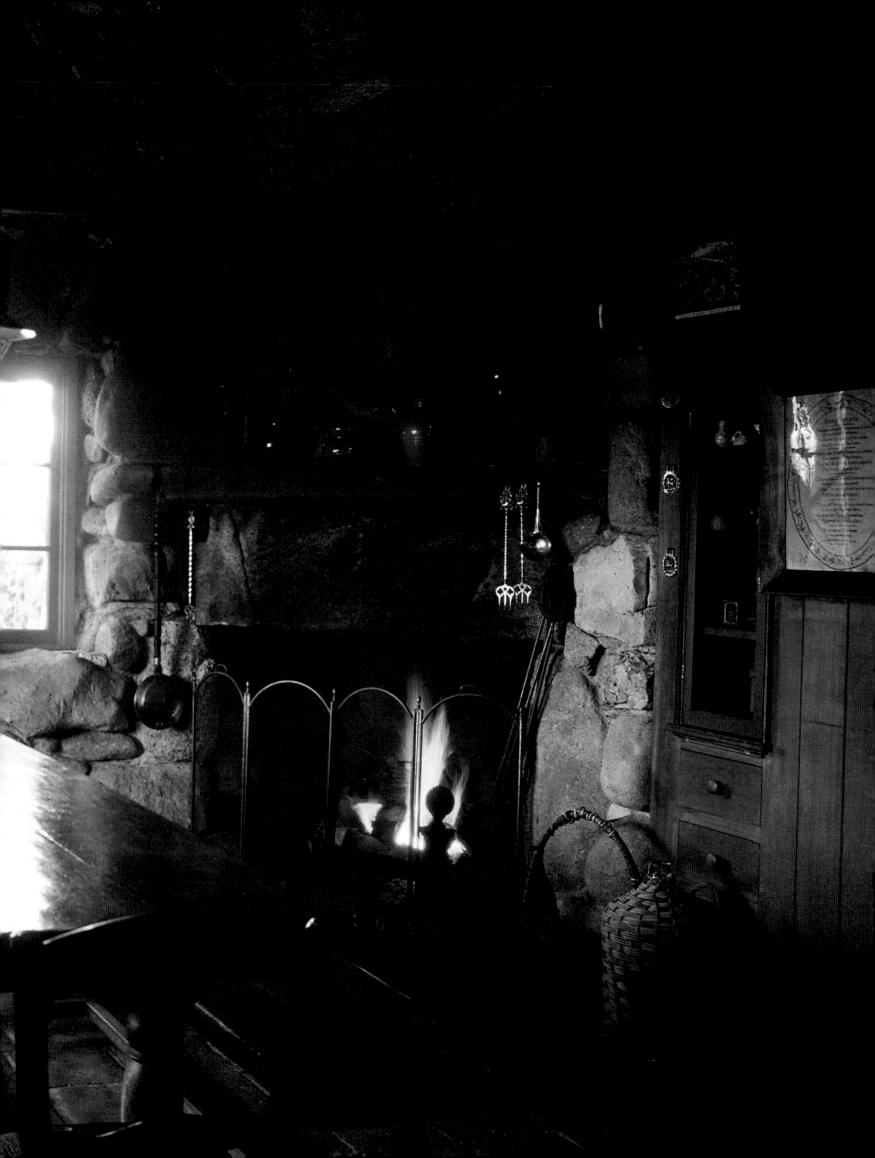

by wheelbarrow, by sheer brute force, Jeffers brought stone after stone up from the ocean to raise his tower. The third floor is an open platform, with marble paving and a surrounding battlement, reached by a staircase lighted by an inset porthole from the ship in which Napoleon fled Elba. From there one climbs to the open turret another story up—from which one gazes at sea or stars.

"Tor" is an old Celtic word for rock outcropping, and clearly Jeffers wanted his tower to be a part of the landscape. Yet it literally aspires. Some of the rocks Jeffers used weigh nearly four-hundred pounds, and the rugged monumentality of Hawk Tower is immediately apparent. It is a homage to permanent things as well as a shelter for the fleeting . . . the visible embodiment of his work as a poet:

> *For man will be blotted out, the blithe*
> *earth die, the brave sun*
> *Die blind and blacken to the heart:*
> *Yet stones have stood for a thousand*
> *years, and pained thoughts found*
> *The honey of peace in old poems.*

But as in his poems, there are delicate memories embedded among the stone of both Tor House and Hawk Tower. As he mortared the stones into place, he would often set between them an object gathered from afar. Fossils and arrowheads, stones from Angkor Wat or Lord Byron's Newstead Abbey or Cecil Rhodes's tomb in Rhodesia, pebbles from the beach below King Arthur's castle at Tintagel, a Chinese statue and Italian tiles, bits of meteorites, lava from Kilauea and Vesuvius, a part of the Great Wall of China, a fragment from Yeats's Thor Ballylee.

As he grew older, Jeffers was increasingly pessimistic and bitter; his work soured. Puzzled or discomfited, readers fell away. Jeffers paid no mind. For him, poetry was "a beautiful work of nature, like an eagle or a high sunrise. You owe it no duty. If you like it, listen to it; if not, let it alone." Failure or success, pain or happiness were all the same to him. To the end, he stood like a massive stone, rooted to his place, defiant, indifferent, one with the elements:

> *My ghost you needn't look for; it*
> *is probably*
> *Here, but a dark one, deep in the granite,*
> *not dancing on wind*
> *With the mad wings and the day moon.*

poems in the tower, but it was always intended as a retreat for Una. There is a sunken "dungeon" and a small ground-floor room, but the second-floor room, paneled in mahogany, with an oriel and Gothic-arched windows and secret stairway, was the study where she would read and write. Near her desk are dried leaves from Shelley's grave, a melodeon, and Edward Weston's dramatic 1929 photograph of her husband. Carved into a stone in her room is a line of Virgil: *Ipsi sibi somnia fingunt* (they make their own dreams for themselves). They do, they do. Hawk Tower was a dream. Pictures of the Unicorn Tapestry in Una's room suggest it represented a vision of noble innocence, of detached irreality, of idealized love. In any case, dedicated in devotion to her, the tower continued to rise: citadel, belfry, beacon light. By inclined plane and pulley system,

Views inside and outside of Hawk Tower. The structure was as much symbolic as practical. Jeffers and Una placed emblems of female power around the tower: in one niche, an antique doll of an Indian woman in a black velvet dress; in another, a Babylonian tile inscribed in cuneiform with a prayer to the goddess Ishtar.

OPPOSITE: Una's desk in Hawk Tower, overseen by a portrait of her husband. After her death, the poet was almost inconsolable. He tried alcohol to still his grief—a bottle of whiskey a day and three gallons of wine a week. He tried poems. "Una has died," says one, "and I / Am left waiting for death, like a leafless tree / Waiting for the roots to rot and the trunk to fall."

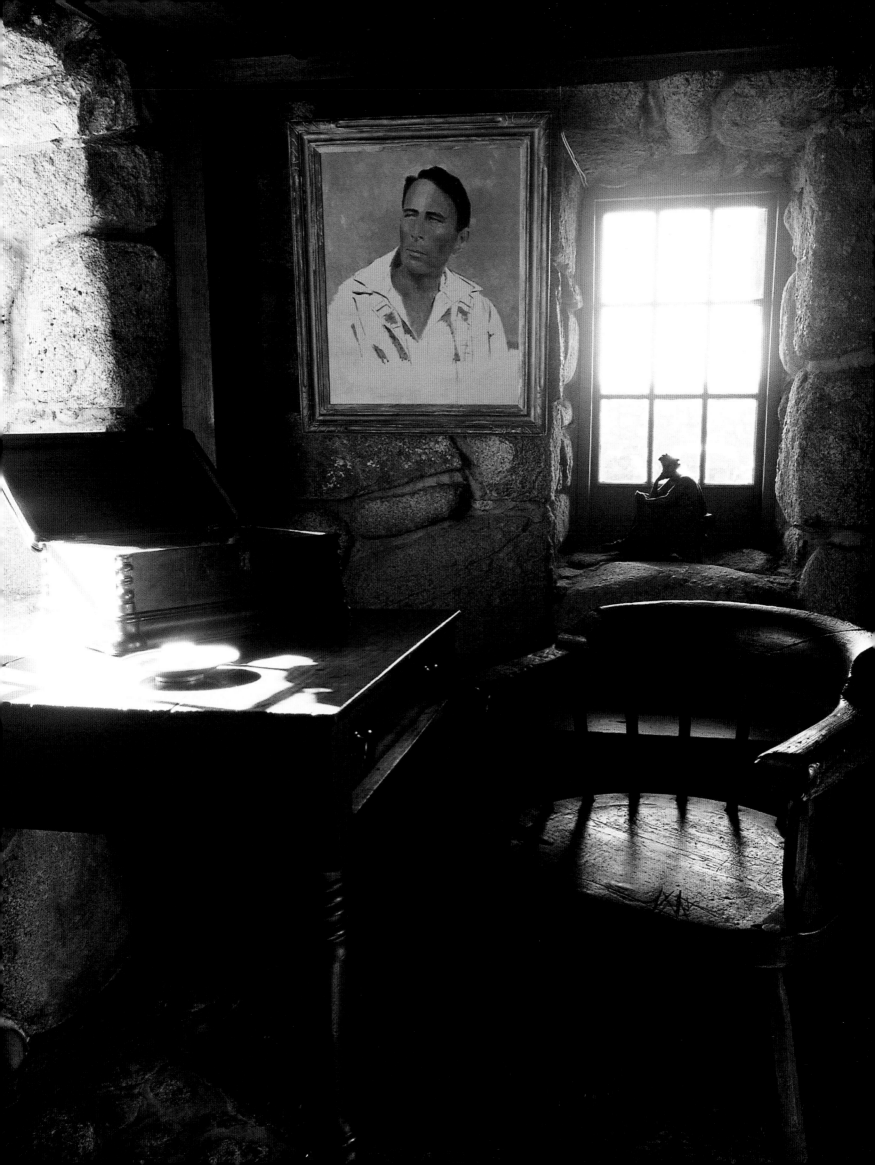

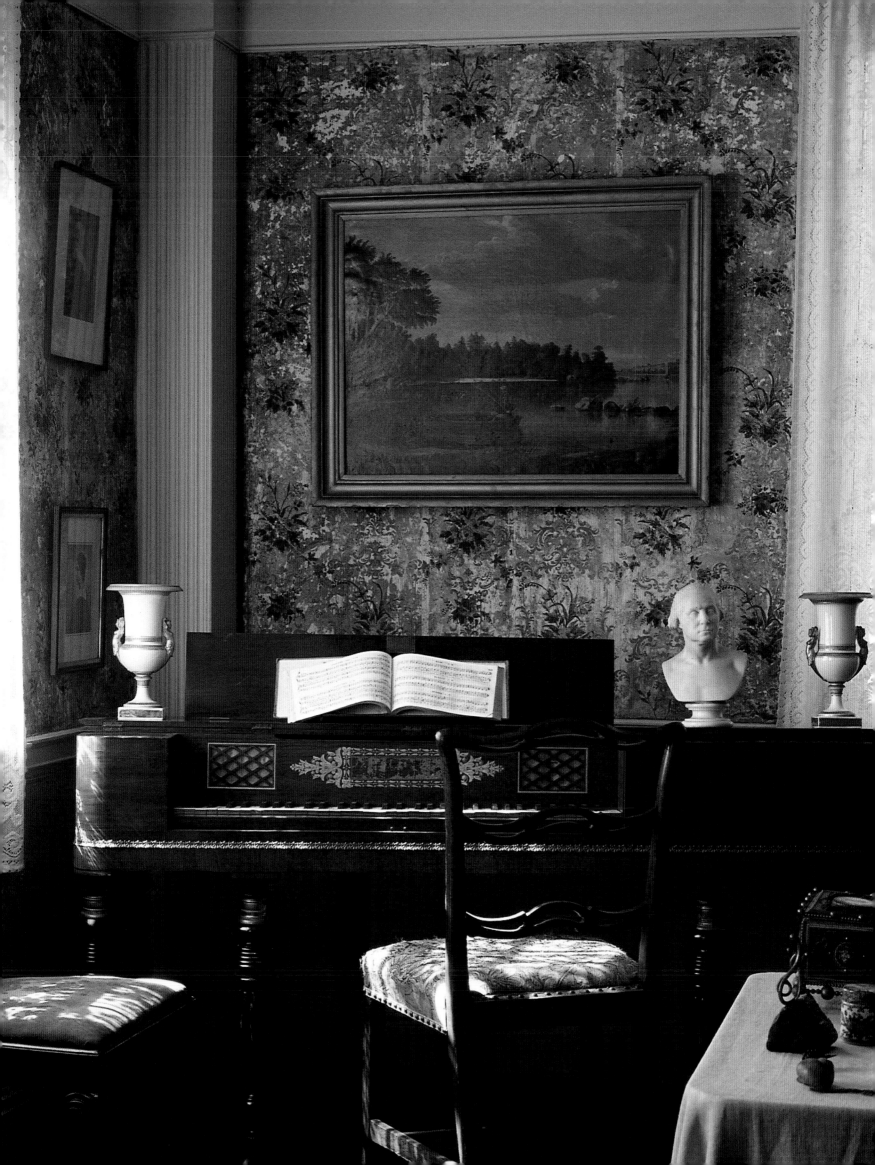

Sarah Orne Jewett

1849 – 1909

OPPOSITE: The parlor and its spinet. Jewett once spoke with an inquiring reporter about her love for her South Berwick home, "I was born here and I hope to die here leaving the lilac bushes still green, and all the chairs in their places." Having been for so many generations in the family, the house was a treasure chest of objects and styles. The flocked wallpaper, made in France, was hung in the 1780s.

RIGHT: The elegant Jewett House, originally called the Haggins Mansion, built in 1774 in Maine.

Sarah Orne Jewett was born and died in this house, but it was known as The Jewett House before her time. Her grandfather, Captain Theodore Furber Jewett, had bought the house in 1834. Born in 1787, he had run away from home as a boy, and went to sea in whaling ships. He later fought the English, was captured and imprisoned in Dartmoor prison. After the War of 1812, he became a ship owner and a prosperous merchant—and bought the grandest house in town. The house itself, known then as the Haggins Mansion, had been built in 1774 by John "Tilly" Haggins, a member of the so-called River Society, wealthy gentry who built grand houses in the area around the Piscataqua, the river that marks the border of Maine and New Hampshire. A local legend had it that three ship's carpenters took one hundred days to build the house. Whatever the truth of that, the detail outside and inside is evidence of highly skilled labor. Fluted columns, carved balusters, dentelated cornices, delicate newel posts, and paneled wainscoting—the craftsmanship everywhere is exquisite. And when Captain Jewett took possession, he embellished the house further with French tapestries and wallpaper (some of it flocked with mica) and exotic souvenirs from his travels. Cabinets of fine china, highboys and carpets, leather-bound books and Adams mirrors gave the house a comfortable provincial grandeur. When Sarah Orne Jewett, named for her paternal grandmother, was born, it was occupied by her parents and older sister Mary, her father's brother William, her grandfather and his third wife, plus her great-grandfather. Within a year, her father decided to build a smaller house for his family in the garden of the "great house," and the four of them—soon joined by a third daughter, Caroline, born in 1855—moved across the lawn. The result was a sort of family compound.

As a girl, Jewett was both active and sickly. She was fascinated by the natural world and explored the nearby woods, collecting mice and turtles and insects. She enjoyed skating and sledding, long walks, and horseback rides. The landscape of her childhood was picturesque. The Piscataqua ("river of right angles") led to Newichawannock Falls ("my place of wigwams") and to Quampeagan ("great fishing place"), and one could hear the echo of waterfalls in the village. Beyond were distant mountains, fields strewn with wildflowers, sprawling pine forests. While her sister Mary, two years older, excelled in school, Jewett was only an average student. And the arthritis that afflicted her even as a child—and later plagued her adult life—often kept her away from class. But that turned out to be time better spent than at a desk. Jewett was taken by her father on his rounds.

Theodore Herman Jewett was a doctor of genuine renown. He had graduated from Bowdoin and took his medical degree in 1839 from Jefferson Medical College in Philadelphia. He married a doctor's daughter (herself descended from the Gilmans, a famous New England family), and at his father's urging established a rural

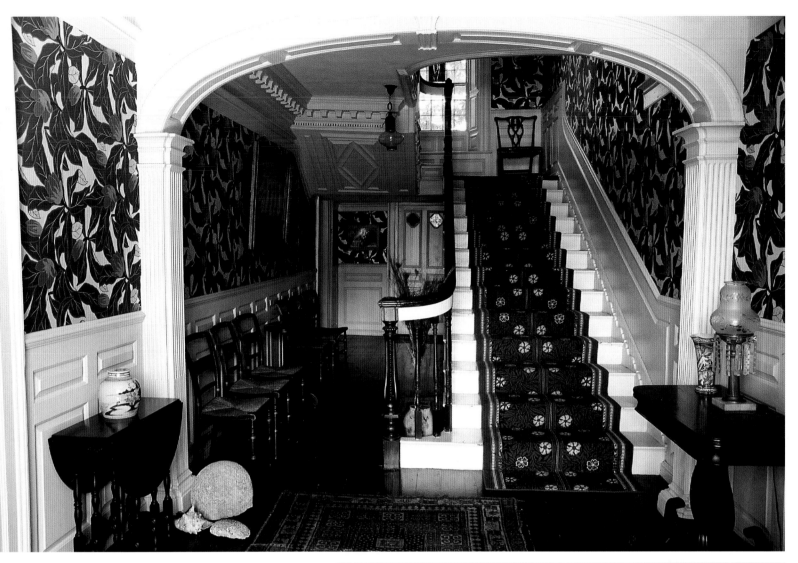

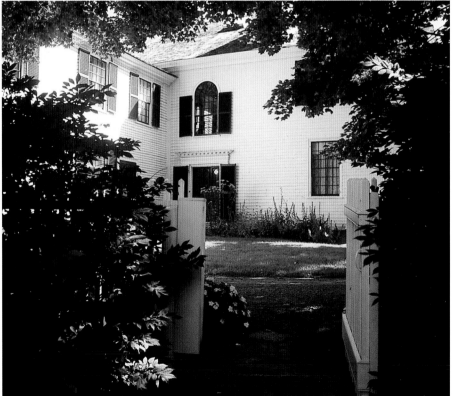

practice in South Berwick. He was later a professor of obstetrics at Bowdoin and published in national medical journals. Jewett adored her father. Her 1881 collection of sketches called *Country By-Ways* is dedicated to "my dear father; my dear friend; the best and wisest man I ever knew; who taught me many lessons and showed me many things as we went together along the Country By-Ways." He encouraged her writing and her curiosity, and above all, as they visited the homes of his patients, he introduced her to the whole range of social life in Maine, an experience that fired her imagination and informed the precise realism with which she later wrote. He also took his family to cities—Cincinnati, Boston—and gave them a taste for cosmopolitan pleasures and brought young Sarah books. "In my youthful appetite for knowledge," she later recalled, "I could even in the driest find something vital, and in the more entertaining I was completely lost." Before long, she was imitating what she had read, and in 1868, her first story appeared in print, signed "A. C. Eliot." A year later, William Dean Howells, then assistant editor of the *Atlantic Monthly*, accepted a story.

OPPOSITE, ABOVE: The entrance hallway. Its spacious dimensions and considerable staircase attest to the wealth of its owners. In her novel *Deephaven*, Jewett describes it: ". . . the lower hall is very fine, with an archway dividing it, and panelings of all sorts, and a great door at each end, through which the lilacs in front and the pensioner plum trees in the garden are seen exchanging bows and gestures." The Palladian window on the upper landing is an unusual effect.

OPPOSITE, BELOW: The rear of the house and the entrance to the gardens. Jewett and her sister Mary were avid gardeners, and would sometimes dine under the honeysuckle-covered trellised archway.

RIGHT: The secretary in the upstairs hallway, by the center window overlooking the town, where Jewett kept up with her correspondence. A letter to her friend Sara Norton, for instance, ends, "I have been busy enough since I came home, chiefly here at the old desk. There are a great many birds already, robins and song-sparrows have all come, but there are some old snow-drifts sitting round on the hills to keep watch."

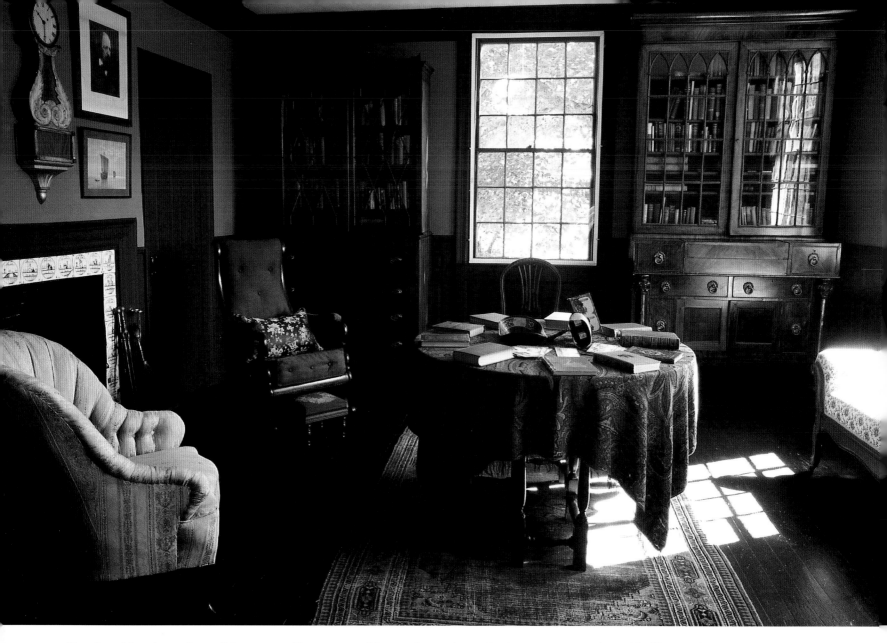

Her sister Mary, her only confidante, urged her to tell the family of her success, and once she had, Sarah regretted the decision: "I wish with all my heart I had never told any body; it seems as if it no longer belonged *all to me*."

The end of the Civil War hastened many changes in rural Maine. The railroads and increasing industrialization brought both immigrants and summer people. Jewett's distress strengthened her resolve to write about what was disappearing or too easily overlooked.

Her first novel, *Deephaven* (1877), does just that. Essentially a suite of sketches, it depicts two young girls, visitors from Boston, who arrive at a relative's house in Maine and discover over the course of a summer the area's rocky coast and fishermen's cottages, lighthouse keepers and bayberry patches, along with a series of vivid characters drawn with a naturalist's sure hand. She wanted, she explained, "to see that there is deep and true sentiment and loyalty and tenderness and courtesy and patience—where at first sight there is only roughness and coarseness and something to be ridiculed."

The stories and novels she wrote over the next twenty-five years testify to her commitment, and she found those virtues in the midst of difficult circumstances—the plight of poor Irish immigrants, the cost of shady welfare practices, and the pollution caused by factories and sawmills. She fastened over her desk two sentences by Gustave Flaubert. One advised "write the life of ordinary people as if you were writing history," and the other was "not to make your reader laugh or cry or become angry but, like nature, to make him dream." Her dreamiest idyll, and best-known novel, is *The Country of the Pointed Firs* (1896). Rudyard Kipling wrote to Jewett: "It's immense—it is the very life. So many of the people of lesser sympathy have missed the lovely New England landscape, and the genuine New England nature." He added, "I don't believe even you know how good the work is." Willa Cather went further, when she claimed that the three American novels destined for literary immortality were *The Scarlet Letter*, *Huckleberry Finn*, and *The Country of the Pointed Firs*. Set in fictional Dunnet Landing—a

The library with its center table, matching bookcases, and tiled fireplace. The walls are painted a Pompeian red. From the start, Jewett's father encouraged her reading. The woman in the portrait (opposite, above) is Jewett herself.

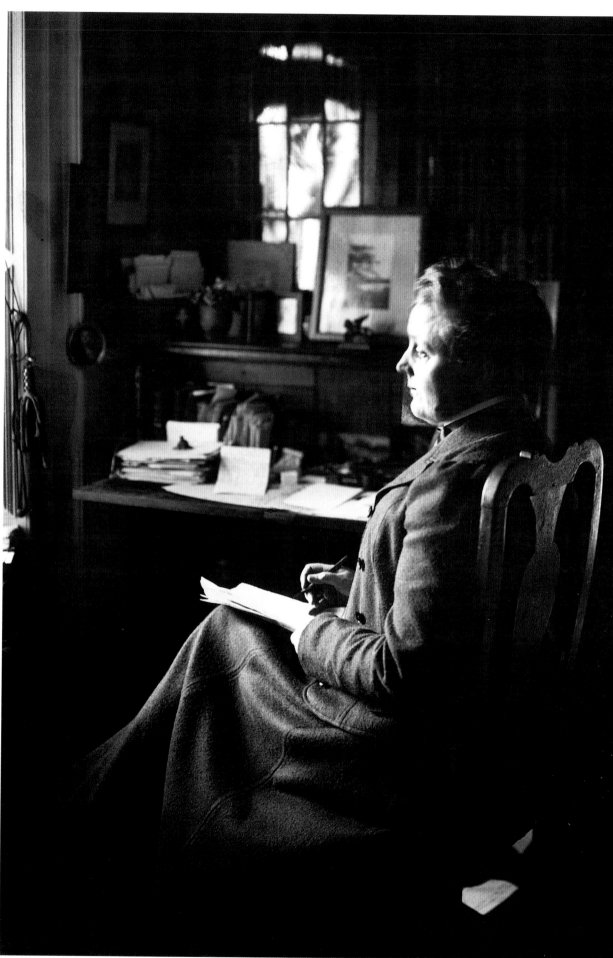

RIGHT: Jewett at her desk. A part of the writing process, she acknowledged, was unconscious. "What a wonderful kind of chemistry it is that evolves all the details of a story and writes them presently in one flash of time! Who does it? For I grow more and more sure that I don't!" And sometimes the business end of writing annoyed her. She wrote to her friend Annie Fields, "I wonder if in heaven our best thoughts—poet's thoughts, especially—will not be flowers, somehow or some sort of beautiful live things that stand about and grow, and don't have to be chaffered over and bought and sold."

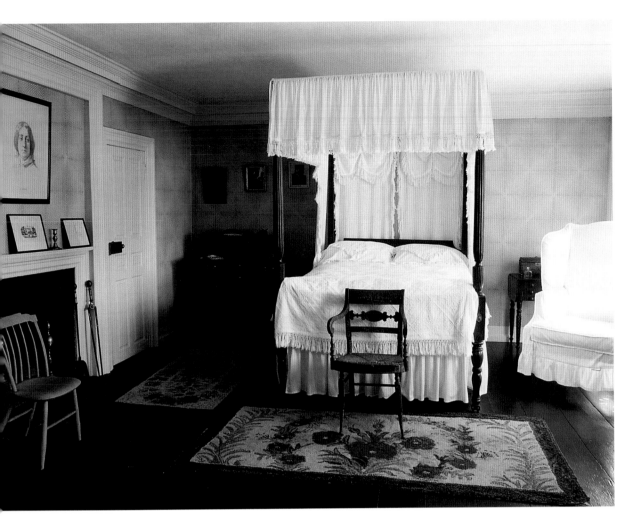

LEFT: The guest room in the Jewett house.
ABOVE: Sarah Orne Jewett standing next to her sister, Mary Rice Jewett, c. 1870.
BELOW: Mary's bedroom at the front of the house.
OPPOSITE: A view out the window of the guest room. The teacup is by Jewett's friend Celia Thaxter. Known for her writings of the sea and the New Hampshire coast, especially *Among the Isles of Shoals*, she also produced sketches and watercolors, and specialized in painting on china.

composite of coastal towns in Maine around Boothbay Harbor she had visited and studied—the story is again about an outsider's deepening understanding of a close-knit community with its own history and legends. This time, though, Jewett created characters of almost mythic dimensions, especially Almira Todd, landlady and herbalist, a huge, strong woman, fiercely independent. The skill with which Jewett handles local idiom is masterful. Here, for instance, an old sailor named Elijah Tilley is explaining to the narrator why a lobster smack has been drifting offshore: "Boy got kind o' drowsy steerin' of her; Monroe he hove him right overboard; 'wake now fast enough." And the great Bowden family reunion—a moving celebration of a New England sense of inheritance and tradition—dramatizes how "clannishness is an instinct of the heart." Throughout this short novel are portraits—old Mrs. Blackett on Green Island, the lovelorn Joanna on barren Sheep-heap Island—of men and women isolated with their memories, in a land at once harsh and captivating.

In 1887, following the death of their uncle William, who had inherited it from his father, Sarah and Mary moved back into the "great house" as mistresses of the home in which they had been born. The changes they made were small, but the look of the grand central hallway is a curious mixture of eighteenth-century antiques and, with its magnolia-patterned Morris wallpaper, Arts and Crafts decor.

There are four large rooms downstairs. At the front of the house, on the right, is the library, painted Pompeian red, with its tiled fireplace and matching bookcases. (It was said that in order to sit down anywhere in the Jewett household, you had to remove a pile of books from the chair.) On the walls are keepsake photographs of writers whom Jewett esteemed:

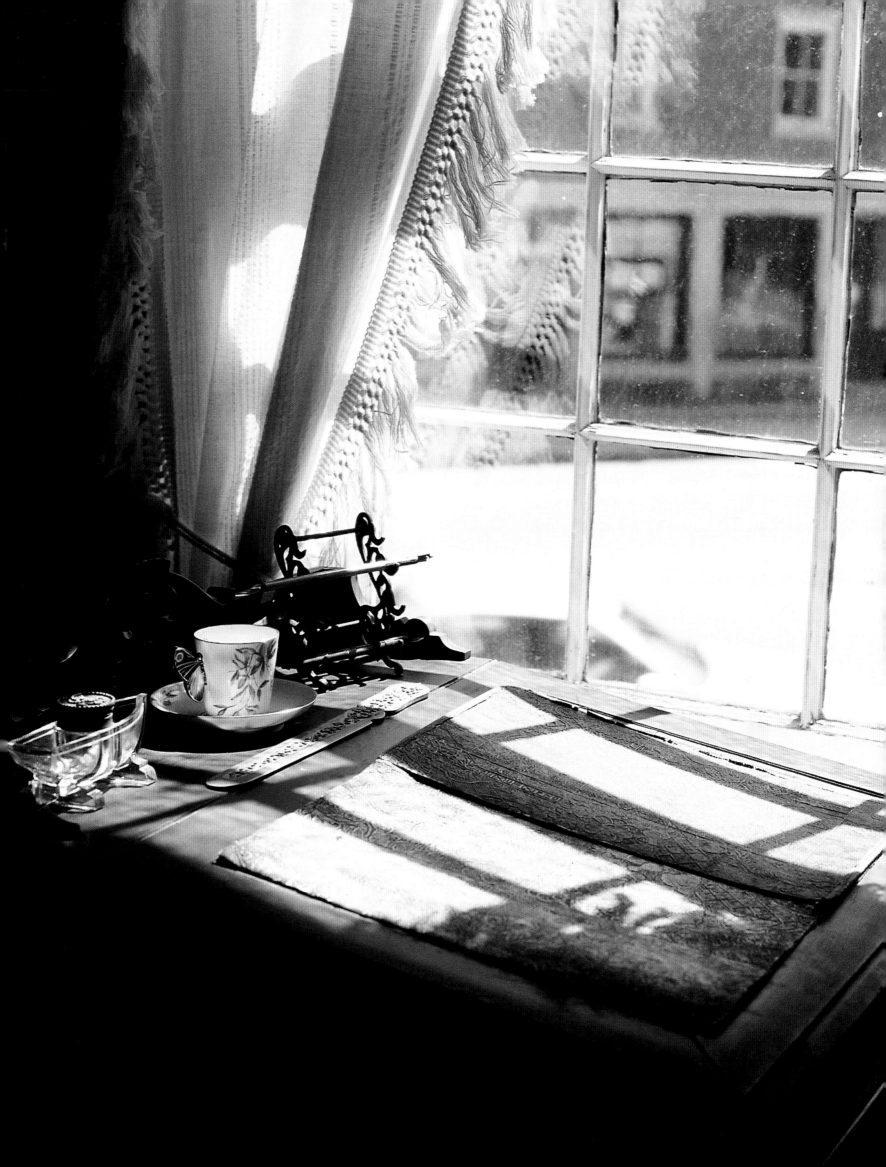

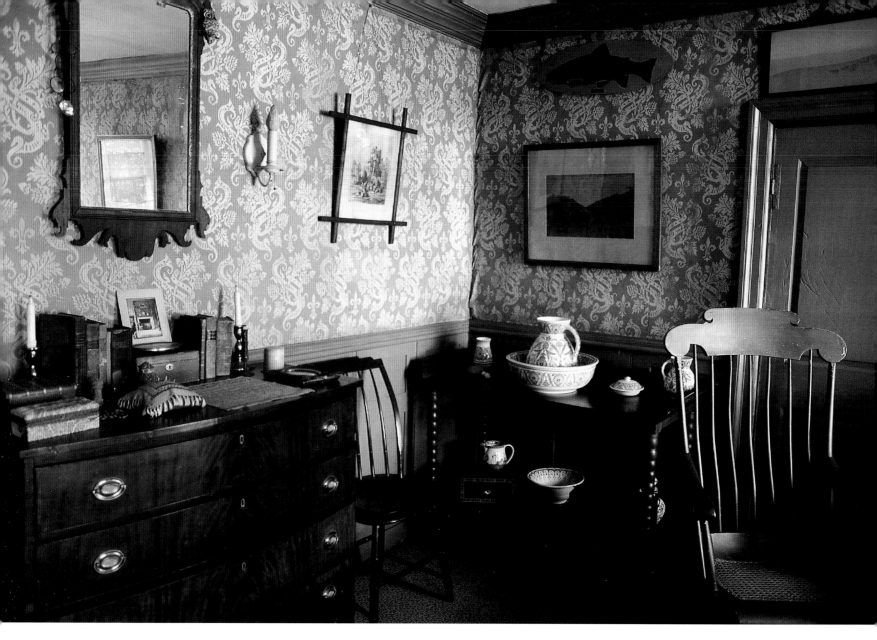

Ralph Waldo Emerson and Henry Wadsworth Longfellow, Mark Twain and Henry James and Charles Dickens. Opposite is the parlor, with its decorative 1840s wallpaper and spinet. Again, *Deephaven* catches the feel of the room, what a family of sea captains and naturalists might collect:

> *There was a large cabinet holding all the small curiosities and knick-knacks there seemed to be no other place for;—odd china figures and cups and vases, unaccountable Chinese carvings and exquisite corals and sea-shells, minerals and Swiss wood-work, and articles of vertu from the South Seas. Underneath were stored boxes of letters and old magazines; for this was one of the houses where nothing seems to have been thrown away.*

Between the parlor and the dining room is a small hallway with facing china closets, stocked with what she called "a power of china." (Grandfather Jewett had four wives, each presumably preferring a different pattern.) On the walls of the handsome dining room are portraits of Dr. Jewett's brothers and several engravings, including a Nicolas Poussin, a Claude Lorraine, and a spirited portrait of Benjamin Franklin at the Court of France in 1778. The house's original kitchen was used by the sisters as a breakfast room, a much larger kitchen having been added on in earlier years. Above it were quarters for Jewett's two Irish maids, and at the rear of the house there were stables, ornamental gardens, and land that stretched far back through the village.

Mary's bedroom is at the front of the upstairs, and it shows her taste for Colonial revival. A large guest room is opposite, and toward the rear the room of their nephew, Theodore Eastman. (His parents died when he was eighteen, and his aunts, who doted on him, took him in. He too became a doctor, and his medical bag, his golf clubs, and his school pennants are still kept in the room.) All of these rooms give onto a large hallway, with engravings of Webster, Washington, and Kossuth, and dominated by a large secretary at which Jewett

OPPOSITE AND RIGHT: Three views of
Jewett's bedroom. Much the
smallest of all the primary
bedrooms in the house, it was
tucked away at the rear—a sort of
retreat. Ill health kept her confined
to bed for much of the time in her
last years, but she had always
preferred to write fiction there in
any case. A small cup attached to
the wall above her bed held pens
and pencils, along with a bell to
summon a servant for help. From
her bed, she could look out the
window at her childhood home,
and ahead to the fireplace, on the
mantel over which she kept
pictures of her mother and of her
beloved Annie Fields.

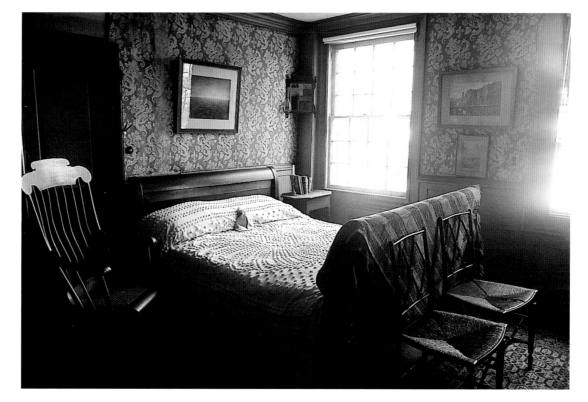

would write, looking out over the front of the
house and into the center of South Berwick.
Her own bedroom, smaller than the others,
was tucked into the rear of the second floor. It
is half-paneled, the wood taken from the pew
boxes of a demolished church. By the bed are
a bell to ring for servants and a cup attached to
the wall to hold her chewed pens. In a corner
is a small desk at which she made fair copies of
what she had written in bed. Over the tiled
fireplace are crossed arrows and riding crops,
a chalice, a child's stirrup, an ornamental oil
lamp, a conch shell, a picture of her mother—
a small shrine, in other words, of fetishes and
mementos. The last seven years of her life she
spent a good deal of time in bed, and the view
from her window as she lay there was of her
childhood home across the lawn. On September
3, 1902, her fifty-third birthday, she was out for
a carriage ride with friends. The horse slipped
on a loose stone and Jewett was thrown out of
the carriage over the horse's head. The injuries
to her head and spine were severe; bouts of
vertigo necessitated complete inactivity, and
Jewett was never really able to write again. She
could write letters and with a cane would try
"walking zig-zag" and swaying about in her
garden, but she was unable to sit at a desk.

As she lay in bed, the picture on her mantel
that stared back at her day and night was of
Annie Fields. After her father, the love of Jewett's
life was Annie Fields, sixteen years her senior
and the widow of Jewett's first publisher, the
distinguished James Fields. Jewett and Fields
grew particularly close after the death of James

in 1881 and thereafter spent most of their time
together, in South Berwick, in Fields' Boston
home, where Jewett was introduced to a wide
circle of luminaries, or on long trips abroad. They
were inseparable and were thought of as a cou-
ple. Throughout her life, Jewett had had passion-
ate friendships with other women, but it is idle to
speculate on their erotic nature, or on the exact
terms of the "Boston marriage" she and Annie
Fields cultivated over many years. Jewett craved
figures of authority; she wanted affection and
security, encouragement and companionship—
none of them certain in a conventional marriage.
Her fiction is filled with examples of female char-
acters in search of the freedom to live independ-
ently. Above all Jewett cherished friendship, and
her intimates included Celia Thaxter, Sarah
Wyman Whitman, Sara Norton, John Greenleaf
Whittier, and the young Willa Cather, to whom
she became a literary mentor. She once advised
Cather to find "your own quiet centre of life,
and write from that to the world that holds
offices, and all society, all Bohemia; the city, the
country—in short, you must write to the human
heart, the great consciousness that all humanity
goes to make up. Otherwise what might be
strength in a writer is only crudeness, and what
might be insight is only observation."

A series of strokes left her paralyzed but still
witty. A month before she died, she wrote to
Fields, "Dear, I do not know what to do with me!"
She is buried in the Portland Street Cemetery,
close to her home, and beside her parents and
sisters. On her tombstone is carved: *Until the
day breaks, & the shadows flee away.*

Henry Wadsworth Longfellow

1807 – 1882

OPPOSITE: The blue entry hallway at Craigie House. During his frequent travels in Europe, Longfellow accumulated a great deal of the art—paintings, prints, busts, *objets*—he used to adorn the public rooms of his home, reflecting both the romanticized classicism of his taste and the diversity of his interests.

Once when the poet Henry Wadsworth Longfellow was in England in 1868 to receive an honorary degree from Cambridge, Queen Victoria invited him to tea. She was a great admirer of his work, and found his company delightful. The visit was a success. She then accompanied the poet to the door, watched him walk down the long castle corridor, and she witnessed something slightly disconcerting. "I noticed," she confided to her diary that night, "an unusual interest among the attendants and servants. I could scarcely credit that they so generally understood who he was. When he took leave, they concealed themselves in places from which they could get a good look at him as he passed. I have since inquired among them, and am surprised and pleased to find that many of his poems are familiar to them. No other distinguished person has come here that has excited so peculiar an interest." Monarch and manservant, coolie and carpetbagger, the whole world read Longfellow. He outsold Browning and Tennyson. In the White House, Lincoln asked to have Longfellow's poems recited to him, and wept. When the emperor of Brazil made a state visit to America, his only request was to have dinner with the great bard. The poet's seventieth birthday, in 1877, was a day of national celebration, commemorated by parading schoolchildren around the country. It was proclaimed on that day that "there is no man living for whom there is so universal a feeling of love and gratitude, and no man who ever wore so great a fame so gently and simply."

In part because of his celebrity, but mostly because for generations his family had been great keepers of diaries, letters, and ledgers, we know more about Longfellow than about nearly any other American literary figure. For almost any day of his life, we know what he ate and wore, what he did and who visited. The arc of his career, from its modest beginnings in Maine to his worldwide fame, can be traced in detail, which makes his achievement at once more obvious and more mysterious. His first poem appeared in the *Portland Gazette* at the age of fourteen, and as an undergraduate at Bowdoin College (one of his classmates was Nathaniel Hawthorne) he wrote to his father, "I most eagerly aspire after future eminence in literature, my whole soul burns most ardently for it, and every earthly thought centers on it." Yet he was slow to become a poet. His prodigious scholarly gifts attracted attention instead. No sooner had he graduated from Bowdoin than he was offered its professorship of modern languages—on the condition that he travel to Europe and actually learn the languages. He did, and eventually mastered eleven of them. He taught and translated, wrote scholarly articles and textbooks. At the age of twenty-seven, he was invited to join the Harvard faculty—but felt he needed to polish his German. So he embarked on yet another European trip, this time with fateful consequences. His wife, Mary, suffered a miscarriage in Rotterdam and died soon after of an infection. "I have a void in my heart," he wrote, "a constant feeling of sorrow and bereavement, and utter loneliness." He wandered listlessly from country to country— until one day in Switzerland he met the Appleton family. Nathan Appleton, a wealthy Boston merchant, and his children invited him to join them on their travels, and before long he fell in love with nineteen-year-old Fanny, who initially rejected his advances. He returned to America, and took up his new position at Harvard—but his muse had been found, and the course of his life been set.

In Cambridge, he first took rooms in a boardinghouse on Kirkland Street, near the Harvard campus, but a year later rented two

LEFT: Longfellow and his daughter Edith in front of Craigie House, September, 1878.

BELOW: The entrance hallway. The window on the landing looks through to another staircase. The grandfather clock is reminiscent of the one in his well-known poem "The Old Clock on the Stairs," but in fact the poem recalls a clock in the Gold mansion in Pittsfield, Massachusetts, the homestead of his wife's maternal grandfather. The bust of George Washington speaks to Longfellow's pride in the house's association with the War of Independence. In 1843, he wrote to his father, "We have purchased a mansion, built before the Revolution, and occupied by Washington as his Headquarters when the American Army was at Cambridge."

rooms on the second floor of a large house at 105 Brattle Street. It was called the Craigie House and Longfellow would live there until his death forty-five years later. It had been built in 1759 for Major John Vassall, Jr., and beginning on July 15, 1775, it became for almost nine months the headquarters for General George Washington. It was here that he planned the siege of Boston and met with representatives of the Continental Congress. From the start, Longfellow, whose grandfather had served as an officer under Washington and whose father was a friend of Lafayette, was entranced by the proud history of the house. After the War of Independence the house and 140 acres around it was bought by Andrew Craigie, the former apothecary general of the Continental Army. When Craigie died in 1819, his debts left his widow in difficulties. She sold the land around the house and began taking in boarders. Professor Longfellow seemed ideal, and he soon began to entertain his colleagues and friends at the house. Mrs. Craigie died in 1841, but Longfellow stayed on while her heirs

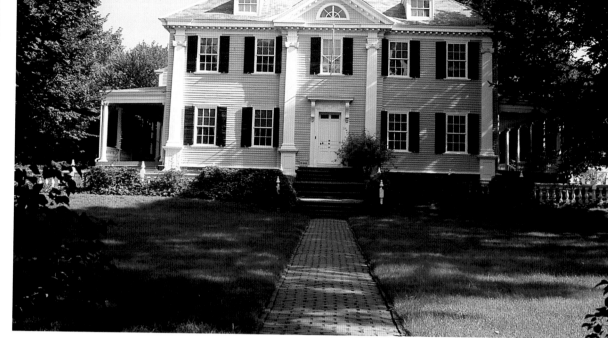

LEFT: In the blue entry.
RIGHT: Craigie House, on Brattle Street in Cambridge, is in the midst of an area rich in historical and architectural associations. Harvard College, where Longfellow began teaching in 1836, is a few blocks away. Among Longfellow's closest friends were Cornelius Fenton, a professor of Greek who became president of Harvard in 1860; Charles Eliot Norton, who lectured on art history at Harvard for 23 years and was known as the "Disciple of Culture"; Louis Agassiz, the Swiss-born professor of American natural history and founder of the University Museum at Harvard; and Oliver Wendell Holmes, Sr., who was professor of anatomy and physiology at Harvard, and whose poem "Old Ironsides" helped save the frigate U.S.S. *Constitution* from destruction. One humbler clapboard house on Brattle Street belonged to Dexter Pratt, who appears in Longfellow's poem "The Village Blacksmith": "Under a spreading chestnut-tree / The village smithy stands . . ."

wrangled over her estate. Two years later, when he finally married Fanny, his father-in-law made the couple a wedding gift of the house and the five acres around it. He later added the land across the street, reaching to the Charles River. The price was $10,000.

For the rest of their lives, Henry and Fanny lived here, along with their five children: Charles, Ernest, Alice, Edith, and Anne Allegra. And it was here that Longfellow worked. Family life steadied his resolve, and the poems that helped define the American imagination began to accumulate. Fanny was a devoted helper, and supervised the house staff. And if the children sometimes interrupted him, he made poetry out it:

> Between the dark and the daylight,
> When the night is beginning to lower,
> Comes a pause in the day's occupations,
> That is known as the Children's Hour.
>
> I hear in the chamber above me
> The patter of little feet,
> The sound of a door that is opened,
> And voices soft and sweet.
>
> From my study I see in the lamplight,
> Descending the broad hall stair,
> Grave Alice, and laughing Allegra,
> And Edith with golden hair.

Longfellow's brother Samuel, in his 1886 biography of the poet, left us a brief description of the house, which one approached, by way of a stand of elms, through a gateway in the lilac hedge:

> In the white-wainscoted hall is a handsome staircase, with broad, low steps, and variously twisted balusters. On the left opens the drawing-room, which, with its deep window-seats, its arched recesses, its marble mantel surmounted by a broad panel set in an architectural frame, remains a fine specimen of a "colonial" interior. Opposite to this is a similar room, of much simpler, but still substantial, style,—in all the later years the poet's study. Beyond is a spacious apartment now used as a library, whose windows command the garden and grounds. Above are the chambers, whose broad fireplaces are framed in old-fashioned Dutch tiles.

Over the years, the furnishings of the house came to match its noble spaciousness. From his travels, Longfellow accumulated paintings and books, tables and *objets* that filled Craigie House with a fine Victorian glut. He and Fanny liked to live well; they had a well-stocked wine cellar, and entertained constantly. His gentleness and warm good spirits attracted a widening circle of friends,

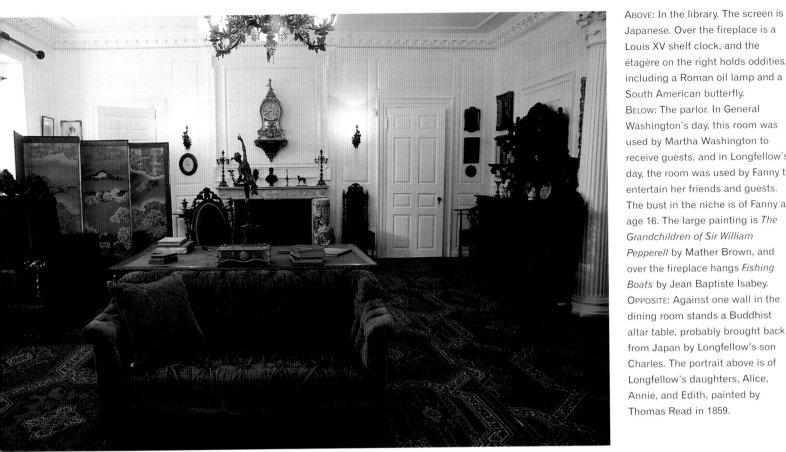

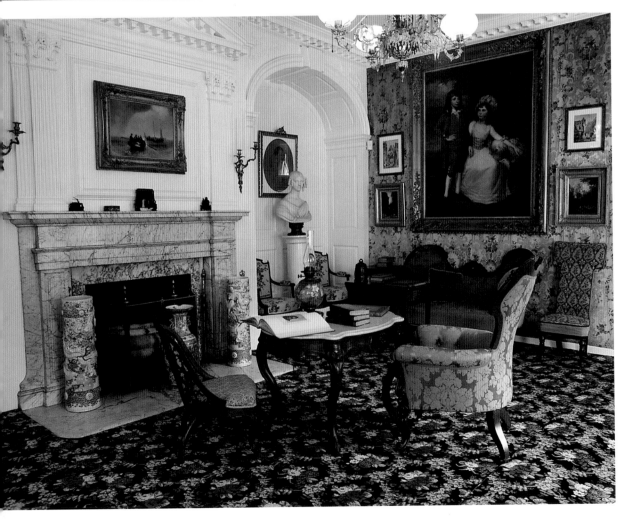

ABOVE: In the library. The screen is Japanese. Over the fireplace is a Louis XV shelf clock, and the étagère on the right holds oddities, including a Roman oil lamp and a South American butterfly.

BELOW: The parlor. In General Washington's day, this room was used by Martha Washington to receive guests, and in Longfellow's day, the room was used by Fanny to entertain her friends and guests. The bust in the niche is of Fanny at age 16. The large painting is *The Grandchildren of Sir William Pepperell* by Mather Brown, and over the fireplace hangs *Fishing Boats* by Jean Baptiste Isabey.

OPPOSITE: Against one wall in the dining room stands a Buddhist altar table, probably brought back from Japan by Longfellow's son Charles. The portrait above is of Longfellow's daughters, Alice, Annie, and Edith, painted by Thomas Read in 1859.

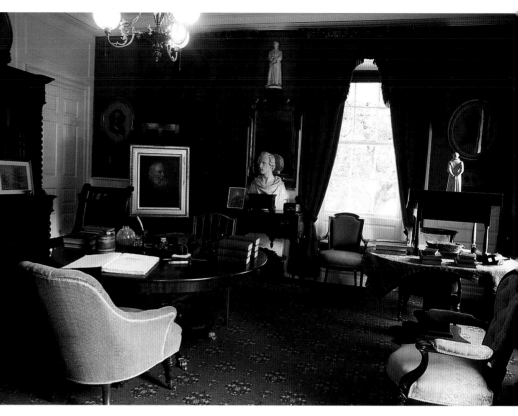

from his intimates like Charles Sumner (later a senator) and Cornelius Conway Felton (later president of Harvard) to Boston's intellectual elite like William Dean Howells, James Russell Lowell, Charles Eliot Norton, and George Ticknor, to still other luminaries like Ralph Waldo Emerson, Nathaniel Hawthorne, Walt Whitman, and Samuel Clemens, and distinguished foreigners like Charles Dickens or Anthony Trollope. Everyone, it seemed, came to call on Longfellow. There were famous singers and actors and musicians; a barefoot Carmelite preacher from Paris, and the Russian anarchist Mikhail Bakúnin. Even Oscar Wilde paid a visit. "However fantastic he may be in public," the poet wrote to a friend, "in private he is a very agreeable and intelligent young man." One day Longfellow answered the door and a woman asked if this was the house where Longfellow had been born. He explained that it was not, but she went on, "Did he die here?" Most typical, perhaps, of his fame was the remark by a visiting Englishman who noted that in other countries one visited ruins, "but you have no ruins in your country, and I thought I would call and see *you*."

The focus of the house, of course, was Longfellow's study. There was a large table in the middle of the room, always piled with books, letters to be answered (he wrote about fifteen hundred a year), and curiosities that admirers had sent him, such as Samuel Taylor Coleridge's inkstand. But that was not where the poet wrote. Because he was continually plagued with eye problems and needed as much light as possible, he wrote at a standing desk in the corner, adjacent to two corner windows. On top of the desk, staring straight at him, was a small statue of Goethe, whom he idolized. The rest of the room was equally devoted to the literary great. There were busts of Shakespeare, Virgil, and Molière, and a shrine to his beloved Dante that included a box containing a piece of Dante's coffin. There were portraits of his friends, photographs and mirrors, a comfortable chair by the fire, where he

read, and opposite it another chair, presented to him by the children of Cambridge on his seventy-second birthday, carved from the remains of the spreading chestnut tree made famous in Longfellow's poem, "The Village Blacksmith."

It was in this room that sessions of the Dante Club were held. His friends Norton, Lowell, and Oliver Wendell Holmes would gather—with wine and cigars and the poet's dog Trap—to hear Longfellow read his latest translation of a canto of Dante's *Divine Comedy* as he put together his monumental edition, the first by an American. And it was here too that he wrote his poems. It could be said that Longfellow was America's first professional poet. Not only was he able to make a living from his writing, but he worked carefully to establish for American poetry a cultural eminence. To do so, he drew on literary qualities that rarely coincide. He had an authority based on learning and allusion, gaining for his work an intellectual respect. And he had a narrative gift both sweeping and canny, along with a near perfect ear, that made his work memorable and gave it an enormous popular appeal. He cared for his readers, for the language of their hearts and memories, and they responded. When *The Courtship of Miles Standish and Other Poems* appeared in 1858, it sold twenty-five thousand copies in the first two months, and ten thousand copies in London the first day. There was hardly a home in America without its hearthside copy of *Evangeline*. And in the wake of *The Song of Hiawatha* in 1855 . . . well, the nation is still

Three views of Longfellow's study. The poet himself sits by the fireplace (left) in a photograph made in the 1870s. The table at the center was used to pile up books to be read and letters to be answered, but Longfellow worked at the standing desk at the rear of the room, situated between two windows and thereby giving him the most light. Eye problems plagued him all his adult life, and he needed as much light as possible while he worked. He evidently needed friends and heroes as well: their portraits throng this room. Around the room are photographs or drawings or busts of his intimates, including George Washington Greene, Charles Sumner, and Nathaniel Hawthorne. There were also busts of Shakespeare, Virgil, and Molière. Even the chairs in the room had private literary associations. One he sat in to write *Evangeline*, another was that mentioned in "The Children's Hour," a third was carved from the famous "spreading chestnut-tree."

When Longfellow first rented rooms in Craigie House in 1834, this room served as his study and dining room. (He also rented an adjacent bedroom.) After he and Fanny owned the entire house, it was used as the family nursery. OPPOSITE, BELOW: This same room, seen from the second-floor hallway. OPPOSITE, ABOVE: The master bedroom. Both Fanny and Henry died in the sleigh bed, over which hang crayon drawings of their sons Charles and Ernest, done by Eastman Johnson. The screen was brought back from Japan by Charles after his visit there in 1870–71. It depicts a series of fans spread against a stylized river.

cluttered with motels and steamboats, summer camps and high schools that bear the name. He was a "professional" in every sense of the term. He carefully monitored his sales figures and made certain that, in addition to morocco-bound volumes printed for the carriage trade, there were broadsides and cheap pamphlets available for the common reader. As a result, he was more widely read, more widely *appreciated* than any American writer of his time.

His long lifetime spanned the age when America sought to define itself, and what Longfellow gave his countrymen—who spurned history—was the mythology they needed. Evangeline in the forest primeval, Hiawatha by the shores of Gitche Gumee, the midnight ride of Paul Revere, the wreck of the Hesperus, the village blacksmith under the spreading chestnut tree, the strange courtship of Miles Standish, the maiden Priscilla and the hesitant John Alden, even the lonely striver's footprints on the sands of time . . . together they form a nostalgic image of innocence, of a people starting over, of a muted but forceful heroism in touch with the rhythms and harmonies of the natural world—in other words, the Great Good Place. Neither the city nor the wilderness attracted him. Neither the thronged metropolis of Whitman nor the solitary pond of Thoreau drew out his sympathies. Instead, Longfellow felt himself most at home in the village, its dimensions contained, its

inhabitants known, its cozy routines established, its eccentric novelties cherished, a civilized community on the edge of the unfamiliar.

That particular sense of *civilization* can be felt in Craigie House nowhere more strongly than in the library adjoining Longfellow's study—what had been the house's original ballroom. With its stately French Renaissance Revival bookcases (Longfellow kept about fourteen thousand books in his home), its paintings, the busts of Sappho and of the Greek philosophers, its grand piano and Oriental carpets, its Chippendale and Queen Anne furniture, and the tall windows giving onto the lawn and garden, here was the summation of a life lived for the enjoyment of culture and of family love. But this room was also the scene for the most terrible event in the poet's life. On July 9, 1861, Fanny and her daughters Edith and Anne Allegra were there wrapping a package—it contained curls snipped from the girls' heads, to be sent to a friend—when a match, lit to melt the sealing wax, dropped to the floor and ignited Fanny's light summer dress. She ran into her husband's study, where he tried to extinguish the flames by wrapping her in a rug, keeping his arms around her neck to keep the fire from nearing her head. In her panic and pain, she broke from his embrace and stumbled into the hallway, as if to run outside—but stopped, staggered to the stairway, and collapsed. The fire

doused, she was carried upstairs, and died the next morning. She was buried on July 13, the couple's eighteenth wedding anniversary. Seriously burned himself, Longfellow was unable to attend the funeral. On the very next day, his father-in-law, Nathan Appleton, died. The next month, Longfellow wrote to his sister-in-law, "How I am alive after what my eyes have seen, I know not. I am at least patient, if not resigned; and I thank God hourly—as I have from the beginning—for the beautiful life we led together, and that I loved her more and more to the end."

He never spoke to his children about their mother's death, and the next Christmas they received presents marked as if from their mother. He grew a beard when his burns prevented him from shaving. Ironically, the bardic white-bearded image we have of Longfellow came from his effort to hide his pain. On the eighteenth anniversary of Fanny's death—July 10, 1879— he was lying in bed staring at the portrait of his wife that hung on the opposite wall. Earlier that day he had seen a photograph of the Mountain

of the Holy Cross in Colorado, where snow stays an unseasonably long time in a cruciform crevasse on the mountainside. He wrote this sonnet, which was revealed only after his death. It is called "The Cross of Snow."

> In the long, sleepless watches of the night,
> A gentle face—the face of one long dead—
> Looks at me from the wall, where
> round its head
> The night-lamp casts a halo of pale light.
> Here in this room she died; and soul
> more white
> Never through martyrdom of fire was led
> To its repose; nor can in books be read
> The legend of a life more benedight.
> There is a mountain in the distant West
> That, sun-defying, in its deep ravines
> Displays a cross of snow upon its side.
> Such is the cross I wear upon my breast
> These eighteen years, through all the
> changing scenes
> And seasons, changeless since the day
> she died.

Herman
Melville

OPPOSITE: The view of Mt. Greylock from Melville's study. During the first weeks of life at Arrowhead, he was busy with chores. He wrote to a friend in October, 1850, "Until to day I have been as busy as man could be. Every thing to be done, and scarcely any one to help me do it. But I trust that before a great while we shall be all 'to rights,' and I shall take my ease on mine mountain." When he was finally able to return to his desk, he set about finishing *Moby-Dick* while gazing on the whale-like shape of Greylock.

RIGHT: The piazza, or veranda, that Melville had added to the shady side of his house, again so that he could view the mountain. It was too narrow for rocking chairs, but ideally suited to Melville's desire to pace back and forth.

N o American novelist approaches the grandeur of Herman Melville. Sometimes rough-hewn or long-winded, his books are those of a natural writer. Their rhetorical elegance, the sweep of their narratives, the illuminating details, their psychological complexity, and mythological resonance—with such advantages, his novels are unsurpassed. And what American novel is greater than *Moby-Dick*? What novel has so thrilled and haunted its readers? What novel has so embodied the contradictions of the American quest, its daunting heroics and eerie obsessions? If Melville is the greatest of our novelists, his life is also the saddest, its grisly disappointments made all the more dark by its bright beginning and flickering successes.

His childhood, for instance, was a privileged and happy one. Both his grandfathers had fought in the War of Independence. His father's family were Boston merchants. His mother's family, the Gansevoorts of Albany, were prosperous. Melville was born in New York City, where his father had moved to pursue his dry-goods importing business. But Allan Melville was both importunate and ill-fated, and his wife Maria shrill and extravagant. During their first years in Manhattan, there was a governess for the children, and a French manservant, but by the time Herman was ten, creditors were at the door, and financial ruin drove them back to Albany. Once again, bankruptcy hounded Melville's father, and he died soon after, leaving his wife and eight children at the mercy of expediency and relatives. There followed an impoverished life and a fitful education for the children. One year, to escape, the fifteen-year-old Herman was sent to live at his Uncle Thomas's farm in Pittsfield, to work in the hayfields along the Housatonic. He stayed on to try his hand at schoolteaching, then wanted to study surveying—until, finally, in 1839, at the age

of twenty, he traveled to New York and signed on as a cabin boy aboard a merchant ship, the *St. Lawrence*, bound for Liverpool.

Early on in life, Melville had experienced "a vague prophetic thought, that I was fated, one day or other, to be a great voyager." When he returned from this first voyage, he found his mother mired in more debt and desperation. He fled to Uncle Thomas, now living in Illinois, who urged him to consider going West. Instead, he decided to go to sea again, and signed on for a four-year stint as a foremasthand—he loathed what he called the "sultanism" of officers—on the maiden voyage of the whaler *Acushnet*, sailing out of New Bedford. He set sail on January 3, 1841, rounded the tip of South America, and headed toward the South Pacific. Just before he left, he read in *Knickerbocker* magazine an exciting account by J. N. Reynolds called "Mocha Dick: or the White Whale of the Pacific." But many adventures and five novels intervened before he returned to the story of the white whale.

Eighteen months later the *Acushnet* was cruising the whaling grounds around the

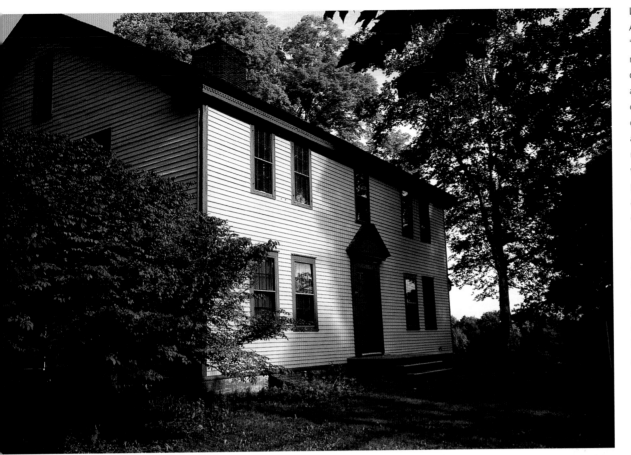

Left: Arrowhead. Melville's sister Augusta described it in a letter: "Our old farm house cannot boast much in point of beauty, but it is delightfully comfortable and that is all that is really necessary in the country. It is an old house, counting its seventy years or more, and though outwardly modernized, retains all its ancient appearance within. It is built after that peculiarly quaint style of architecture which places the chimney—the hugest in proportions—immediately in the centre, and the rooms around it. An arrangement so totally void of grace and beauty, must surely possess some counterbalancing advantage, but as yet I have been unable to discover it."
Below: An 1862 photograph of Arrowhead taken from the north meadow.

Marquesas Islands and had dropped anchor in the bay of Nukuhiva. The disease, the floggings, the cruelty, the exhaustion—life on the whaler had become intolerable for Melville, and he and a companion, Toby Greene, jumped ship and fled to the interior of the lush island. His adventures among the cannibalistic natives and his rescue became his famous "peep at Polynesian life" when he returned home to his mother's house two years later and set them down in his first novel, *Typee*. The book, first published in London, was a success, and he quickly followed it with another South Seas novel, *Omoo*, a year later. Three more quite different novels about sea life rapidly appeared, *Mardi* (1849), *Redburn* (1849), and *White-Jacket* (1850), all of them filled with brilliant description, learned allusions, and technical lore. "If at my death," he once said, "my executors, or more properly my creditors, find any precious MSS. in my desk, then there I prospectively ascribe all the honor and glory to whaling; for a whale-ship was my Yale College and my Harvard." In fact, after those first two voyages, he rarely went to sea again, but he read voraciously, Shakespeare and Sir Thomas Browne and volumes of marine history and zoology, and his imagination spun the web that held the facts together. It was truly a frenzy of writing, and in the midst of it, on August 4, 1847, three days after his twenty-eighth birthday, he married. Elizabeth

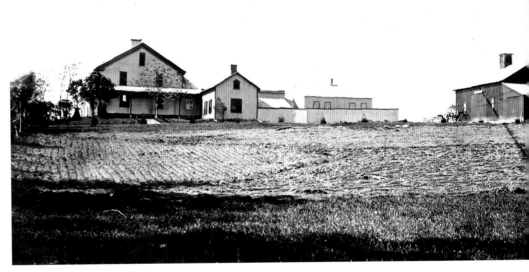

Shaw was the daughter of the chief justice of Massachusetts, Lemuel Shaw, an eminent jurist and an old friend of Melville's father. In the difficult times to come, he was often Melville's generous patron as well. D. H. Lawrence, who described Melville's whole life as one long "writhing," once remarked, "He married and had an ecstasy of a courtship and fifty years of disillusions. . . . A mother: a gorgon. A home: a torture box. A wife: a thing with clay feet. Life: a sort of disgrace." Though at one point, tired of his drinking and mania, she contemplated divorce, Lizzie Melville stood by her husband to the end, though two of their four children died

Opposite: A detail of the barn behind the main house.
Overleaf: The dining room, with the fireplace made famous in Melville's 1856 story "I and My Chimney." In 1863, Allan Melville had passages from his brother's work inscribed into the stone.

as young men (one a suicide) and her own life—spent copying his manuscripts and trying to run a household on next to nothing—was a trial.

Once married, he moved to New York, and took into the household his mother and four sisters; his first son, Malcolm, was born in 1849. He was desperate for money to support them, and traveled to England, where he was more highly regarded than in America, with the hope of fresh prospects. Nothing came of it. He returned home and, remembering Owen Chase's 1821 account of the sinking of the *Essex* by an avenging whale, he started on a new novel. In the summer of 1850, to escape the distractions of the city, he and Lizzie and their baby went to Pittsfield to stay at his Uncle Thomas's old house, Broadhall, now presided over by his cousin Robert. The visit brought back memories of his earlier happiness in the area and by fall he was determined to move there. With money borrowed from Judge Shaw, he purchased an old-fashioned farmhouse, built in 1780, and 180 acres surrounding it. He had meant to build a house for himself farther up the hill, complete with a writing study, but there was no money for such a scheme; he settled on the house by the road, which was operated as a tavern, and sold half his acreage to settle debts. Between the house and the barn behind, though, he built a series of outbuildings. In a letter, he told how "I have been building some shanties of houses (connected with the old one) and likewise some shanties of chapters & essays. I have been ploughing & sowing & raising & printing & praying, and now begin to come out upon a less bristling time, and to enjoy the calm prospect of things from a fair piazza at the north of the old farmhouse here." His neighbors chided him for building his piazza, or porch, on the shady north side of the house, but its prospect delighted Melville. He would pace back and forth, smoking his pipe, or sit there in his rocking chair and gaze into the distance where, twelve miles away, humpbacked Mt. Greylock rose—which he also saw through his study window. In his short story "The Piazza" he wrote of this view as "nothing less

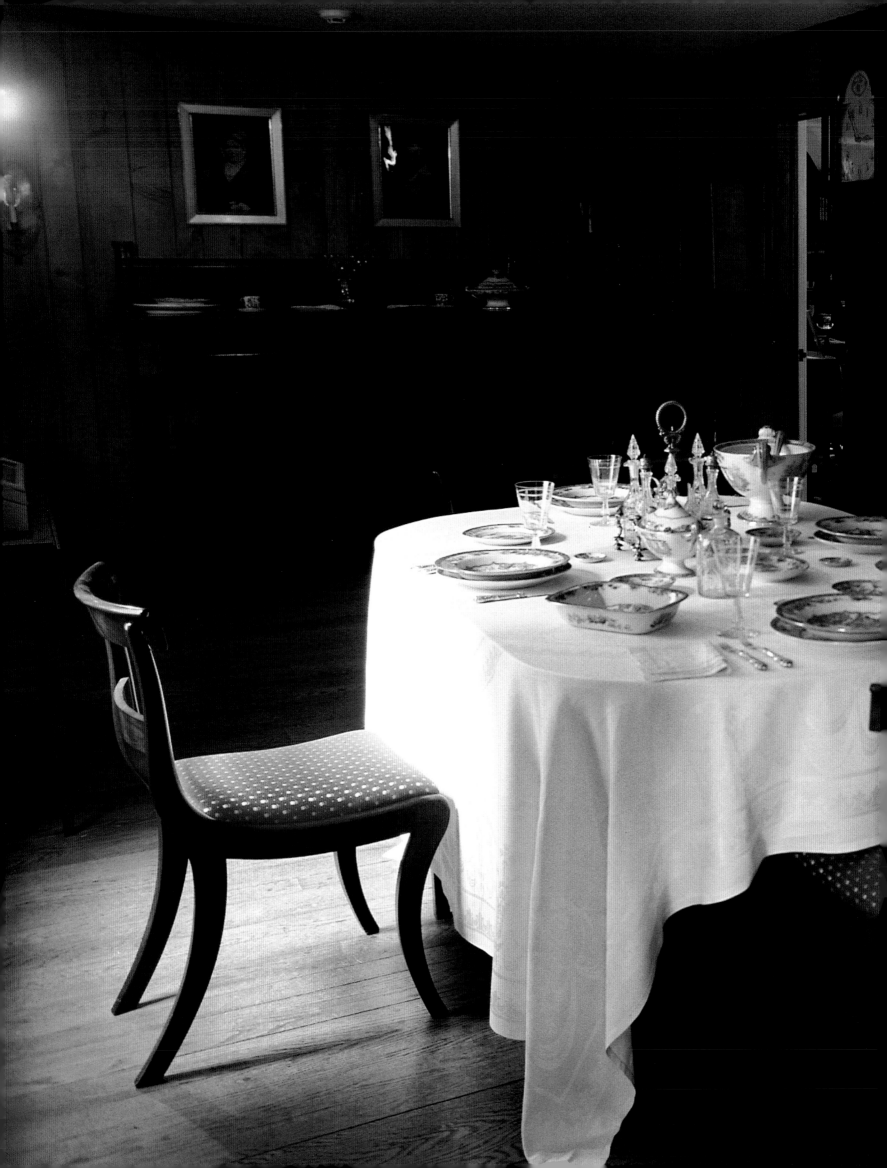

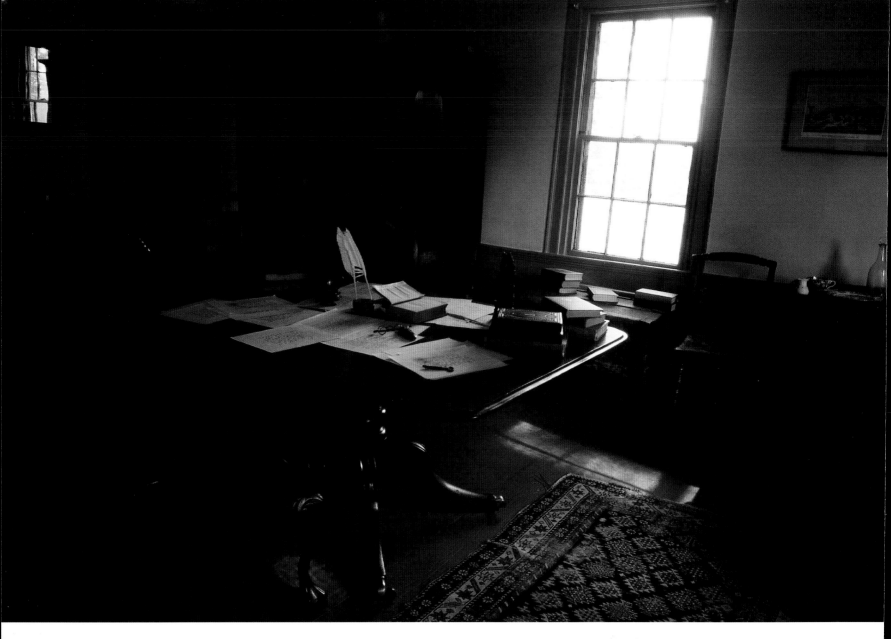

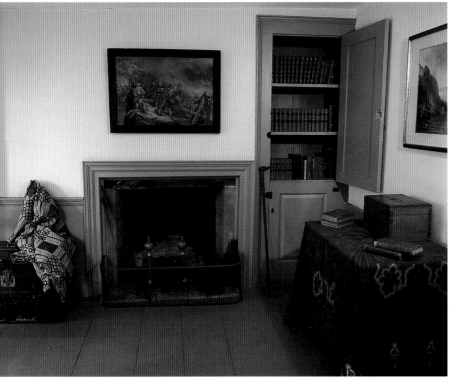

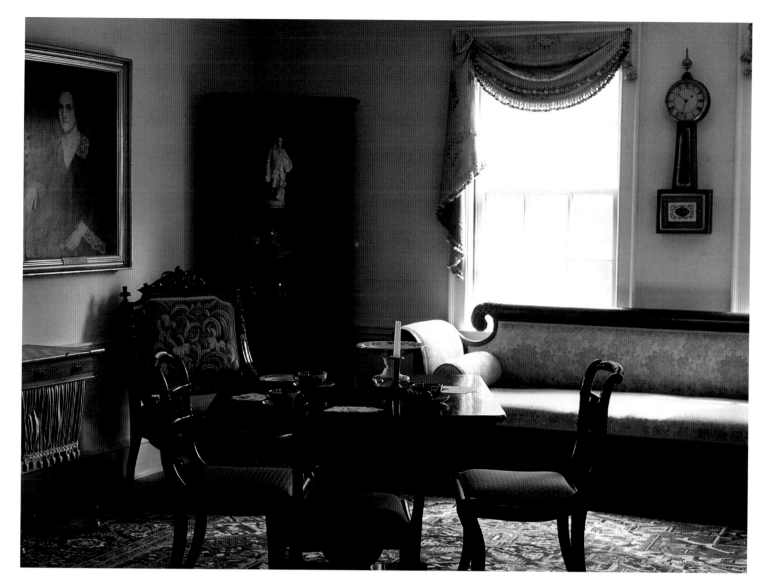

than Greylock, with all his hills about him, like Charlemagne among his peers." He even dedicated his 1852 novel *Pierre* to Greylock's "most excellent majesty." Between the mountain and the house were stands of maple and elm, hayfields and orchards that stretched before him like ocean swells. In winter, the effect was even more pronounced:

I have a sort of sea-feeling here in the country, now that the ground is all covered with snow. I look out of my window in the morning when I rise as I would out of a port-hole of a ship in the Atlantic. My room seems a ship's cabin; & at night when I wake up & hear the wind shrieking, I almost fancy there is too much sail on the house, & I had better go on the roof & rig in the chimney.

Melville named his new house Arrowhead after some Native American artifacts he dug up while ploughing his fields. The so-called "Chimney Room," at the back of the house,

served as the family dining room, and with its cavernous fireplace had been the tavern's kitchen. Inscribed inside the fireplace and on the mantel by Melville's brother Allan are passages from his story "I and My Chimney," which he included in his 1856 collection *The Piazza Tales*. The two downstairs parlors—the north parlor, used to entertain guests, and the smaller south parlor, where Melville kept his collection of engraved seascapes by Turner (he owned over four hundred)—are genteel retreats. Upstairs are the main bedchamber, a childbed at the bottom of the four-poster, and across the hall, Melville's study. It is the largest room in the house, and despite having up to ten people at a time living under his roof, he kept this room exclusively for himself. The fireplace on one wall faces the window opposite, and between them Melville's large writing table, books, and papers piled up, and a holder for the quill pens he preferred to use rather than the more modern types available to him. In a letter to his friend Evert Duyckinck, he described his daily routine:

LEFT, ABOVE AND BELOW: Melville's bedroom. Even at the end of his life, he could still remember the four-leaf clover he had found on his wedding day. And his last book he dedicated to his wife, Lizzie (née Elizabeth Shaw), after 44 years of marriage, using as the book's emblem the common red clover, while perhaps recalling that while living at Arrowhead he had gathered a handful of late blossoms, saving them from the first snow, and that Lizzie had called the melting snowflakes on the flowers the "tears of the happy."
LEFT, BELOW: The children's room.

mountain. "On the hither side of Pittsfield," wrote Nathaniel Hawthorne in 1851, the year the novel was published, "sits Herman Melville, shaping out the gigantic conception of his white whale, while the gigantic shape of Greylock looms upon him from his study window." It was Melville's fortuitous meeting with Hawthorne, who was then living in nearby Lenox, that led him to change the direction of *Moby-Dick* and make it the tragic masterpiece it is. On August 5, 1850, literary friends from New York had arrived, and together with Oliver Wendell Holmes (who lived down the road from Melville) and the publisher James T. Fields, Hawthorne and Melville were introduced, and the whole group went for a picnic on Monument Mountain, on whose summit Melville, perched on a jutting rock, boyishly pretended to pull and haul on imaginary rigging. Later, there was a dinner, with wine and cigars, and Hawthorne and Melville both realized they had met a kindred soul. Though the more reticent Hawthorne liked his new friend at once, it was Melville who was especially enthralled by this meeting with an admired elder. It was a signal moment in American literature. *The Scarlet Letter* had just been published, and *Moby-Dick*, dedicated to Hawthorne, appeared the next year. What Hawthorne wrote to Melville after receiving the novel has been lost, but Melville's return letter declared, "I feel that the Godhead is broken up like bread at the Supper, and that we are the pieces."

It is astonishing to remember that Melville was only thirty-two when *Moby-Dick* was published and had already written five novels. Ishmael, Queequeg, Starbuck, Stubb, Fedallah, Father Mapple, Pip—the characters in the novel have a startling presence. And none more so than the fearsome and fearless Captain Ahab with his "close-coiled woe," his leg made of whalebone, and his tragic obsession as he pursues the "grand hooded phantom, like a snow hill in the air." Moby Dick has been interpreted as God and as The Void. "Of course he is a symbol," wrote D. H. Lawrence. "Of what? I doubt even Melville knew exactly. That's the best of it." It is the monomaniacal hunt that pulls us along until the end, when Ahab is choked on his own rope and casts one look back. "The ship?" he screams. "Great God, where is the ship?" And Melville goes on to describe the concentric circles that had "seized the lone boat itself, and all its crew, and each floating oar, and every lance-pole, and spinning, animate and inanimate, all round and round in one vortex, carried the smallest chip of the *Pequod* out of sight."

Melville lived at Arrowhead for thirteen years, and wrote *Pierre* (1852), *Israel Potter* (1855), *The Confidence-Man* (1857), as well as *The Piazza Tales* there. But illness hounded him—

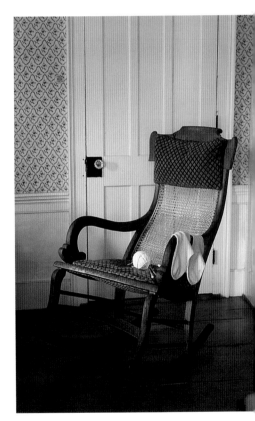

Do you want to know how I pass my time?—I rise at eight—thereabouts—& go to my barn—say good-morning to the horse, & give him his breakfast. (It goes to my heart to give him a cold one, but it can't be helped.) Then, pay a visit to my cow—cut up a pumpkin or two for her, & stand by to see her eat it—for it's a pleasant sight to see a cow move her jaws—she does it so mildly & with such a sanctity.— My own breakfast over, I go to my work-room & light my fire—then spread my M.S.S on the table—take one business squint at it, & fall to with a will. At 2 P.M. I hear a preconcerted knock at my door, which (by request) continues till I rise & go to the door, which serves to wean me effectively from my writing, however interested I may be. . . . My evenings I spend in a sort of mesmeric state in my room—not being able to read—only now & then skimming over some large-printed book.

It was in that room, where he worked hurriedly or sat dreamily, that *Moby-Dick* was written. In the books around him were the seeds of the great tale, and out the window was the

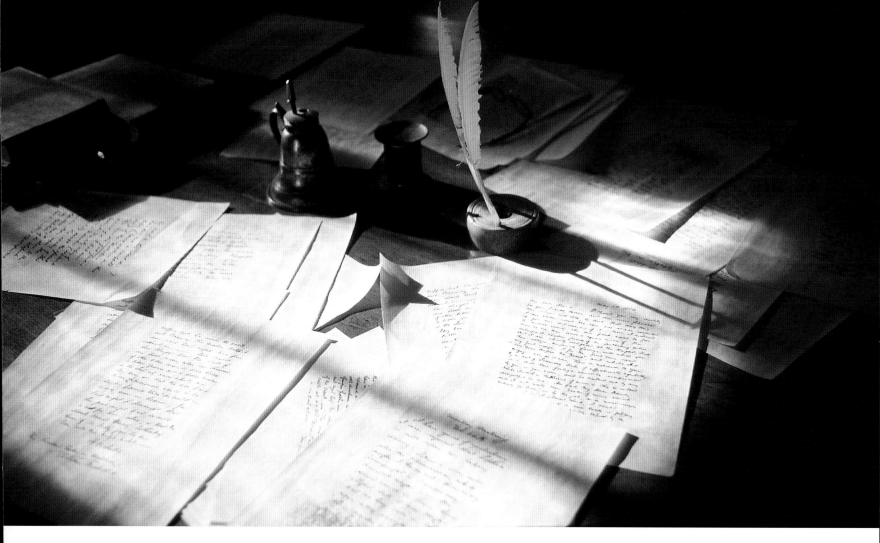

his family sometimes feared madness–and his fortunes continued to decline. *Moby-Dick*, for instance, earned him just $556.37. In 1863 he traded Arrowhead for his brother's house on East Twenty-sixth Street in Manhattan and returned to New York to work as a customs inspector for four dollars a day. Horrified by the Civil War, he started writing poetry, a decision that prompted his wife to declare, "Herman has taken to writing poetry. You need not tell anyone, for you know how such things get around." Just before his death, he wrote his parable of the angelic and the demonic, the incandescent *Billy Budd, Sailor* but it was not discovered and published until 1924. The notice in *The New York Times* when he died printed his name as Henry Melville and referred to him as "the former writer." It was Hawthorne, though, who had the last word. In his journal, he recorded a visit he had from Melville in 1856. Hawthorne was then the American consul in Liverpool, and when he heard that Melville—on his way to the Holy Land—was in town, he invited him to stay, though he was disconcerted to realize that the bundle Melville was traveling with contained only a nightshirt and a toothbrush. The two friends took long walks and smoked cigars. Hawthorne noted

Melville's restless spirit, doubting the existence of an afterlife, yet challenging the limits of despair.

> *It is strange how he persists—and had persisted ever since I knew him, and probably long before—in wandering to and fro over these deserts, as dismal and monotonous as the sand hills amid which we were sitting. He can neither believe, nor be comfortable in his unbelief; and he is too honest and courageous not to try to do one or the other. If he were a religious man, he would be one of the most truly religious and reverential; he has a very high and noble nature, and better worthy of immortality than most of us.*

Hawthorne's sense of his inner struggle, valiant and doomed, brings to mind all the struggles at the heart of Melville's novels. And the greatest of them was written in his room at Arrowhead. It is less the story of a spiritual cripple facing an overwhelming enemy and an implacable fate, but more of a man at sea, alone with a limitless, mysterious, unfathomable immensity. Melville was a man who faced that himself, every day—after watching his cow eat a pumpkin.

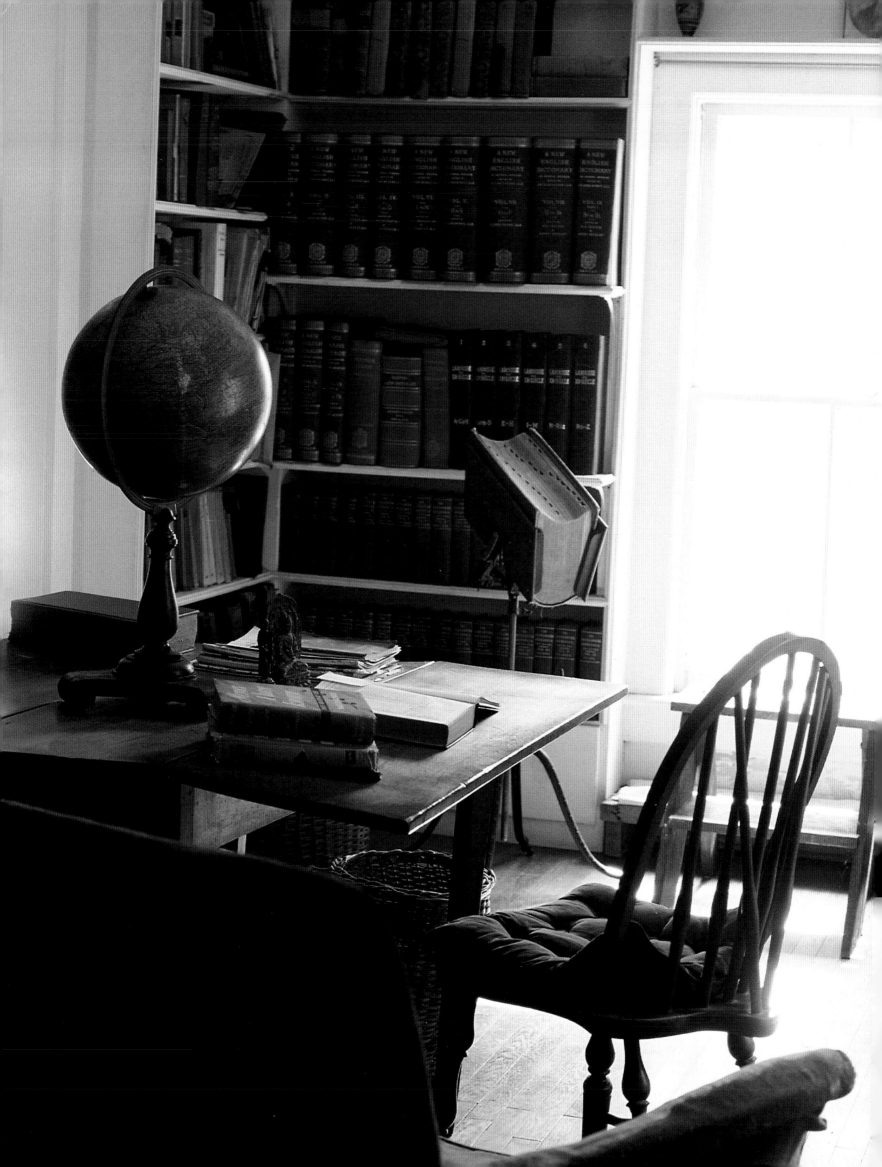

Millay
Edna St. Vincent
1 8 9 2 – 1 9 5 0

OPPOSITE: Millay's library at Steepletop. She didn't write in this room, preferring either to go to her writing cabin or to stay in bed with pen and paper.

My candle burns at both ends;
It will not last the night;
But ah, my foes, and oh, my friends—
It gives a lovely light!

By 1923, Edna St. Vincent's Millay's candle was sputtering. She was famous, glamorous, and exhausted. That same year she had become the first woman to win the Pulitzer Prize for poetry, but, as a friend of hers put it, "she was tired of breaking hearts and spreading havoc." She had been dealing with adoring crowds, clamoring publishers, reading tours. She had been traveling abroad and juggling love affairs. She was ill. She was fragile. And she was in love.

Discouraged with her work, she had taken a break from it and gone to visit friends for a country weekend in Croton-on-Hudson. Acquaintances kept stopping by. One of them, a friend of a friend, was a tall, handsome Dutchman named Eugen Boissevain, who lived nearby and whom Millay had met in passing once or twice in Manhattan. They had all been talking about a recent Broadway hit, and a party game was soon devised: they'd take the plot of the play, turn it inside out, assign roles, and improvise. Millay, who had written and acted in plays since childhood, and whose one-act *Aria da Capo* had been a sold-out smash at the Provincetown Playhouse two years earlier, fell in with the fun of it. It turned out that she and Boissevain were given the roles of an innocent city couple who fall into the clutches of depraved country bumpkins and are ruined. By the end of the third act, Edna and Eugen had themselves fallen in love. A few months later, they married.

In a sense, Boissevain patched together Millay's jumbled life. Eleven years older, he was a protective father figure, replacing the parent who had abandoned Millay's family when she

was a child in Maine. Boissevain was practical and devoted, sympathetic to her ailments and determined that nothing should get in the way of her work. As soon as they could spend time together, he realized how frail she was beneath her "high, bright gaiety." He insisted that she rest, avoid the city, see doctors and have tests. On July 18, 1923, they married, and the garden snapshots show a thin, slightly dazed bride in a mosquito-netting veil. Directly from the ceremony, he drove her off to the hospital for intestinal surgery. She joked to a friend, "Well, if I die now, I shall be immortal." She didn't die, but she kicked up more publicity. It was front page news in the New York papers: POETESS BRIDE TO GO UNDER KNIFE, FAMOUS LOVE LYRICIST BELIES HER OWN PHILOSOPHY BY MARRYING, HONEYMOONING ALONE IN HOSPITAL.

They lived in a narrow three-story brick house on Bedford Street in Greenwich Village, they traveled to Asia, she wrote, her health remained precarious, she kept on writing, he tended to her needs, she wrote. But she needed more stability, and she found it in an advertisement in *The New York Times*. One morning she noticed that an abandoned dairy farm was for sale in the town of Austerlitz, in upstate Columbia County, among the Berkshire foothills. They went to investigate and once again fell immediately in love. On May 21, 1925, for $9,000, they found themselves the owners of a house and barn on 435 acres of forest-fringed, rolling hills overlooking the expanse of Lebanon Valley. They named it Steepletop, after a wildflower—the tall pink spires of steeple bush (*Spiraea tomentosa*)—that grew in the surrounding fields. A month later, she was writing to her mother: "Here we are, in one of the loveliest places in the world, I am sure, working like Trojans, dogs, slaves, etc., having chimneys put in, & plumbing put in, & a garage built, etc.—We are crazy about it." There was endless work to do—now a furnace, now a

generator. They had plumbing but no water (on the first sunny day, the plumber left the job to start haying), so she and Eugen and their friends all bathed in the brook. "I made them give me upstream," she insisted, "because I was cleaner."

Slowly, the house took shape. The farmhouse had been Victorian in style, but Millay wanted it to remind her of Maine, so the front door was moved to the side of the house, the long porch was removed, and the two parlors combined into a single drawing room. (She had display trays of shells here and there in the house, also to recall her childhood by the sea.) Another two hundred acres on the other side of the road was eventually added to the property. They bought and had erected an elegant Sears, Roebuck barn and stocked the spread with goats, sheep, pigs, a small herd of Guernseys, and horses (Millay's own favorite was named "Rob Roy"). They took down the old barn and in its foundation they installed a swimming pool, sunken gardens, and an outdoor bar. A writing cabin was put up a hundred yards from the house—just a Franklin stove, a table and chair, and a chaise by the window for reading. Here, too, she had pines and blueberry fields planted around the cabin to evoke the sound and smell of Maine. Before too long, on the property's highest point, they had a tennis court constructed. Odd gates were set up—just a gate, no fence or wall on either side of it—leading to different areas and outbuildings, and Millay's brother-in-

law, the painter Charles Ellis, created rondelles with automobile paint to be attached to each gate—nymphs for the pool, a female nude for the bar, and so on. Eugen, as he did all his life, worked on the grounds and the extensive vegetable gardens, and took care of the livestock. Their longtime caretaker, John Pinnie, helped, and when times were flush, there was help in the house as well. The housemaids and secretaries were usually locals (one of them, years later, still remembered Millay rolling up the rug and teaching her how to dance), but Millay and Boissevain shared a taste for all things French and tried to hire a Continental couple. Eugen once interviewed a French pair newly arrived in New York City, and lured them with stories of his "estate." Whatever sort of manor the Frenchman and his wife may have expected, they were disappointed in Steepletop, dreaded being so isolated, and fled.

The house is at once small and rambling. At one end of the drawing room is a fireplace and comfortable furniture. The walls had Chinese hangings. The other end is dominated by two Steinways, one concert sized and the other smaller, on which Millay would play duets with friends and accompany musical evenings. Sitting at the keyboard, she could look directly at a bronze bust of Sappho on its marble plinth. An admirer had sent it to her from Herculaneum, and it was the perfect household god. Until Millay, few women poets since Sappho had

written so explicitly about erotic passion and anguished romance. Her poems, which thrilled the Jazz Babies of the twenties, gave a generation its new voice—edgy, silvery, urgent. For men, her poems made the complexities of passion alluring; for women, they made it real.

I know my mind and I have made
my choice;
Not from your temper does my doom
depend;
Love me or love me not, you have no voice
In this, which is my portion to the end. . . .
Here might you bless me; what you
cannot do
Is bow me down, who have been loved
by you.

The two most important rooms on the second floor are Millay's. (Tensions in the marriage eventually banished Eugen to a small bedroom in the back.) The poet's bedroom has a fireplace, a reading chair, a vanity, and bureau. On the bureau are her copies of favorite authors—Dante, Petrarch, Catullus, and Keats. But Steepletop has

one detail that is more intimate and startling than that in any other house in this book. To this day, in the bureau and closets are her clothes. Her riding boots in their boot trees show you how small she was. (Her shoe size was 4½, and she stood just 5'1".) In one of the bureau's top drawers are her gloves—long white kid gloves with pearl buttons. In another are her purses, leather or beaded, evening bags with exquisite Art Deco initialed clasps. In them still are her jeweled Coty compacts or change purses; in one is a pencil, and in another a cigarette case with a few Pall Malls in it. Several have lipstick cases, the lipstick in them long since dried out but still a ghostly red. Satin sachets still have her stockings and undergarments in them. On closet shelves are ravishing dresses and hats—a peacock cloche is a rare beauty—all of them haunted with what once swirled around them, once beat inside them.

A "sewing room" adjoins the bedroom and bath. It was originally Eugen's room, but once he was elsewhere, Millay used to lay out on a large table the books she was working on at the moment. Through its opposite door is her library, very much the literary artist's area, filled with reference books. One scans the shelves and spots the Koran, say, or books on telegraphic code, dog breeding, or ocean tides. There's a Russian grammar, a medical dictionary, and *Light Houses of the Maine Coast*. A hand-painted sign hangs from the ceiling: SILENCE. One end of the library was her poetry corner. This was the room where she read; she mostly wrote in bed or in her writing cabin. In a corner is an overstuffed chair, a lamp beside it with a Chinese shade. On the wall is a framed photograph of Robinson Jeffers, and everywhere collections of poetry, either inscribed to Millay or with her ownership signature in them.

There are home movies of Millay bundled up in a porch chair, while a maid in cap and apron lights a cigarette for her; of Boissevain and an attractive house guest playing tennis while the poet watches from her judge's perched chair; of the couple and their guests in the pool or sitting around the rustic bar. They loved organizing evenings and house parties at Steepletop. Students from the Bloch Hillsdale Music College were invited to present recitals for her guests; or a traveling theater company agreed to perform on her hillside for the sixty "souls" she had invited over. Though it was always jolly, over time it grew a little easier. Electricity, for instance, didn't arrive until 1947, when wires were finally brought in from the state road. Millay had had to write to the governor, complaining:

Dear Governor Dewey,
I simply must have electric light in this house to write my new book by. Every farmer for miles around has electric light

LEFT: The breakfast table in her kitchen. The *Ladies' Home Journal* article that described this new kitchen noted: "The old kitchen was as inconvenient and difficult as a room could be; but even with no modern conveniences, Edna kept it in spotless order. Lacking a towel rack, she made one of an old curtain roller. . . . An old cheese box held her clothes-pins in rows with their heads together like toy soldiers."
BELOW: Her typewriter.
OPPOSITE: One of the two Steinways in her living room. At the rear can be seen the bust of Sappho she treasured. As a youth, she had dreamed of being a concert pianist, but her reach was too small.
OVERLEAF: The living room.

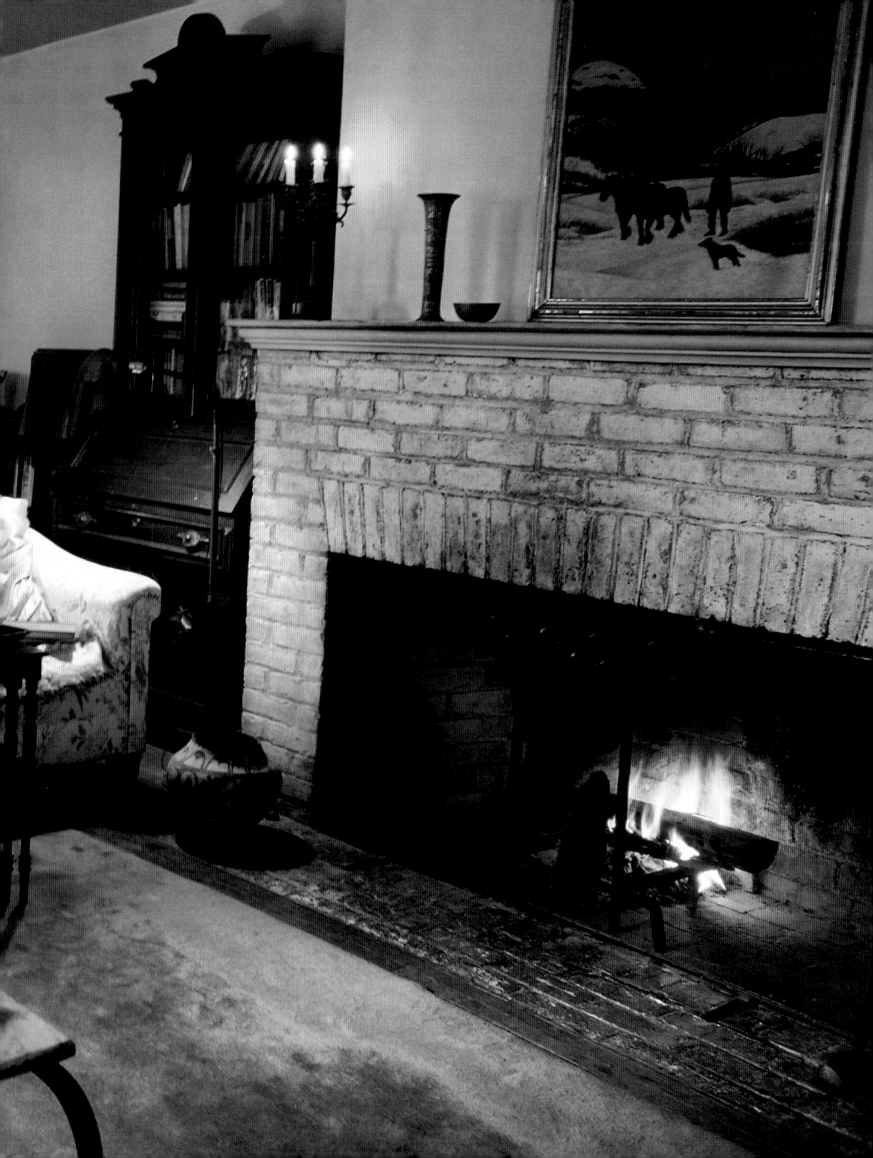

in his barn to do his chores by, whereas I must sit in my study writing down my poems by the light of a candle.

They are willing to put in the light, they tell me; but they are holding me up for an enormous installation fee. Every farmer has had the light installed for nothing.

This is a farm, too, in case you need this as a talking-point. All through the war we sold butter—at ceiling prices, please remark—to the surrounding countryside. But our hired man, who had free electric light in his own barn, had to milk our cows in the winter by the light of a kerosene lantern.

However, my main point is this: there have been instances in which the writing of a book was quite as important as the milking of a cow.

Respectfully yours

She won. And soon after, as a publicity stunt, *Ladies' Home Journal* offered them a new state-of-the-art kitchen, on the condition they could feature a before-and-after article in the magazine; it begins: "This kitchen is in an old white house at the top of a climbing green hill at the end of a steep and hazardous road. Actually it should be on Mount Parnassus, for here at this very sink, in this very kitchen, Edna St. Vincent Millay washes dishes and scours the pots and pans!"

Of course they took extensive trips, and in 1933 purchased Ragged Island in Maine's Casco Bay, which they used as a summer retreat. But Steepletop was home, and Eugen oversaw both the household and Millay's peace of mind. He kept the accounts and drove her around. He organized her day and prevented interruptions. He would rush to answer the telephone on the first ring lest it disturb her—or have it disconnected for months to ensure her privacy. But Millay's temperament craved stimulants as much as it needed peace. In 1928, during a stop in Chicago on a triumphal reading tour, she met a handsome, feckless young poet named George Dillon and was smitten at once. Their affair flared and dimmed. She moved with him to Paris, while Eugen waited patiently at Steepletop, begging her to return and at one point even proposing a ménage. Behind her reckless behavior was the drive to create the emotional chaos her poems fed on, and out of this tumult she wrote her best book, *Fatal Interview*—which, when it was first published in 1931, in the depths of the Depression, sold 50,000 copies in the first months, and which contains sonnets of a shimmering fame.

*Love is not all: it is not meat nor drink
Nor slumber nor a roof against the rain;
Nor yet a floating spar to men that sink
And rise and sink and rise and sink again;*

American Writers at Home

*I might be driven to sell your love for
 peace,
Or trade the memory of this night for food.
It well may be. I do not think I would.*

And in the end, she didn't sell her love or
trade her memories. She returned to Boissevain,
though treatment after a freak car accident in
1936 left her addicted to drugs and alcohol for
the rest of her life. Eugen saw her through
hospital stays and rest cures, and at one point
tried to take morphine himself, the better to
understand how to help her withdraw from it.
And when he died suddenly, after an operation
in 1949, Millay was helpless. She stayed on
listlessly at Steepletop. A year later, alone, she
left a note for the maid reminding her not to set
the iron too high. "I have been working all night.
I am going to bed." But at some point in the
night, sitting at the top of the staircase, a bottle
of wine beside her, she pitched forward, down
the stairs, breaking her neck. She was fifty-
eight. In her notebook, it was discovered that
she had penciled a ring around the last three
lines of a poem she had drafted:

*I will control myself, or go inside,
I will not flaw perfection with my grief,
Handsome, this day: no matter who has died.*

*Love can not fill the thickened lung with
 breath,
Nor clean the blood, nor set the fractured
 bone;
Yet many a man is making friends with
 death
Even as I speak, for lack of love alone.
It well may be that in a difficult hour,
Pinned down by pain and moaning for
 release,
Or nagged by want past resolution's power,*

LEFT, ABOVE: The inside of her
writing cabin. Undoubtedly its
austerity helped her concentration.
The woodstove is a "Sylvan Red
Cross" model, an appropriate name
for a cabin in the woods.

LEFT, BELOW: One of the trays of
seashells she kept about the
house, perhaps to remind her of
the Maine coastline of her
childhood, and certainly because
she was fascinated by their
intricate shapes and colors.

ABOVE, RIGHT: Millay with her
husband Eugen and friends at the
sunken bar they created out of an
old stone foundation found on the
property, c. 1945.

OPPOSITE: One of the doors-leading-
nowhere on the property, its
rondelle painted by her brother-in-
law Charles Ellis.

Flannery O'Connor

1 9 2 5 – 1 9 6 4

OPPOSITE: O'Connor's typewriter, in her bedroom at Andalusia. Of her harrowing stories, she once wrote to poet Elizabeth Bishop, "I am glad to say that most of the violences carried to their logical conclusions in the stories manage to be warded off in fact here— though most of them exist in potentiality."

One drives there today on pretty much the same route taken by General Sherman on his march to the sea during the Civil War. Having burned Atlanta, he and his army sped 125 miles southeast, pillaging the stately homes and rich agricultural bounty of middle Georgia, toward Milledgeville, then the state capital. Once there, he installed himself in the governor's mansion, an opulent example of antebellum Greek Revival in pink stucco and grand portico columns, where decades earlier Lafayette and Tocqueville had been guests. As a girl growing up in Milledgeville, in her own mother's birthplace at 311 W. Greene Street, Flannery O'Connor could look out her bedroom window at the governor's mansion next door. The South she wrote about, though, was not the doomed, romantic, history-haunted land of Faulkner. Why compete? Or, as she once put it, "nobody wants his mule and wagon stalled on the same track the Dixie Limited is roaring down." Instead, she explored an eerie, God-forsaken landscape of white trash and poor blacks beset with corn likker and ecstatic visions, every one of them freakish, violent, and, as rendered in her prose, utterly compelling. Her South is the fallen world, a land of murderers and misfits and madmen, idiot children and one-legged women, thieves and illiterates and prophets, white and black. That she wrote so much and so well seems, in retrospect, almost miraculous. At the age of twenty-seven, she learned she would die young, and everything she wrote thereafter— the novels and stories that secured her fame— was imagined and completed under that fatal shadow. Betrayed by her body and seemingly by the God she so fervently believed in, she must have felt unbearably alone. A woman, a Southerner, a Catholic, and the author of fiction that her neighbors felt ridiculed them ("ask her why she don't write about some nice people," her Uncle Louis was told by the folks at the hardware store), she was isolated both in the literary world-at-large and in the local community. But she persisted for another dozen years, and is now recognized as one of the most original and powerful voices in twentieth-century American fiction.

Rural Georgia and its hardscrabble folk were the world of her fiction, the back country of roadside red-clay banks and pine-lined horizons, the spiring chimneys of burned-out houses and scarecrows in cotton fields, gas pumps and chenille shops, itinerant preachers and tent revivals, and the highway body shop whose sign reads "Jesus Christ is the Way, Truth & Life. Free Estimates." "The South blossoms with every kind of complication and contradiction," she once told a reporter, and the paradoxes of the mid-twentieth-century South intrigued her. She had an eye for detail, and an ear for eccentric turns of phrase. But "country" meant something more to O'Connor. It was "everything from the actual countryside that the novelist describes, on to and through the peculiar characteristics of his region and his nation, and on, through, and under all of these to his true country, which the writer with Christian convictions will consider to be what is eternal and absolute." Her deep religious faith inclined her to look for mystery— the strange workings of God's will in human affairs—and that in turn led to her fascination with the grotesque, the maimed and inexplicable. She was suitably wry on the subject. "Whenever I'm asked why Southern writers particularly have a penchant for writing about freaks," she explained, "I say it is because we are still able to recognize one." The "eternal and absolute" she aimed for give her fiction its allegorical flavor. "Of course," she wrote, "I have found that anything that comes out of the South is going to be

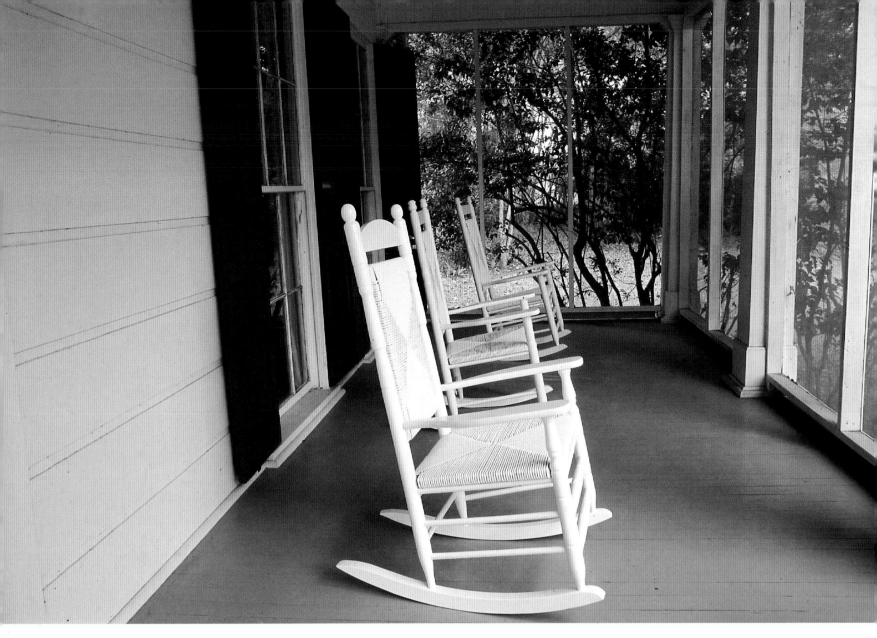

called grotesque by the Northern reader, unless it is grotesque, in which case it is going to be called realistic." Simple realism was never her goal, in much the same way that she could say, "The Georgia writer's true country is not Georgia, but Georgia is an entrance to it for him." In the sliver of difference between farce and horror, she searched for transcendence.

The lives she wrote about and the life she herself lived were far apart. Her family was genteel, well educated, and mildly successful. Born in Savannah, Flannery and her mother had moved from Atlanta in 1938 to Milledgeville where she attended school and college. O'Connor's uncle, Bernard McHugh Cline, a prominent Atlanta doctor, had purchased a property outside of town where she often visited. He had bought it in parcels between 1931 and 1933, in the end accumulating 544 acres in the rolling hills at the edge of the Piedmont, with a plantation house and outbuildings. He called it Sorrel Farm, and in his spare time raised horses there and ran a dairy farm for which his sister, Flannery's mother, Regina, kept the books.

Riding home on a train one day, Flannery fell into a conversation with a woman who remembered that the farm, before the War Between the States, had been called "Andalusia." Thinking it far more exotic, Flannery persuaded her uncle to change the name of his farm. When Bernard died in 1947, he left it to his sister Regina and brother Louis. By this time, Flannery's stories were beginning to appear in prestigious magazines, the literary world was beginning to pay attention, she enjoyed stays at the Yaddo writers' colony and for a time moved in with friends in Connecticut, determinedly writing four hours every day. But by 1950, something was badly wrong. She was first diagnosed with rheumatoid arthritis and returned to Milledgeville for cortisone treatments. But before long, the doctors knew it was lupus erythematosus, the same disease that had killed her father in 1941 at the age of forty-five. (It was not then known that lupus is genetically transmitted.) Her mother decided to withhold the diagnosis from her, fearful that news of an incurable disease would only cause a further

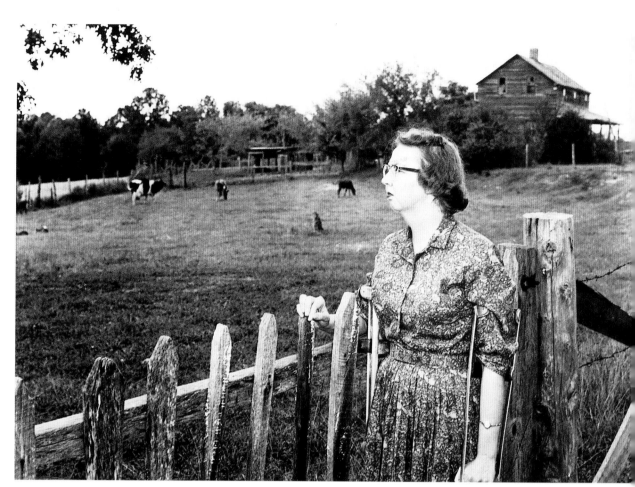

decline. O'Connor was too weak even to climb stairs, so in 1951 she and her mother moved from town to Andalusia, where Flannery was given a bedroom on the ground floor, at the front of the house. She worked on revising her first novel, while her mother ran the dairy farm. Flannery's condition fluctuated, with frequent blood transfusions and constant injections. But the novel, *Wise Blood*, appeared in 1952, not long before she learned the real truth about her health. From then on, she had only her religious faith, her mother's devotion, and the peace and quiet of Andalusia to sustain her.

When her health permitted, over the years left to her, O'Connor would travel for speaking engagements; she even went to Europe, where she felt a visit to the shrine at Lourdes helped her. But for the most part, travel meant a trip to town for a social event or to attend mass at the Sacred Heart Catholic Church. The rest of her time was spent at the farm. The house itself, dating from the 1850s, is a classic two-over-two, lengthened in the back by two shed-roof additions, and on the eastern side by the addition of two rooms for Uncle Louis. On the front of the house is a great screened-in porch with a set of white wicker rocking chairs, from which the property can be savored. There is a live oak directly in front of the house, like an attendant spirit, and at a greater distance white oaks and

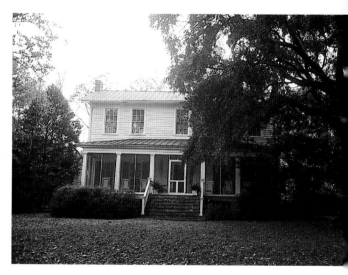

magnolias, hickories and pines. To the rear are pecan trees and cedars, where O'Connor's peacocks would perch. In 1952, she placed her first order to a breeder in Florida and was sent a pair of three-year-old peafowl and four chicks. To the rear of the main house was a garage known as the Nail House, and she extended it with pens and runs for her birds. She eventually had about forty peacocks and peahens. "I used to say I wanted so many of them that every time I went out the door I stepped on one," she wrote to a friend. "Now every time I go out the door, one steps on me." And to them she added

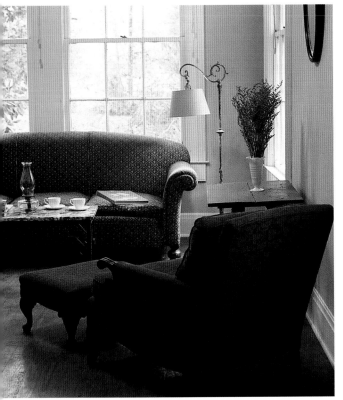

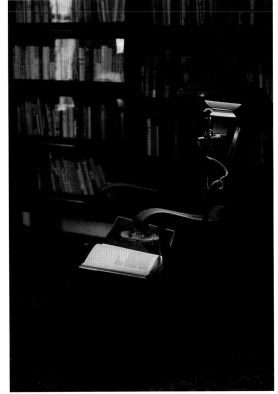

guinea fowl, ducks, Chinese geese, swans, and chickens—a brood that she tended daily with affection. Nearby is the house Jack and Louise Hill lived in, with their boarder Willie "Shot" Mason. Along with Joe Butts, they looked after things and helped the women in the main house with the farm. There were also three tenant shacks on the property, sometimes occupied by hired help, and, after the war, by a Polish family living in one of them at the behest of a Catholic relief agency. There is also a machine shed, a clay-tiled milkhouse where cans of milk were stored, and the dairy barn itself, with a milking parlor below and a hay loft overhead, where bales were taken up with a pulley and hinged hayfork. To one side is the silage ditch, where ground corn was stored for wintertime animal feed. The herd—pastured separately, milk cows, dry cows, and bulls—was driven to the pond-flecked fields beyond.

The O'Connors were never a wealthy family, though they lived in houses that belied that fact. Inside, Andalusia was comfortable, but the paintings on the wall were mostly by Flannery, and the curtains had all been stitched by her mother. The main hallway is large and bright, and to the right is a dining room that was also used as a parlor. The dining table which Mrs. O'Connor insisted be called a tea table and chairs are in its middle, but there is also a sofa along one wall. Heavy carved sideboards with marble tops dominate one side of the room, and staring at them from the wall opposite hung Flannery's well-known self-portrait with peacock. Over the fireplace mantel hung an engraving of a Scottish hunting scene, and nearby was a spindle-turned étagère with its shelves of dishes and figurines. Through the swinging door lay the kitchen, and the "back parlor" with large walnut bookcases and Victorian furniture added by Uncle Louis, where Flannery would receive visitors. Upstairs were two rooms for guests. Regina kept her bedroom downstairs, adjacent to Flannery's, obviously to be near her daughter in case her help was needed.

Flannery's bedroom was also her study. Its walls are lined with glass-fronted bookcases, and her writing table is in the middle of the room, backed by a chiffonier. It was here she wrote routinely, every morning until noon. It was a short distance from her bed, and nearby were her Morris reading chair and a phonograph, with a stack underneath of LPs of music by Beethoven, Schubert, and Scarlatti. The room has the air of a writer's orderly clutter, the heavy reference books and the frail, useless mementos that help to dredge up things into words. There is a black-painted brick fireplace in her room, for instance, and on its mantel are shells, bird bookends, a lens for her box camera, a postcard of a detail from a Botticelli painting, photographs of friends (and one of herself as a child standing with a great aunt), a bottle of aspirin and a Yardley cologne stick, an eggcup and candy box. There is a chipped piece of "Disappointment Agate," and a drops dispenser from Overstreets Pharmacy, phone 452–2255. On the prescription label is typed, "Miss Flannery O'Connor. Drop in ears as directed. Dr. Fulghum. 3-19-62." And

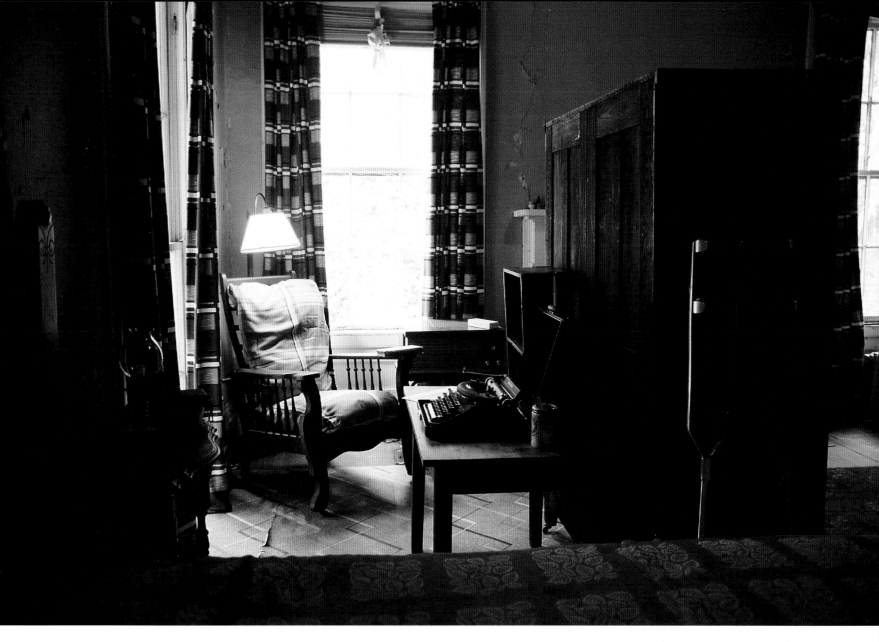

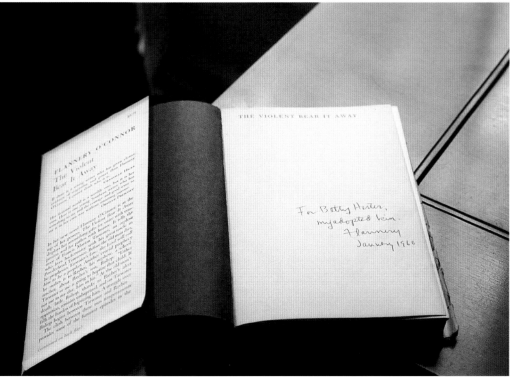

above, hovering over everything in fact, is an engraving of the Sacred Heart.

Of necessity, much of O'Connor's contact with the world beyond Andalusia was through her voluminous correspondence. But the farm became a sort of pilgrimage stop for her admirers, and local friends with stories—even people who'd just heard she was a writer—would constantly be stopping by. Her mother would supply her with anecdotes of her trips to town, and Flannery herself pored over Milledgeville's weekly newspaper, the *Union-Recorder*, and the advertisements in the *Farmer's Market Bulletin*. From the extraordinary details of ordinary life she made harrowing fictions. In a letter to a friend she reported on a student she had met during a reading tour of Texas who "fixed me with a seedy eye and said, 'Miss O'Connor, what is your motivation in writing?' 'Because I'm good at it,' says I. He thought I hadn't understood him right." By now, everyone understands she was right.

Eugene O'Neill

1888 – 1953

OPPOSITE: In O'Neill's study. The paneled walls and ship models were a nostalgic effort to recall his days at sea and his childhood in New London, Connecticut. At one time he had a larger collection of ship models, all made by Don Pace—five clipper ships and a Chinese junk. "You see," he wrote, "one of my greatest interests in selecting these models is to have before me, comparatively, the changes in the McKay design in the fastest ships, to have them all on tables side by side."
RIGHT: The front of Tao House.

On Eugene O'Neill's desk at Tao House there is a photocopy of a page of manuscript in the playwright's spidery hand, as an example of what went on day after day there: the drama of making memories into words, into scenes, into plays. The letterhead on the page reads "Le Plessis," which was the thirty-six-room chateau near Tours that O'Neill and his third wife, the actress Carlotta Monterey, had rented in 1929 and lived in for three years, while he worked on *Mourning Becomes Electra*, the play that led to his Nobel Prize in 1936. But on this page stolen from the past he is at work on another play. The page is dated June 39 in the top left corner, the very month when he first conceived of the new play. The French address has been crossed out, and the play's title written above it: "A Long Day's Journey." He hasn't quite worked out the title yet. Should it be called "*The* Long Day's Journey"? Then, in the margin, he tries out other possible titles. "The Long Day's Immuration." Perhaps "The Long Day's Retirement." Or "The Long Day's Retreat." The question is left unresolved. Then he lists the characters, the setting, the division of acts, but again each has alternatives. The character listed as "The Husband and Father," for instance, might be called Edmund Tyrone, but then again he might be called James Lutrell. "The Wife and Mother" might be Mary, or perhaps Stella. Should the direction for Act Two say "12:45 p.m." or "just before lunch"? And so on. Day after day, for two years, O'Neill wrestled with a thousand such decisions. What reads today with the inevitability of a classic was, during its composition, a struggle over small words and nuances of emotion. For two years, O'Neill would rise early, have breakfast on a tray in his bedroom, then retreat to the adjacent study and work until the early afternoon. "Orders were," his wife recalled, "that

nobody was to go near him, not even if the house was on fire. He was never to be disturbed." But of course *disturbed* is exactly what he was. Dredging up the bitter memories of his tortured family as he was growing up in the New London summer cottage named "Monte Cristo" in honor of his actor-father's most celebrated role on the stage was as difficult a task as he had ever undertaken. He grew more and more obsessed with the process. He slept badly, and worked later and later, often weeping as he wrote. At night, wracked with insomnia, he would go into his wife's bedroom and wake her to talk about the play and his anguish. "He explained to me that he *had* to write the play," she later said. "He had to write it because it was a thing that haunted him and he had to forgive his family and himself."

As the son of an itinerant actor, O'Neill never had a permanent home other than his imagination, and he searched restlessly for a calm place to live and work. In 1931, he and his wife—who longed for a lively social life after years of isolation in France—leased an apartment on Park Avenue in New York, but within months O'Neill realized he couldn't work in the city and would

have to move. They built a beach house on Sea Island, Georgia, and called it Casa Genotta (a combination of Gene and Carlotta), but the roof leaked and the heating malfunctioned. His health was precarious; there were drinking binges; he was depressed and often on the verge of collapse; and by 1934 his right hand had developed a tremor as a side effect of the insulin he was taking. But, when allowed by his doctors, he pressed on with his work, honing in play after play his sense of the tragic, and conceiving of a giant cycle—never completed—of eleven plays that would chronicle nothing less than the psychological and economic course of American history. He came to think that north-

ern California, which he remembered touring with his father as a boy, might provide the seclusion necessary to recover his health and finish his cycle. Friends convinced O'Neill and Carlotta that Seattle would be better, and no sooner had they gotten off the train there than news reached him of the award of the Nobel Prize. The honor sent him into a further depression—and it seemed best to move south. They checked into the Fairmont Hotel in San Francisco, but his health continued to deteriorate, and the Swedish consul had to bring the Nobel Medal and certificate to O'Neill's hospital room. He was determined to stay in California, and Carlotta (born Hazel Tharsing, she was a native Californian) started searching. There was too much fog in one direction, too many socialites in the other. But when a real estate agent showed them a property above the small town of Danville, about thirty-five miles from San Francisco, in the San Ramon Valley, she knew she had found the right place, isolated and peaceful, a place where O'Neill could work. They purchased 158 acres, tore down the adobe farmhouse on the property, and began planning the construction of a new home.

At the time, O'Neill wrote to a friend that Tao House was "the final home and harbor for me." It is nestled on a slope of the Las Trampas Ridge, a mosaic of oak woodland and grassland green in winter, brown in summer. There were almond and walnut orchards nearby, and the vista from

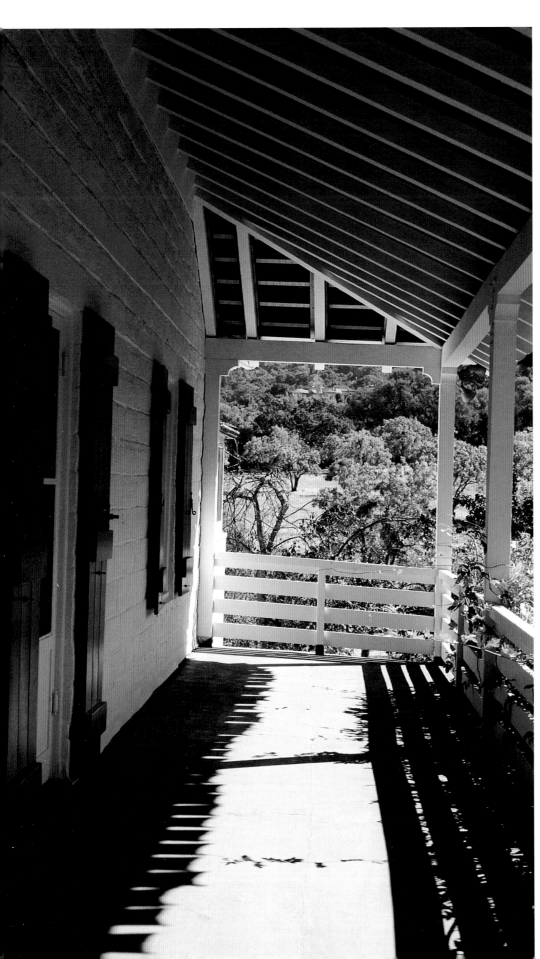

the house was out over the agricultural valley, dominated in the distance by Mount Diablo—"one of the most beautiful views I've ever seen," said O'Neill. A car climbs a long road up to the house, ending in a turnaround circled with sycamore trees, with an oak in the middle, facing the courtyard wall that shields the house itself from easy view. As its name suggests, the house was meant to display Carlotta's fascination with the Orient. The term Tao, before it was used as the name for Lao Tzu's philosophical system, referred to the revolution of the heavens around the earth, and came to designate the cosmic energy behind the visible order of nature, abstract, eternal, and omnipotent, working for the highest good in all things. A visitor entering the courtyard will see how Carlotta's obsessions worked themselves out. At first sight, from the courtyard gateway, the house looks like a handsome mission-inspired Monterey Revival-style edifice, but the box-lined brick path to it zigs and zags, arriving at—wait, there is no front door! Her enchantment with Asian arts and philosophy led her to design the courtyard and house on feng shui principles, so that the angles of the path are meant to capture the good *chi* or energy and to thwart the bad. (Hence the lack of an obvious

same time, Carlotta's taste in plantings was eastern (as in Massachusetts), and she was continually making flowerbeds of, for example, peonies that wilted and died. The walls are covered with star jasmine, there is a large chinaberry tree, a locust, and a plum, along with swaths of magnolia, oleander, and wisteria. Oddly, there is an Italian-style, cast-cement birdbath, with a seahorse fount, but there is also a small fish pond and the terrace is outlined by stones, punctuated by larger "guardian stones" meant to invite good spirits within.

The house itself, just a single room in depth, is built of baselite, an early type of poured-concrete block, painted white, inside and out. One notices the feng shui touch at once. The floor is made of Mexican clay tiles, but they are laid in no pattern, to represent the randomness of life on earth. Overhead, the ceilings are painted blue. That of the entrance hallway is a very dark blue, and the ceilings of the rooms that radiate off it are each a paler shade of blue to replicate the effect of staring at the sky, the intensity of whose color diminishes as the horizon is approached.

The entrance hall is decorated with a series of Oriental masks, an appropriate detail in a playwright's home, and especially that of O'Neill, who made use of masks to explore dual identities in such innovative plays as *Strange Interlude* and *The Great God Brown*. A pair of carved wooden Fu dogs guard the staircase.

Carpets and chests, decorative plates and reading chairs—Carlotta filled the house with Chinese accents. In fact, she had gone to Gump's department store in San Francisco and ordered up a stockpile, including a bed for her husband that had formerly graced an opium palace, screens and lamps, a Manchurian desk and T'ang horses, and a pair of pottery elephants to lead the way to the swimming pool they built for O'Neill to exercise in. The effect was of an oasis of civilized calm. Off the modern kitchen were quarters for three servants, including the indispensable Herbert Freeman, who first worked for the O'Neills in Georgia and moved west with them to tend to the Tao House property, while also serving as chauffeur, gardener, and jack-of-all-trades.

OPPOSITE: The entrance hall of Tao House, looking toward the living room. The outside of the stairwell was decorated with a series of masks, African, Chinese, Japanese, Noh, and American Indian. Masks seem an appropriate collection for a playwright.

ABOVE: The living room. A pair of teak, two-fold screens flanked the entrance way, and elsewhere in the room were pieces of Chinese furniture—inlaid cabinets, a traveling desk, lacquer tables, and a Coromandel screen that faced a blue mirror. Carlotta had overseen the interior decoration of the house.

BELOW: O'Neill and Carlotta in their living room, 1943.

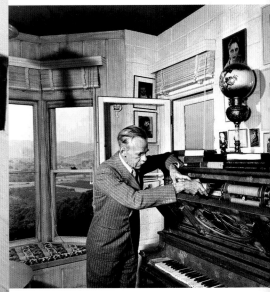

LEFT: In Rosie's Room. Rosie, a coin-operated player piano with its stained glass panels, was a present to O'Neill from Carlotta on his forty-fifth birthday. In her diary, Carlotta noted it was "the sort of piano that, in years past, was in salons and 'other places!' This particular one was in one of the 'other places' in New Orleans. . . . Gene is pleased—that is all I care about!"

BELOW: O'Neill changing the piano roll in Rosie, 1943.

OPPOSITE: One of Carlotta's dresses, in the dressing room off her bedroom. She was a theatrically elegant woman, sometimes called "The Swan," sometimes compared to Cleopatra. Ilka Chase, who acted with her, called her "the most immaculate creature I have ever known."

In the living room, as elsewhere in the house, built-in niches served as bookcases. At a certain point, Carlotta complained that the house was looking like a library; and in several niches she had Chinese screens installed to replace the books. In their elegant living room, they would read in the evenings. Guests were few. (There is only one guest room.) In part, Carlotta wanted to protect O'Neill's privacy, and in part she knew that too much alcohol flowed when old friends were nearby. Nearly every room in the house has a sweeping view toward Mount Diablo, and it is that note of natural sublimity that dominates the interiors, rather than wall-hung art. The anomaly downstairs is Rosie's Room, a small room off the entryway in

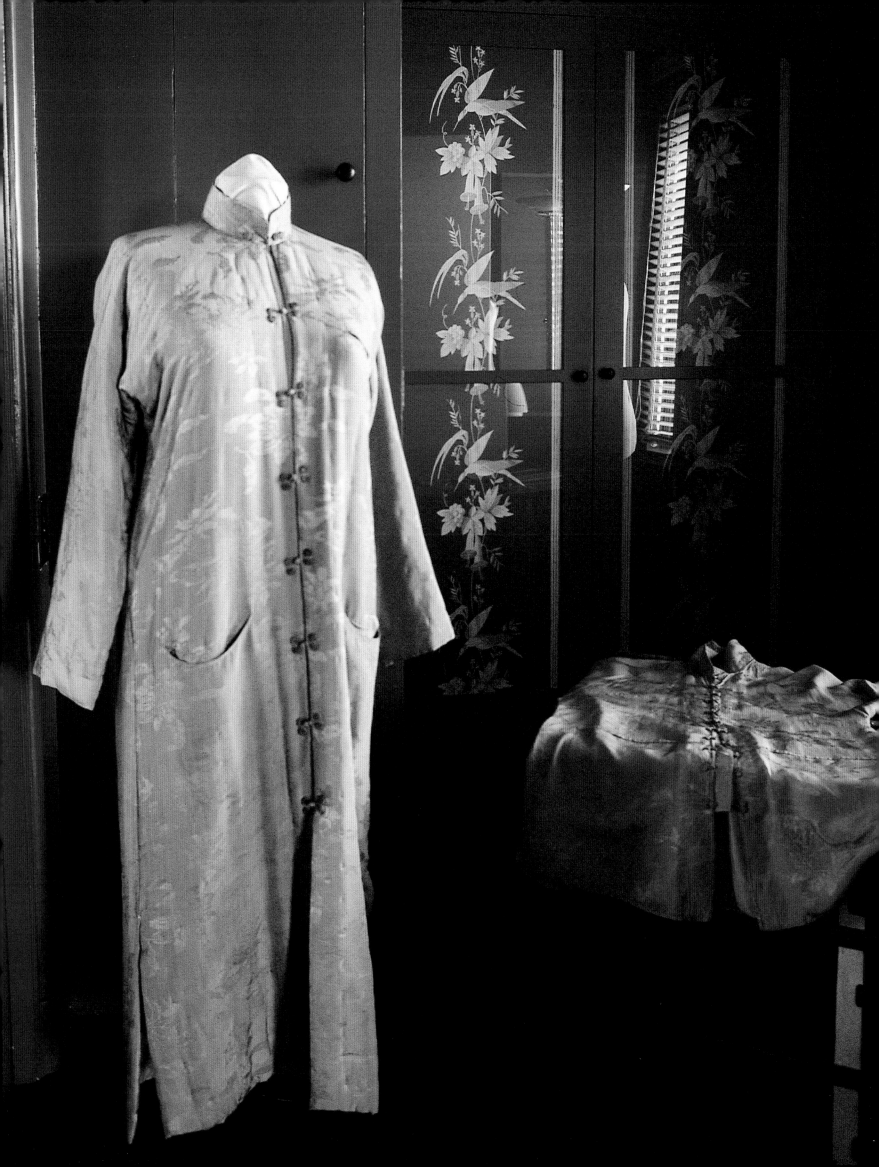

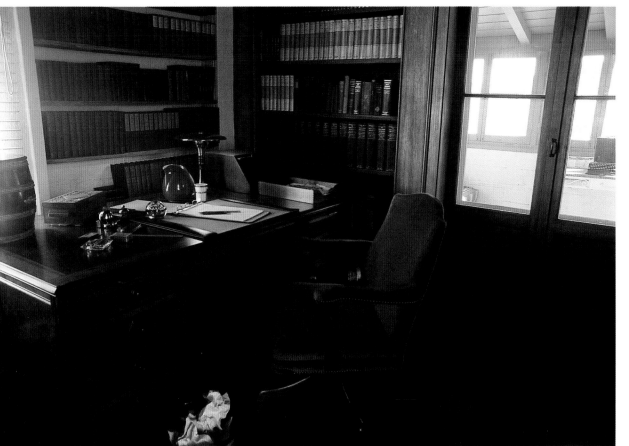

LEFT: One of two desks, on opposite walls, in O'Neill's study. His years at Tao House were the most productive of his career. While living in California, he wrote *Long Day's Journey Into Night*, *A Moon for the Misbegotten*, *The Iceman Cometh*, *Hughie*, and most of *A Tale of Possessors, Self-dispossessed*.

OPPOSITE: A spring couch and writing table on the sun porch off O'Neill's study.

BELOW: The view from the back of the house, looking toward Mount Diablo. "We stayed at Tao House for six whole years," Carlotta later said, "longer than we lived anywhere else. Of course, there were many hardships, but it was a beautiful place and I hated to leave."

which O'Neill kept Rosie, a player piano with green and pink stained-glass rescued from a San Francisco brothel. The walls in this room were covered with photographs, many of his father in various roles. There was also a phonograph and a large console radio. It was here that he and Carlotta would listen to the news in the evening, and follow war developments in Europe with the help of a large map tacked to the wall behind the radio.

Upstairs are their two bedrooms. Carlotta's is at the top of the stairs, so that she could function as guardian and intermediary. Everything Carlotta did was an elegant gesture, and her bedroom and dressing room had an imperial chic. There were no rooms for any other members of the family. O'Neill had failed as a parent, and his three children disliked Carlotta. (His two sons eventually committed suicide, and he disowned his daughter Oona when she decided to marry Charlie Chaplin, a man as old as O'Neill.) Instead, they devoted themselves to a beloved dalmatian, Blemie, whose full name was Silverdene Emblem O'Neill. Lord of the manor at Tao House, he had been born in England, and would later be seen at the end of a tooled leather leash on the Place Vendôme or Park Avenue in a raincoat custom-tailored by Hermès. He was served only the finest cuts of prime beef, and slept in Carlotta's bedroom—on a specially made bed fitted with silk scarves. At Tao House, he mostly chased

jackrabbits, and O'Neill referred to him as his "good and faithful friend."

To enter O'Neill's bedroom—and, beyond it and a large dressing-room, his study, the house's inner sanctum—is to enter another world from the rest of the house. Instead of the white-and-blue motifs found elsewhere, his bedroom is painted entirely in fog-gray, reminiscent of his days on the Connecticut shore of Long Island Sound. Between the windows facing Mount. Diablo, inset in the wall, is a tall black-tinged mirror. His study, paneled in faux-finished wood with a timbered ceiling, resembles a ship's cabin. Displayed on the walls are ship models, and (instead of, say, his Nobel Prize) the framed certificate of his discharge from the American Line as an able-bodied seaman, dated August 13, 1911. There are two desks in the room, each facing an opposite wall. He used them both, for different projects. A small sun-porch is beyond, and access to the second-floor balcony that wraps around the house.

It was in this study that O'Neill at first worked hard on his American Cycle. In the end, though, he abandoned his overly ambitious project, after completing *A Touch of the Poet* and *More Stately Mansions*. He felt something more urgent welling up, and began writing the plays that many consider his best, *The Iceman Cometh* and *Long Day's Journey into Night*, working so feverishly that he exhausted himself.

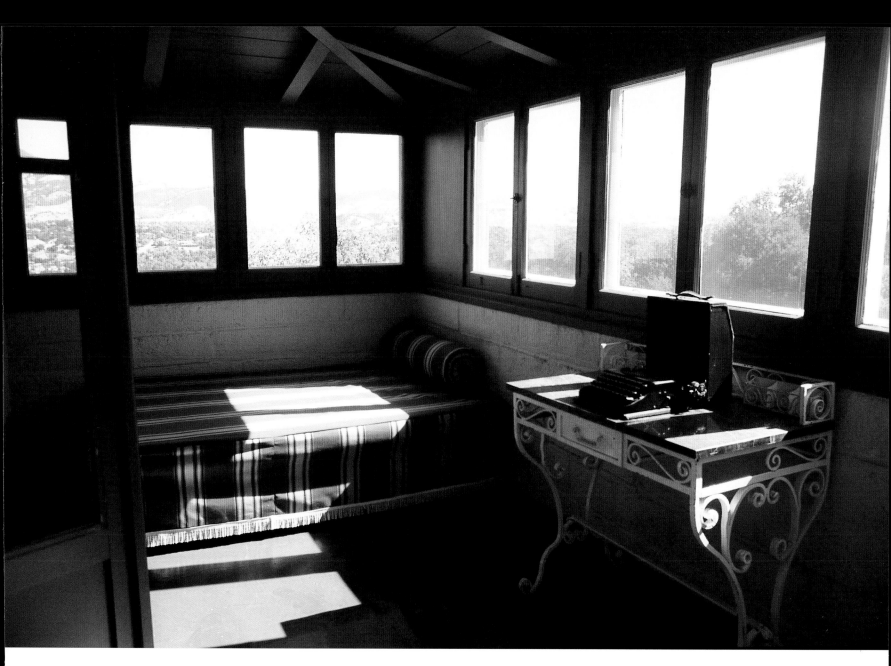

Tortured by his portrait of his addicted mother and miserly father—he called it "a play of old sorrow, written in blood and tears"— he did not want *Long Day's Journey* performed or published in his lifetime, or for long afterward, but he did present the completed manuscript to Carlotta on their twelfth wedding anniversary. It is a searing play that vindicates O'Neill's long-held belief: "To me, the tragic alone has that significant beauty which is truth." After his death, Carlotta defied his wishes and arranged for it to be performed, entrusting it to director José Quintero who in 1954 had finally made a success of *The Iceman Cometh*, which had been initially scorned. His 1956 production of *Long Day's Journey into Night* was a triumph, posthumously earning O'Neill his fourth Pulitzer Prize, and reviving his reputation.

Though he began one more play at Tao House, *A Moon for the Misbegotten,* he was having trouble writing. The tremor in his right hand was debilitating, and he would have to clench that hand with his left to steady it and keep the pen close to the paper. His handwriting grew illegible and the pain unbearable, to the point where he was forced to stop writing altogether. And as the rigors of wartime made life difficult, the O'Neills considered leaving California. Freeman enlisted in the army, and they found it impossible to keep the house in order without him. The Brahma chickens that O'Neill liked to look after (he named his favorite rooster "Sugar Ray" in honor of the boxer) had to be used for food or given away to neighbors. In a letter of December 28, 1943, Carlotta wrote, "All the chickens have gone. The beautiful Brahmas! Even the pets 'Doc' & 'Charlie.' It seems impossible for Gene & me to keep pets, homes, or anything!" By February 1944, they had sold the house, sold the furniture back to Gump's, and left for New York and the rootless life he loathed. He had lived in Tao House longer than in any one place his whole life, but it was not to be his final harbor. O'Neill died in a Boston hotel room on November 27, 1953, and his last recorded words were, "Born in a hotel room, and God damn it, died in a hotel room."

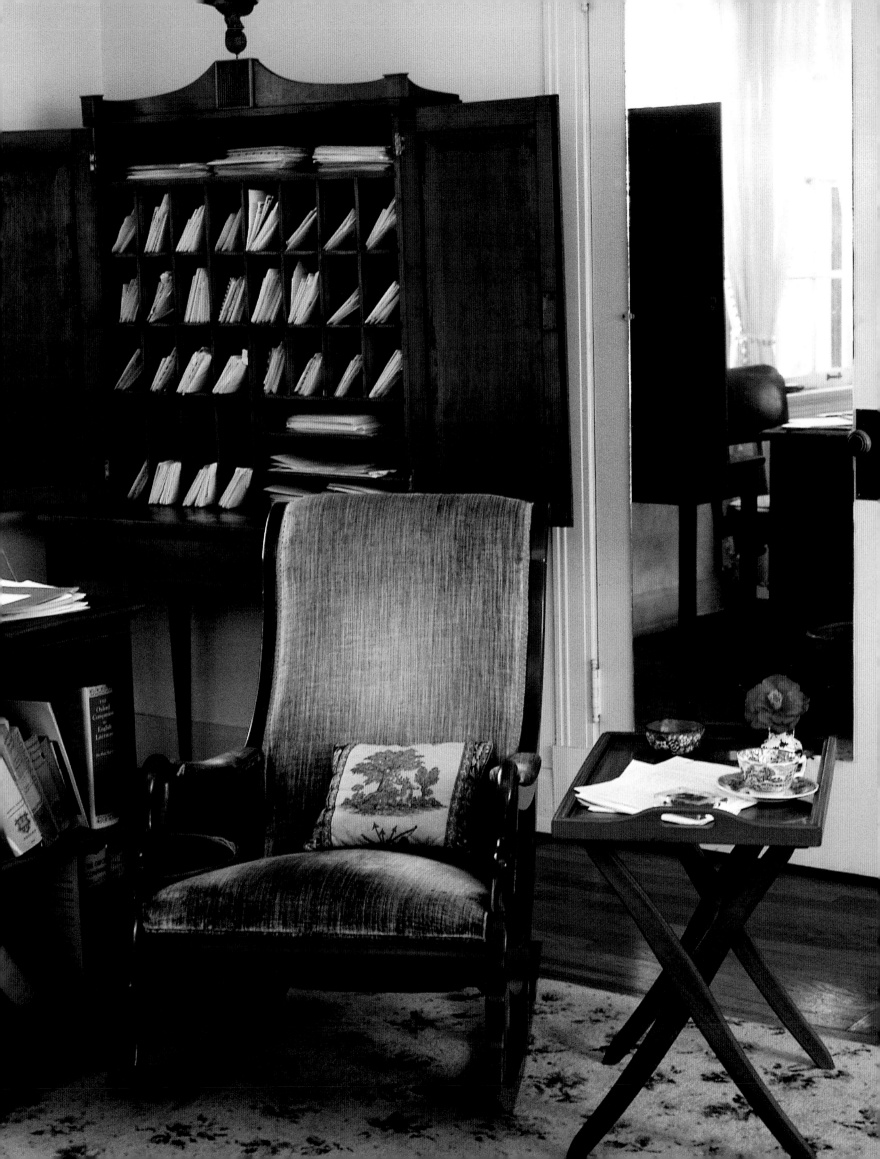

Welty
Eudora

OPPOSITE: At the front of her bedroom, near the desk where she wrote, Welty kept a tall secretary, its slots holding correspondence grouped by writers. Her many friendships were at the heart of her life, and she was the kind of author whose intimate tone encouraged strangers to write to her. "My God," she once told a reporter, "I don't know what they're trying to say, very often, or what they're trying to say I said. Some time ago, I got a long letter from some graduate student who had 'perceived' this parallel between my work and, of all things, Dante's *Inferno*. Or was it Milton's *Paradise Lost*? Oh, something. I never answered the letter. No need to. Whatever would I say?"

In the top drawer of the secretary in her sitting room, Eudora Welty always kept a little commemorative book that had belonged to her father as a boy. Grown-ups had written encouraging messages in it to speed him on life's way. One entry, though, is heartbreaking. He was seven years old and is addressed by his childhood nickname. "My dearest Webbie: I want you to be a good boy and to meet me in heaven. Your loving Mother." It is dated April 1, 1886—the very day she died. If Christian Webb Welty didn't speed toward heaven, he certainly kept his eye on the future. He grew up to become a successful insurance agent and eventually a director of the Lamar Life Insurance Company in Jackson. He was fascinated by science, by gadgets, and inventions. When he moved his young family into a new house in 1925, he bought an Encyclopedia Britannica for his oldest child, Eudora, who was named for her grandmother. Eudora's mother too was a determined woman. Born on a farm in the West Virginia mountains, she educated herself and became a teacher. It was not an easy life, but through it all she held on to her cherished set of Charles Dickens, which she later boasted had been saved from trials by fire and water. In fact, her daughter, Eudora, kept the set, and you can open one of the ragged books today and still find dried dabs of river mud. Young Christian Welty came from Ohio to West Virginia in 1904 to work for a lumber company and met and fell in love with Chestina Andrews. When they decided to marry, they vowed to make a new life for themselves. He gave her a choice. They would move either to the Thousand Lakes region in upstate New York or to Jackson, Mississippi. Chestina chose Jackson, though as their daughter wrote in her memoir, *One Writer's Beginnings*, "from rural Ohio and rural West Virginia, that must have seemed, in 1904, as far away as Bangkok might possibly seem to young people today."

Eudora Welty revered her parents, and saw to it that her own home became a shrine to their memory. But in one crucial way, she was not like her parents at all. It was the present and the past that fascinated her, not the future. Her novels and stories testify to her conviction that "fiction is properly at work on the here and now, or the past made here and now." Where her parents were intrigued by knowledge and improvement, she was drawn by observation and memory. Few writers have so cherished the past, for she lived in it, literally. The house that her father built in 1925, when she was sixteen, was the house she lived in for the rest of her life. Her bedroom was hers for more than seventy-five years. And in that room she wrote the novels that earned her a beloved reputation among readers and the esteem of critics, from *The Robber Bridegroom* in 1942 to *The Optimist's Daughter*, for which she received the Pulitzer Prize in 1972. Along the way were *Delta Wedding* (1946), *The Ponder Heart* (1954), which was made into a Broadway play, and the popular *Losing Battles* (1970).

But readers remain most strongly attached to Welty's short stories, beginning with her first collection and first book, *A Curtain of Green*. Katherine Anne Porter wrote an introduction to that book and praised Welty for having a blistering humor and a just cruelty: "She has simply an eye and an ear sharp, shrewd, and true as a tuning fork." This and later collections demonstrate her mastery of the form. Nothing is blurred, nothing is unremarked. There can be raucous humor, or an eerie stillness when her descriptions drape a light, gauzy surrealism over the narrative. Her poised moral sense of the ordinary is matched by her sympathy with the outcast. Though she wrote of England, Ireland, and New York, her best work was set in Mississippi, because she recognized that "we put out roots, wherever birth, chance, fate or

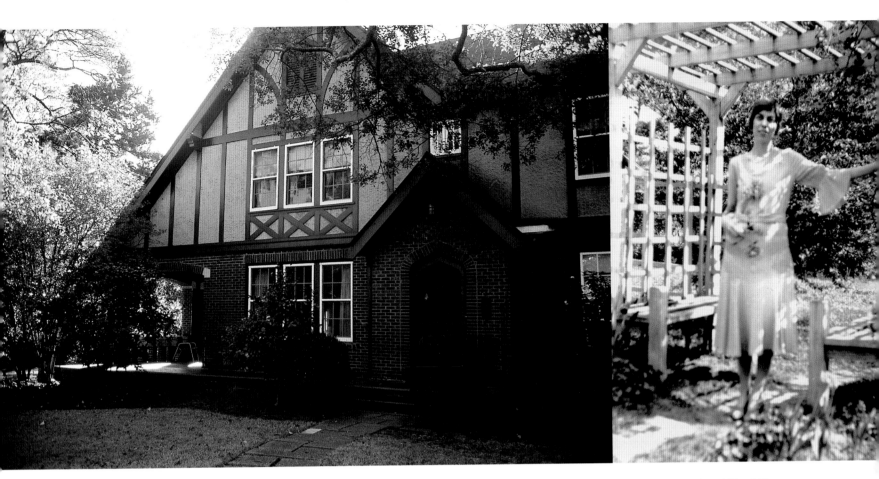

our traveling selves set us down" and that where those roots in turn "reach toward is the deep and running vein, eternal and consistent and everywhere purely itself, that feeds and is fed by the human understanding."

Her own roots were deep in Jackson. She was born in the family's first house there, on North Congress Street. On the same street was the state Capitol, and in order to get to the public library as a child, Welty would roller-skate through the Capitol's marble hallways, in the near door and out the far for her encounters with the strict librarian, Mrs. Calloway, who would allow her only two books at a time and would banish her if she was not wearing enough petticoats. There were books at home as well—from fairy tales to dictionaries—and the young Welty spent all her time dreamily among them. In 1925, the Lamar Life Insurance Company built a new headquarters, a six-story gothic building known as "Jackson's first skyscraper." Welty's father was so impressed by the Fort Worth architect who had designed it that he commissioned from him a new house for his family as well—not downtown but at the streetcar's farthest stop, quiet Pinehurst Street, across from the campus of Belhaven College, a Presbyterian school for women. The design of the house is of a familiar suburban type, Tudor with brick below and half-timbered stucco above. It sits on a lot of about three-quarters of an acre, back from the street,

and is ringed with camellia bushes, edged by pine and oak. Past an arbor and down steps through a small rock garden, there are flowers in the back. A perennial bed and a cutting garden face each other across a small lawn. Through another arbor are a rose garden and, at the rear, a woodland garden. Like her mother, and often with her, Welty was an avid gardener, and alludes to over 150 species of plants in her work.

To the left of the entrance hall is the large living room. Sofas and chairs make a wide semi-circle around the fireplace over whose mantel hangs a painting by Agnes Sims. Staffordshire statuettes of Shakespeare and Queen Victoria stand guard on the mantel, surrounded by photographs, decorative boxes, tin plates—the trail that travels and friends leave in their wake. On a wall of bookcases are her favorite writers: Colette and Joyce, Eliot and Auden, but also Henry Green, Elizabeth Bowen, Virginia Woolf, William Trevor, Howard Moss, Mary Lavin, Peter Taylor, Willa Cather. In one corner, flanked by the front window and a pair of French doors leading to the porch, is her chair, and beside it the little TV-tray table where she kept a copy of *Brewer's Dictionary of Phrase and Fable* along with a box of chocolates and a pile of letters to be answered. It is the bane of every writer's life to be sent—every day, it seems—new books by hopeful publishers and dog-eared manuscripts by eager authors. Radiating out from Welty's chair

LEFT: 1119 Pinehurst Street. The porch on the left had at one time been enclosed, until a hurricane changed things.

RIGHT: Welty in the arbor of her garden, c. 1930. "When I first began to write," she later recalled, "I hadn't worked in the garden the way I came to do later, and I may have made plenty of mistakes in those first stories which I don't know. I once got a letter from a stranger after I published a story called 'The Wide Net,' I think. Anyway it was in that first book, and he wrote and said, 'Dear Madam, I enjoyed your stories, but bluejays do not sit on railroad tracks.' And sure enough, they don't. But you know, I didn't think anything of it. I didn't know anything about birds. Probably bluejay was the only name I knew at the time. But that's the kind of thing you don't want to get wrong."

RIGHT: As you enter the house, you would turn left into the living room, or right into the sitting room pictured here. It was once her parents' bedroom. During her later years, having decided to leave her house to the state of Mississippi, she wanted to ensure that it would in part be a shrine to her parents, whose memories she cherished above all else. She commissioned several portraits of them, hung now about the house. "They were extraordinarily sympathetic parents, both of them," she recalled. From the beginning, they encouraged her efforts to be a writer.

are piles of these books, cluttering the sofa, in stacks on the carpet, piled on the cocktail table, along with copies of the daily *New York Times*, this week's *New Yorker*, and back issues of *Natural History*. She would sit here in the afternoons, reading her mail, or in the evenings to entertain her lively circle of friends. Late in the day, she'd enjoy a bourbon or two, and walk across the hall to her sitting room to watch "The MacNeil/Lehrer Report" on television.

On the other side of the room is the Steinway upright bought for her when she was nine by her mother, "so far beyond her means," Welty recalled, "and had paid for herself out of the housekeeping money, which she added to by buying a Jersey cow, milking her, and selling part of the milk to the neighbors on our street, in quart bottles which I delivered on my bicycle. While I sat on the piano stool practicing my scales, I imagined my mother sitting on her stool in the cowshed, her fingers just as rhythmically pulling the teats of Daisy." When Welty was grown, her mother gave the piano to one of Eudora's brothers, for his children to play on, but in her final years (she died at home, after a long series of illnesses, in 1966, cared for to the end by her daughter) she asked for the piano to be brought back to the house so she could hear the old songs played again. After her mother's death, Welty gave the piano away again, this time to her niece's children. But in the early 1990s, wanting herself to hear those same old

LEFT: The sitting room. In the secretary—a gift from Welty's father to his wife—she kept special editions of her work, and the copies of her novels especially inscribed to her mother. In its bottom drawers are family Bibles and her father's watches.

BELOW: The dining room. The table was usually stacked with papers that had to be cleared away for dinner parties. The portrait is of her father.

OPPOSITE, ABOVE: The living room. Welty's favorite reading chair is the flower-print Queen Anne chair on the left.

OPPOSITE, BELOW: Her sister-in-law, Mittie Creekmore Welty; her mother, Chestina Andrews Welty; her brother, Walter Welty; and Eudora Welty in the living room during the 1940s.

OVERLEAF: Welty's bedroom, from behind the desk where she wrote. "I'm a morning person," she once said. "The earlier I can begin, the better. I wake up knowing what I want to write—when I'm in progress with a story. So I wake up ready to go, and I try to use that morning energy and freshness."

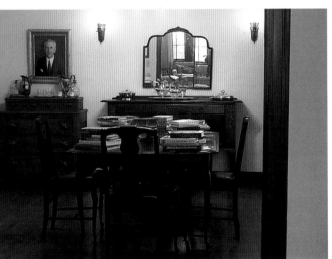

songs, she asked for the piano to be returned— one last time.

The sitting room across the hallway— originally her parents' bedroom—is also lined with bookcases; in one of them is her set of Mark Twain, a revered author in the household. Above them are hung small prints and engravings, along with a framed Christmas card from Bernard Berenson and an encouraging letter from E. M. Forster. She used to chuckle over its very British opening, "Finding myself in your country . . ." The handsome secretary in the front of the room, a gift from Welty's father to his wife, houses the special editions of her

books that Welty inscribed over the years for her mother. Here too are the family Bibles, her father's watches, and one of his telescopes. In one of its drawers is a small appointment book from 1952, which she kept to jot down names she might use in future stories: Listerbee, Hubbard, Growan, Pargetter, Hassle, Mr. Freathy. In another drawer, she kept a piece of paper all childishly scribbled over, with a notation at the bottom in her mother's hand: "From Eudora Alice, age 4 months. Her first letter. Aug 31, 1909." To the rear of the house are the dining room, with pieces belonging to her parents— sideboard, cabinets, and a dining table that was often piled with books and cleared off only for company. On one wall during her lifetime were two landscapes by the noted Mississippi painter William Hollingsworth. Here too is her old record player, an Aynsley Dynaphone, on which she loved to listen to both classical music and jazz. A plain kitchen, and a breakfast room overlooking the gardens, follow. On the wall of the breakfast room, Welty had framed a letter from the artist Joseph Cornell. It is dated 1945 and typed on a long blue sheet of paper which Cornell had decorated with one of his strange collages. It was written in response to her story "The Winds," and reads in part: "Anyone who can write so authentically about little girls like Josie and Cornella I consider a special kind of person."

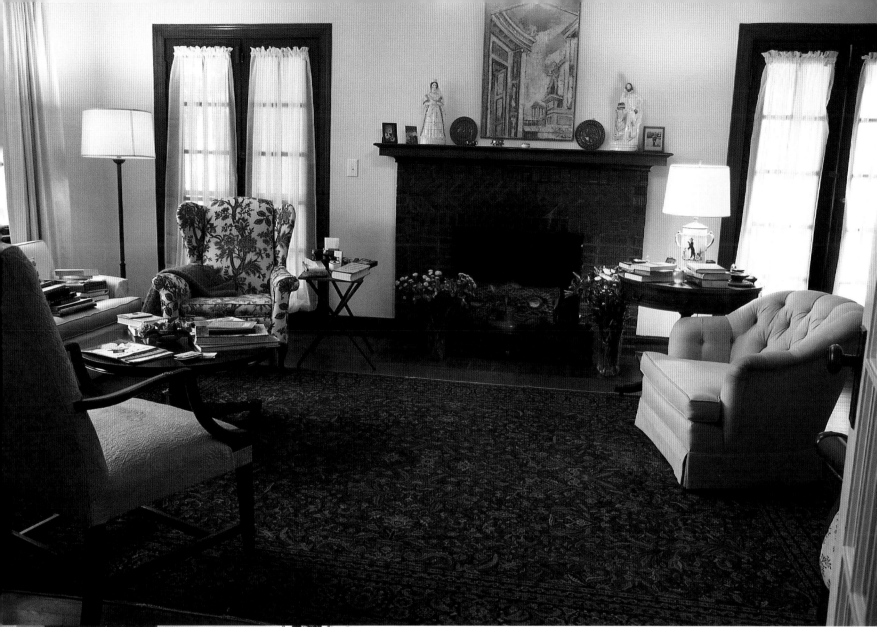

The second floor has two bedrooms and an enclosed sleeping porch. The guest room, once used by her young brothers, became yet another storeroom for books, including the paperback mysteries she enjoyed. She sorted and kept all the correspondence she received, so there are teetering cardboard fileboxes filled with letters. On top of one is her old Kodak box camera with bellows. Her own bedroom, at the front of the house and over the living room, seems nearly austere by comparison with the spillover in the rest of the house. Against the rear wall is a four-poster bed with pineapple finials. Over her dresser is an inscribed photograph of V. S. Pritchett, and over the fireplace are a Pierre Bonnard lithograph and several color pencil drawings by Æ (George Russell), whose son Diarmuid was Welty's lifelong agent and friend. Her desk is at the front of the room where she could sometimes hear music students practicing at the college across the street as she worked. Her old Smith-Corona electric typewriter is there, and beside it her manuscript pages. (She used to cut up pages and attach the

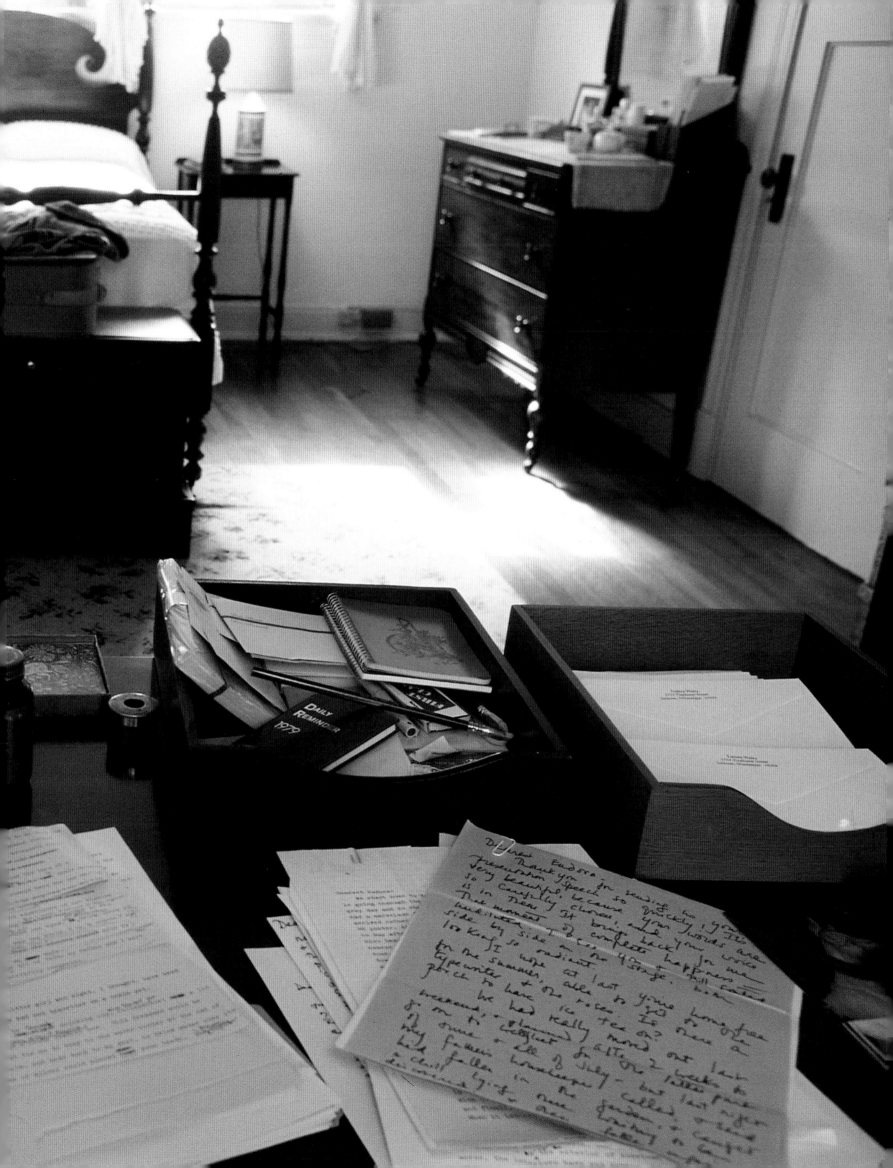

passages she wanted to keep with straight pins.) More correspondence boxes are piled up along the walls, together with a plain old metal filing cabinet. Welty's friendships were legendary. Her lively circle of friends in Jackson treasured her genial and witty company, but she maintained dozens of epistolary friendships as well, and the boxes testify to her loyalty. Next to her desk is another secretary, whose doors open on to columns of slots that also held mail. Behind her are more bookshelves, with reference books and editions of Yeats and Chekhov and Jane Austen.

She lived in this house so long it is sometimes easy to forget that she traveled a good deal, especially as a younger woman. It was when she first went, in 1925, to the Mississippi State College for Women in Columbus that she heard a variety of accents and began to understand just how complex her own small part of the world was. That led her to insist on exploring further, so she transferred to the University of Wisconsin. But, weary of Madison's "icy world," she grew homesick. It was a pattern

that persisted. She once tried to explain the emotional dynamics in her family:

Taking trips tore all of us up inside, for they seemed, each journey away from home, something that might have been less selfishly undertaken, or something that would test us, or something that had better be momentous, to justify such a leap in the dark. The torment and guilt—the torment of having the loved one go, the guilt of being the loved one gone—comes into my fiction as it did and does into my life.

Though she would later live for extended periods in New York and San Francisco, and travel all over Europe, it was always to Jackson—to her parents' home—that she returned to live. "I am a writer," she wrote, "who came of a sheltered life. A sheltered life can be a daring life as well. For all serious daring starts from within." True enough, though what is *without* has first to be brought within. Welty was a passionate observer with an uncanny memory, so that a cascade of vivid details was the foundation of her fictions. A brilliant example of her eye are the photographs she took as a publicity agent for the Works Progress Administration in the late 1930s, when she traveled throughout Mississippi to record WPA projects and the people they were meant to serve. (It is odd that none of those photographs are on the walls of her home.) They are masterful studies, every bit as exacting and compassionate as the photographs of Walker Evans.

Welty lived through tumultuous times in Mississippi. The state never recovered from the poverty inflicted on it first by the destruction of the Civil War and then by the Great Depression. In photographs and in prose, she recorded its history. In both, she kept her distance. "My temperament and my instinct," she wrote, "has told me alike that the author, who writes at his own emergency, remains and needs to remain at his private remove. I wish to be, not effaced, but invisible—actually a powerful position." Perhaps living at home allowed her both the intimacy and the perspective she needed. Even at home, however, she was an outsider. A lifelong Democrat in a deeply conservative region, she once joked that her car carried the only "Dukakis for President" sticker in the entire state. One need only look at her photographs to see her fascination with, and sympathy for, the African-Americans in her state. It was a place where, as several of her stories recount, a boy's first toys were a cap gun and a "nigger-shooter." But she was not a crusader; she distrusted the menace of neat generalities in any zealous argument. A novelist, she felt, has higher responsibilities. Once,

though, her patience broke. It was June 13, 1963. Almost a year earlier, James Meredith had integrated the University of Mississippi under the protection of federal marshals, and Medgar Evers, the field secretary of the Mississippi NAACP, helped him in this historic move. But on the night of June 12, Evers was fatally shot in his own driveway. The very next day, Welty sat down to write a story, "Where Is the Voice Coming From?," a nighttime assassination told from the murderer's point of view. It is a chilling study in bigotry and hatred.

As soon as I heard wheels, I knowed who was coming. That was him and bound to be him. It was the right nigger heading in a new white car up his driveway towards his garage with the light shining, but stopping before he got there, maybe not to wake 'em. That was him. I knowed it when he cut off the car lights and put his foot out and I knowed him standing dark against the light. I knowed him then like I know me now. I knowed him even by his still, listening back.

Never seen him before, never seen him since, never seen anything of his black face but his picture, never seen his face alive, any time at all, or anywheres, and didn't want to, need to, never hope to see that face and never will. As long as there was no question in my mind.

He had to be the one. He stood right still and waited against the light, his back was fixed, fixed on me like a preacher's eyeballs when he's yelling "Are you saved?" He's the one.

I'd already brought up my rifle, I'd already taken my sights. And I'd already got him, because it was too late then for him or me to turn by one hair.

She sent the story to her editor at *The New Yorker*, the renowned William Maxwell, who told her the magazine wanted to print it in their very next issue. Before then, though, Evers' murderer, Byron de la Beckwith, was arrested. (After two trials ended with hung juries, Beckwith was convicted.) He so resembled the portrait of him imagined by Welty that the magazine asked her to make changes in the story. Even then there was worry. Just as the story was being set in type, an anxious Maxwell telephoned to ask if Welty was not concerned that, once published, the story might incite the Ku Klux Klan to burn a cross in her front yard. She just laughed, and replied, "People who burn crosses in front yards don't read *The New Yorker*." She was a woman who savored the ironies, and challenged them, and she stayed at home to do so.

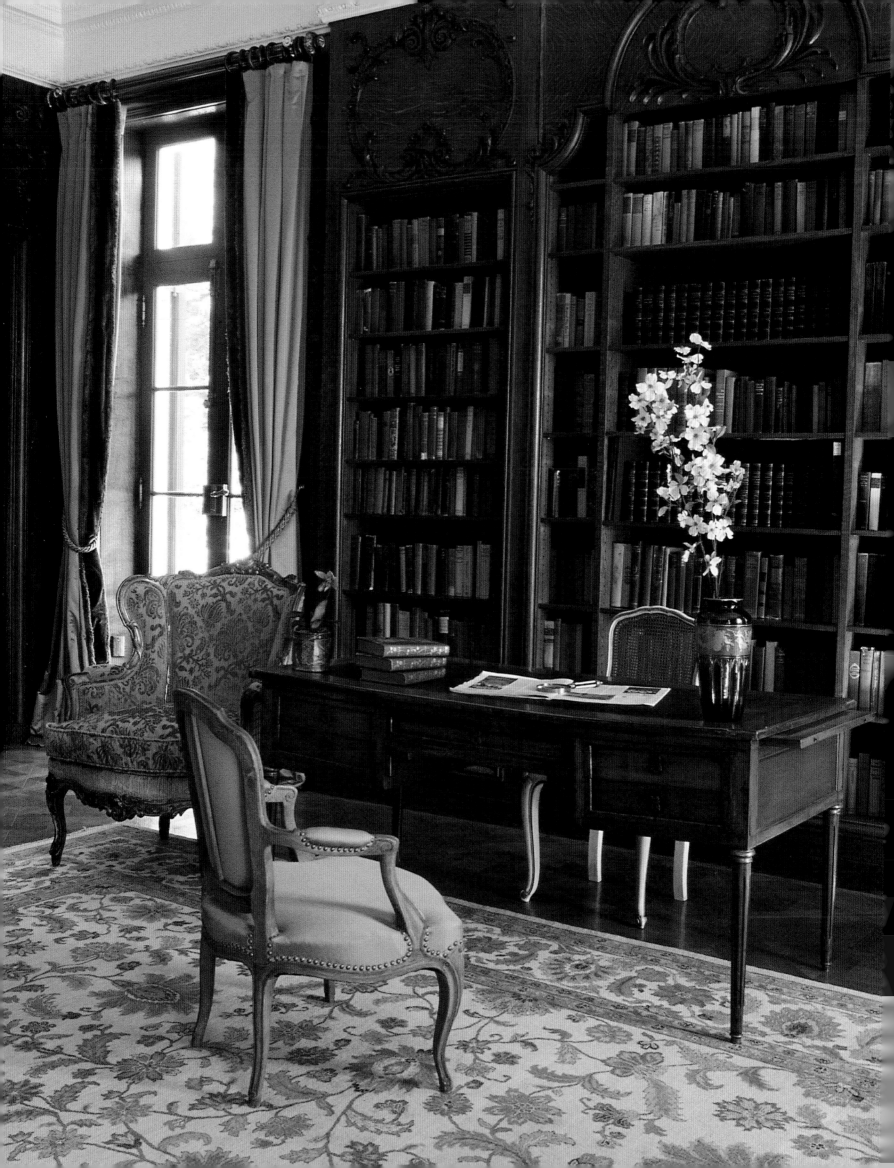

E d i t h
Wharton

1 8 6 2 - 1 9 3 7

OPPOSITE: Her desk in the library at The Mount. She used it only for correspondence, preferring to write fiction in bed. Looking back to the very start of her career, before she began publishing books, Wharton remembered: "I was a failure in Boston, where we used to go stay with my husband's family, because they thought I was too fashionable to be intelligent, and a failure in New York because they were afraid I was too intelligent to be fashionable."

In 1922, Edith Wharton was at the height of her fame. The year before, she had become the first woman to win the Pulitzer Prize for fiction, awarded to her magisterial novel *The Age of Innocence.* Her new novel, *The Glimpses of the Moon,* was a bestseller. (The next year it was made into a successful film starring Nita Naldi and Bebe Daniels, with titles by F. Scott Fitzgerald.) Like many of her novels, *The Glimpses of the Moon* is a portrait of disillusionment. A young American couple, Nick and Susy Lansing, as cynical as they are romantic, are, in Wharton's own words, "continually tripped up by obsolete sensibilities and discarded ideals." But long before they are caught by the consequences of their own desires, Susy is thinking of their English friend Strefford. The Americans are rootless and idly adrift as houseguests of posh cosmopolites, but Strefford is different. Strefford has a great dull country house he thinks of continually,

> *where a life as monotonous and self-contained as his own was chequered and dispersed had gone on for generation after generation; and it was the sense of that house, and of all it typified even to his vagrancy and irreverence, which, coming out now and then in his talk, or in his attitude toward something or somebody, gave him a firmer outline and a steadier footing than the other marionettes in the dance.*

If her dream had lasted, that might have been Edith Wharton's relationship with The Mount—a rock, a refuge, a steady footing. But by the time she wrote that passage, her own dream had already shattered, and the house lost. A decade later still, in her autobiography *A Backward Glance,* she could still write of the remnants of that dream: "The Mount was my

first real home, and though it is nearly twenty years since I last saw it (for I was too happy there ever to want to revisit it as a stranger) its blessed influence still lives in me."

In truth, Wharton hadn't *found* The Mount so much as *fled* to it. By 1899, she had been unhappily married to Edward Wharton ("Teddy" to his friends) for fourteen years, the couple dividing their time between a brownstone in Manhattan, a "cottage" in Newport, and hotels in Europe. She was a published writer of genuine promise, but subject to recurring illness. In Newport that summer she was stricken again by what she called "seasickness," a nearly paralyzing depression characterized by nausea and extreme fatigue. Hearing that her mother-in-law's home in Lenox, Massachusetts, was vacant, on impulse she packed up and went to the Berkshires. The dry mountain air relaxed and refreshed her, and she began returning whenever the exhaustions of life in Newport or of travel overwhelmed her. Within a few years, her literary success gave her a new confidence, and she determined to design and build a house for herself in Lenox. In February, 1901, she negotiated the purchase of a property of 113 acres, for which she paid $40,600. The deed was in her name only. At once, she consulted architect Ogden Codman, Jr. Two years earlier the pair of them had published *The Decoration of Houses,* still a remarkable handbook on design as an extension of architecture. Their enemy was what they dismissed as the "varnished barbarism" of the day, and Wharton now wanted a house, all harmony and proportion, that turned its back on the vulgarities of the Gilded Age.

A dispute over Codman's fee prompted her to hire Francis V. L. Hoppin instead to draw up the blueprints and oversee construction. He and Wharton spent hours devising a plan modeled on Sir Christopher Wren's Belton House in

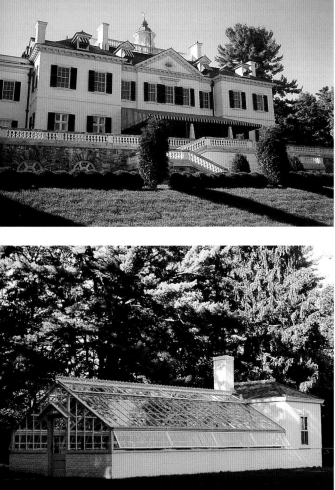

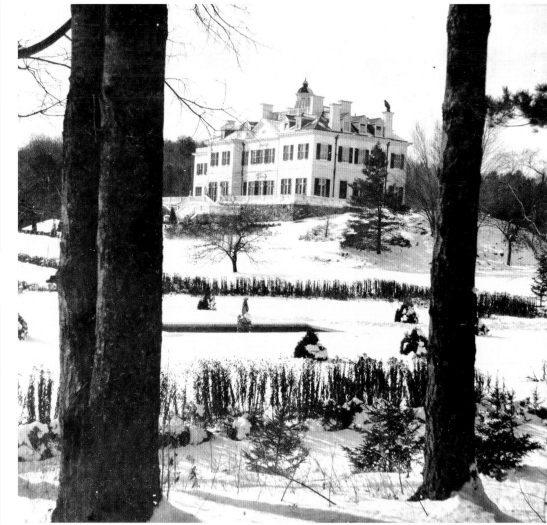

Lincolnshire. Meanwhile, her first novel was a success (it was greatly admired by President Theodore Roosevelt), and she turned forty. It was a moment of decision. She threw all of her energies into The Mount (so called after the Long Island home of her distinguished ancestor Ebenezer Stephens, an instigator of the Boston Tea Party and colleague of Lafayette). By the summer of 1902, she could write to a friend, "Everything is pushing up new shoots—not only cabbages and strawberries, but electric lights and plumbing." Soon after, the Whartons moved in. Her health was restored, her reputation as America's pre-eminent woman of letters secure. The Mount was a glistening symbol of her independence as a woman, and of her success as a writer.

Wharton hadn't designed The Mount along the lines of the Newport mansions she was long used to. The ostentation of the Vanderbilts and Astors, with their grand staircases and immense rooms, was not for her. "I have sometimes thought," she had written, "that a woman's nature is like a great house full of rooms." If the reverse it also true, we can see Wharton's nature in her design for The Mount. Above all,

she designed a house for privacy rather than show, a house for her to write in, and to entertain her small circle of close friends. A visitor to the house arrives at an enclosed courtyard of brick painted white. Since she believed that rooms should be distinctive yet flow into one another naturally, the visitor enters first into a room decorated as a grotto—the outdoors brought inside—and ascends to the *piano nobile* by a discrete side stairway. Even having reached the main hall, with its rich display of statuary, the visitor is turned away from the staircase to the bedroom floor, reinforcing the sense of privacy. It was upstairs, after all, that Wharton assiduously wrote all morning in bed. Not until she decided to descend and join her company was the house brought to life.

On the main floor, one circulates through Teddy's small study, then to the impressive paneled library, and on to the drawing room, with its ornamental plaster ceiling and tapestries. It is surprisingly narrow but gives immediately onto a sweeping terrace, nearly the length of the house and trimmed with a green-and-white-striped awning. On the other side of the drawing room is her dining room with its round table, which she

The Mount, today and in the winter of 1906. The greenhouse was one of several outbuildings on the property; they included a stable with fourteen stalls, a barn, a gatehouse, and several small cottages—in one of which lived their butler, Arthur White. By 1904, the gardens were in place. Following principles she had espoused in her book *Italian Villas and Their Gardens*, she insisted on enclosed gardens areas, to mirror the division of the house into distinct rooms, flowing together but each with its own character.

felt promoted conversation. She preferred small groups, just six or eight for dinner, and her cherished group of friends—among them Walter Berry, Bernard Berenson, Gaillard Lapsley, George Cabot Lodge, and most of all Henry James—would gather round her. With strangers, Wharton often disguised her innate shyness by an icy imperiousness, a metallic radiance, but among her friends she was warm, witty, and loyal. Similarly, beyond the formal public rooms was a network of kitchens and pantries, laundries and servants quarters (she employed over a dozen in help, plus gardeners).

Upstairs there were guest rooms, Teddy's bedroom, and her private suite—her ample corner bedroom, dressing room, and bathroom. Like many writers, she wrote in bed, the pages dropped to the floor when filled, to be picked up and transcribed by her secretary. Unlike Proust's bedroom, though, Wharton's was dominated by windows and filled with light. It was here she explored the dark linings of her silvery characters.

Like the layout of the house itself, the gardens of The Mount stand in classical contrast to their picturesque setting. The long sugar maple allée leading to the house, the approach curving through wooded hillocks and a meandering brook, is matched at the front by a nearly mile-long meadow stretching down to spruce-edged Laurel Lake and a vista of the Tyringham Mountains behind. But Wharton resisted the rugged terrain, and envisioned for The Mount a series of gardens based on Italian models she had studied and written so well about in her *Italian Villas and Their Gardens*, published in 1904, just the year before her stunning novel *The House of Mirth*, the success of which allowed her to complete her plans. She may have had advice from her niece Beatrix Jones. (As Beatrix Farrand, she went on to become a renowned landscape architect and designed Dumbarton Oaks and the campuses at Yale and Princeton.) But Wharton was in charge, and her fixed ideas about gardens—notably that they are "the prolongation of the house"—prevailed. Three bordered lawn terraces descend from the house, and at either end of the lowest are her two principal gardens, joined by a 300-foot graveled walk lined with lindens. As viewed from the house, to the right is her *giardino segreto*, a partially sunken walled garden, its shade beds centered on a circular pool with fountain. Its rough pastoralism is balanced, on the other side of the house, by a formal flower garden, its four L-shaped beds and 12-foot outer borders aswarm with color—snapdragon and petunia, pinks and penstemons, phlox and delphinium. This was the view Wharton had from her bedroom—she once called it "an Oriental carpet floating in the sun"—out past the rock garden immediately under her windows.

It was on The Mount's terrace, looking out over these gardens, that Wharton and her guests would sit on mild evenings. Certainly the most memorable evening was in mid-October of 1904. Henry James was visiting. After dinner, he and Wharton retired to the terrace to read aloud to each other, as they often did. In her autobiography, she recalls for us James's thrilling manner of reading poetry—almost chanting it, never faltering over the most complex prosody, but sweeping forward "on great rollers of sound till the full weight of his voice fell on the last cadence. . . . James's reading was a thing apart, an emanation of his inmost soul, unaffected by fashion or elocutionary artifice. He read from his soul." On that particular evening, their talk turned to the poems of Walt Whitman. To their surprise, they each discovered that Whitman was the other's favorite, both of them convinced he was the greatest of American poets. A copy of *Leaves of Grass* was fetched from the library, and long into the evening they spoke of the poet's genius and

took turns reading out the mighty poems—"Song of Myself" and "When Lilacs Last in the Door-Yard Bloom'd." When James turned finally to "Out of the Cradle," Wharton remembered that he didn't read it so much as he crooned it "in a mood of subdued ecstasy till the fivefold invocation of Death tolled out like the knocks in the opening bars of the Fifth Symphony."

With James too she adored to motor furiously through New England. James was always rather intimidated by Wharton's tireless energy, never more so than when the two novelists were bundled into the backseat of her sputtering automobile, her husband and Pekinese in tow, and the chauffeur was given his instructions. Wharton admired the countryside, while she sometimes despaired of its inhabitants. "The American landscape has no foreground," she once said, "and the American mind no background." On one excursion, the car broke down at Petersham, Massachusetts, and Wharton was forced to spend the night at a hotel called The Nichewaug. She was not amused—and wrote to a friend:

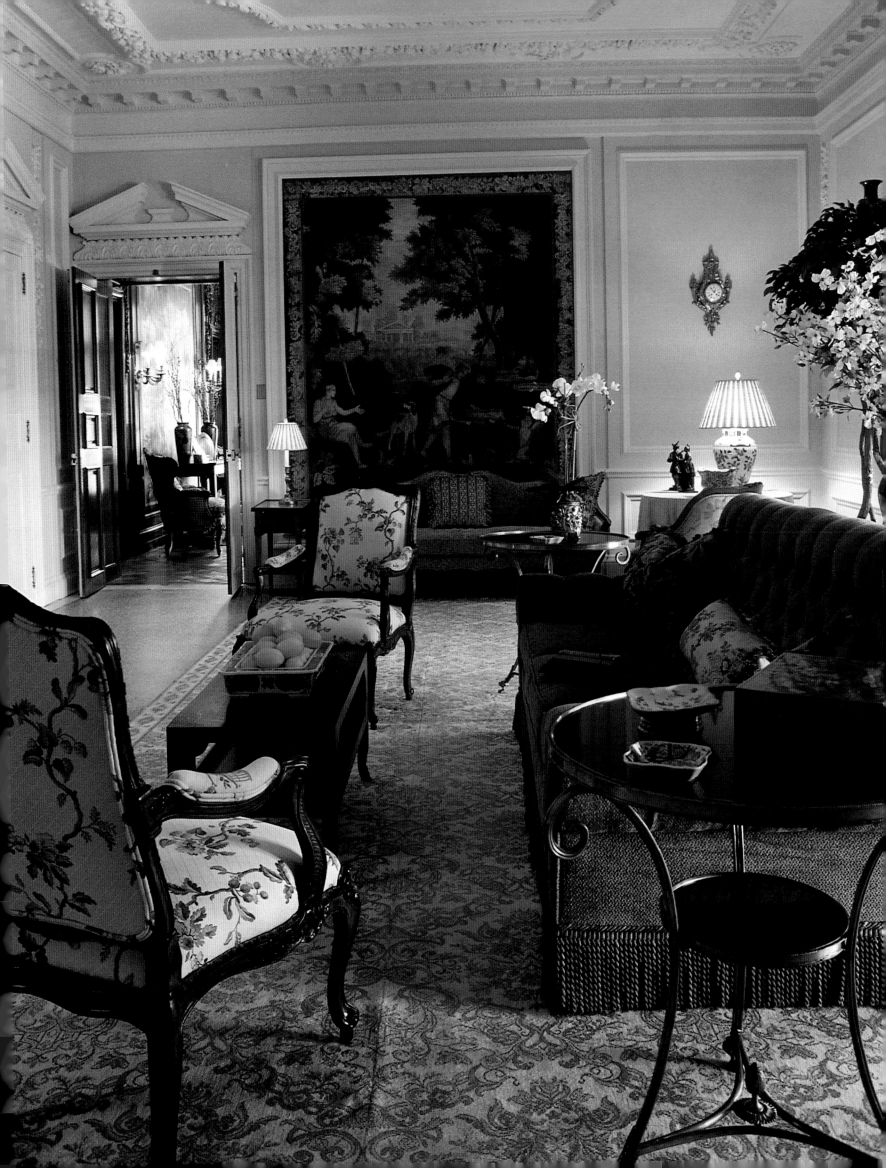

I have been spending my first night in an American "summer hotel," and I despair of the Republic! Such dreariness, such whining callow women, such utter absence of the amenities, such crass food, crass manners, crass landscape!! And, mind you, it is a new and fashionable hotel. What a horror it is for a whole nation to be developing without a sense of beauty, and eating bananas for breakfast.

But that was the brittle, snobbish side of Wharton. Not only did she appreciate the natural beauty of New England, its "sky of flying gleams and leaden clouds," its mountains and forests, but she was a close observer of its customs and lore. It was some years earlier, at the start of her career, that Henry James gave her a crucial piece of advice. Her first books had impressed him, as he wrote to a friend, with "her diabolical little cleverness, the quantity of intention and intelligence in her style," but he wrote to Wharton herself, urging her to abandon her fascination with Continental manners and concentrate instead on her native land. "Profit, be warned, by my awful example of exile and ignorance," he admonished her. "There it is around you. Don't pass it by—the immediate, the real, the only, the yours, the novelist's that it waits for. Take hold of it and keep hold, and let it pull you where it will." It was the best advice she ever received, and she took it to heart. Not only did she move on to chronicle the tumultuous changes in New York's social life, and to dissect the hypocrisies of new wealth and the cruelties of ambition, in such novels as *The House of Mirth* and *The Age of Innocence*, but she listened keenly to the less obvious intricacies of life in rural New England villages as well.

The most famous result of her attentions derives from a horrible sledding accident at the foot of Courthouse Hill in Lenox. She turned it into *Ethan Frome*, published in 1911, which tells the story of Frome's unhappy marriage to an older woman, Zenobia, and of his infatuation with his wife's young cousin, Mattie Silver. Their tragic decision to kill themselves rather than be separated is part of the eerie romance, in the spirit of Hawthorne, at the heart of a blisteringly realistic novel. Six years later she published a companion to *Ethan Frome* called *Summer*—or "the Hot Ethan," as she called it. She has transformed Pittsfield into the fictional town of Nettleton, where Charity Royall goes to watch fireworks with Lucius Harvey. Charity, a vulnerable, passionate, and unsophisticated girl, is seduced and abandoned by the city slicker Harvey, and has to deal with an unscrupulous abortionist, until she is rescued by her lonely and troubled guardian. Bear Mountain, about fifteen miles from Lee, Massachussets, is the model of The Mountain in the book, a squalid home of outcasts that shadows the civilized homes of nearby villages, and stands in for the violence underlying both the social proprieties and the human heart. Wharton's genteel readers were shocked. Her admirers marveled again at her daring.

All along, Wharton's fiction drew on the emotional tumults in her own life. The unhappy marriages in her novels mirrored her own. Her marriage to Teddy was an empty and sexless one, and her erotic salvation—her affair with the Paris-based American journalist Morton

ABOVE, LEFT: Wharton, with a dog in her lap, and Henry James in the backseat of her new Pope-Hartford motorcar, about to depart on a Berkshire "motor-flight" in October, 1904. Her chauffeur Charles Cook is at the wheel, and stay-at-home Teddy Wharton stands by with two more dogs.

ABOVE, RIGHT: One of Wharton's traveling cases, at the foot of her bed. Travel, for her, was a discipline as well as a pleasure, a means of study as well as of escape.

OPPOSITE: A room she cannot have spent too much time in, despite her protest to a friend that she had a "housekeeperish" side. Obviously, she was more hostess than housekeeper, and a demanding one. She oversaw a large staff. The most devoted of them was the Alsatian Catharine Gross, who worked for Wharton for nearly five decades.

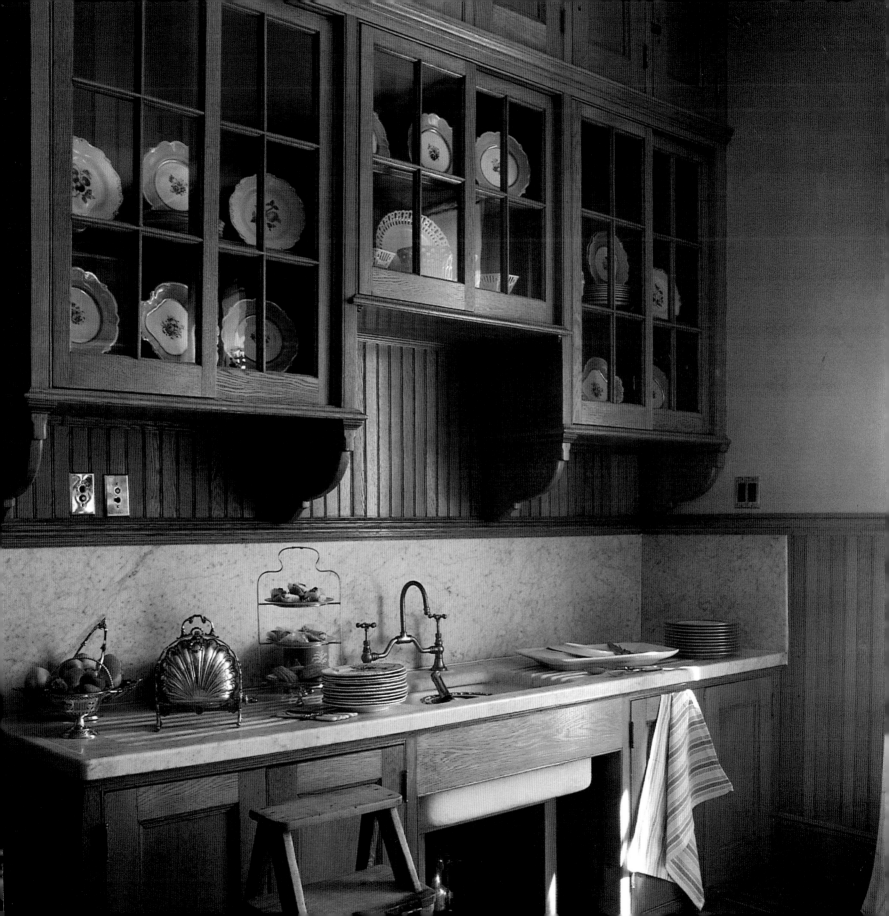

Fullerton had its touching start one afternoon at The Mount. Henry James had given Fullerton a letter of introduction to Wharton, and he came to call on her in the autumn of 1907. She was forty-five years old, he was three years younger. On the second day of his visit, they were out for a snowy drive, and the chauffeur stopped to put chains on the tires. Wharton and Fullerton lit cigarettes and walked to a stream bank and noticed a late-blooming witch hazel shrub. Wharton picked a sprig, and the sight of its flower bursting through the snow—it is sometimes called "the old woman's bloom"—struck her forcibly as an emblem of her own feelings. Fullerton had picked a sprig too, and enclosed it in his thank-you note a few days later. Wharton had already fallen in love, and two years later, in a London hotel, the flame that sparked at The Mount ignited.

Morton Fullerton was the erotic center of her life, but meanwhile her marriage was disintegrating. Teddy was what we would now call a manic-depressive, given to episodes of garish grandiosity and pitiable melancholy. During one spree, while Edith was in Europe, he set up a mistress in Boston and embezzled $50,000 from Edith's accounts. When depression subsequently set in, he confessed everything to his wife. Wharton, who had inherited some of her wealth, but had made most of it by her writings, was unforgiving. She refused to let Teddy, who was used to managing his wife's finances, have anything more to do with them, and put him on a short leash and an adequate allowance. She sought refuge with friends in Europe, and decided divorce was her only course. During the summer, she spent tense weeks at her beloved estate—her intimates urging her to leave America, her heart reluctant to let go of her home. Five or six times, she had turned down offers to buy The Mount, but she was under pressure now to resolve her future. She sailed for Europe on September 7, 1911, and left things in Teddy's hands, expecting to be consulted. By early November, he had abruptly, and without telling her, arranged to sell the house.

Her affair over and her marriage dissolved, Wharton lived on for another quarter century, working steadily and brilliantly, even in the midst of the disasters of World War I, during which she performed heroically: her charitable work with French and Belgian refugees earned her the Legion of Honor from the French government. When peace returned to Europe, she traveled compulsively, established two beautiful residences, one just outside Paris and the other in the south of France. She cultivated the joys of old friendships and made interesting young acquaintances. But the new is no substitute for the lost. To the end, she was haunted by the "blessed influence" of her shining white house on the hill.

ABOVE: One of Wharton's own fountain pens and the manuscript of the opening of *Ethan Frome*, based on an incident that occurred in Lenox. Her clear, fluent handwriting show the changes she made to her text. Her fictional town of Starkfield, for instance, is first set in Vermont, and later changed to Massachusetts.

OPPOSITE: The view of the library from the drawing room. One friend observed: "Both Edith and Teddy loved to entertain amusing people, though sometimes I thought them more amusing than well-bred. On that point Teddy was more sensitive than Edith, who could occasionally tolerate men who interested her when he could not."

Walt Whitman

OPPOSITE: Whitman's wooden row house on Mickle Street.

RIGHT: Whitman's live-in cook and housekeeper, Mary O. Davis, his nurse, Warren Fritzinger, and Whitman's coach dog, Watch, in front of the house. Whitman's friend Horace Traubel noted: "People often criticize Mrs. Davis because of the confusion apparent in the parlor and W.'s bedroom. The fact is W. does not encourage any interference even by her with his papers."

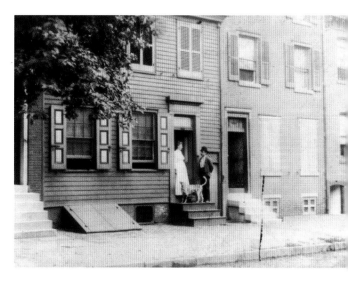

At Whitman's funeral, on March 30, 1892, as his disciples gathered around his coffin under a small open tent in the Harleigh Cemetery in Camden, the poet was remembered less as a poet than as a philosopher. His mourners knew, of course, that he was the great original, the poet who had swept all the stuffy traditions aside and boldly created a poetry of sublime intentions and inclusive range. He was the poet whose words, at the very start, Ralph Waldo Emerson had called "the most extraordinary piece of wit and wisdom that America has yet contributed." He inspired writers around the world, and his influence in his own country has, happily, never diminished, even as its intense and majestic and tender monumentality have come to define the American imagination itself. And indeed a section of "When Lilacs Last in the Door-Yard Bloom'd" was read out at the service. But far more time was taken up memorializing Whitman's messianic role as The Cosmic Democrat, the Liberator. He was recalled, in the words of one speaker that afternoon, as "arduous, contentious, undissuadable and infinitely loving. He came bearing the burden of a Gospel, the Gospel of the Individual Man; he came teaching that the soul is not more than the body, and that the body is not more than the soul; and that nothing, not God himself, is greater to one than one's self is." And to exemplify his universality, passages were read out from Confucius and Plato, from the Buddha and the Koran. And when a passage from the New Testament was read it was thought singularly appropriate for a man of such infinite sympathies: "Blessed are the poor in spirit, for theirs is the kingdom of heaven."

A visitor to Whitman's house in Camden today should keep those words in mind. Camden today is a blasted city, and 328 Mickle Street is in a desolate part of town. Directly across the street is an ugly and massive county jail. The garden behind the house is fenced in with barbed wire. But the little clapboard row house stands there pluckily, and the man who once lived there had in his own day cast his poetic gaze lovingly on "the crazed, prisoners in jail, the horrible, rank, malignant."

Whitman felt entirely at home on Mickle Street, and when he moved there in 1884, just a couple of blocks from the Camden waterfront, with a vista of Philadelphia steeples across the broad Delaware River, it might have reminded him of Brooklyn when he lived there in the 1840s and 50s, working as a printer and reporter. Camden was a working-class city, a thriving transportation hub busy with shipping, railroads, and ferries. And a photograph of Mickle Street when Whitman lived there shows it tree-lined, a neat parade of brick row houses on either side. But in fact, the poet's friends considered it a poor choice. The rail depots made it a noisy part of town, and a guano factory across the river made it foul-smelling as well.

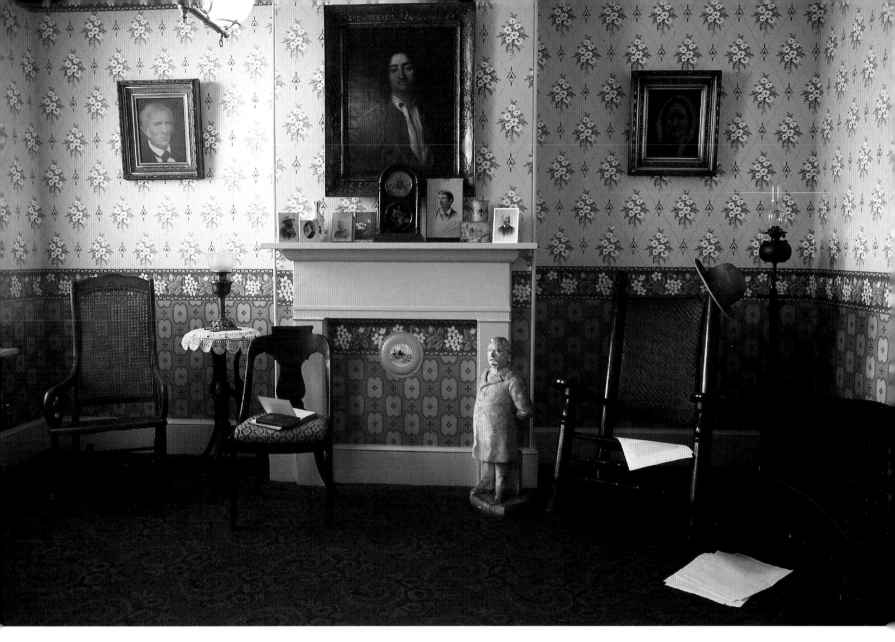

Elizabeth Keller, who helped care for Whitman toward the end of his life, remembered the house as "sadly out of repair, and decidedly the poorest tenement on the block." There was an "uninterrupted racket day and night," and the new electric streetlamp, just outside the poet's bedroom window, was an intrusive annoyance. The block "was anything but inviting, and the locality was one that few would choose to live in." The staircase and hallways, she complained, were narrow, the kitchen more like the cabin of a ship, and Whitman's bedroom a "hillock of débris." Whitman himself, of course, loved it. He called it his "little old shanty" or "my nook," and would sit all day by an open window downstairs, chatting with passersby, listening to his housekeeper's canary. Above all, it was his, the first and only house he ever owned, a refuge from the wide world and a shrine where he could receive its homage. (A letter from England, addressed only to "Walt Whitman, America," arrived at Mickle Street without delay.) But it was a series of bitter trials that had brought him there.

In July 1855, twelve untitled poems and a prose preface appeared in a book called *Leaves of Grass*. Its binding was elaborately tooled, and inside was a lithograph of the author, his head jauntily cocked above an open shirt . . . "Walt Whitman, a kosmos, one of the roughs." There were 795 copies printed, and Whitman himself wrote three unsigned reviews of the book, all of them raves. It was a commercial failure, and a personal humiliation, but he persisted. The very next year, he published a new and expanded edition, and began to envision "the Great Construction of the New Bible," an ideal *Leaves of Grass* that would inspirit the nation. But then the Civil War wrought its havoc and shattered his utopian dreams. Hearing that his brother George has been wounded in Virginia, Whitman rushed to the front to care for him. Getting off the train near Fredericksburg, the first thing he saw, as he wrote to his mother, "was a heap of feet, arms, legs, &c. under a tree in front of a hospital." He found his brother, but much more besides: "I go around from one case to another. I do not see that I do much good to these

The front parlor. Among the curios in the room is a pair of small statues of Grover Cleveland. They were not there for patriotic or sentimental reasons. Once they were heated by the stove behind them, they became additional sources of warmth for the room.

wounded and dying; but I cannot leave them." He eventually settled in Washington and tended to the patients in military hospitals, while supporting himself doing part-time clerical work in the Army Paymaster's office. All the while, he wrote down his impressions of young soldiers and their fates in a book he later published as *Specimen Days*, the most harrowing and moving document to have emerged from those bloody years. The war shook Whitman to the core and left him a weakened man. He accepted a post at the Department of the Interior in 1865, but was fired by Secretary James Harlan, who came upon a copy of *Leaves of Grass* in Whitman's office desk and considered it obscene. When his hero Abraham Lincoln was assassinated, he knew that the country's convulsions had ruined its best hopes. Still, he kept publishing, and attracted notice from around the world for the humane power of his words. But he was stalked by illness, and in January, 1873, suffered a paralytic stroke. A few months later, hearing from his brother George, a pipe inspector in Camden, that their mother was sinking, he rushed to her side. She died three days later. He had meant to return to Washington, but he lingered. He liked his sister-in-law, Louisa, he liked the proximity to cosmopolitan Philadelphia as well as the restorative New Jersey countryside.

In 1882, not long after a new edition of *Leaves of Grass* was published in Boston, the city's district attorney warned that he considered certain poems in the book to be filthy, and the publisher withdrew the book—which, predictably, so increased sales elsewhere that for the first time in his life Whitman came into some money. That year his royalties were $1439. The year before, they had amounted to just $25. The timing was fortuitous, because the next year, his brother George moved to Burlington, New Jersey, and the poet was uprooted. In March of 1884,Whitman moved into 328 Mickle Street, and a month later purchased it from Rebecca Jane Hare, a widowed dressmaker, for $1750.

The house is something of a rarity, not because of its architectural style—a mongrel amalgamation of details from Greek Revival and Colonial Revival—but because it is constructed of wood. It was built in 1848, the first house on the block, and five years later the city of Camden enacted an ordinance forbidding new houses made of wood. So, while all its neighbors are brick, Whitman's new house may have appealed to him—who so loved long tramps through the fields or to swim in the Jersey ponds—precisely because of its rustic appearance.

His first housekeeper, Mrs. Lay—his increasing lameness meant that he required help—came to displease him, and the next year she was replaced by the devoted Mary Davis, who fussed over him, made his shirts, and tended to his appearance. She would pick him up at the ferry and accompany him on the omnibus, and best of all, would bring him his favorite dinner of stewed oysters and toasted graham bread and beer. In his first years on Mickle Street, he would take his meals in the front parlor, where he would often spend the day at a cluttered table near the window, his coach dog, Watch, curled at the foot of his rattan rocker. The house had gas lighting and running water, and its wallpaper and carpets have the florid look of the late Victorian era. On either side of the fireplace were oil portraits of his parents, and over the mantel a genre painting of a hearty burgher Whitman always referred to as "the Hollander." Littering the mantel were the photo-cards left by visitors and admirers. The back parlor stood on the other side of sliding doors that could be opened up for receptions. Horsehair chairs flank walnut bookcases filled with editions of Shakespeare and Scott, Dante and Emerson, George Sand and Epictetus. Beyond are the

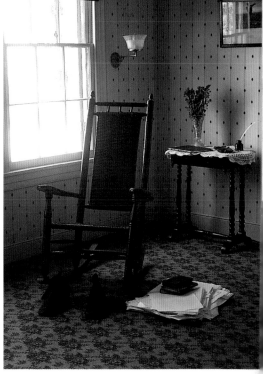

kitchen, and outside a back garden with annuals and herbs, hydrangea, a small pergola entwined with wisteria, and an outhouse. In the rear of the upper floor was Mrs. Davis's room, and a room that contained Whitman's copper-lined bathtub. Closer to the front was a small bedroom for Warren Fritzinger, Mary Davis's foster son, who worked as Whitman's nurse in the final years. And at the front of the house was Whitman's own bedroom. When he could no longer manage the stairs, the poet would spend all his days in this room. He finished his last collections here, *November Boughs* (1888) and *Good-Bye my Fancy* (1891), and oversaw the final, so-called "deathbed" edition of *Leaves of Grass*, as well as his *Complete Prose Works*. These were the years he endeavored to put the finishing touches on his legend, and it is interesting to note that in 1890 he arranged to have a "burial house" of his own design constructed in the Harleigh Cemetery. The contract with P. Reinhalter & Co. stipulated that the platform, walls, and cap and roof all be of the best Quincy, Massachusetts, granite, and that the eight catacombs within (where later his parents, his brother George, and his wife and an infant son of theirs, plus Whitman's mentally retarded brother Eddy were all re-interred) be made of Pennsylvania blue marble. For this mausoleum, he agreed to pay $4,678, more than double the cost of his house.

Whitman himself, in some of his very last writings, left vivid descriptions of his bedroom, where he would sit in a huge armchair, with a black and silver wolf-hide spread over its back, and poke with his cane through the "deep litter of books, papers, magazines, thrown-down letters and circulars, rejected manuscripts, memoranda, bits of light or strong twine, a bundle to be 'express'd,' and two or three venerable scrap books." Against the walls were trunks of his papers, piles of books, and a strew of printer's proofs and slips. In the center of the room were two large tables covered with papers and writing materials, along with "several glass and china vessels or jars, some with cologne-water, others with real honey, granulated sugar, a large bunch of beautiful fresh yellow chrysanthemums, some letters and envelope papers ready for the post office, many photographs and a hundred indescribable things besides." A year before his death, he wrote that "I keep generally buoyant spirits, write often as there comes any lull in physical sufferings, get in the sun and down to the river whenever I can." Above all, he said, "I retain my heart's and soul's unmitigated faith not only in their own original literary plans, but in the essential bulk of American humanity east and west, north and south, city and country, through thick and thin, to the last." He was the poet who believed that in writing the 'Song of Myself', he could encompass all of humanity:

> *I celebrate myself,*
> *And what I assume you shall assume,*
> *For every atom belonging to me as good*
> *belongs to you. . . .*

Two views of Whitman's bedroom, the bed he died in and the rocker he sat in. In his lifetime, the floor would have been cluttered with papers; today the room has a convent-like austerity to it. The pair of his sturdy shoes on the floor recall his immortal lines, "If you want me again look for me under your bootsoles."
OPPOSITE, ABOVE: His masterpiece.
OPPOSITE, BELOW: His famous 1865 dirge for the assassinated Lincoln, "O Captain! My Captain!" with Whitman's corrections to a later reprinting.

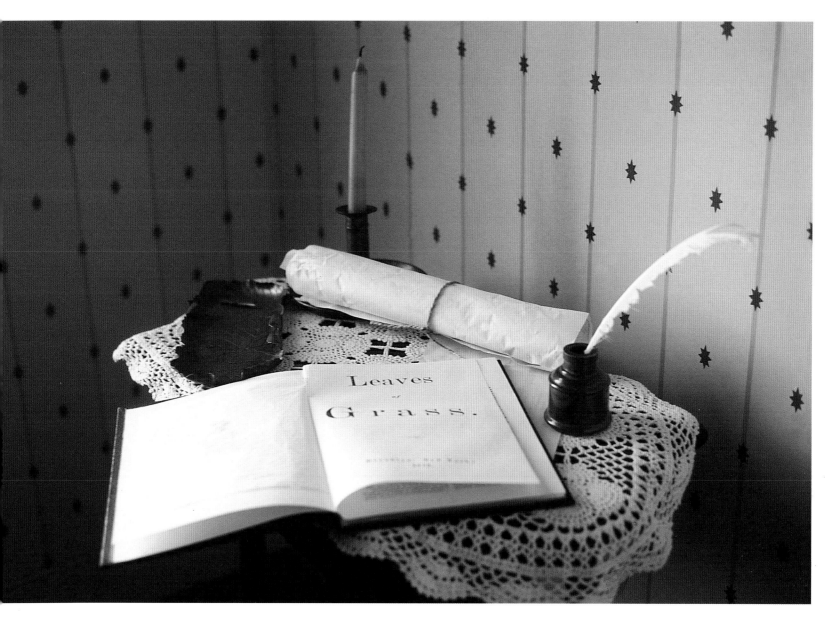

O the bleeding drops of red!

O CAPTAIN! MY CAPTAIN!

BY WALT WHITMAN.

I.

O CAPTAIN! my captain! our fearful trip is done,
The ship has weathered every rack, the prize we sought is won,
The port is near, the bells I hear, the people all exulting,
While follow eyes the steady keel, the vessel grim and daring.
But O heart! heart! heart!
~~Leave you not the little spot~~
Where on the deck my captain lies,
Fallen cold and dead.

II.

O captain! my captain! rise up and hear the bells;
Rise up! for you the flag is flung, for you the bugle trills;
For you bouquets and ribboned wreaths, for you the shores a-crowd-
ing;
For you they call, the swaying mass, their eager faces turning.
O captain! dear father!
This arm ~~I push beneath you~~ beneath your head,
It is some dream that on the deck
You've fallen cold and dead.

III.

My captain does not answer, his lips are pale and still;
My father does not feel my arm, he has no pulse nor will.
~~But the ship,~~ The ship is anchored safe, its voyage closed and done; and
From fearful trip the victor ship comes in with object won! sound.
Exult, O shores! and ring, O bells!
But I, with silent tread,
Walk the spot my captain lies
Fallen cold and dead.

Do I contradict myself?
Very well then . . . I contradict myself;
I am large . . . I contain multitudes. . . .

The last scud of day holds back for me,
It flings my likeness after the rest and true
 as any on the shadowed wilds,
It coaxes me to the vapor and the dusk.
I depart as air I shake my white locks
 at the runaway sun,
I effuse my flesh in eddies and drift in
 lacy jags.

I bequeath myself to the dirt to grow from
 the grass I love,
If you want me again look for me under
 your bootsoles.

You will hardly know who I am or
 what I mean,
But I shall be good health to you
 nevertheless,
And filter and fibre your blood.

Failing to fetch me at first keep encouraged,
Missing me one place search another,
I stop somewhere waiting for you.

A few months before he died, Whitman's friends bought for him a new bed with a handsome oak headboard, and later a water mattress to ease his pain. But he remained cheerful to the end, even joking that he could remember just enough of a thing to remind him of how much was forgotten. "Here I am," he said, "tied up at the wharf, rotting in the sun." But he could remember his ecstatic "poems of the morning," his vision of a spiritual and heroic America leading mankind into a future of freedom and equality, of comrades secure in their devotion to their belief in "the divine aggregate, the People." On his last afternoon, sinking rapidly, he clutched a friend's hand and urged him to be strong: "Keep a firm hand—stand on your own feet. Long have I kept my road—*made* my road: long, long! Now I am at bay—the last mile is driven: but the book—the book is safe!"

Louisa May Alcott : Orchard House

Her father incapacitated by a stroke, Louisa May Alcott sold Orchard House for $3,500 in 1884 to a disciple of Bronson Alcott named William Torrey Harris (later U.S. commissioner of education). By 1910 it was in bad repair and the neighbors were complaining that it had become an eyesore. Plans were afoot to raze the house, but Harriet Lothrop, living next door in The Wayside, saw that young girls were continually visiting and peeking in the windows of Orchard House. To save the house, she purchased it that year, went to the Woman's Club of Concord with an appeal, and founded the Louisa May Alcott Memorial Association, which by 1911 had raised the necessary $8,000 to buy the house and land from Lothrop and undertake their restoration. It has been open to the public ever since, and was designated a National Historic Landmark in 1963.

Orchard House
399 Lexington Road
Concord, Massachusetts 01742
Open: April through October, Monday–Saturday,
 10am–4:30pm; Sunday, 1pm–4:30pm.
 November through March, Monday–Friday,
 11am–3pm; Saturday, 10am–4:30pm;
 Sunday 1pm–4:30pm. Closed: January 1–15,
 Easter, Thanksgiving, and December 25.
Information: 978-369-4118
www.louisamayalcott.org

Kate Chopin : Kate Chopin House

In 1898 Chopin sold her Cloutierville home to Pierre Rosenthal, a German-born merchant. After that date, the history of the house is obscure, though it was always occupied—and in the 1920s, when the lower floor was put to more use, the front staircase was removed in favor of two adjacent staircases leading to the upper galleries. In 1938 it was sold to Dr. Lloyd Wink, who in 1965, for $300 in legal fees, transferred the deed to Mildred L. McCoy, founder of the Bayou Folk Museum, housed then in the house. In 1979 McCoy donated the house and a trust fund to Northwestern State University in nearby Nachitoches. In 1987 ownership was again transferred, this time to the Association for the Preservation of Historic Nachitoches, which now maintains the house. In 1993 it was designated a National Historic Landmark.

Kate Chopin House
243 Highway 495
Cloutierville, Louisiana 71416
Open: Monday through Saturday, 10am–5pm;
 Sunday, 1pm–5pm. Closed: January 1,
 Easter, Thanksgiving, and December 25.
Information: 318-379-2233
www.natchitoches.net/melrose/chopin.htm

Samuel Clemens : The Mark Twain House

Twain and his wife left the house for good in 1891, and in 1903 sold it to Richard Bissell for $27,000; what furniture they didn't keep or give to friends was auctioned off. The Bissell family lived in the house until 1917; it was then leased for five years to the Kingswood School for Boys, and for some years after that it was used as an apartment building. The Friends of Hartford, under the leadership of Catherine Seymour Day, a grandniece of Harriet Beecher Stowe, started the Mark Twain Memorial Foundation in 1929 and purchased the house. During the 1930s and 40s it was rented to the Hartford Public Library system and became its Mark Twain branch. All the while apartments upstairs were rented; the top floor of the carriage house was still leased as recently as 1974. In 1955 extensive renovations began, and the search for auctioned-off pieces of furniture began. (Most of the furnishings are period pieces, but many important original objects have been retrieved.) The house was opened to the public in 1974.

The Mark Twain House
351 Farmington Avenue
Hartford, Connecticut 06105
Open: year round, daily 9:30am–5:30pm,
 Thursday until 8pm. Closed: Tuesday, January
 through April; January 1, Easter, Thanksgiving,
 and December 24–25.
Information: 860-247-0998
www.MarkTwainHouse.org

Emily Dickinson : Dickinson Homestead

After Emily Dickinson's death, her sister Lavinia lived on in the house until her death in 1899. The family then rented it to tenants until 1916, when it was sold to Hervey Parke, minister of the Grace Episcopal Church in Amherst, who moved in with his wife and five children. The house stayed in the Parke family until 1965, when it was sold to Amherst College, which used it in part as a faculty residence until 1999 but also opened it to tourists. In 2003, Amherst also acquired The Evergreens from the Martha Dickinson Bianchi Trust, and combined the two houses into the Emily Dickinson Museum.

The Emily Dickinson Museum
280 Main Street
Amherst, Massachusetts 01002
Open: March through mid-December;
 days and hours vary seasonally.
Information: 413-542-8161
www.emilydickinsonmuseum.org

Frederick Douglass : The Frederick Douglass House

In his will, Douglass left the house to his second wife, Helen, but the children of his first marriage contested her ownership in court. They forced Helen to purchase the house and its belongings, and by 1898 she had borrowed the $5,000 necessary to do so. Determined to preserve her husband's legacy, she helped establish the Frederick Douglass Memorial and Historical Association, to which she deeded the house and its contents at the time of her own death in 1903. The association, which in 1916 joined with the National Association of Colored Women's Clubs, struggled to maintain the property, and finally arranged to transfer ownership to the National Park Service in 1962. Following ten years of restoration, the house was opened to the public in 1972 and designated a National Historical Site in 1988.

Frederick Douglass National Historic Site
1411 W Street, SE
Washington, D.C. 20020
Open: daily; spring–summer, 9am–5pm; fall–winter,
 9am–4 pm. Closed: January 1, Thanksgiving,
 and December 25.
Information: 202-426-5961
www.nps.gov/frdo

Ralph Waldo Emerson : The Emerson House

After Emerson's death, his wife and daughter Ellen stayed on. During Ellen's years in the house alone, she took two schoolteachers, Helen Legate and Grace Heard, as boarders, stipulating that after her death—when it would pass to her brother Edward and his family—the teachers could continue to live in the house. Helen Legate was there until 1948. Since then, a caretaking couple has always lived in the house: until 1981, Vicky Dempsey (who had worked under Miss Legate for many years and succeeded her as house manager) and her husband Johnny (who maintained the bounteous vegetable gardens). In 1930, the family formed the Ralph Waldo Emerson Memorial Association, a non-profit organization that owns the house today. The house was designated a National Historic Landmark in 1963.

There were always visitors to Emerson's study, and after another fire in the house in 1929, the family worried about its preservation. A year later the Emerson Memorial Association sent the contents of the study across the street to the Concord Museum, where an exact replica of the room was constructed and can be visited. The old study, in the house itself, was reconstituted with books and furnishings from Edward Emerson's collection, similar to the original contents.

Emerson Memorial House
28 Cambridge Turnpike
Concord, Massachusetts 01742
Open: mid-April through mid-October,
 Thursday–Saturday, 10am–4:30pm;
 Sunday, 12pm–4:30pm.
Information: 978-369-2236

Concord Museum
Cambridge Turnpike
Concord, Massachusetts 01742
Open: Monday–Saturday, 9am–5pm;
 Sunday, 12pm–5pm.
Information: 978-369-9609
www.concordmuseum.org

William Faulkner : Rowan Oak

In an effort to avoid inheritance taxes, Faulkner deeded Rowan Oak to his daughter Jill in 1954. After his death eight years later, Jill and her mother, Estelle, who lived mostly in Virginia, would occasionally visit, but leased the house to the University of Mississippi, stipulating that Mrs. Faulkner could live there for as long as she wished and that the University, which would keep up the house and grounds, could show Faulkner's library and study to the public by appointment. These tours were presided over by Dorothy Oldham, Estelle's sister and a manuscript librarian at the university. Estelle died in 1973. The next year, Jill sold the house outright to the university. Renovations were carried out from 1973 until 1977, and from 2001 until 2003. The outbuildings were restored from 1992 until 1994.

Rowan Oak
Old Taylor Road
Oxford, Mississippi 38655
Open: Tuesday–Saturday, 12pm–4:30pm.
 Closed: January 1, December 24 and 25.
Information: 662-234-3284
www.mcsr.olemiss.edu/~egjbp/faulkner/
 rowanoak.html

Robert Frost : The Robert Frost Farm

After Frost sold the farm in 1911, the house had at least two owners. Then, in 1942, it was purchased by Joseph Van Dyne, who restored the house and installed central heating. In 1953 he sold it to a man named Lee, who made the property into a junkyard dealing in used car parts. (Supposedly by coincidence, he named it "Frosty Acres.") The State of New Hampshire purchased the property in 1964, and it was given National Historic Landmark status. After an extensive period of restoration, it was opened to the public in 1975.

The Robert Frost Farm New Hampshire State Park
Route 28
Derry, New Hampshire 03820
Open: summer, Monday–Saturday,10am–5pm,
 Sunday, 12pm–5pm; spring and fall, Saturday,
 Sunday, and holidays, 10am–5pm.
Information: 603-432-3091.
www.nhstateparks.org/ParksPages/FrostFarm/
 Frost.html

Nathaniel Hawthorne : The Old Manse

Hawthorne rented The Old Manse from Samuel Ripley, an uncle of Ralph Waldo Emerson, from July 1842 until October 1845. Ripley died a year later, and the house passed on through his family until 1939 when Ripley's granddaughter, Sarah Thayer Ames, died and the house, its contents, and nine acres of property was conveyed to The Trustees of Reservations, a conservation organization that runs the house today. National Landmark status was awarded in 1967.

 The Wayside, which Hawthorne owned from 1852 until his death in 1864, was sold by his family in 1871 to George Arthur Gray. Eight years later, Hawthorne's youngest daughter, Rose, and her husband, George Lathrop, bought the house back, but two years later their young son died and grief drove them from The Wayside. In 1883 it was sold to Daniel and Harriet Lothrop. (Under the pseudonym Margaret Sidney, Harriet Lothrop was the author of the popular *The Five Little Peppers* series of books.) Their daughter Margaret Lothrop lived in the house until 1965, when it became the first literary site to be purchased by the National Park Service. It was opened to the public in 1971 and designated a National Historic Landmark first in 1963 and again in 1985.

The Old Manse
269 Monument Street
Concord, Massachusetts 01742
Open: mid-April through October,
 Monday–Saturday, 10am–4:30pm;
 Sunday and holidays, 12pm–4:30pm.
Information: 978-369-3909
www.concord.org/town/manse/old_manse.html

The Wayside
455 Lexington Road
Concord, Massachusetts 01742
Open: May though October, 10am–4:30pm.
Information: 978-369-6992, ext. 22
www.nps.gov/mima/wayside

Ernest Hemingway : Ernest Hemingway Home

As part of Hemingway's divorce settlement with Pauline, the Florida National Bank of Miami was made trustee of the house, which Pauline could rent during her lifetime. Hemingway retained first refusal in any sale. If Pauline were to die, her sixty percent share would be given equally to her sons. During the 1940s, with her sons away at school, she decided the main house was too large for her. She rented it out and made a small apartment for herself in the carriage house behind, and built a garage with an apartment above it for the boys when they were home. Pauline died suddenly in 1951; through his friend and factotum Toby Bruce, Hemingway continued to rent out the house and outbuildings. After his death in 1961, the estate continued renting it until March, 1963, when Bernice Dickson, who owned a jewelry store in Key West and was a Hemingway admirer, purchased the house for $80,000. The next year, she inaugurated self-guided tours of the house for the public, and in 1968 it was designated a National Historic Landmark. The Dickson family still owns the property.

The Ernest Hemingway Home and Museum
907 Whitehead Street
Key West, Florida 33040
Open: daily 9am–5pm.
Information: 305-294-1136
www.hemingwayhome.com

Washington Irving : Sunnyside

In his will, Irving left Sunnyside to his brother Ebenezer, at whose death the property passed to Irving's nieces Catherine and Sarah, who lived in the house until 1875. The house was then transferred to Alexander Duer Irving, and in 1896 an additional wing was added. Eventually the house was "modernized" with electricity and plumbing. The Irving family continued to live there, mostly in the summers, until 1945, when Alexander's son Louis sold Sunnyside to John D. Rockefeller Jr. as a part of his philanthropic Sleepy Hollow Restorations project. Over the next two years, the house was refurbished, and it was opened to the public in 1947. In the mid-1950s, the house was restored to its original dimensions. In 1965 Sunnyside was designated a National Historic Landmark, and in 1987 Sleepy Hollow Restorations became the Historic Hudson Valley organization, which maintains the house today. In 1996 the residents of North Tarrytown voted to change the name of their town to Sleepy Hollow to honor Irving's memory.

Sunnyside
Sunnyside Lane (Route 9)
Tarrytown, New York 10591
Open: April through October, 10am–5pm;
 November and December, 10am–4pm;
 March, weekends, 10am–4pm.
 Closed: January and February.
Information: 914-591-8763, ext. 12
www.hudsonvalley.org

Robinson Jeffers : Tor House

After Una died, the couple's son Donnan, his wife Lee, and their children moved into the house to look after Jeffers. Donnan continued the building project of his father, extending the house further. When Jeffers died in 1962, Donnan and his family stayed on, though most of the property was sold off over the years. The Robinson Jeffers Tor House Foundation was established in 1978 and took partial ownership, with a life tenancy for Lee, who died in 1999.

Tor House
26304 Ocean View Avenue
Carmel, CA 93923
Open: docent-led tours hourly on Friday and
 Saturday, 10am–3pm.
Information and reservations:
 831-624-1813 (Monday–Thursday, 9am–1pm)
 831-624-1840 (Friday–Saturday, 10am–4pm)
www.torhouse.org

Sarah Orne Jewett : The Jewett House

After Jewett died in 1909, her sister Mary continued to live in the house until her death in 1930. Her nephew Theodore Eastman, who had lived there as a teenager and had become a well-known physician in Boston, inherited the house, but died a year later. In his will he left it to the Society for the Preservation of New England Antiquities, which maintains the site today.

The Sarah Orne Jewett House
5 Portland Street
South Berwick, Maine 03908
Open: June 1–October 15, Friday–Sunday; hourly
 tours, 11am–4pm; call in advance.
Information: 207-384-2454
www.spnea.org/visit/homes/jewett.htm

Henry Wadsworth Longfellow : Craigie House

Longfellow's oldest daughter, Alice, continued to live in the house after the poet's death, preserving it as a shrine and donating the property between the house and the Charles River to the city of Cambridge for the creation of Longfellow Park. In 1913 the Longfellow House Trust was created,

allowing Alice to remain in the house until her death in 1928 while using it for educational purposes and opening it to the public. In 1935 the trustees tried to transfer the house to Harvard, and later offered it to Radcliffe as the president's home, but Longfellow family members protested and blocked these arrangements. Until 1950 family members continued to live in the house, which was then overseen by Anne Longfellow Thorpe, the poet's granddaughter. In 1972 Congress authorized the Longfellow National Historic Site, and two years later the National Park Service assumed management of the property.

Longfellow National Historic Site
105 Brattle Street
Cambridge, Massachusetts 02138
Open: Wednesday–Sunday, 10am–4pm.
Information: 617-876-4491
www.nps.gov/long

Herman Melville : Arrowhead

After Melville left Arrowhead in 1863, the house remained in the family. In 1927 Dr. Henry Murray, a young Melville scholar, spoke to Margaret Morewood, Melville's niece, of his desire to purchase Arrowhead and make it a Melville museum. They never came to an agreement, and Morewood sold the house to the first of five subsequent owners, and the furniture was sold at auction. In 1953 Murray donated his collection of Melville memorabilia to the Berkshire Athenaeum in Pittsfield, five miles away from Arrowhead, whose "Melville Room" today houses a trove of rarities. The Berkshire Historical Society purchased Arrowhead in 1975 and has since maintained it. It was designated a National Historic Landmark in 1962.

Arrowhead
780 Holmes Road
Pittsfield, Massachusetts 01201
Open: daily, Memorial Day weekend through
 Columbus Day weekend, 9:30am–5pm.
Information: 413-442-1793
www.mobydick.org

Edna St. Vincent Millay : Steepletop

After Millay's death, her sister Norma moved into Steepletop. She and her husband, painter Charles Ellis, kept everything in the house as it had been in the poet's day. Norma even hung her clothes on the bathroom shower rod rather than disturb Millay's dresses still hanging in the closet. Steepletop was designated a National Historic Landmark in 1971. Following Norma's death in 1986, ownership of the house and property passed to The Edna St. Vincent Millay Society, which presently maintains the site. Restoration is underway, but the house is not presently open to the public.

Information: millaysoc@aol.com

Flannery O'Connor : Andalusia

After Flannery O'Connor's death, her mother Regina returned to the Cline home in Milledgeville to care for her ailing sister. She rarely visited the farm, whose condition deteriorated. Regina died in 1995 at the age of ninety-nine, and left Andalusia to her nieces Margaret and Louise Florencourt. The farm was subsequently given to the Flannery O'Connor-Andalusia Foundation, which maintains the property now.

Anadalusia
2628 N. Columbia Street (Rte. 441)
Milledgeville, Georgia 31059
Open: tours Tuesday and Saturday, 10am–4pm.
Information or to schedule a visit: 478-454-4029 or
 call the Milledgeville Convention & Visitors
 Bureau at 800-653-1804.
www.andalusiafarm.org

Eugene O'Neill : Tao House

In February 1944, the O'Neills sold Tao House to an Oakland attorney, Arthur Carlson, and his wife for about $60,000, a considerable loss considering that it had cost them $100,000. After the sale, O'Neill met with the Carlsons and mentioned that he thought the nearby hills had a "corduroy texture" in winter. The Carlsons soon renamed the property "Corduroy Hills Ranch," and removed the wrought-iron Chinese characters that spelled "Tao House" from the west garden gate. Many other alterations ensued, and they added hundreds of acres to the property. The house was designated a Registered National Historic Landmark in 1971, and five years later Tao House and thirteen acres of its grounds were named a National Historic Site. The property was transferred to the United States government in 1980, when the National Park Service began to restore the house to its original condition.

Eugene O'Neill National Historic Site
4202 Alhambra Avenue
Martinez, CA 94553
Open: year round, daily, tours at 10am and 12:30pm.
 Admission is free, but reservations are required
 and transportation is provided to the site.
 Closed: January 1, Thanksgiving, December 25.
Information and reservations: 925-838-0249
www.nps.gov/euon

Eudora Welty : The Eudora Welty House

Eudora Welty died in 2001. In 1986 in exchange for a life tenancy, she deeded her house and property, along with her books, manuscripts, and correspondence to the Department of Archives and History of the State of Mississippi. The contents of the house she left to her nieces, who have in turn donated them back to the state.

Eudora Welty House
1119 Pinehurst Street
Jackson, Mississippi 39202
Information: 601-353-7762. (During her lifetime,
 Welty's own telephone number.)
www.mdah.state.ms.us/welty

Edith Wharton : The Mount

The Mount was sold by the Whartons for an undisclosed sum to its 1909 summer tenants, Albert and Mary Shattuck of Greenwich, Connecticut. The deed of sale stated, in the manner of the times, that the price paid for the house, property, and furniture was one dollar and "other valuable considerations"—a sum reckoned to be $180,000. They renamed the house "White Lodge," made $200,000 worth of alterations to the estate, and lived there until Mrs. Shattuck's death in 1935. Her heirs auctioned off her possessions (including the eighteenth-century Flemish tapestries installed by Wharton), and sold the property in 1938 to Carr and Louise Van Anda for $25,600, and in 1942 it was re-sold, for an even smaller amount, to the Foxhollow School, a preparatory school for girls. For the next thirty years, The Mount was a dormitory for juniors and seniors. In 1971, The Mount was designated a National Historic Landmark; the next year the school closed due to financial difficulties. The house was unoccupied until it was purchased in 1977 for development into a condominium/time-share resort. While those plans were afoot, a theater company rented The Mount with an option to buy, but they could not raise sufficient funding. In 1979 the private, non-profit Edith Wharton Restoration, Inc. was formed and, in an arrangement with the National Trust for Historic Preservation, acquired the property. They have managed it since. Restoration began in 1997.

The Mount
2 Plunkett Street (off Route 7)
Lenox, Massachusetts 01240
Open: daily, May through November, 9am–5pm.
Information: 413-637-1899
www.EdithWharton.org

Walt Whitman : The Walt Whitman House

Having promised his dying mother that he would always look after his younger brother Eddy, Whitman left the house to him in his will. Eddy was then living in Camden, at the Stevens Street home of his brother George and his wife Louisa, who cared for him. Following closely on Whitman's own death, both Eddy and Louisa also died in 1892, so ownership passed to George, and after his death to his niece Jessie, the daughter of Whitman's brother Jefferson, who was living in St. Louis. The house was rented out all the while. Whitman's disciple Horace Traubel had always wanted to have the house become a historic shrine, and after his death in 1919 there was renewed interest in doing so. The city of Camden purchased the house in 1920, and within a few years opened it to the public. The Walt Whitman Foundation, whose early members included members of the Whitman circle, helped reacquire original furniture, and Jessie Whitman was a large benefactor. In 1947 the State of New Jersey purchased the house, and in 1963 it was designated a National Historic Landmark.

Walt Whitman House
328 Mickle Boulevard
Camden, New Jersey 08103
Open: year round, Wednesday–Saturday.
Information: 856-964-5383.
www.njparksandforests.org/historic/whitman

Louisa May Alcott
The Journals of Louisa May Alcott.
 Edited by Joel Meyerson and Daniel Shealy,
 with Madeleine B. Stern. Little, Brown, 1989.
Little Women, Little Men, Jo's Boys. Edited by
 Elaine Showalter. Library of America, 2005.
Selected Fiction. Edited by Daniel Shealy,
 Madeleine B. Stern, and Joel Myerson. Little,
 Brown, 1990.
The Selected Letters of Louisa May Alcott. Edited
 by Joel Meyerson and Daniel Shealy, with
 Madeleine B. Stern. Little, Brown, 1987.

Saxton, Martha. *Louisa May Alcott: A Modern
 Biography*. Houghton Mifflin, 1977.
Stern, Madeleine B. *Louisa May Alcott: A
 Biography*. 2nd ed. Random House, 1996.

Kate Chopin
Complete Novels and Stories. Edited by Sandra
 M. Gilbert. Library of America, 2002.

Toth, Emily. *Kate Chopin*. William Morrow, 1990.
——. *Unveiling Kate Chopin*. University Press of
 Mississippi, 1999.
Walker, Nancy A. *Kate Chopin: A Literary Life*.
 Palgrave, 2001.

Emily Dickinson
The Letters of Emily Dickinson. Edited by
 Thomas H. Johnson and Theodora Ward. The
 Belknap Press of Harvard University Press,
 1958.
The Poems of Emily Dickinson. Edited by R. W.
 Franklin. Harvard University Press, 1998.

Benfy, Christopher, Polly Longworth, and Barton
 Levi St. Aubin (with photographs by Jerome
 Liebling). *The Dickinsons of Amherst*.
 University Press of New England. 2001.
Farr, Judith. *The Passion of Emily Dickinson*.
 Harvard University Press. 1992.
Habegger, Alfred. *My Wars Are Laid Away in
 Books: The Life of Emily Dickinson*. Random
 House, 2001.
Sewell, Richard B. *The Life of Emily Dickinson*.
 Farrar, Straus & Giroux, 1974.

Frederick Douglass
Autobiographies. Edited by Henry Louis Gates, Jr.
 Library of America, 1994.

Foner, Philip S. *Frederick Douglass*. Citadel Press,
 1964.
Huggins, Nathan I. *Slave and Citizen: The Life of
 Frederick Douglass*. Little, Brown, 1980
Martin, Waldo E. *The Mind of Frederick
 Douglass*. University of North Carolina Press,
 1984.
McFeely, William S. *Frederick Douglass*. W. W.
 Norton, 1991.

Ralph Waldo Emerson
Collected Poems and Translations. Edited by
 Harold Bloom and Paul Kane. Library of
 America, 1994.
Essays and Lectures. Edited by Joel Porte. Library
 of America, 1983.
The Selected Letters of Ralph Waldo Emerson.
 Edited by Joel Myerson. Columbia University
 Press, 1998.

Buell, Lawrence. *Emerson*. Harvard University
 Press, 2003.
Reynolds, David. *Beneath the American
 Renaissance: The Subversive Imagination in
 the Age of Emerson and Melville*. Knopf, 1988.
Richardson, Robert D., Jr., *Emerson: The Mind on
 Fire*. University of California Press, 1995.

William Faulkner
Conversations with William Faulkner. Edited by
 M. Thomas Inge. University Press of
 Mississippi, 1999.
Novels 1930–1935. Edited by Joseph Blotner and
 Noel Polk. Library of America, 1985.
Novels 1936–1940. Edited by Joseph Blotner and
 Noel Polk. Library of America, 1990.
Novels 1942–1954. Edited by Joseph Blotner and
 Noel Polk. Library of America, 1994.
Novels 1957–1962. Edited by Joseph Blotner and
 Noel Polk. Library of America, 1999.

Blotner, Joseph. *Faulkner: A Biography*. Random
 House, 1984.
Gray, Richard. *The Life of William Faulkner: A
 Critical Biography*. Blackwell, 1994.
Williamson, Joel. *William Faulkner and Southern
 History*. Oxford University Press, 1996.

Robert Frost
Collected Poems, Prose, and Plays. Edited by
 Richard Poirier and Mark Richardson. Library
 of America, 1995.
Selected Letters of Robert Frost. Edited by
 Lawrance Thompson. Holt, Rinehart and
 Winston, 1964.

Cox, James B. *Robert Frost: A Collection of
 Critical Views*. Prentice-Hall, 1962.
Frost, Lesley. *New Hampshire's Child*. State
 University of New York Press, 1969.
Parini, Jay. *Robert Frost: A Life*. Henry Holt, 1999.
Poirier, Richard. *Robert Frost: The Work of
 Knowing*. Oxford University Press, 1977.
Pritchard, William H. *Frost: A Literary Life
 Reconsidered*. Oxford University Press, 1989.

Nathaniel Hawthorne
Collected Novels. Edited by Millicent Bell. Library
 of America, 1983.
Tale and Sketches. Edited by Roy Harvey Pearce.
 Library of America, 1982.

Brodhead, Richard. *Hawthorne, Melville, and the
 Novel*. University of Chicago Press, 1982.
James, Henry. *Hawthorne* (1879). Cornell
 University Press, 1998.
Mellow, James. *Nathaniel Hawthorne in His
 Times*. Houghton Mifflin, 1980.
Miller, Edwin Haviland. *Salem Is My Dwelling
 Place: A Life of Nathaniel Hawthorne*.
 University of Iowa Press, 1991.
Wineapple, Brenda. *Hawthorne: A Life*. Knopf,
 2003.

Ernest Hemingway
A Farewell to Arms. Charles Scribner's Sons,
 1929.
Green Hills of Africa. Charles Scribner's Sons,
 1935.
To Have and Have Not. Charles Scribner's Sons,
 1937.
A Moveable Feast. Charles Scribner's Sons, 1964.
Selected Letters 1917–1961. Edited by Carlos
 Baker. Charles Scribner's Sons, 1981.
The Short Stories of Ernest Hemingway. Charles
 Scribner's Sons, 1966.
The Sun Also Rises. Charles Scribner's Sons, 1926.
For Whom the Bell Tolls. Charles Scribner's Sons,
 1940.

Baker, Carlos. *Ernest Hemingway: A Life Story*.
 Charles Scribner's Sons, 1969.
Lynn, Kenneth S. *Hemingway*. Harvard University
 Press, 1987.
McLendon, James. *Papa: Hemingway in Key
 West*. Langley Press, 1990.
Reynolds, Michael. *Hemingway: The 1930s*.
 Norton, 1997.

Washington Irving
*Bracebridge Hall, Tales of a Traveller, The
 Alhambra*. Edited by Andrew B. Myers.
 Library of America, 1991.
History, Tales and Sketches. Edited by James W.
 Tuttleton. Library of America, 1983.
Letters. Edited by Ralph M. Aderman, Herbert L.
 Kleinfield, and Jenifer S. Banks. Twayne,
 1979–82.
Three Western Narratives. Edited by James P.
 Ronda. Library of America, 2004.

Wagenknecht, Edward. *Washington Irving:
 Moderation Displayed*. Oxford, 1962.
Williams, Stanley T. *The Life of Washington
 Irving*. Oxford, 1935.

Robinson Jeffers
The Collected Poetry of Robinson Jeffers. Edited
 by Tim Hunt. Stanford University Press, 5 vols.,
 1988–2001.
*The Selected Letters of Robinson Jeffers,
 1897–1962*. Edited by Ann N. Ridgeway. Johns
 Hopkins Press, 1968.

The Selected Poetry of Robinson Jeffers. Edited by Tim Hunt. Stanford University Press, 2001.
The Wild God of the World: An Anthology of Robinson Jeffers. Edited by Albert Gelpi. Stanford University Press, 2003.

Karman, James. *Robinson Jeffers: Poet of California.* Revised edition. Story Line Press, 2001.

Sarah Orne Jewett
Novels and Stories. Edited Michael Davitt Bell. Library of America, 1994.

Green, David Bunnell. *The World of Dunnett Landing: A Sarah Orne Jewett Collection.* University of Nebraska Press, 1962.
Matthiessen, F. O. *Sarah Orne Jewett.* Houghton Mifflin, 1929.
Sherman, Sarah Way. *Sarah Orne Jewett: An American Persephone.* University Press of New England, 1989.
Silverthorne, Elizabeth. *Sarah Orne Jewett: A Writer's Life.* Overlook Press, 1993.

Henry Wadsworth Longfellow
Poems and Other Writings. Edited by J. D. McClatchy. Library of America, 2000.

Arvin, Newton. *Longfellow: His Life and Work.* Atlantic Little Brown, 1963.
Calhoun, Charles C. *Longfellow: A Rediscovered Life.* Beacon, 2004.

Herman Melville
Pierre, Israel Potter, The Confidence-Man, Tales, and Billy Budd. Edited by Harrison Hayford. Library of America, 1984.
Redburn, White-Jacket, Moby-Dick. Edited G. Thomas Tanselle. Library of America, 1983.
Typee, Omoo, Mardi. Edited by G. Thomas Tanselle. Library of America, 1982.

Arvin, Newton. *Herman Melville.* William Sloane, 1950.
Hardwick, Elizabeth. *Herman Melville.* Viking, 2000.
Parker, Hershel. *Herman Melville: A Biography, Vol. 1, 1819–1851.* John Hopkins University Press, 1996.
———. *Herman Melville: A Biography, Vol. 2, 1851–1891.* John Hopkins University Press, 2002.
Robertson-Lorant, Laurie. *Melville, a Biography.* Clarkson Potter, 1996.

Edna St. Vincent Millay
Collected Poems. Edited by Norma Millay. Harper & Row, 1956.
Letters of Edna St. Vincent Millay. Edited by Allan Ross Macdougall. Harper & Row, 1952.
Selected Poems. Edited J. D. McClatchy. Library of America, 2003.

Epstein, Daniel Mark. *What Lips My Lips Have Kissed: The Loves and Love Poems of Edna St. Vincent Millay.* Henry Holt, 2001.
Milford, Nancy. *Savage Beauty: The Life of Edna St. Vincent Millay.* Random House, 2001.

Flannery O'Connor
Collected Works. Edited by Sally Fitzgerald. Library of America, 1988.
Conversations with Flannery O'Connor. Edited by Rosemary M. Magee. University Press of Mississippi, 1987.
The Habit of Being: Letters of Flannery O'Connor. Edited by Sally Fitzgerald. Farrar, Straus & Giroux, 1979.

Asals, Frederick. *Flannery O'Connor: The Imagination of Extremity.* University of Georgia Press, 1982.
Cash, Jean W. *Flannery O'Connor: A Life.* University of Tennessee Press, 2002.
Elie, Paul. *The Life You Save May Be Your Own: An American Pilgrimage.* Farrar, Straus & Giroux, 2003.

Eugene O'Neill
Complete Plays 1913–1920. Edited by Travis Bogard. Library of America, 1988.
Complete Plays 1920–1931. Edited by Travis Bogard. Library of America, 1988.
Complete Plays 1932–1943. Edited by Travis Bogard. Library of America, 1988.
Selected Letters of Eugene O'Neill. Edited by Travis Bogard and Jackson R. Bryer. Yale University Press, 1988.
Work Diary, 1924–1941. Edited by Donald Gallup. Yale University Press, 1981.

Black, Stephen A. *Eugene O'Neill: Beyond Mourning and Tragedy.* Yale University Press, 1999.
Gelb, Arthur, and Barbara Gelb. *O'Neill.* Harper & Brothers, 1962.
Sheaffer, Louis. *O'Neill, Son and Playwright.* Little, Brown, 1968.
———. *O'Neill, Son and Artist.* Little, Brown, 1973.

Mark Twain (Samuel Clemens)
Collected Tales, Sketches, Speeches, and Essays 1852–1890. Edited by Louis J. Budd. Library of America, 1992.
Collected Tales, Sketches, Speeches, and Essays 1891–1910. Edited by Louis J. Budd. Library of America, 1992.
The Gilded Age and Later Novels. Edited by Hamlin L. Hill. Library of America, 2002.
Historical Romances. Edited by Susan K. Harris. Library of America, 1994.
The Innocents Abroad and Roughing It. Edited by Guy Cardwell. Library of America, 1984.
Mississippi Writings. Edited by Guy Cardwell. Library of America, 1982.

Andrews, Kenneth R. *Nook Farm: Mark Twain's Hartford Circle.* Harvard University Press, 1950.
Geismar, Maxwell. *Mark Twain: An American Prophet.* Houghton Mifflin, 1970.
Kaplan, Fred. *The Singular Mark Twain.* Doubleday, 2003.
Kaplan, Justin. *Mr. Clemens and Mark Twain.* Simon and Schuster, 1966.
Ward, Geoffrey C., and Dayton Duncan. *Mark Twain.* Knopf, 2001.

Eudora Welty
Conversations with Eudora Welty. Edited by Peggy Whitman Prenshaw. University Press of Mississippi, 1984.
Complete Novels. Edited by Richard Ford and Michael Kreyling. Library of America, 1998.
Eudora Welty Photographs. Foreword by Reynolds Price. University Press of Mississippi, 1989.
More Conversations with Eudora Welty. Edited by Peggy Whitman Prenshaw. University Press of Mississippi, 1996.
Stories, Essays, and Memoir. Edited by Richard Ford and Michael Kreyling. Library of America, 1998.
A Writer's Eye: Collected Book Reviews. Edited by Pearl Amelia McHaney. University Press of Mississippi, 1994.

Kreyling, Michael. *Author and Agent: Eudora Welty and Diarmuid Russell.* Farrar, Straus & Giroux, 1991.
Marrs, Susanne. *One Writer's Imagination: The Fiction of Eudora Welty.* Louisiana State University Press, 2002.
Waldron, Ann. *Eudora: A Writer's Life.* Doubleday, 1998.

Edith Wharton
Collected Stories 1891–1910. Edited by Maureen Howard. Library of America, 2001.
Collected Stories 1911–1937. Edited by Maureen Howard. Library of America, 2001.
The Letters of Edith Wharton. Edited by R.W.B. Lewis and Nancy Lewis. Scribners, 1988.
Novellas and Other Writings. Edited by Cynthia Griffin Wolff. Library of America, 1990.
Novels. Edited by R.W.B. Lewis, Library of America, 1985.

Benstock, Shari. *No Gifts from Chance: A Biography of Edith Wharton.* Scribners, 1994.
Craig, Theresa. *Edith Wharton, A House Full of Rooms: Architecture, Interiors, and Gardens.* Monacelli, 1996.
Dwight, Eleanor. *Edith Wharton: An Extraordinary Life.* Harry N. Abrams, 1994.
Lewis, R.W.B. *Edith Wharton: A Biography.* Harper & Row, 1975.
Wolff, Cynthia Griffin. *A Feast of Words: The Triumph of Edith Wharton.* Oxford, 1993.

Walt Whitman
Intimate with Walt: Selections from Whitman's Conversations with Horace Traubel 1888–1892. Edited by Gary Schmidgall. University of Iowa Press, 2001.
Poetry and Prose. Edited by Justin Kaplan. Library of America, 1982.
Selected Poems. Edited by Harold Bloom. Library of America, 2002.

Kaplan, Justin. *Walt Whitman: A Life.* Simon and Schuster, 1980.
Loving, Jerome. *Walt Whitman: The Song of Himself.* University of California Press, 1999.
Reynolds, David S. *Walt Whitman's America: A Cultural Biography.* Alfred A. Knopf, 1995.